U0136676

Shung Ye Museum of Formosan Aborigines Monograph 1

THE FORMOSAN ENCOUNTER

THE FORMOSAN ENCOUNTER

Notes on Formosa's Aboriginal Society:
A Selection of Documents from
Dutch Archival Sources

Volume I: 1623-1635

Edited by
Leonard Blussé, Natalie Everts & Evelien Frech

Published by
Shung Ye Museum of Formosan Aborigines
Taipei 1999

This publication has been sponsored by
Shung Ye Museum of Formosan Aborigines

Cover illustration: 'Ein Formosan'. Drawing by C. Schmalkalden.
From: *Die wundersamen Reisen des Casper Schmalkalden nach West- und Ostindiën 1642-1652/[Casper Schmalkalden]*. Nach einer bisher unveröffentlichten Handschrift bearbeitet und herausgegeben von Wolfgang Joost. Leipzig 1983.

ISBN 957-99767-2-4

Distributor:
SMC PUBLISHING INC.
14, Alley 14, Lane 283, Roosevelt Rd. Sec. 3
Taipei 106, Taiwan, ROC
Tel. (886-2) 2362-0190 Fax (886-2) 2362-3834

CONTENTS

PREFACE

This publication has been commissioned and funded by the Shung Ye Museum of Formosan Aborigines, Taiwan.

The groundwork for this source publication was laid by Mrs Evelien Frech. Hers was the painstaking labour of selecting and transcribing most of the seventeenth-century Dutch sources used for this publication. Other responsibilities forced her to hand over her assignment to Miss Natalie Everts. Therefore, this publication is the result of a combined undertaking.

It is our pleasant duty to thank Professor Ts'ao Yung-ho, Professor James Liang, Professor Tsuchida Shigeru, Miss Chen Yi-chun, and Mr Eric Yu for enabling a close co-operation between the Shung Ye Museum of Formosan Aborigines and Leiden University. Mrs Wilma van der Schrier retyped various parts of the transcribed texts, Mrs Rosemary Robson critically went through the English translation and improved on its style, and Mrs Ria Hogervorst processed the final text for publication. Finally we would like to thank Miss Cynthia Viallé for assisting the editors in the final phase of this volume.

Any remaining errors are to be blamed on the editors, who are cheerfully looking forward to publishing the next volume, on Formosan society in the 1640s, in the near future.

Leiden, 3 October 1997
The Editors

INTRODUCTION

It is not easy to write an autonomous history of the Formosan Aborigines: of course the island enjoys a rich oral tradition, but in other respects the tribal people - devoid of a written tradition - belong to those people whom Eric Wolf has called 'the people without history'.[1]

Yet it would be wrong to assume that there is no literature about the Formosans. If we peruse the written sources left by the settlers and the colonizers of the island in early modern times - the Han Chinese from Fukien Province, the Dutch, and the Spaniards - we come across a considerable amount of 'contact literature', in which the encounter with 'the Other' is described. Accounts like Ch'en Ti's observations of *Tung Fan* (1603),[2] the description of Soolangh by Constant and Pessaert (1623), or the 'Discourse' by Reverend Candidius (1628) - the latter two are included in this volume - are fine examples of the early genre of contact literature for which every historian or anthropologist searching for ethnographical data craves.[3]

The publication of such more or less complete accounts is a fairly straightforward process of editing, annotation, and etymological explanation. But when the researcher has to scrape together scattered data from a vast body of different sources with the ultimate aim of creating a larger picture, it is almost like gathering loose strands and frayed ends in order to reweave them into a tapestry. Consequently, this kind of selective collecting of source material, which we have undertaken for the present publication, is a risky enterprise for which we alone are accountable. First of all, the basic decision of what to include and what to exclude has to be made. Secondly, editors have to suppress their own opinion and refrain from drawing conclusions freely or spinning narratives: that remains the domain of the historian.

These were the challenges faced by the editorial team at Leiden University, which was commissioned by the Shung Ye Museum of Formosan Aborigines three years ago to look into the possibility of creating a series of source publications in English about Formosan society during the Dutch period (1623-1662). The name Formosa is deliberately employed here, as Taiwan (Tayouan) - Terrace Bay - had not yet come into use as *pars pro toto*, a name for the whole island. In the seventeenth century, pre-

sent-day Taiwan was known among Europeans by the name given to it by Portuguese seafarers: Isla Formosa, the beautiful island.

Within a seventeenth-century context it would amount to a pleonasm to speak of Formosan aborigines. The Dutch always referred to the population as 'Formosanen' and wrote about 'Chineesen' whenever they referred to the Chinese settlers, fishermen, and traders on the island. Thus the title of this publication presented itself almost naturally: *The Formosan Encounter. Notes on Formosa's Aboriginal Society: A Selection of Documents from Dutch Archival Sources*.

Once the challenge of making a 'selection raisonnée' from the extant Dutch sources had been accepted, we had to make the decision what to include and what to exclude. It seemed reasonable to think that the first-hand accounts would be the most detailed and trustworthy ones. Generally speaking, this is true, but there are exceptions to which we would like to draw attention. Paradoxically, the more general reports drawn up at Zeelandia Castle, the headquarters of the Dutch East India Company on Formosa, often contain more interesting information than the first-hand observations on which they were based, because they are of a more reflective nature and are based on various sources. Consequently, in a number of cases in which the same events are mentioned in first and second-hand sources, we have given preference to the second-hand accounts. Whenever we have considered different reports to be of a complimentary nature, we have published them together.

In order to account more specifically for the kind of archival data we have selected, a brief introduction into the Dutch sources would be useful.

The sources

The Dutch East India Company, the territorial ruler of the island from 1624 to 1662, has left a large corpus of records about Formosa. They yield information of all kinds: elaborate, ethnographic descriptions, expedition reports, sympathetic remarks or pejorative smears, and a scattering of matter-of-fact statements concerning issues such as demography, education, religion, local enterprise, and so on. When the gradual imposition of Dutch rule replaced the first phase of encounter and wonder, the aboriginal population was commented upon by the Dutch from the point of view of policy making or crisis management.

It is not clear what has happened to the original archives of the colonial administration at Zeelandia Castle (today's Tainan city). Part of the records must have been shipped home on board the Dutch fleet, another part probably got lost after the transfer of power to Chinese warlord and Ming loyalist Cheng Ch'eng-kung on 1 February 1662. Nonetheless, over 3,000 entries on Taiwan are still at our disposal at the General State Archives in The Hague. These are to be found in the documents which were sent from Batavia, the headquarters of the Dutch East India Company in Asia, to the Company headquarters in Holland. This means that the historical evidence on Taiwan is scattered over and filed under different headings in the vast archives of the VOC, which cover a total length of 1277 metres.[4]

The directorate of the Dutch East India Company centred the formation of its archival deposits on its own administrative needs and goals. At the top of the administrative pyramid we find the Governor-General and Council, the High Government at Batavia, which reported to and corresponded with the Gentlemen XVII, the Company directors in the Netherlands. The High Government issued orders to the lower local echelons, in our case the Governor of Taiwan and his council. They in turn reported to and corresponded with Batavia. The governor issued orders to his military commanders and political commissioners in the field, who in return reported to and corresponded with the governor. Parallel to this administrative pyramid we find letters written by clerics, either to the administration, or to their *classis* in Holland.

The Governor and Council of Taiwan met almost daily at Zeelandia Castle to discuss administrative and trading matters. The decisions or *resoluties* taken during these meetings were duly noted down. To what extent the resolutions were really carried out and what results they yielded can be studied in the *dagregister* or diary that was kept by the governor.

The Zeelandia Castle diary was kept for several reasons. It could serve as a reference tool for Company officials who wanted to ascertain what decisions their predecessors had taken under certain circumstances and what deals had been made. Whenever a ship left for Batavia, the Governor of Taiwan would report in a seasonal letter on the general political situation on the island and the trading activities of the Company. These letters were accompanied by a considerable number of documents, varying from the Zeelandia Castle diary and the Resolutions of Governor and Council to local

correspondence or information on such widely different issues as school examinations in the Formosan villages or bills of lading of VOC vessels. These batches of documents essentially constitute the body of records concerning Taiwan that have been stored in the VOC archives in the Netherlands.

When the mail from Taiwan arrived in Batavia, one officially designated Councillor of the High Government, quite often an experienced person who had served in Taiwan in the past, would scrutinize the documents and draw up a reply in which he included the most recent instructions from the Netherlands concerning Taiwan.

This Councillor had another important task: he also had to report to the Board of Directors in the Netherlands on recent developments in the South China Sea region. Twice, or sometimes even three times a year, depending on the number of departures of the 'home fleets' leaving for the Netherlands, the High Government in Batavia prepared a so-called *Generale Missive* (General Letter). This letter was in fact a general survey of all recent political, social, and economic developments in the Asian regions in which the VOC traded, and included a survey of all important events in Taiwan during the past season prepared by the Councillor in charge of Formosan affairs.

Large collections of other documents, generally copies of the original correspondence between Batavia and the other VOC establishments in Asia accompanied the General Missives. Those extant are to be found in the series of the *Overgekomen Brieven en Papieren* (Letters and Annexes Received from the Indies) in the VOC archives. This so-called *OBP* collection, contains the bulk of the documents about Taiwan which have been preserved.

One of the great frustrations of the historian working with these VOC records on Taiwan is the relative dearth of material, documents, and maps alike, of an administrative nature. In the past the lack of this kind of material has been explained by the simple fact that the Dutch were first and foremost merchants, who only were interested in maritime trade. Yet it is most likely that these materials did exist in the local archive of Zeelandia Castle, but they must have been lost after the surrender in 1662.

Historical research on seventeenth-century Taiwan has still not taken off, because the full potential of the VOC archives has not yet been properly

exploited. Recently, a concerted effort has been made to make these sources available to a larger public. The publication of all the remaining *daghregisters*, or diaries, of Zeelandia Castle, is now reaching completion. The fourth and last volume will be published in 1998.[5] According to our latest information, Professor Chiang Shu-sheng is now preparing a Chinese translation of these diaries. A fully annotated translation into Chinese of all entries on Taiwan in the so-called *Generale Missiven* has been made by Dr Cheng Shaogang. It will be published in 1998 by Lien Ching Publishers. Already more than a hundred years old is the source publication on religious matters by J.A. Grothe.[6] Without doubt, these source publications will lay a firm foundation for further research on Taiwan.[7]

Historical background

In 1622 the Governor-General of the Netherlands East Indies, Jan Pieterszoon Coen, sent a strong fleet of twelve ships manned by more than one thousand sailors and soldiers to the south-east coast of China, in order either to attack and occupy Portuguese-held Macao or 'to occupy and fortify another strategic place on the Chinese coast'. In his instructions to the admiral of this fleet, Cornelis Reijersen, Coen wrote:

'If the attack on Macao is given up, we intend to have a fortress built on one of the most appropriate places that can be found in the neighbourhood of Macao or Chincheu (the Bay of Amoy). We believe this must be done on the Pescadores (P'eng-hu archipelago) or the island of Lequeo Pequeno (Formosa). We understand that the Pescadores provide a very good roadstead. Because these islands are very conveniently situated close to Chincheu, we prefer this location, yet it greatly bothers us that these islands are very sandy, infertile, and devoid of wood and stone.

The island of Lequeo Pequeno is indeed beautiful and abundant with deer, but so far we have not been able to find out whether there is a good roadstead for big ships.'[8]

Suffering from the repulse of the attack on Macao by the valiant Portuguese defenders, the Dutch fleet did indeed head for the Pescadores. There, in the autumn of 1622, the construction of a fortress was started. In the following year Dutch sailors began to explore the coasts of nearby Lequeo Pequeno or Isla Formosa. During their explorations, they were greatly helped by a Chinese merchant called Li Tan, who used the bay of

Taiwan as an illegal barter harbour for his smuggling activities between Japan and China.[9]

Taiwan - then known to the Chinese as *Tung-fan* - was not just an entrepôt for Chinese and Japanese smugglers and traders. Chinese fishermen, who occasionally used the island as a typhoon shelter when fishing in the adjacent fishing grounds, soon discovered that the Formosan people gladly traded deerskins and venison for ironware, earthenware, piece-goods and other Chinese commodities. Most of the trading went on in the Bay of Taiwan, near present-day Tainan, and it was here that the Dutch started to build a bamboo stockade on a sand dune as early as 1623. After the evacuation of the Pescadores, this stockade was replaced in the summer of 1624 by the stone walls of Zeelandia Castle.

Until the summer of 1661 - when the island was invaded by Cheng Ch'eng-kung - the Dutch East India Company extended its rule over the western side of the island and built more fortifications at Tan-shui (*Tamsuy*) and Chi-lung (*Quelang*) in north Formosa, at the expense of the Spaniards whom they chased away. The story of this colonial period is of particular interest, because during these almost forty years, Formosa developed from being a relatively isolated island into an entrepôt of international trade. The native hunting communities of the island witnessed a large influx of Han Chinese settlers who came to seek a living in hunting, handicrafts, trade, or agriculture. When Cheng Ch'eng-kung arrived in 1661, the island of Formosa had developed an agricultural infrastructure strong enough to feed and house his troops.

When the Dutch East India Company established Zeelandia Castle at the entrance of the Bay of Taiwan, with the intention of winning a place in the trade in Far Eastern waters, initially relations with the Formosan population remained limited to daily contacts with the tribal populations of the villages across the Bay of Taiwan.

In early 1626 Governor-General Pieter de Carpentier still had a dim view about the possibilities of developing a closer relationship with the Formosans in the near future:

'We were on good and friendly terms with the inhabitants of the place, not so much because of the expected profits as by not turning them into enemies, as they are a disorderly, fierce, malicious, lazy, and greedy

people, of whom something good can only be expected after a very long time and through the disintegration of their depraved nature.'[10]

Nonetheless, the Dutch soon found themselves on more intimate terms with the Formosan population, witness the formidable ethnographical account of Reverend George Candidius who felt great sympathy for the people among whom he had chosen to propagate the Gospel in 1627:
'Generally speaking these people are very friendly, faithful and good-hearted. They will treat our nation in a very friendly fashion to food and drinks as much as they can, as long as these do not come to visit them too often and are not rude in their behaviour (...) They are not treacherous, yea indeed would rather die or suffer any hardship than inflict sorrow upon others because of their treachery. They have a sound mind and a good memory, understanding and remembering things easily.'[11]

During the first ten years (1624-1634) the Dutch merchants in Zeelandia Castle focused their efforts on reaching a stable trading relationship with their Chinese counterparts in Fukien Province rather than on developing the economic prospects of the island of Formosa itself. In order to gain the upperhand in the trade with Fukien, no efforts were spared to discourage Japanese traders from expanding their trade with visiting Chinese merchants. This resulted in an unexpected move on the part of the Japanese, which drew the Formosans into the Dutch-Japanese track rivalry. A delegation of Formosan villagers was shipped on board a Japanese junk to Nagasaki to present the sovereignty over Formosa to the Shogun in Edo.

In 1627, the newly-appointed Governor of Formosa, Pieter Nuyts, was sent on an official embassy to the shogunal court to settle the problems with the Japanese traders on Formosa once and for all. But, on his arrival in Japan, he was informed that a delegation of sixteen Sincandian 'ambassadors' from Formosa had arrived in Nagasaki before him, with the intention of paying tribute to the Shogun as an acknowledgement of the transfer of the sovereignty of Formosa. The adventures of the Formosan ambassadors in Japan and the aftermath of their return to their native village read almost like a tragicomedy. The whole affair actually earned their headman, Dika,[12] a good deal of respect among his own people and strengthened the self-confidence of the Formosans in their negotiations with the Dutch.

Although Governor Nuyts chose to follow a policy of non-interference, he became so embroiled in the aftermath of this affair and the increasingly truculent behaviour of the neighbouring villages of Mattau and

Baccaluan that he lost control. In the summer of 1629, a force of sixty handpicked Dutch musketeers were ambushed by the people of Mattau and overnight the Dutch forfeited all their gradually acquired respect. Governor Nuyts was recalled to Batavia. He was finally even dispatched to Japan to account for his past behaviour towards the Japanese traders on Formosa.

After the arrival of Nuyts' successor, Hans Putmans, and of the Reverend Robertus Junius the relationship with the Formosans intensified. Junius advocated a more agressive policy towards the warlike villages but it was not until three years later - when trade with China had obtained a firm footing in 1633 - that the Dutch administration in Zeelandia Castle could finally turn its attention to the 'pacification' of the countryside and to the development of the natural resources of Formosa proper. A policy of territorial expansion was initiated, in which the clerics of the Dutch Reformed Church played an important role.[13] The personal correspondence between Junius and Putmans, from which we have selected extensive quotations, bears witness to this more pragmatic approach towards Formosan affairs. Two punitive expeditions (against the island of Lamey and the village of Mattau) form the last part of this source publication. These campaigns provide an overture to the pacification of the warring tribes on the Western Plains of the island in the early 1640s. That story remains to be told in the next volume.

Notes:

1. Eric R. Wolf, *Europe and the people without history*, Berkeley, 1982.
2. Laurence Thompson, 'The Earliest Chinese Eyewitness Accounts of the Formosan Aborigines', in: *Monumenta Serica* 23: 163-204.
3. See for instance John Robert Shepherd's formidable *Statecraft and Political Economy on the Taiwan Frontier 1600-1800*, Stanford University Press 1993.
4. See: Ts'ao Yung-ho, Pau Lo-shih, Chiang Shu-sheng eds., The Inventory of Dutch East India Company Related Documents (Ho-lan Tung In-du kung-sze you kuan T'ai-wan tang-an mu-lu), Vol. 10 of the *T'ai-wan-shih tang-an, wen-shu mu-lu* series, Taiwan University, Taipei, 1997.
5. J.L. Blussé, M.E. van Opstall and Ts'ao Yung-ho eds., *Dagregisters van het Kasteel Zeelandia 1629-1662*, Rijksgeschiedkundige Publicatiën series, Vol. I: 1629-1641, 's-Gravenhage 1986; Volume II: 1641-1648, RGP, grote serie 229. ('s-Gravenhage 1995); Volume III: 1648-1655. RGP, grote serie 223. 's-Gravenhage 1996.
6. J.A. Grothe ed. *Archief voor de Geschiedenis der Oude Hollandsche Zending*. Volumes III, IV. Utrecht 1886, 1887.
7. A detailed study of the attempts that have been made in the past by such pioneers as Murakami Naojiro, Iwao Seichii, Nakamura Takashi, Lai Yung-hsiang, and last but not least Ts'ao Yung-ho to make Dutch sources accessible to historians who cannot read Dutch still remains to be compiled.
8. General Missive Governor-General Jan Pietersz Coen, Batavia, 26 March 1622. VOC 1075, fol. 94-102. Published in: Cheng Shaogang ed. *De VOC en Formosa 1624-1662, een vergeten geschiedenis*, (thesis) Leiden 1995, p. 12.
9. Iwao Seiichi, 'Li Tan, Chief of the Chinese Residents at Hirado, Japan, in the Last Days of the Ming Dynasty', in: *Memoirs of the Research Department of the Toyo Bunko 17* (1958), pp. 27-83.
10. See entry 18 of this volume.
11. See entry 51 of this volume.
12. Dika's importance is revealed by a later entry in the Dagregister Zeelandia (dated shortly before March 1650) when the death of headman Dika in Sincan is mentioned: '(...) who long before was made King of Formosa in Japan.' *Dagregisters van het kasteel Zeelandia*, Volume III: 1648-1655. RGP, grote serie 233. ('s-Gravenhage 1996), p. 101.
13. See L. Blussé, 'Dutch Protestant Missionaries as Protagonists of the Territorial Expansion of the VOC on Formosa', in: D. Kooiman ed., *Conversion, Competition and Conflict*, Amsterdam 1984, pp. 155-184; W.A. Ginsel, *De Gereformeerde Kerk op Formosa; of de Lotgevallen ener handelskerk onder de OIC, 1627-1662*, Leiden 1931.

ILLUSTRATIONS

Map of Formosa and the Pescadores

Originally published in: *Dagregisters van het kasteel Zeelandia,* Vol. I, RGP 195.

Geographical names used in the documents:

Seventeenth Century:

1. Vuyle eilanden
2. Lange eiland
3. Pehouw
4. Vissers eiland
5. Kleine Tafel
6. Grote Tafel
7. Westelijk eiland
8. Rovers eiland
9. Kerkbaai
10. Groot eiland Pehouw
11. Swarte Clippen
12. Zuider eiland
13. Steenklippen eiland
14. Zuidooster eiland
15. Mattau River
16. Soulang
17. Mattau
18. Baccaluan
19. Tevorang
20. Sincan
21. Tavocan
22. Saccam
23. Paxemboy
24. Zeelandia castle, Tayouan
25. Zoute Rivier
26. Jouckan
27. Apenberg
28. Tancoya
29. Verovorong
30. Tamsuy River
31. Dolatock
32. Pangsoor
33. Kattangh
34. Lamey
35. Lonkjauw
36. Dolaswock
37. Tavaly
38. Pimaba
39. Linauw
40. St. Laurens Baai
41. Keriwan River
42. Cavolan
43. Tarochian River
44. Torockjam
45. St. Jago
46. Quelang
47. Tamsuy
48. Tamsuy River
49. Lamkam
50. Sinkangja
51. Texam
52. Goema
53. Pangsoa
54. Gierim
55. Heyaukan
56. Vasikan
57. Favorlang
58. Teribo
59. Poncan River
60. Poncan
61. Tirosen
62. Wancan River
63. Wancan
64. Dorcko

At present:

1. Kuo Hsü
2. Chipei Hsü
3. Paisha Tao
4. Yüweng Tao
5. Tungpan
6. Huching
7. Hua Hsü
8. Pachao Tao
9. Makung Wan
10. Penghu Tao
11. Licheng Chiao
12. Chimei Hsü
13. Tungsüping
14. Tungshi Hsü
15. Tshengwen Chi
16. Chiali
17. Matou
18. Anting
19. Shanhua
20. Hsinshih
21. Hsinhua
22. Tainan
23. (Tainan)
24. Anping
25. Erhjen Chi
26. Yunga
27. Shoushan
28. Kaohsiung
29. Wantan
30. Hsiatanshui Chi
31. Tungchiang
32. Linping
33. Chiatung
34. Hsiao Liuchiu
35. Hengchun
36. Manchou
37. Taimali
38. Taitung
39. Chian
40. Suao Wan
41. Lanyang Chi
42. Ilan
43. Chiwulan Chuan
44. Toucheng
45. Santiao Chiao
46. Chilung
47. Tanshui
48. Tanshui Chi
49. Nankan
50. Hsinfeng
51. Hsingchu
52. Chingshui
53. Changhua
54. Erhlin
55. Wenchiang
56. Lunpei
57. Huwei
58. Tounan
59. Peichiang Chi
60. Peichiang
61. Chiayi
62. Pachang Chi
63. Haomei
64. Tungshan

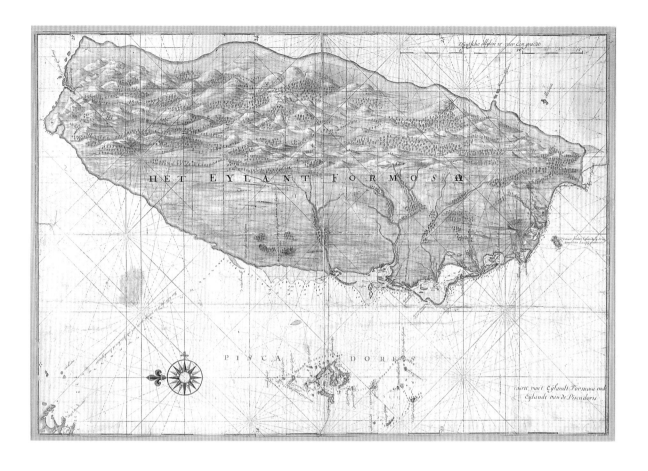

Map of the island of Formosa and the Pescadores (1636)

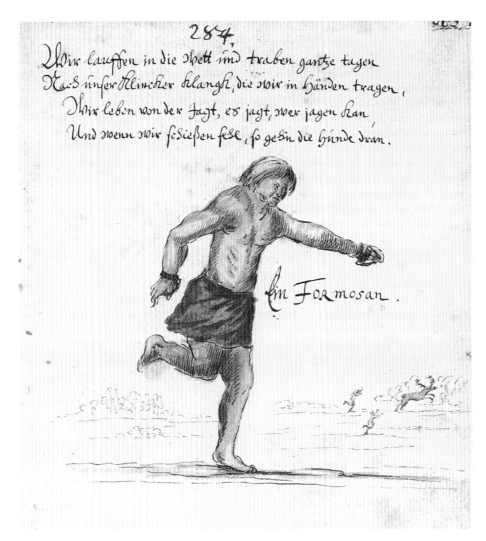

Formosan Deerhunter

'A Formosan'

'We walk in the fields and run all day
Close to us you can hear the sound of the little bells we carry in our hands
We live by hunting, everyone who is able goes out hunting
And when our shots miss then the dogs will hunt the prey'

Drawing from: *Die wundersame reisen des Caspar Schmalkalden nach West- und Ostindiën 1642-1652*. Original manuscript in: Forschungsbibliothek Gotha (signature Chart B 535) Reprint by W. Joost (Leipzig 1983) p. 145.
Library Algemeen Rijksarchief Den Haag.
Illustration also published in: *Dagregisters Taiwan*, Volume II: RGP 229 ('s-Gravenhage 1995), p. XVI.

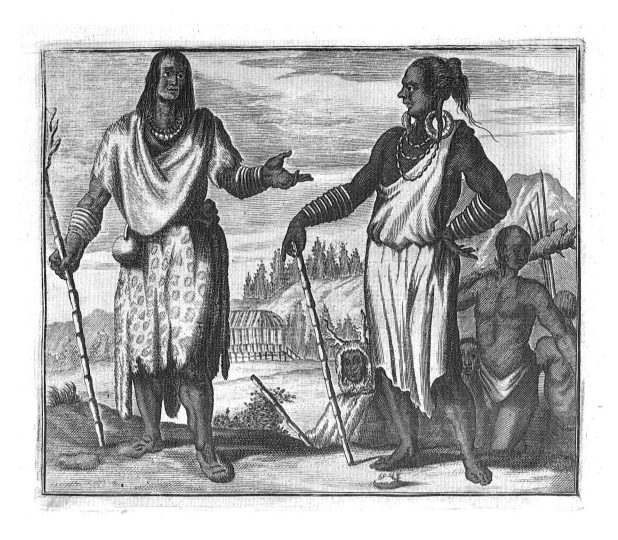

Inhabitants of Formosa

From: O. Dapper, *Gedenkwaardig bedrijf der Nederlandsche Oost-Indische Maet-schappye op de Kuste en in het keizerrijk van Taising of Sina*. Amsterdam 1670.
Library Algemeen Rijksarchief Den Haag.
Illustration also published in: *Dagregisters Taiwan*, Volume II: RGP 229
('s-Gravenhage 1995), p. XVII.

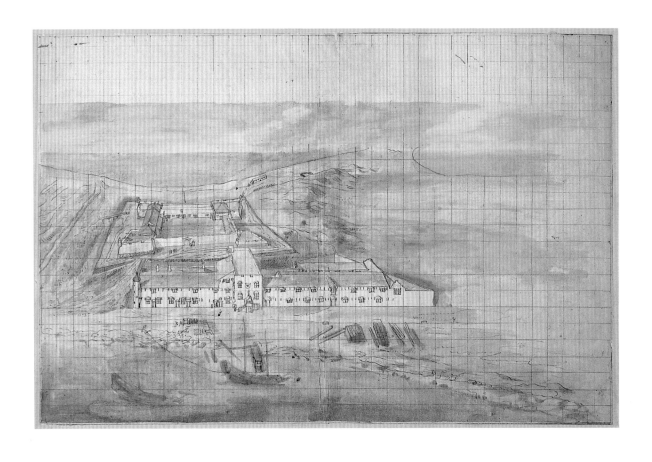

Drawing of a VOC-factory and fort. Now identified as Zeelandia Castle on the Tayouan peninsula (circa 1634)

Vingboons-Atlas, Algemeen Rijksarchief Den Haag. inv.nr. 4 VELH 619.
Published in: Dagregisters Taiwan, Volume II: RGP 229 ('s-Gravenhage 1995),
p. XIV.

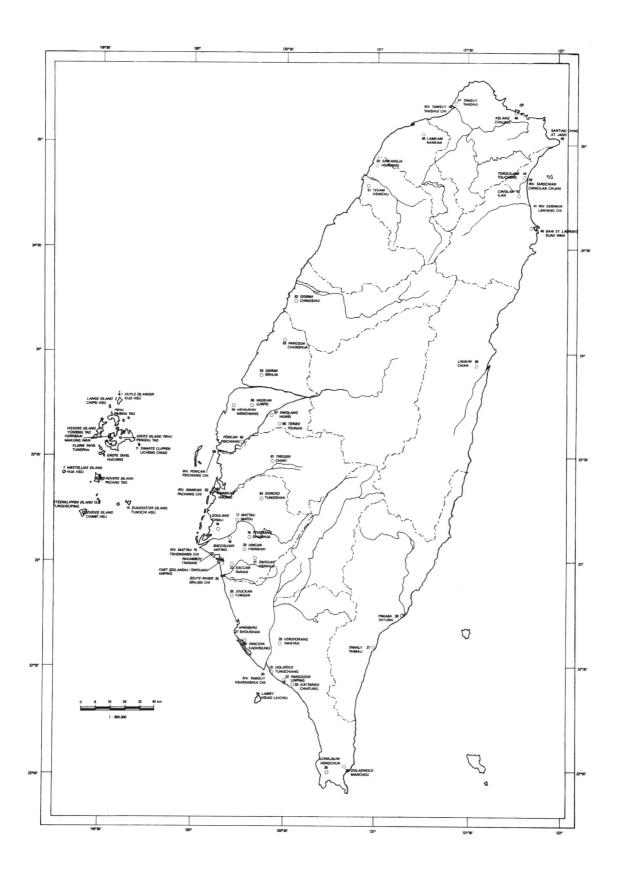

LIST OF DOCUMENTS

All documents are stored at the Algemeen Rijksarchief (General State Archives) in The Hague, the Netherlands, with the exception of the *Discourse* (entry 49) by Reverend Georgius Candidius, which is kept at the Rijksarchief Utrecht.

The major part of the documents at the Algemeen Rijksarchief belong to the Archives of the Verenigde Oost-Indische Compagnie (VOC). The remaining documents are to be found in the Teding van Berkhout Collection.

After the number and heading of each entry the following information is given:

- Location reference of the original:

VOC	Archives of the Dutch East India Company and the inventory number as listed in *The Archives of the Dutch East India Company (1602-1795)*. The page numbers (abbreviated *fol.*) are those of the original manuscripts.
TEDING	Teding van Berkhout Collection and the inventory number as listed in the inventory of the collection.

- References to previously published excerpts. These appear in abbreviated form. Full citations are given in the bibliography.

DRZ	*Dagregisters van het kasteel Zeelandia, Taiwan 1629-1662*, Volume I: 1629-1641
FORMOSA	*De VOC en Formosa 1624-1662, een vergeten geschiedenis*
BESCHEIDEN	*Jan Pietersz. Coen, Bescheiden omtrent zijn bedrijf in Indië*, Volumes I-VII
ZENDING	*Archief voor de Geschiedenis der Oude Hollandsche Zending*, Volume III
DRB	*Daghregisters gehouden in 't Casteel Batavia 1624-1629*

65. Dagregister Zeelandia.
 VOC 1101, fol. 390v. Extract 23 November 1629.
 DRZ, Vol. I, pp. 4-5.

66. Dagregister Zeelandia.
 VOC 1101, fol. 390. Extract 28 November 1629.
 DRZ, Vol. I, p. 5.

67. Dagregister Zeelandia.
 VOC 1101, fol. 391. Extract 2 December 1629.
 DRZ, Vol. I, pp. 5-6.

68. Original Missive Pieter Nuyts to the Amsterdam Chamber. Batavia,
 15 December 1629.
 VOC 1098, fol. 319-320. See also: General Missive, VOC 1097, fol.
 51.
 FORMOSA, p. 92.

69. Dagregister Zeelandia.
 VOC 1101, fol. 396-397. Extracts 1, 2, 3, February 1630.
 DRZ, Vol. I, pp. 15-16.

70. Missive Reverend Georgius Candidius to Governor-General Jacques
 Specx. Tayouan, 27 March 1630.
 VOC 1100, fol. 6.

71. Dagregister Zeelandia.
 VOC 1101, fol. 441. Extract 17 April 1630.
 DRZ, Vol. I, pp. 27-28.

72. Dagregister Zeelandia.
 VOC 1101, fol. 441. Extract 13 May 1630.
 DRZ, Vol. I, pp. 28-29.

73. Dagregister Zeelandia.
 VOC 1101, fol. 443v. Extract 8 July 1630.
 DRZ, Vol. I, p. 33.

74. Resolution. Tayouan, 10 July 1630.
 VOC 1101, fol. (...).
 ZENDING, Vol. III, p. 52.

75. Interrogation Corporal Jan Barentsen, of Delft, and Lancer Juriaen
 Smith, of Strasbourg. Tayouan, 27 July 1630.
 VOC 1100, fol. 13-14.

76. Interrogation Merchant Paulus Traudenius. Tayouan, 29 July 1630.
 VOC 1100. fol. 10-12. Extracts.

134. Dagregister Zeelandia.
 VOC 1114, fol. 56v. Extract 29 April 1634.
 DRZ, Vol. I, p. 171.

135. Missive Governor-General Hendrick Brouwer to Governor Hans Putmans. Batavia, 13 May 1634.
 VOC 1111, fol. 327-336.

136. Missive Reverend Georgius Candidius to Governor Hans Putmans. Sincan, 14 May 1634.
 TEDING 15, fol. 10.

137. Missive Governor-General Hendrick Brouwer to the Church Council in Tayouan. Batavia, 27 June 1634.
 VOC 1111, fol. 376-378.

138. General Missive.
 VOC 1111, fol. 4-143.
 FORMOSA, p. 135. Extract 15 August 1634.

139. Dagregister Zeelandia.
 VOC 1114, fol. 67. Extract 25 August 1634.
 DRZ, Vol. I, p. 188.

140. Missive Governor Hans Putmans to the Reverends Georgius Candidius and Robertus Junius. Tayouan, 8 September 1634.
 TEDING 14, fol. 3.

141. Missive Governor Hans Putmans to Governor-General Hendrick Brouwer. Tayouan, 28 September 1634.
 VOC 1116, fol. 333-348.
 Duplicate: VOC 1116, fol. 362-363v.
 ZENDING, Vol. III, p. 69.

142. Dagregister Zeelandia.
 VOC 1114, fol. 71. Extract 7, 8 October 1634.
 DRZ, Vol. I, p. 195.

143. Original Missive Governor Hans Putmans to the Amsterdam Chamber.
 VOC 1114, fol. 1-14. Extract.
 ZENDING, Vol. III, pp. 71-72.

144. Dagregister Zeelandia.
 VOC 1116, fol. 232. Extracts 29, 30, 31 October 1634.
 DRZ, Vol. I. pp. 199.

DOCUMENTS

1623

1. Journal Commander Cornelis Reyersen. Pescadores, 5 January 1623-4 September 1623.
VOC 1081, fol. 57-75. Extract 1 March.

fol. 62: "Hebben uyt de mond van Hongtsieusou verstaan, alsoo hij tegenwoordich bij ons nu in de schepen is om naer de Piscadores te seylen, dat wij geen bequamer plaets hier ontrent gelegen (buyten de juridictie van China) als de baey Tayouan, sullen vinden, seggende mede dat inde voors. baeij van alles te becomen was, te weten allerley vee, overvloedich van vis oock mede een groote partije hartevellen te becomen waeren, datter oock veel Chinesen waren die met de vrouwen vant lant getrout waren.
Bij aldien wij daer een vasticheyt maeckten, soude met deselfde seer wel terechtraecken, naer sijn seggen, soo en connen de naturalen van 't lant gout nochte silver. Den handel die men met haer doet moet geschieden met groff porceleijn ende eenich groff linnen. Hoewel deselffde naeckt gaen, sijn tot het linnen genegen. Dan hebben weijnich kennis welck 't best is, twijffelen niet soo wij daer waeren geseten, ofte souden van alle plaetsen hierontrent gelegen toevoeringe genoech crijgen, soo van Hoccheuw, Sinhowa, Tsobihaua, Songsieu, Tanoua, Tseusieu, mede datter veel Chinesen daer bij ons soude comen woonen."

fol. 62: We heard from Hung Yü-yu[1], since he is now with us with the fleet to sail to the Pescadores, that we will not find a place in this area (outside the jurisdiction of China) more suitable than the Bay of Tayouan. And he also said that in this bay were to be had all sorts of things such as divers sorts of animals, a great abundance of fish, and lots of deerskins, and that there also are Chinese living there, who have married local women.
Were we to build a fortification there we would be able to get along with them. According to him, the inhabitants of the land know neither gold nor silver. One must trade with them in coarse porcelain and some unbleached linen. Although they go naked, they have a liking for linen. As our knowl-

edge of what is for the best is small, indubitably were we to settle down there, we will be amply supplied from all the places in the vicinity such as Hoccheuw (Fu-chou), Sinhowa (Hsin-hua), Tsobihaua (?), Songsieu (Chang-chou), Tanoua (Cheng-hua), Tseusieu (Ch'üan-chou); all the more so as many Chinese are likely to come and live with us.

2. Copy from the journal kept by Adam Verhult on his voyage to Ta-youan, 26 March-26 April 1623. In the journal of Cornelis Reyersen. VOC 1081, fol. 65-67. Extracts March-April.

> fol. 65v.: [26 March] "Met de jachten den *Haen* ende *Victoria* vertrocken om naer Taijouan te zeylen. [27 March] Des morgens saegen Isla Formosa (...). Zijn in de baeij van Tayouan wel gearriveert.
> 4 ende 5 [April] ditto. Waeren daegelijcks doende met waeter te haelen aen de Noort wal, doch altoos gewaepent, alsoo verstonden de swarten van 't landt altemets daer ontrent quaemen met boogen ende assagaeijen.
> fol. 66 v: (...) [April 22] "Sr. Constant gesprooken hem afgeraeden nae Keij-lang Tamasuijth te zeijlen om reede wille aldaer geen bequaeme reede te weesen, scherpe gronden ende seer periculoos om scheepen te verliesen. d'Inwoonders seer moordadig volck, daer niet veel meede ter spraecke was te commen (...)."

fol. 65v.: On March 26 we set sail for Tayouan with the vessels the *Haen* and the *Victoria*. In the morning of 27 March we saw Isla Formosa and made port in the Bay of Tayouan.

April 4 and 5: We have been accustomed to fetching fresh water on the nor-thern coast every day, but are always armed because we have heard that the dark-coloured natives sometimes come down to the place with arrows and assegais.

(On April 21 we departed in order to report to Commander Reyersen on the discovery of the coast of Isla Formosa.)

fol. 66v.: April 22: I have spoken to Mr Constant and advised him not to sail to Quelang and Tamsuy[2] because there are no suitable roadsteads for ships over there, but reefs, posing great danger for losing ships. The inhabitants are a most murderous people so we hardly could communicate with them.

3. Resolutions taken by Cornelis Reyersen. Pescadores, 17 March 1623-23 September 1623.
VOC 1081, fol. 111-138. Extract 20 May.

fol. 119: "Alsoo op den 20e Mey Anno 1623 (...) beneffens de Chineese piloten die ontdeckingen langs Isla Formosa met een jonck hebben gedaen, hier zijn gearriveert.
(...) vonden geen bequamer [plaats] als de baey Teyouan; hadden aen de noortzijde van Isla Formosa in de baai van Quilang geweest, doch onbequam voor schepen te leggen, naementlijck voor 't noorder mousson, alsoo de baey geen beschutte en heeft ende is een cleene inbocht, daer woont een heel wilt volck (...)."

fol. 119: On May 20 (...) [two Dutch mates and] the Chinese pilots who had been on reconnaissance trips along Isla Formosa on a junk, arrived here. (...) they did not find any places more suitable than Tayouan. They had visited the bay of Quelang, situated on the northern side of Isla Formosa, which is not a suitable roadstead for ships because it does not offer shelter from the northerly monsoon; besides the inhabitants are very wild people.[3]

4. Missive Cornelis Reyersen to Governor-General Pieter de Carpentier. Pescadores, 26 September 1623.
VOC 1081, fol. 139-144. Extract.

fol. 142: "(...) want hierontrent op de eijlanden geen houdt anders dan in Tayowan te becomen is, 't welck over de 26 treeden van waterkant naest is staende, oock 't selfde met groote moeytes ende sonder perijckel niet uyt hett bosch timmerhoudt ende brandthoudt te haelen is, soodat een man geladen ten hoogsten 3 tochten daechs can doen. Souden 't selfde wel gevoechelijck met de veroverde Chineesen connen geschieden, dan, alsoo der in Tayowan veel Chineesen woonen, souden listelijck d'inwoonders opruijen om den oorloch tegen ons te vatten, dwelck ons in desen standt seer quaelijck soude comen (...)."

fol. 142: (...) because here on the islands [the Pescadores] there is no wood available except in Tayouan where it grows 26 paces from the waterfront. It is only with great difficulty that one can get timber and firewood from the forest without danger, so that a laden man can make at most three trips daily.

This could be arranged satisfactorily by using the kidnapped Chinese[4] but as many Chinese live in Tayouan, they could incite the natives to make war against us, which would be greatly to our disadvantage.

(In October, 1623, Commander Reyersen himself made a trip to Tayouan in order to survey the local situation. In the following November two merchants, Jacob Constant and Barend Pessaert, made a two-day trip to Soulang. Reyersen returned to the Pescadores on November 18, 1623.)

5. Description of the village of Soulang on the island of Liqueo Pequeno[5], its situation, the daily life of the people, wars, and so forth, as far as we have discovered this and learned from our own experience. VOC 1081, fol. 105-109.[6]

fol. 105: "Scheepende van de reede van Taijowan naer de Stadt Soolangh set men sijn coers Noordoost ten Ooosten aen, totdat men compt bij 6 à 7 eylan-deckens, die geheel vlack, ende sonder heuvelen sijn met groene ruijchten sonder geboomte gewoosen. Deselve altesamen aen backboort van sich latende, de lenghte van ontrent 2 à 3 musquets schoots, alwaer men gront heeft op 5, 4 en 3 voeten waeters minder ofte allensckens totdat men ontrent het verdroncke en moerassich lant van de cust van Lique Pequeno comt, twelck heel laach en onganckbaer is door de scherpe wortelen, die daer uit de bracke gront voort spruijten, daer men niet meer als een ofte ten uytersten 1½ voet waters heeft (soo dat men hier de Chineese champantgens voort ende over sleepen moet), totdat men alle de voorsz. eylandekens verbij, ende op ontrent een gootelingh schoots, het voorsz. verdroncke lant genaeckt is, het welck ontrent 4 à 5 mijl van de voorsz. reede van Taijowan mach sijn. Hier sal sich terstond een emboccadehro ofte mont van een revier openbaren, hebben de wijde van ontrent 50 passen in het incomen, daer men allenskens dieper water crijcht, tot de 20 voeten ende meer toe, dat is vol santplaten, door het scheuren van aff en oploopende stroomen, gemenght met de cromic-heyt des voorsz. reviers gecauseert, twelck den voorsichtigen genochsaem ende lichtelijck te mijden sal sijn, ist bij soo verde hij yets op reviere bedre-ven is.

Dese revier ontrent ¼ van een hollantse mijl opgevaren sijnde vint men een harde, vlack, ende dorre camp ofte stuck lants, palende aan het voorsz. scherpe ende wortelachtich morasch, sonder eenich teijcken ofte merck, dat aldaer de plaetse is, daer de champans der Chineesen aenleggen also de vloet het water van de reviere (die hier noch sout is) over 't voorsz. lant doet

loopen, waer door de mercken afgespoelt, ende te niet worden; welck vloet de voorsz. camp ofte gront, deselffs soo brack maeckt, dat de son daer over schijnnende alst water gevallen is, een natuerlijck sout bact, twelck de passanten, doort flicker van de sonne d'oogen doet schemmeren soodat het wonderlijck bequaem soude sijn om soutpannen te maecken de natuer deslants met onse ofte der Chineese indust[rie] een weijnich geholpen sijnde. Ende alsoo ick dagelijcx mercke, de Chineesen met d'inwoonders in sout waeren met de Chineesen handelende 't welck sij met wancans uit China brachten, communiceeren het selve met cappitein China, hem vragende waerom de Chineesen sout uijt China herwaerts over brachte naerdemael de naetuere van 't lant, door 't toedoen van de son en zeewater, het selve haer in overvloedicheijt was schenckende. Creech hierop voor antwoort dat dit fol. 105v.: de Chineesen seer wel bewust was ende schrander genoech waren omtselve uijt deese naturelijcke mildicheijt te trecken, dan soo wanneer sij het selve de inwoonders eens voor gedaen souden hebben, den proffijt geven- de handel der selven te niet soude gebracht sijn, als sijnde een cunst en we- tens, die alleenlijck doort gesicht geleert can worden. Derhalven haer tot in dese heeme devotie ende simpelheijt waeren houdende.

Comende weeder tot ons propoost, soo gaet men van de oevere van reviere over het voorschreven soutlant ('t welck vlack, door en cael is) door een bebaent pat, 't welck leijt tot eenighen velden, die al gepagert sijn met rijs ende andere groenten besaijt, ontrent dewelck eenighe cleene huijskens ofte schueren staen, van bamboese ende stroo opgemaeckt tot gerief dergeenen dit lant bearbeijden. Tusschen desen leijt het pat door en breinght op een wech, die hier ende daer met eenighe overdecte valeijn beset is, daer men overdach voor de hette der sonne in can rusten. Alles sonder te connen bespeuren, waer ofte waeromtrent de stadt leijt, voor ende alleer men deselve onversints op het lieff is, want deselve onbemaeckt ende niet dicht bebout is maer soo haest men een groote bosschagie ende lommeringh van rieden ofte bamboe- sen verneempt, doen hen de huyse ofte eer de stadt selffs op, met soo treffe- lijcke gebouen dat men ider huijs een tempel soude meenen te sijn, sijnde de selve rontsom met heele bamboese bepagert.

't Fatsoen derselver is min ofte meer als een omgekeert schip, te weten in deser voeghen: sijn ontren een groot mans lenghde verheven boven der aerde gefondeert op cleij, daer sij in ende op gebouwt sijn, welcke cleij soo cuerieus ende net bestreecken is, dat niet soude seggen tselve van wilde, maer Europische meesters gedaen te sijn. Vergelijcke deselve cleijge fonde- menten bij het verdeck ende overloop van een neerlants schip, daert geen quade forme ofte gelijckenisse van heeft.

Het voorhuijs compt ront ende crom gelijck de boech van een schip ende ter contrarie het achterste plat gelijck een spiegel. In ofte op de cleyege fondement sijn tot stutten van het dack drie sware mastboomen haest swaer genoech tot masten voor eenighe onser middelbaere schepen, proportioneelsgewijs geordineert: staende de grootste ende swaerste in 't midden, de swaerste aen dese voor ende de cleenste achter gelijck groote focke, ende besaens mast op de scheepen ider naer sijn proportie geordineert wort; de opperste ende derselver stutten besnoeijt sijnde werde in een lange ende smalle balck gevouchst, die van vooren tot het achterste van 't huijs reijct ende thop desselffs maeckt, alleens gelijck de kiel het onderste van onse scheepen is, waerin de masten gevoecht werden. Het dack is onder van geheele bamboese 3 à 4 dick boven den anderen waerover noch ruychte compt van ontrent een en halff voet dick, soo dat het onmogelijck is door 't selve eenighe reegen door trecken mach ofte mede door den wint beschadicht can werden.

fol. 106: Hebben voor ende achter twee deuren, sommighe oock van terzijden, door een van deswelcke men aan ider zijde met een stelingh ofte planck op en aff gaet om in ofte uijt het huijs te geraecken, wiens lueningh sij met veel ende verscheijde groente behangen en vercieren, waer in sij eenighe superstitie hebben dat mij onbekent sijn. Het geheele binnenhuijs in de lengte is in twee, 3 ende meer verstreckt plaetsen affgeschut; ider hed 2 doorgaende poorten sonder deuren doch alle eeven onvrij alsoo niet affgeslooten connen werden. Aen de wanghden ofte sijde des voorsz. binnenhuijs hebbende sommighe 100, 150, 200 canasters met verscheijde sorteringhe van cleeden, soowel Chineese als inlantsche die se van bast ende wortelen van boomen weven ende bereijden, sijnde dit al het eenichste huijsraet dat se besitten. Ende alhoewel dese Liqueers haere huijsen ende wooninghe obschuere ende doncker sijn, soo dat men op den claren middach malcanderen schier niet dan van bijnaer kennen can, soecken deselve nochtans door 't sluijten van haere deure bij dach noch meer te obschueren soodat sij in een bedompte ende donckere kelder schijnnen te woonnen.

Brandende voor de duijsterheijt des nachts, ofte avonts, noch olij, want sij die niet en hebben, noch smeere nochte eenighe vetticheijt waermede sij haere lamp ofte licht soude connen toestellen, haer behelpende met een cleen viertgen, ind'een ofte d'ander hoeck des huijs tusschen 3 à 4 steenen gestoockt. Ende ist saecke dat se ijts moeten soecken waertoe haer licht van noode is, neemen een brant hout uijt het vuer ende blasen 't selve dat het glants en licht van hem geeft, ofte steecken een bondecken stroo aen, dat in een ooghenblick in roock ende asch verdwijnt.

Aen d'een zijde van haer huijsinghe heeft ider binnen 't begrijp van sijn pager 5, 10, 15 coocos ofte calappus boomen, die sij niet en tijfferen maer de jonghe callapusnooten tot dranck daer aff haelen ofte laeten verouderen. Sommighe hebbe mede eenighe lamoenboomen.

Aen d'ander zijde des huijs staen sommighe cleene hutteckens op crijsse-linghe staecken gestelt, van sterck gebouw, daer sij haer rijs en eetwaere voor 't geheele jaer in bewaeren, sijnde deselve met stercke dueren tegen het inbreecken versien. Ende dit soo veel haer huijsinghe belanght.

Comende nu tot haer huijshouwen, alsoo weijnich ofte eer geen huijsraet niet alleen en hebben, valt selve haer niet lastich, ofte swaer. Het mannevolck bemoeijen hen met 't selve gants niet, want haer werck jaghen ende ten oorloch trecken is. De vrouwen vegen het huijs, waerin sij seer curieus ende gunstich sijn, 't selve hondert mael op een dach schoon maeckende. Koocen ende smoocken haer rijs (die root is) dan seer papich. Gaen in het bosch vruchten ende aen de seekant ofte reviere oesters, schelpen, ende cleene visch haelen (alsoo sonderlingh geen verse visch ofte vischerije hebben). Versorgen de tamme verckens haer dorst, waer in sij haer van den morgen tot den avont becommeren.

Andere van minder middelen (fol. 106v.) ofte aensien, loopen op de oever van de zee tot den hals toe in 't water, vischende quallen, slecken en andere lompen om te eten, daer haer geen manspersoonnen bij voegen. Andere die thuijs ende bijderhant blijven rijgen stroijtgens aen malcanderen, om haer kinders ofte hen eijgen schamelheijt te bedecken, die doch soo de lende licht sijn, dat de minste wint deselve omruct tot haer verschoningh maeckt. Som-mighe oude vrouwen cloppen ende spouwen wortelen van boomen, deselve tot garen bereijden, wiens eynde sij aen malcanderen rollen ende hechten, gelijck bij onse zeevarende lieden het schiemansgaeren gevlochten ende gesponnen wert.

Het cieraet van haer huijs sijn, behalve de voorgemelde canasters met gesor-teerde cleeden, hartevellen die sij in haer bijeencompst malcanderen voorle-gen, om op te sitten ofte te slaepen; proncken meede met haer hasegayen, houw ofte hackmessen, diens hantvant selffs van hartevellen gemaect sijn, aerdich ofte cuerieus gedrilt ende gegraveert, waerin sij sonderlingh polijt sijn. In ofte rontsom haer huijs en is post, stijl, pilaer ofte yets wat daer men eenich dinck soude moghen aen hechten off binden, dat met geen hartshoo-ren, hooffde, kaeckebeenders ofte anderen vodde behanghen is. Wat sij daer mede meenen, 't sij dat sij uijt curieusheijt, superstitie ofte andersints, is mij onbewust.

In haere houwelijcken gebruijcken gantsgeen ceremonie. Want des bruijts ouders, vrienden ofte beckenden van een onderlinghe huelijck aenge-

sproocken sijnde, leveren de jonghman de voorsz. dochter over sonder
eenich goet ofte houwelijcx peninck te geeven. Eer dese dochter haer man
ofte haer man haer compt te beckennen, werden haer twee van haer bovenste
tanden met steenen uijt den mont geslaghen, waeraen men sien can, off sij
getrouwt is ofte niet. Des daechs coomen de mans niet bij haer vrouwen
noch de vrouwen bij haer mans, dan den man bestelt sijn vrouw tot een van
sijn naeste vrunden ofte bekende, ende deese vrient wederom de sijnne ten
huijse van den anderen. Reciproelijck dan des avonts compt ider man ten
huijse van sijn vrient daer sijn vrouw logeert, voldoende des houwelijcx
plicht, waermede ider weer naer sijn slaepplaetse en huijs vertreckt.
't Schijnt sij niet seer jeloers op haer vrouwen sijn nochte het werck der
generatie voor onschamel achten, want het ons aldaer sijnde gebeurt is, dat
een man sijn wijff (met reverentie gesproocken) natuerlijcker wijse gebruijckt
hebbende - ende dat in onse presentie - deselve bij der hant nam ende
leijdense ons toe, omt selve werck met haer te plegen, ende hem in arbeijt
te vervanghen, twelck tot een verwonderingh (als oncristelijck) geweijgert
wert.
Ende hoewel beijde soo mans als vrouwen naeckt ende (fol. 107) onschan-
delijck voor malcanderen gaen, dunck mij nochtans dat sij in luxurie ofte
oncuysche begeerte minder sijn brande[nde] als eenighe natie die tot noch toe
beamt hebbe, voor sooveel indeese weijnich dagen, door conversatie, ende
ommeganck van dochters ende jongmans, gehoude vrouw en manspersoonen
alsmede vrij jonghelieden, hebbe connen colligeeren ende opnemen. De
vrouwen betoonen haer mans, de kinders haer ouders, de jong de oudelieden,
noch de gemeenen man haer overicheijt geen onderdanicheijt, eer ofte reve-
rentie; loopende soo heen ende doende wat haer in de sin compt, als die wilt
ende woest opgevoet sijn, nochte door vrees, schaemte, eerbaerheijt ofte
wetten bedwongen worden. Haer kinderen brenghen sij hart ende sorgeloos
op, houdende nochtans meer van de meijsckens als van de knechtens, twelck
sij schijnnen te bethoonen doort cieraet, welck sij de meijsckens meer als de
knechtkens om 't lijff geven: soo van armringhen, coraelen ende andere
vodden, daer sij voorts even naeckt sijn. Worden meede meer op den arm
ende schoudere gedragen, daer de knechtkens (sonder acht op te slaen)
heenloopen.
Manspersoonen sijn door de banck hals ende hooft langer als onse gemeene
mans is, gaen (als geseijt is) moederlijck naeckt sonder yts voor haer scha-
melheijt te hebben. Heb lanck haer als de vrouwen in ons lant, 't welck sij
laeten hangen sonder te vlechten. Sommighe oudelien hebben 't geheel
licham van onder tot boven met heet isser geschroeijt ende geschildert, 't

welck in geen jonghe ofte bejaerde persoonen gesien ofte vernomen hebbe, want deese geheel gaeff ende glat over 't lijff sijn.

Seer cloeck wel dispoost volck is het door den banck. Sijn wonder snel en aerdich in 't loopen, soodat ick geloff sij een paert onderloopen soude. Sijn van geschicte en volmaeckte forme, soodat sij de natuere niet te wandancken hebben, behalve in haer bruijnvernich lijff ende huijt, die de Tarnatansche swaerticheijt niet toe en geeft, hoe wel de kinderen ende jonghelinghe van blancker ende geelder coleur gevonden worden. Haer spraeck valt bevallich, modest, lancksaem, ende met sonderlinghe gratie, soodat men haer aen de selve soude oordelen geen wilde, maer uijtmunte wijse manen te sijn, die tot de crop toe vol seedicheijt ende modestie staecke. Gebruijcken een vrem- spraeck op haer selve gemenght met veel Maleijsche ende andere vremde ofte uijthemsche woorde, als sijn *babij*, *tacot*, *boesock*, *maccan*, *ican*, etc. meede *maccselo* ende *mapilo*, welck op het eijlant De Talao, ontrent Sangij gebruijckt wort. Wat het voor een casto is is mij onbekent, doch hebbe ver- staen affcompstich te sijn van de Joristen die op dito eylanden varende ofte per avontuere vervallende hier gebleven ende voort geteelt sijn. Doch watter van is ofte niet, referere mij aen de waerheijt.

fol. 107v.: Haer religie is diversch. Somighe schijnnen naer der Mooren andere naer het heijdendom te aerden, want somighe met ons veel verc- kensvleesch aten, andere ter contrarie scheenen daer en schrik ende tegen- heijt in te hebben.

Hebben onder haer in ider stadt maer één paep, die sij als een affgodt eeren, dan en hebben daerenboven menichte van ouwe wijven die sij int selve officie sijn gebruijckende. Hoewel niet hebbe connen bemercken sij eenighe godtsdienste pleegden ofte hanteerden, sooveel isser nochtans als dat ider huijs sijn besondere altaer heeft, slordich, vuijl ende vervallen genoch, met raechstoff ende vuijlicheijt bemorst ende beslommert. Op dese altaren setten sij de dootshoofden ende beenderen haerder vijanden die sij in de oorloch verslagen hebben. Rontsom dese voorsz. altaer sijn eenighe snoerckens geschooven die rontsoom met haer der voorsz. verslagene sijn behangen; sijn gedeelt aen cleene vlechtkens, omdat het soude schijnnen sij der veel ver- wonnen ende verslagen hadden. Hierbij ende ontrent voeghen sij haer houmessen, hasagaijen ende ander geweer dien mede tot cieraet vant voorsz. altaer. Dan soo veel als heb connen bespeure gebruijcken voorts in 't selve geen groote superstitie, noch vragen der weijnich naer ofte men haer super- stieuse ende affgodische gereets. aentast, verset ofte oock onwaerdelijck handelt en verwerpt. Geloove doch sij eenighe ceremonie met deselve sijn gebruijckende, tegen dat sij ten oorloch trecken, ofte uijt de selve wederom thuijscoomen, 't welck één à tweemael sjaers geschiet; ende dat wanneer het

gewas ende ooghst in de scheure is, om het gewas niet te vertreen, bedor-
ven, ofte vruchteloos te laeten leggen. Wat het motijff, finael ofte oochmerck
van dese partijschap is, hebbe niet ondervraecht, derhalve (als mij onbewust)
daervan stil swijghe.

Als sij den oorloch aenvanghen sullen brenght ider vleck off stat sooveel
bejaerde persoonen op als immers can ofte mach, die sij tegen den anderen
te velt brenghen, hoewel sij voorts een geheel jaer door gealieerde ende
vrunden sijn. De vrouwen ende onbejaerde blijven thuijs als onnut tot de
wapenen. Die daghelijcx op de openbaere merckten, die der 5 ende tamelijck
groot sijn, door den anderen geexerceert worden, alwaer tegens den anderen
omtseers loopen, met riet ofte bamboes dreigende, ende den anderen voordel
affsiende. Hier ende daer sitten eenighe soo mans als vrouwen die deese
exercitie aensien en een die op een trom van een gespannen hertevel slaet die
de speellieden representeere, gelijck in onse exercitie de trommen ende
trompetten sijn.

Dese voorsz. jonghmans, hoewel moedernaeckt, vercieren haer hooft, middel
ende armen met groente, min ofte meer off men Bacchus met sijn clim omt
lijff uijtgeschildert sach. Andere hebbe cransckens gevlochten uijt de vlacke
van de hartestaerte met alderhande coleuren gevervt, die sij van gelijcke omt
hooft, armen ende middel winden, waerin sij groote hovaerdij schijnnen te
hebben.

Die in den oorloch de (fol. 108) meeste verslagen heeft ofte meerder hooffden
thuijsbrenght, is bij haer de opperste geacht ende wort int getal van de seven
principaelste gestelt; daer anders niet mede winnen dan dat sij de preferentie
in de jacht hebben ende over het geschooten wilt mogen disponneeren. Ten
anderen crijghen een sitplaets ofte (gelijck wij seggen) een cussen onder
degeen, die in de regeringhe sijn, wiens officie is, daghelijcx voor sonne-
opganck (als wanneer de lijt ofte tromme geslagen wort) op een van de
merckten te compareeren, alwaer dan alleman cleijn ende groot sonder getal
vergaderen, wien sij t'een ofte t'ander van haer voorvallende saecken voor
houden, waerin de minste sooveel stemt als de meeste sonder onderscheijt
van persoone, qualiteijte ofte waerdicheerde.

De stadt is (genamt Soolangh) seer groot int begrijp sijnde, soodat (mijns
oordeels) in groote wel met eenighe van de grootste steeden in Nederlant
mach vergeleecken worden. Doch ombemuert ofte onaffgepaelt, nochte oock
soo dicht bebouwt, want ider huijs een groote spaetse binnen sijn paggert be-
grijpt, sluijtende malcanderen door dito paggers. Affpalende dito paggers aen
de doorgaende passagie ofte algemeyne straten die heel engh ende nauw sijn,
fraij belommert door de bamboesen die aen wederzijde daer oeverheen
wassen ende den passant voor son ende regen beschut ende vrij houden,

twelck een plaijsier ende lust om sien is. Ider huijs heeft bijnaer sijn water-
put binnen de pagger 40 à 50 voeten diep die schoon, claer, coel ende soet
water geven. Heeft als voorgeseijt is 5 gemeene plaetse ofte merckten die
met baleijen ende andere algemeijne huijsen versien sijn. Is seer volckrijck
soo van man als vrouwpersoonen, doch bijsondere van kindere die daer in
soo groote menichte crioelen.

Is een mensgierich volck tot verwonderens toe, besonder over ons lichaem,
maeniere van doen en cleedinghe, welck sij soo nauw besagen dat het schan-
delijck soude zijn te vertellen. Segge allenlijck dat sij, tsij niet ofte tegen
onse wil ofte danck, onse clederen, wambaijsen ende broecken, jae mouwen
ende andersints opende, over de witticheijt vant vel hen verwonderende. Ja
dat meer is: aent selve rieckende, soo datter qualijck ofte geen lidt aen ons
naecte lichaem en was dat sij niet en wilde besien ende aent selve rieckende
soo wel vrouwen, jonghedochters als mans sonder eenige revenrentie, schae-
mte ofte achterdencken.

Sijn uijtermaten nidich ende jaloers onder malcanderen, want soo men den
een in presentie van de anderen iets geeft, brenght men stracx een onder-
linghe haet onder haer. Van gelijcke soo men den een dese ende den anderen
sulcke sorteringhe van cleden, coraelen ofte andersints geeft. Hoewel van
gelijcke maet, specie ende valeure, meenende altij het beste sij dat men eerst
geeft.

fol. 108v.: Wonderlijck graechgierich sijn sij naer Chineese toback, die wij
met pijpckens tevens altemets uijtdeelen. Sooveel vrouwlien als mans hebbe
deselve aldaer niet, nochte en comen se naer behooren niet gebruijcken, 't
welck wonder is dat dese swarte natie alleenlijck (van alle degeene die tot
noch toe gesien ende gekent hebbe) van dese vrucht ende roockgevende
blaederen onbloot sijn. Sullen niet meer als eens aen een volle pijp suijgen,
het resterende als onnut verwerpende. Het gelt, silver ofte gout, is haer
onbekent. Maecken mede geen onderscheijt in de cleeden dan alleenlijck, als
geseijt is, houden eerste gift voor de beste. Sijn seer bedelachtich, onbe-
schaempt en inportuijm in 't eijschen, hen selve over het weijgeren mercke-
lijck stoorende.

Sijn altsamen sonder onderscheijt eeve vrij en onvrij, den een niet meer
meester als den anderen, want hebbe geen slaven, dienaers ofte onderdannen,
die sij vercoopen, verhoueren ofte uittleenen moghen, hebbende mede den
eenen in des anderens saecke ofte doen, niet te seggen.

Gebruijcken een heel andere maeniere in het herte jaghen dan die van Siam
ende andere plaetse. Want daer dese, namentlijck de Siammers, met het
overloopen van de reviere ende waters de harten ende het wilt bij den
anderen vergaderen ende tselve door dese vloet benaren, gebruijcken sij een

heel contrarie von(s)t ende wetenschap. Want vergaderen tesamen, laete haer
gelijckelijck aen een zijde van d'een ofte ander bosch vinde waerin sij de
concurentie van herten weten te sijn, steekende het selve bosch van d'ander
zijde in den brant om door het vuere de harten ende het wilt daer uijt ende
op haer te jaghen, die sij beloeren ende met haer slitse ende hasegaijen
schieten ende vellen; deselve, alsoo snel int loopen sijn, volgen, totdat het
wilt moede is ofte doot ter aerden valt. Hierdoor staet te vermoeden, de
harten in sulcker abondantie als in Siam niet connen gevangen worden,
hoewel niet en twijffele ofte dit lant geen minder abondantie van wilt is heb-
bende dan Siam ofte eenighe andere plaetse, want dwars van de reede van
Taijowan alleenlijck aen lant gaende springhen met groote menichte voor ons
op, alsmede de wilde verckens, wiens abondantie meenen met weijnich lande
te vergelijcken is.

Het lant van binnen is meestendeel ofte gelijck cleij gront ende soude voor-
waer (mijns oordeel) geheel vruchtbaer wesen, waert saecke het aen de
wetenschap, delegentie ende industrie der inwoonderen niet en ontbrack ofte
dat de Chineese die aldaer onder de inwoonders houden niet flau en waeren
om den hant aen ploech te slaen. Wiens getal (soo uit andere verstaen hebbe)
de 1000 ofte 1500 passeert, welcke chineese (alsoo de inwoonders gants geen
vaertuijch en hebben) van deen plaetse tot ander langs de cust vaeren om
haer neringhe ende proffijt te soecken.

Voorders, wat hier ten dienste van U.Ed. Compagnie soude connen verrich-
ten werden, is weijnich, ende ider welbekent, te weten: goede reede ende
berginigh voor scheepen; seecker ende tamelijck quantiteijt van hertevellen,
die doch verlancsaam

fol. 109: soude moeten ingewacht worde; menichte van rieden ofte bamboese,
materiael tot huijs, werckgebouw ende fortificatie, alsmede ternauwernoot,
maste ende ronthout voor onse scheepen, hoewel een weijnich lantwert in
ende met moeijten souden moeten gehaelt werden. Ten anderen, soude men
in tijt van noot de naerbijlegende Piscadores met verversingh connen hier-
vandaen secoers, soo van lemoenen, wilde apelen, banannen, aijuijn, ver-
ckens, hoenders, harten, ende hondertleij andere verversinghe, behalve dat
men aldaer uijt China met de wancans soude mogen verwachten ofte selffs
steelsgewijs vandaer laeten brengen ende met haer wancans herrewaerts over
beschicken.

Hebbe hier vergeten haerlieder feest ende festdagen aen te roeren ende hoe
sij haer in deselve sijn houdende ende aenstellende, maer wat feeste sij
vieren ende solemnelijck celebreren, is mij onbekent. Van gelijck, hoe sij
haer houden in het versterven van haer ouders, vrienden ofte magen, waer-
om daer van stilswijghe als van onbekende dinghen. Alleenlijck hebbe

verstaen dat soo wanneer van haer iemant overleijt, de doode rompen niet verbranden maer begraven, stellende op hen grafs de goederen bij den voorsz. overlede naergelaten, twelck haer canasters met cleeden sijn. Ende dat tot den derden dach toe, tot een pompe ende ostentatie van haer rijck-dom, welcke canasters de kinderen ende erffgenamen naer den derden dach van daer lichten ende naer haer nemen.

Stellen mede tweederleij soort van dranck, ontrent de rustsplaetse ofte gracht des overledene, den eenen gecouleurt sijnde gelijck 'kielangh' ofte Spaense wijn, hebbende een seltsame smaeck, en de andere wit gelijck melck, doch heel onclaer ende met veel witte correls van rijs gemenght, daer sijt selve van maecken, destieleere ofte brouwen, sijnde beijde bequaem tot hooffdicht ende dronkensz. te causeren. Want het droncken drincken bij haer niet vremt is ende ons geduijrich hetselve presenteerde ende genochsaem tegen ons danck int lijff dronghen meenende ons sonderlingh daermede te carassere.

Ende dit is hetgene 't welck soo door eijgen aenmerckinghe, ondervindinghe, alsmede doort vragen der Leeckender Chijnen, mitsgaders uijt het raport van een Maniliaen, die aldaer met de Spanjaerts veeleertijts schipbreuck geleden heeft, hebbe connen ondertasten ende bespeuren; welcke Maniliaen nu aldaer getrout ende kinderen is hebbende. Watter voorde[r]s vereijst vernomen ofte ondervraecht te sijn, can door last van overricheijt t'allentijde wel geschie-den."

Sailing from the Tayouan roads to the town of Soulang one sets a course east-north-east until one reaches six or seven small islands which are com-pletely flat and without hills, with green patches of scrub and devoid of trees. One keeps all of this to leeward, at a distance of two or three musket-shots, where one can touch bottom at a depth of five, four, or three feet of water or less, until one approaches the drowned and swampy land of the coast of Liqueo Pequeno. This is very low and impenetrable because of the sharp roots growing out of the brackish soil there, where one has no more than one or one and a half feet of water at most (so that small Chinese sampans have to be dragged over it), until one has sailed past the aforesaid small islands and has approached the aforementioned sunken land at a distance of a musket-shot which may be four or five miles distant from the aforesaid Tayouan harbour.

At this point soon an *emboccadero* or river mouth will reveal itself, which as it debouches has a width of approximately fifty paces. After that one comes into deeper water, up to twenty feet and more, full of sandbars as the result of the scouring caused by the tides, combined with the meandering of

the river, which can easily be avoided by a careful sailor, should he be experienced in river navigation.

Sailing up this river for about a quarter of a Dutch mile[7], one comes across a hard, flat, and barren field or piece of land, adjacent to the afore-said sharp and root-filled swamp, without any sign or indication that this is the place where the Chinese sampans moor, because the high tide causes the river water (still salt here) to flood over the aforesaid land, causing the signs to disappear. This tide makes the aforesaid field or ground so brackish that the sun shining over it at low tide bakes a natural salt, which from the reflection of the sun dazzles the eyes of the passers-by, so that it lends itself extremely fortuitously to the making of saltpans, if nature is helped but a little by our own industry or that of the Chinese.

And because every day I noticed that the Chinese were trading salt with the natives bringing it from China with wancans[8], we brought this up with the Captain China[9], asking why the Chinese brought salt all the way from China the more so nature gave it to the land in abundance through the sun and seawater. The reply was (fol. 105v.) that the Chinese were fully aware of this fact and were clever enough to extract it from this natural bounty themselves, but were they once to show the natives how to do it, this would destroy their profitable trade. After all, it is a skill and knowledge that can be learned simply by observation. Therefore they have kept them in this respect in their own belief and ignorance.

Taking up the threads of the story: you go from the riverbank via the afore-said saltpan (which is a flat and barren piece of land) over a beaten path, which leads to a couple of fields already fenced off, planted with rice and other vegetables. Some small huts or barns made out of bamboo and straw stand nearby, for the use of the people working in this field. The path runs through the middle and leads to a road, bedecked here and there with some awnings, where one can seek shelter from the heat of the sun during the day.

Meanwhile, one is still without any notion of where or whereabouts the town is situated, until suddenly one is right in the middle of it, for it is neither laid out nor densely built, but as soon as one spies a large shady forest of reeds or bamboos, the houses or rather the town itself appears, with such exquisite buildings that you should take every house for a temple, fenced as they are by whole bamboos on all sides.

Their form is more or less like an upside-down ship, meaning this: situated above the ground at about the height of a man, they are set on clay foundations, in and on which they are built. The clay has been smoothed out so artfully and neatly that one could not say that this is not the work of uncivilized people but of European master craftsmen. The clay floors may be compared to the deck and poop of a Dutch ship, the shape of which it resembles in a striking way. The front of the house is round and curved like a ship's bow and the back, in contrast, is flat like a stern. In or on the clay foundation there are three heavy posts to support the roof, almost strong enough to serve as masts for some of our medium-sized ships. They are erected according to size: the tallest and heaviest in the middle, the next less heavy in front, and the smallest one at the back, as the foremast and the mizzen-mast on ships are raised according to size. The tops of these supporting posts are cut and are joined to a long narrow ridge-pole, which runs from the front to the back of the house and represents its dome, like the keel is the bottom part of our ships, on which the masts are checked. The roof consists of a substructure of whole bamboos, laid three or four on top of each other. This is covered by sods of approximately one and a half feet so it is impossible for the rain to penetrate, nor can it be damaged by winds. fol. 106: They have two doors, a front door and a back door and some have a side door as well. Through each of them on either side they enter or leave the house by walking up or down a ladder or a plank. They decorate and adorn its handrails with many different foliages, to which they give a superstitious meaning, unknown to me.

The interior of the house is divided into two, three, or more long rooms over the entire length, each connected by two doorways without doors; consequently there is no privacy since the doors cannot be closed. On the walls or sides of this interior of the house some people have 100, 150, or 200 baskets with assorted pieces of cloth, both Chinese and indigenous, which they weave and prepare out of bark and roots of trees, being the only goods and chattels they own.

And although the houses and dwellings of these Liqueans are so obscure and dark that on a bright afternoon you cannot recognize each other except from very close by, they try to darken their houses even more in daylight by closing their doors, so they seem to live in a stuffy, dark cellar.

During the darkness of the night or evening they do not burn oil, for they do not have this, nor grease or any fat by which they could light their lamps

or lights, but they manage with a small fire, burning in one of the corners of the house between three or four stones. And if they need a light to find something they take a burning brand of wood from the fire and blow on it so that it glows and gives off light, or burn a bundle of straw that very quickly disintegrates into smoke and ashes.

On one side of their dwelling everyone has five, ten, or fifteen coconut or calappus palmtrees inside the fence which they do not tap but from which they pick the young coconuts and drink from them or keep them to ripen. Some people also have a few limetrees. On the other side of the house stand small cabins on crossed piles of a solid construction for the storage of their rice and food during the year. These have solid doors to prevent theft. And this is all concerning the houses.

Moving on to speak of their household, it does not bother them nor is it a burden, for they have few or no possessions in the house. The men have no interest in it whatsoever because their task is hunting and warfare. The women sweep the house and they are very skilful and good at it, cleaning it a hundred times a day. They cook and steam their rice (which is red) until it resembles porridge. They gather fruits in the forest and oysters, shellfish and small fish at the seaside or in the river (but strangely enough they do not have fresh fish nor fishery), and take care of the needs of the tame swine and with all this they are busy from morning till night.

Other women of less means (fol. 106v.) or status walk along the seashore into the water up to their necks, fishing for jellyfish, snails, and other rubbish to eat, this is done without the company of men. Other women who stay at home or in the near vicinity, plait together blades of grass to cover their own private parts or those of their children, but this hangs so lightly around their loins that the slightest breeze blows it up and embarrasses them. Some old women split and beat the roots of trees and make yarn out of this. They roll the ends together and join them, like our sailors twine and splice their yarn.

The treasure of their house, apart from the aforesaid basketry with the assorted cloths, consists of deerskins which they lay down for each other at their gatherings, to sit or to sleep on. They also show off their assegais, swords, or choppers, of which even the handles are made of deerskin, nicely or artfully drilled and engraved, in which they are extraordinarily skilful. There is no doorpost, pillar or anything that can possibly have something attached to it in or around the house that has not been covered

with deerhorns, heads, jaw-bones or other trumpery. Why they do this, out of peculiarity, superstition or some other reason, I do not know.

There is no ceremony whatsoever in their marriage customs. For the bride's parents, friends, or acquaintances, being informed of a marriage, give the daughter in question to the young man without the exchange of any dowry or bride price. Before this daughter is acquainted with her husband carnally, or her husband with her, two of her upper teeth are knocked out of her mouth with stones, which shows whether she is married or not.

During the day men do not visit their wives, nor the wives their husbands, but the husband summons his wife to come to (the house of) one of his close friends or acquaintances and this friend sends for his wife to come and meet him at the house of the other. In the evening each husband visits the house of the friend where his wife is lodging in the evening, performs his conjugal duty, after which each returns to their own bed and house.

They do not appear to be very jealous of their wives, nor do they think prudishly of the act of procreation, for it overcame us when we were there that a man who used his wife (said with reverence) in a natural way (and what is more: in our presence), took her by the hand and led her to us to commit the same act and replace him at his work, which to their amazement we refused, deeming this to be unchristian.

And although both men and women appear naked and (fol. 107) unashamed in front of each other, I nevertheless have the impression that they do not revel so much in lasciviousness or unchaste desire as any other nation that I have encountered so far, as far as I could gather and understand from daughters and sons, married women and men as well as unmarried young people in conversation and social intercourse during these few days. None of the wives show their husbands humility, respect, or reverence, no more do the children their parents, the young their elders, or the common people their superiors. They go wherever they want and do whatever springs into their minds, like people who are raised in a rude uncivilized manner, unbridled by fear, shame, honour, or laws.

They raise their children in a tough and ruthless way and love the girls more than the boys. This clearly is shown by the jewellery with which they prefer to deck the girls, rather than the boys: like bangles, beads, and other baubles, apart from this they are naked. Furthermore, they are more often carried on the arm and the shoulders, whereas the boys run around without any heed being paid to them.

Generally speaking the men are taller than is our average man by a head and a neck. They are, as has been mentioned, stark naked without covering up their private parts. Like women in our country they have long hair, which hangs down loose and is not plaited. Some old people have branded their bodies from top to toe with a hot iron and have painted them, which I did not see or notice among the youth or young adults, for they have perfectly unblemished and smooth bodies.

They are a very sturdy and well-built people. Generally speaking they are amazingly fast and skilful runners, I even believe they can outrun a horse. They present a fine and perfect appearance, as nature has been good to them, apart from their brownish body and skin, which equals the darkness of the people from Ternate, although the children and young people appear to be of a fairer and more yellow colour.

Their language sounds pleasant, modest, measured, and extraordinarily graceful, so that judging them in this respect you would not think them to be savage but to be outstandingly wise men, filled to the brim with modesty and virtue. They use a strange language mixed with many Malay and other strange or foreign words like *babi*, *takut*, *busuk*, *makan*, *ikan*[10] etcetera and also *maccselo* and *mapilo*[11], which are used on the island of Talaut near the Sangir archipelago.[12] I am ignorant what sort of dialect this is, but I understood it comes from the Jorists[13], who sailed to this island or ended up there by accident and stayed and begot offspring. But whether it is a fact or not I refer to the truth.

fol. 107v.: Their religion is diverse. Some seem to follow the religion of the Moors, others paganism, for some have eaten much pork with us, while others by contrast seemed frightened to do so and were averse to eating it. There is only one priest in every village, whom they venerate as a deity. In addition, they have a lot of old women whom they use in the same function. Although we did not notice them practising any religious ceremonies, it is a fact that every home has its own special altar, shoddy, dirty and rundown, shrouded and soiled with cobwebs and other filth. On these altars they put the skulls and bones of the enemies they have defeated in war. Around these aforementioned altars there are a few strings to which the hair of the aforesaid vanquished is tied. This has been divided up into small braids to give the impression that they conquered and defeated a host of enemies. To this, here and there, they add their choppers, assegais, and other arms, which also serve to decorate this altar. As far as I could discover, they neit-

her observe much superstition in this respect, nor do they pose any questions if we touch, move or even offend or repudiate their superstitious and idolatrous artefacts.

I believe nevertheless that they use them in some sort of ceremony when they go to war or come home from it, which happens once or twice a year. This is when crops are harvested and in the barns, in order to prevent the crops from being trampled under foot, spoiled, or lying unharvested. I did not ask for the motive, purpose, or intention of this factionalism and, as I do not know it, I therefore remain silent on the matter.

When they go to war, every little hamlet or village drums as many adult males as possible or is allowed, whom they put into the field against the other villages, even though they are allies and friends during the rest of the year. Women and children stay at home, being useless in combat.

At the public marketplaces of the villages, five in number and fairly large, daily drills are held. There they run against each other to gain the upper hand, sparring with reeds or canes and trying to gain advantage over the opponent. Some men and women sit about, watching this exercise and one person beats a drum made out of tautened deerskin, representing the musicians, like we have drums and trumpets at our exercise.

The aforesaid young men, although stark naked, decorate their heads, waists and arms with greenery, more or less like one sees Bacchus depicted, his body wreathed in ivy.

Others have made garlands out of the flat part of the deer's tail, painted in all sorts of colours, which they likewise wind around their heads, arms, and waists and they seem to be very proud of it.

The man who has (fol. 108) defeated the most enemies in war or brings home several heads is greatly revered by them and will be admitted to the number of the seven most important men, which gives him no further gain than the first claim in the hunt and a choice of the quarry. On the other hand they get a seat or as we would say a cushion among the government officials, whose duty it is to appear at one of the marketplaces daily before sunrise (when lute is plucked or a drum is beaten) to inform all the people, young and old, gathered there what is afoot, on which the lowest votes equally with the highest, without discrimination of person, quality, or status.

The town (by the name of Soolangh) is very large, which (in my opinion) makes it comparable in size to some of the largest cities in the Netherlands. But it is not surrounded by walls or palisades, nor is it densely built, becau-

se every house contains a large empty space within its fences, which adjoin the neighbour's terrain. These fences line the throughfares or public streets, which are very narrow and confined and beautifully shaded by bamboos growing over them from either side, thereby protecting the passer-by and shielding him from sun and rain, which is a pleasure and joy to see.

Almost every house has its own well inside the enclosure, some 40 to 50 feet deep with clean, clear, cool, and fresh water. The town has, as mentioned before, five public marketplaces, provided with pavilions and other public buildings. It is very populous, with both men and women, but especially with children, who swarm there in such a great number.

They are an amazingly curious people, particularly about our bodies, manners, and clothing about which they were so inquisitive that it would be shameful to relate. All I shall say is that they, whether we were willing or not, undid our clothes, doublets and trousers, even sleeves and other pieces, astonished as they were at the whiteness of our skin. Nay, to put it bluntly, they even had a smell of it and as a result there was hardly any part of our naked body that they did not want to see and smell, both women, young girls and men, without showing any respect, shame, or even giving it a second thought.

They are extremely envious and jealous of each other, for, if you give something to one of them in the presence of another, you immediately sow discord among them. The same happens when you give one of them this and another one that selection of cloths, beads or something else: although it is of the same size, kind, and value, they always think what is given first best.

fol. 108v.: They are surprisingly eager to get Chinese tobacco, which we also sometimes hand out together with pipes. Neither women nor men have the latter over there, nor do they know how to use them properly. It is strange that among all the people we have seen and met so far, only this black nation lacks this plant and its smoke-producing leaves. They will draw on the filled pipe but once, throwing away the rest as useless.

Money, silver or gold, is unknown to them. They see no difference between the piece-goods, only, as we said before, they consider the first gift the best. They are very given to begging, shameless, and importunate in their demands and clearly grow annoyed at our refusal.

All and sundry without distinction are equally free and unfree. One person is in no way more master than another, because they keep no slaves, ser-

vants, or subjects for selling or lending purposes. Nor do they have any say in other people's business or way of life.

They employ a totally different way of deerhunting than the people of Siam and other places. Because whereas the people of Siam round up the deer and the game when the rivers and waters overflow and corner the animals as a result of the flood, the people over here use a completely contrary invention and expertise. They all assemble on one side of a particular forest in which they know there to be a concentration of deer. They set fire to the same forest from the other side, in order to flush the deer and the game out, so that they may hunt them and take aim at them and shoot them with their slings and assegais, thus killing them. Because they are fast runners, they follow the animals and chase the game until it gets tired or drops dead.

We suppose therefore that the deer cannot be caught in such abundance as in Siam, although we do not doubt that this country has less abundance of game than Siam or any other place, for, as soon as you go ashore, across from the roads of Tayouan it leaps up before your eyes in great number, just like the wild boars whose plentitude in our opinion can be compared only to that of few other countries.

The interior of the land consists more or less of clay and it would be fertile (in my opinion) if the natives did not lack knowledge, diligence, and industry, or if the Chinese who live among the natives were not too weak to turn their hands to the plough. The latter number more than 1000 or even 1500 as I have heard from other people. These Chinese sail from one place to another along the coast (because the natives do not have any sort of vessel) in search of trade and profit.

Apart from this there are only a few things available that would be of use to Your Honour's Company. These are well known to everybody: a good roadstead and safe anchorage for the ships. A steady supply and considerable quantity of deerskins (for which (fol. 109) we would have to wait with patience). An abundance of reeds or canes, material for building houses, workplaces and fortifications, and should the need arise, timber suitable for masts or spars for our ships, although situated a little further inland and difficult to collect.

Another thing is that in time of need we could help out the nearby Pescadores from here with fresh food like lemons, wild apples, bananas, onions, swine, poultry, deer, and hundreds of other sorts of fresh food. This in addition to what we might expect from China on the wancans or have

ordered ourselves to have brought stealthily from there and would have at our disposal over there by means of the wancan trade.

We forgot to dwell upon the festivals and holidays of the natives and how they behave and act on such occasions, but what festivals they hold and solemnly celebrate I do not know. Neither do I know how they behave when their parents, friends, or relatives die. That is why I remain silent about this because they are unknown matters. The only thing I have understood is that when one of them has died, the body is not cremated but buried and the possessions, being the baskets with cloth, of the deceased in question are placed on his grave until the third day, to illustrate his importance and as a token of his wealth. The baskets are taken away by the children and heirs after the third day and brought home.

They put two kinds of liquor around the grave or tomb of the deceased, one coloured, like *kielangh* or Spanish wine and of a rare taste, and the other one white as milk but very cloudy and mixed with a lot of ricegrains, of which it is made, distilled or brewed. Both can easily cause tipsiness and drunkenness, for drunkenness is by no means uncommon among them and they offered the same drink to us over and over again and pushed it down our throats quite against our will, thinking they were doing us a special favour.

And this is all I have been able to learn and discover through my own observation, experience and by questioning the Liqueo Chinese[14], together with the report of a man from Manila who was shipwrecked here with the Spaniards a long time ago. This man from Manila is now married here and has children. Further needful information from hearsay or enquiry, can always be collected by order of the authorities.

1624

6. Missive Commander Cornelis Reyersen to Governor-General Pieter de Carpentier. Pehou, 25 January 1624.
VOC 1083, fol. 252-256. Extract.

fol. 252: "(…) volgens U.Ed. Ordre, een molhoop, ofte vasticheijt, op de zuijt van mont van de baij in Teyouwan te leggen, alsoo ons tot noch geen diensti-ger voor de Compagnie is bekent, alwaer ick op de 25e October voorsz. met 16 soldaten ende alle de Bandanesen, die noch 34 in 't getal zijn, na toe ben vertrocken. Aldaer gearriveert zijnde, hebben dadelijck in 't werck gestelt, om een vasticheijt te maecken.

De inwoonders scheenen ons seer toegedaen, doch door 't opruyen der Chi-nesen sijn seer haest verandert. Hebben ons toegestaen een vasticheijt te maecken, alsmede dat wij de bamboesen vrijelijck uijt het bos mochten halen, die de Chinesen ons voor gelt niet en wilden brengen. d'Inwoonders versochten datter eenighe van d'onse mede in haer dorpen zouden trecken, om met den anderen grooter vrintschapp te maecken, waer over goet gevon-den hebben, dat Sr. Jacob Constant, oppercoopman, ende Barent Pessardt, ondercoopman, met haer souden trecken, om de vrintschap ende kennis soecken te vermeerderen.

Die doen twee dagen boven geweest waren, weder affgecomen sijn. Hebben als doen een boot gemandt met Sr. Constant, eenighe soldaten ende boots-volck om bamboesen te hacken gesonden, 't welck ongeveerlijck 13 dagen heeft gecontinueert en in alles becomen 2100 stucx.

Hadden aldaer dagelijcx veel inwoonders bij haer gehadt, soo van de omleg-gende dorpen als degeene die d'onse gintswaerts hadden gebracht. Sijn onder den anderen (soo se seggen) twistich geworden ende met ontrent 200 per-soonen op ons volck aangevallen, die ontrent 30 soo Duijtsche als Bandane-sen sterck waren. Schooten dapper met hasegaijen en vlidtsboogen, waerdoor d'onse genootsaeckt waren de wapenen inde handt te nemen ende alsoo vechtenderhandt na de boot getrocken. In 't inberqueren sijnder drij van ons volck dootgeschooten, te weten twee soldaten ende een assistent, genaemt Hendrick Jansz. van der Leij. Van haer blevender in alles vier doot, ende 7 swaerlijck gequest hebben.

Anders niet connen bespeuren, oft 't zelvighers doort oprocken der Chinesen geschiet. Zeedert hebben geen inwoonders vernomen, soodat het met ons (Godt betert) soo veer gecomen is, waer wij comen daer Chinesen sijn

handelende, wel op ons hoede moeten wesen, doch hebben met fortificeren hier evenwel voortgegaen (...).

fol. 253: Hier vooren hebben verhaelt hoe wij op Teyouwan een vasticheijt hebben gemaeckt, doch is niet anders als van sant, ende bamboes, sterck genoech voor d'inwoonders, bij aldien 't selffde brandtvrij connen maecken. Want sij alreede listichlijck hebben gebruijckt om de voorz. vasticheijt in den brandt te steecken, 't welck door de schiltwacht ontdeckt worde, soo datter (Godt sij gedanckt) geen schade en is geschiet. Hebben 't daer rontom ontrent 20 treden mett voetangelen beseth, en sijn van meninghe de bamboesen met cleij te bestrijcken, die aen 't vastelandt met groote moeijte te becomen is."

(The missive deals with the events of October and November 1623:)

fol. 252: (...) Complying with Your Honour's orders to set up a mole or fortification on the southern side of the mouth of the bay in Tayouan, because no more suitable site for the Company is so far known to us. So on the 25th October I set off for Tayouan with 16 soldiers and all the Bandanese, still 34 in number. As soon as we arrived there we immediately set to work to build a fortification.

The natives seemed well disposed towards us, but very quickly changed their attitude because of interference by the Chinese. They allowed us to construct a fortification and also to go and collect bamboo out of the forest freely, which the Chinese were not prepared to bring to us for payment.

The natives requested that some of us would also go with them to their villages to make better friends with the others.

That is why we gave permission to Mr Jacob Constant, Senior Merchant, and Barend Pessaert, Junior Merchant, to go with them and try to improve the friendship and gather more information.

After having been up there for two days they came back again. We then manned a boat with Mr Constant, a few soldiers and crew and sent them over to cut bamboos. This took about 13 days and they acquired 2100 pieces altogether.

Over there they daily had many natives around them from the surrounding villages and also the natives who had taken our people to their place.

They started to quarrel with each other (so they say) and with about 200 men they attacked our people, who were 30-man strong, Dutch and Bandanese together. They attacked fiercely with assegais and bows and arrows, so our people had to take up arms and still fighting had to retreat to the

boat. On embarkation three of our people were shot dead, being two soldiers and one assistant by the name of Hendrick Jansz. van der Ley.

On the other side a total of four were killed and seven were severely wounded.

We presume all this happened because of the provocation of the Chinese. Since then we have not had any contact with the inhabitants, so we have landed in a situation (God help us) that wherever we arrive where Chinese are trading, we have to be careful. But we still continue to fortify this place. (…)

fol. 253: We already recounted how we built a fortification at Tayouan, but it is constructed only of sand and bamboo, strong enough to protect us against the natives, if we can make it fireproof, because they have already resorted to ruses to set the aforesaid fort on fire, which, as it was discovered by the sentinel (thank God) did not result in any damage. Over an area of about 20 paces around the stronghold we have set mantraps and we intend to spread clay, which is hard to get on the mainland, over the bamboo.

7. Dagregister Batavia.
VOC 1083, fol. 398-399. Extract 16 February 1624.
DRB, pp. 22-25.

"(…) Ontrent voorschreven baey in Teyowan is een stadt gelegen, by d'inwoonders Solang genaemt, welckers beschryvinge (gelyck die in 't journael by d'onsen in Teyowan gehouden geannotteert is) goet gevonden hebben van woorde tot woorde hier by te vougen, luydende als volcht, te weten:

De vleck ofte plaets Solang gelegen op Formosa in de baey van Teyowan is sober gepeupleert ende bewoont met seer wilde ende barbarische menschen, door den bant grooter van postuer als onse natie. Gaen naeckt, syn sonder schaemte.

De vrouwen willen een weynich eerlycker als de mans syn; hebben voor hare schamelheyt een mattyen van lies oft een linnen cleetgien ontrent een span breet. Syn schroomachtich voor vremde natien, 't welck niet om te verwonderen en is, alsoo overdach by haer mannen niet en comen ende op haer selven huys houden, 't sy 2 à 3, oock 4 by den anderen. Als de mans met haer vereenigen willen, 't welck niet anders als by nacht en geschiet, moeten by haer gaen, twelck voor sommige een quartier uyrs, ja oock ½ ure gaens is ende niet anders als int doncker, want caerssen noch olie gebruycken. Loopen met een brandende stroowis door 't huys. Welcker conversatie

met de vrouwen niet langer duert als een ure 2 à 3, naer hebben connen bespeuren.

Eenige vremde natien ofte vrunden haer versoeckende, schynt de meeste cares te wesen, die malcanderen aendoen, dat se deselve brengen inde huysen daer hare vrouwen woonen. Twelck ons is gebeurt van een die voor de principaelste aldaer geacht wiert, welcke ontrent het huys comende daer syn vrouw woonachtich was, eenen jongen vooruyt sondt om een woort 2 à 3 met haer te mogen spreken. Nadat uyt den tolck verstonden, liet syn vrouw vragen off binnen comen mocht, 't welck sy hem consenteerde ende syn daerover binnen gegaen.

In haer huyshouden syn seer sober, principael in eten en in drincken, want men haer niet een degelycke maeltyt siet doen, niet ander dan van rys met water gekoockt, die se soo lange staen laten dat se goor wert, daertoe een claeutyen groene gember (die daer in abondantie valt) ende gesouten viskens eten, die de vrouwen in der nacht langs de revier met manden gaen vangen. Oock speck dat garstich is, onbequaem om te eten. Wanneer men eerst in haer huysen comt, daer de mans woonen, die als de vrouwen 2 à 3 à 4 by den anderen woonen, hebben oude vrouwen by haer die 't huys op houden, dat naer ick meen hare moeders syn. Comen met dryderley dranck van rys gekoockt in aerde potgiens brengen om te drincken, die niet veel bysonders ende als goor wey is smakende, ja sommige als varkensdraff, onnatuerlyck om drincken, gelyck haer cost oock is om t' eten. Laten niet aff om deselve te bieden oft men moet se proeven. Sy eten oock veel hartevleysch 't welck daer in overvloet is. De voorseyde oude vrouwen die het huys van de mannen als geseyt is ophouden, syn geheele nachten doende met pady te stampen, haer dranck te koocken als andersins, dat ick niet anders en weet wanneer dat rusten. De mannen doen geen werck als de vloer ende de baley om 't huys te vegen.

De voorseyde vleck ofte plaets is ongevaerlyck ½ myl de revier opwaerts ende een quartier uyrs lantwaert in gelegen. Is seer vruchtbaer, maer en wert niet beplant, besaeyt ofte bearbeyt. 't Gene d'inwoonders daervan becomen, wast uyt de natuer, behalven rys ende milie, dien se een weynich sayen, want werden door de Chineesen van rys ende sout geassisteert. Siri, pinangh, clappus, bonannes, limoenen, citroenen, miloenen, calbassen, suykerriet als ander schoone fruytboomen synder in abondantie, maer en worden door haer niet besnoeyt ofte gehavent; oock en hebben se geen wetenschap van cocusboomen te tifferen. Herten synder in groote menichte daer se seer op bedreven syn om te schieten; 't vleesch ende vellen daervan droogende 't welck de Chineesen van haer om een leur ende seur coopen ofte ruylen, doordien geen kennisse van gelt hebben.

Daer is naeulyckx in voorseyde vleck een huys, daer mannen in woonen, oft hebben 1 à 2 à 3 ja sommigen 5 à 6 Chineesen by haer in, die se seer onder den sweep houden ende dreygen se, als se geen deech willen, dadelyck 't hair aff te snyden. Desgelyckx werden se van de Chineesen gequelt, doordien haer niet spysen connen ofte moesten haer handen beter te werck stellen. De Chineesen dreygen haer dadelyck verlegen te laten van sout, waerdoor se onder subjectie van haer staen.

In 't minste en hebben niet connen bespeuren, dat eenige overhoofden onder haerluyden syn, gelyck ons door den tolck oock is geseyt. De meeste isser soo veel als de minste. Hierin bestaet hare valiantheyt, waerdoor in extim geraken, te weten die ten oorloogh gaende (gelyck de mannen niet anders en doen) de meeste hoofden van hare vyanden thuys brengen, werden de treffelyckste onder haer geacht, welcke hoofden [zij] 't hair affdoen, doorcloven, op haer manier chierlyck toemaken ende te pronck stellen, 't haer aen snoeren vlechten, hangen 't op rieden boven de hoofden. Soolange de mans ten stryde gaen ende by haer vrouwen kinderen genereren, brengen se die om den hals, tot der tyt toe dat niet meer ten oorloogh trecken, 't welck is (na aen den anderen hebben gesien) als se ontrent 34 à 36 jaren out syn.

De vrouwen (na connen bemercken) syn seer cuys, gantsch niet tot hoerdom genegen, bevallich ende vriendelyck in 't spreken, proportieus van lichaem ende besneden van tronie als onse natie ende syn castangie bruyn van verwen. De vrouwen ende mannen dragen langh haer; den baert cael geschoren. Gebruycken in haer tael Maleysche woorden als tegen eten: *mackan*; vercken: *baboya*; vier: *api*, als meer andere woorden, soo dattet (doordien oock veel Chinees spreken) een gebroken ende gemengde tael is.

De mans syn seer jelours op haer vrouwen, sien niet gaerne dat men eenige gemeenschap daermede hout. Syn nieusgierich om ons hayr ende lichaem te sien; wanneer by haer comen, nemen onsen hoet aff ende ontcnoppen 't wambuys, als men 't hebben wil.

Hare huysen daerinne se woonen, staen 5 à 6 voeten boven de aerde, seer net van buyten gemaeckt met bamboesen die daer in groote menichte wassen. Wert aldaer anders geen hout als een weynich creupel bos gevonden. Haer huysen syn van binnen als schueren, leech sonder eenigen huysraet, niet anders daerin hebbende als de hoofden ende 't gebeente van hare vijanden, daermede sy langs der straten als kinderen gaen spelen, 't welck alle haer substicie is die se weten te gebruycken.

Hebben oock eenige papen ende 7 kercken van bamboesen gemaeckt, besteken met cakebeenderen van herten ende verckens die daer met menichte syn. Hare papen doen geen sermoen in 't openbaer. Dan alleen degene die ten stryde gaen, hebben twee schiltpadden ontrent een voet groot, aen 't

eynde met een hout aan malcanderen vast gemaeckt. Op ider staet een wipken, aent eynde met een houten cloot van een vuyst groot. Bindende met hout op haren navel, trecken den buyck uyt ende in; bedryven daer wonder sotte kueren mede voor hare kercken, principaellyck alst volle ende aff-gaende mane is. Syn dan altyt twee uren voor dach doende ende scheydender alst dach wert wederom uyt.

Wanneer eenige menschen sterven, werden tot pulver verbrant.

Thien à 12 dagen eer se ten stryde gaen, hangen hare schilden op een van de plaetsen daer de kercken staen ten toon. Haer geweer is een hasegay ende flitsboogh met een paring op de syde, daer seer ras mede omme gaen.

Dit is 't gene hebben gesien ende ten deele ons door den tolck (die goet Portugees conde) geseyt, 't gene hem vraechden."

(...) In the neighbourhood of the aforesaid bay in Tayouan a town is situated, called Solang by its inhabitants. We thought it was a good idea to enclose a description of it (as it is written down in the journal kept by our people in Tayouan) reading as follows, to wit:

The village or town of Soulang, situated on Formosa in the Bay of Tayouan, is sparsely populated and inhabited by very savage and barbaric people, on average of a bigger build than our people. They walk about naked, having no shame. The women try to be a little more decent than the men, for they cover up their private parts with a piece of woven grass or a piece of linen cloth, about a span wide. They are shy when they meet foreigners, which is not surprising, because they do not see their husbands during the day, but stay in their houses with two, three, or four other women. When the men want to be together with them, which happens only at night, they have to go to them, which takes a walk of a quarter of an hour or sometimes even half an hour and always in the dark, for they use neither candles nor oil, but walk in the house with a burning torch of straw. This contact with women does not last any longer than two or three hours, that we have been able to notice.

When some foreigners or friends visit them, it seems to be the greatest courtesy they can show to one another to take the visitor to the houses where their wives live. This happened to us through the agency of a man who is considered to be one of the most important in the village. When he came up to the house where his wife lives, he sent a boy ahead to have a word with her. As we understood from the interpreter, he made him ask his wife if he could come in, to which she consented and after that we entered.

They are very simple in their housekeeping, especially in the way they eat and drink, for one is unable to see them prepare one single substantial meal other than rice boiled in water, which they leave for such a long time that it turns unappetizing. They add to it a lump of green ginger (which grows there in abundance) and little salt fish, caught in baskets by the women along the river at night, and also pork that is rancid, unsuitable for consumption.

Coming then in the men's houses where, like the women two, three, or four men live together, (you notice) they have old women living with them for the housekeeping, who I think are their mothers. They come to bring three kinds of drink brewed from rice in earthenware jars, which do not taste very special, rather like rancid whey, some even like pigs' swill, unnatural to drink, just as their food is unnatural to eat. But they offer it constantly or urge you to try it. They eat a lot of venison as well, of which there is plenty on hand. The aforementioned old women, who take care of the housekeeping for the men, as already related, are busy all night long, pounding the padi and preparing their drinks or doing other business, so I would not know when they take a rest. The men do not do anything but sweep the floor and the veranda around the house.

The aforesaid village or town is situated about half a mile up river and a quarter of an hour inland. It is very fertile, but it is not cultivated, sown, or farmed. Whatever the natives get from it grows naturally, except rice and millet which they do not bother to sow much because the Chinese provide them with rice and salt. Sirih, betelnut, coconuts, bananas, limes, lemons, melons, gourds, sugarcane and other delightful fruit trees grow in abundance, but are not pruned or trimmed by them. Nor do they have any knowledge of how to tap coconut palms. There are deer in great number which they shoot down with great skill. They dry the meat and the skins of the deer which the Chinese buy or barter for a mere song, as the natives do not understand a thing about money.

In this village in almost every house in which men live, one, two, three, nay sometimes even five or six Chinese are lodged, whom they keep very much under control and threaten to cut off their hair if they do not comply with the wishes of their hosts and eat their paste. Likewise they themselves are bullied by the Chinese for not giving them food or not working hard enough. The Chinese immediately threaten to deprive them of salt, which means they are dependent on them.

We were not able to find out if they have leaders among them, as our interpreter had already told us. The highest is no higher than the lowest. The excellence for which they come to be respected is composed of this: those men going out to war (and the men do nothing else than go out to fight) who bring home the most heads of their enemies are considered to be the most outstanding among them. From these heads they remove the hair, split them in half, decorate them nicely in their fashion and show them off to be admired. Plaiting the hair on to cords, these are hung on reeds above the heads. As long as the men go out to fight and breed children with their wives, they hang these around their necks until the time has come that they will no longer go to war, which is (as we have learned seeing the others) when they are about 34 to 36 years of age.

The women (as far as we could remark) are very chaste, not inclined to fornication at all, elegant and friendly in conversation, with a well-proportioned body and finely moulded features like our people and of a chestnut-brown colour.

Women and men wear their hair long; the beard is shaved off. They use Malay words in their language like for eating: *makan*, pig: *babi*, fire: *api*, and some other words, so that it is a broken and mixed language (because many also speak Chinese). The men are very jealous of their wives; they do not like it when one has contact with them. They are curious to see our hair and body. When we come to them, they take off our hats and unbutton the doublet if one allows them.

The houses they live in are raised five to six feet above the ground. The exterior is very neatly constructed from bamboo, which grows there in great abundance. Apart from this no timber is available, except for some undergrowth. Inside, their houses are just like barns: empty, devoid of any furniture. They keep nothing in there but the heads and bones of their enemies, which they play with in the streets like children. This is all the superstition they know how to use.

They also have a few priests and seven 'churches' made of bamboo, adorned with the jaw-bones of deer and pigs, both living there in great numbers. Their priests do not hold sermons in public. Only those men going to war have two turtles each the size of about one foot tied together at the end with a piece of wood. On each turtle there is a seesaw with a wooden ball the size of a fist at the end. They attach this with wood to their navels and pull their bellies in and out, thus performing wonderfully funny tricks

in front of their 'churches', especially when it is the full and waning moon. At this time they are always busy two hours before dawn and stop again at daybreak. When they die they are cremated to ashes.

Ten to twelve days before going to war they hang their shields in one of the places where the churches are to show them to the people. Their weapons are assegais and bows and arrows and a parang on the side, all of which they handle very deftly.

This is what we have seen and partly what has been told to us by the interpreter (who was competent in Portuguese) in answer to our questions.

(On 26 August 1624, Reyersen and his men left the fort near Pehou in the Pescadores. Immediately work was commenced on the building of a fort, later Zeelandia Castle, on the small isthmus of Tayoun, a sandbank lying off the coast of Formosa.)

8. Missive Pieter Jansz. Muyser to Governor-General Pieter de Carpentier. Tayouan, 4 November 1624.
VOC 1083, fol. 506-509. Extract.

fol. 508v.: "(…) Belangende de plaetse mitsgaders 't lant hierontrent, (fol. 509) soude mijns oordeels een treffelijck lant connen worden, wanneer 't door verstandige wel gecultiveert worde. De Chinesen hebben verscheijden hunne vruchten, als groote Chinese appelen, orangen, bannanisen, watermiloenen ande andere diergelijcke vruchten, hier geplant, maer willen soo volcommen niet aarden als in China, 't welck mijns oordeels nergens anders door compt als dat het lant niet genouchsaem sijn eijschen becomt. Voorts is het vol van wilt gedierte als harten, steenbocken, oock wilde varckens, patrijsen, phesanten, wilde duijven ende ander gevogelte.

De inwoonders soo van 't eene als van 't andere dorp, namentlijck van Backlouan, Soulang ende Sinquan toonen ons seer toegedaen, waerom oock d'Heer Gouverneur geresolveert heeft een parsoon als hooft met 2 andere om hem te assisteren, derwaerts te resideren te senden, op hope oft den handel van de hartevellen t'eenemael in onse handen mochte vallen, gelijck sij hunluijden genouchsaem geneijcht om met ons te handelen toonen. Die van Backlouan is een eijlantie suijdelijck ontrent … mijlen van dese baeij gelegen. Daervoorde[r]s d'onse eens ongeluckich aengeweest sijn, verstaende van onse compste alhier, hebben mede d'heer Gouverneur alle vrintschap ende gemeijnschap aengeboden. Doch 't sijn altsamen barbarische menschen; loopende t'eenemael naect; oock gestadelijck tegen den anderen oorlogen;

soo 't schijnt geen wetten ofte politien onderworpen, elckeen levende naer de macht die hij can opbrengen."

fol. 508v.: (...) Regarding the place and surrounding territory, (fol. 509) in my opinion it could become an excellent land if cultivated in a sensible way. The Chinese have planted several of their species of fruit trees here, like big Chinese apples (oranges), oranges (mandarins), bananas, watermelons and the like, but they will not thrive the way they do in China, the cause of which in my opinion is that the soil is not treated in the proper way.

Besides, it is full of wild animals like deer, serows, also wild boars, partridges, pheasants, wild pigeons and other gamebirds.

The inhabitants of the various villages, that is Baccaluan, Soulang, and Sincan, all appear to be very friendly towards us. That is why the Lord Governor decided to send over a representative with 2 others to assist him to take up residence there, hoping that the trade in deerskins may once and for all fall into our hands, as these people show a sufficient inclination to trade with us. Baccaluan is an isle ...[15] miles away from this bay in a southerly direction. Since our people had shown up there by accident before, as soon as they heard about our arrival here they offered all their friendship and company to the Lord Governor, but they are altogether barbaric people, who walk around completely naked and are engaged in continuous internecine wars. Apparently they are not subject to any laws or civil order, everyone living by the power he can lay his hands on.

9. Missive Pieter Jansz. Muyser to the Directors of the Amsterdam Chamber. Tayouan, 4 November 1624.
VOC 1083, fol. 510-511. Extract.

fol. 510v.: "De lant daer wij 't sien schijnt seer schoon vruchtbaer lant te souden connen gemaeckt worden. Is vol van wiltbraet als harten, varckens, steenbocken, duijven, patrijsen, phesanten ende dergelijcke. 't Water is oock visrijck.

De inwoonders sijn rouwe barbarse menschen, leven sonder eenige wetten ofte politien. Nochtans schijnt dat religie moeten hebben, want houden feestdaegen ende rusten van arbeijden. Loopen gans naect, voeren oock oorloch tegen malcander. Op onse compste alhier hebben de Heer Gouverneur alle vrintschap ende geneychtheyt getoont, oock hunnen dienst ende behulp gepresenteert, waarom oock de Heer Gouverneur een ondercoopman

aldaer bij hun te woonen gesonden heeft om mettertijt den handel van de hartevellen van handen van de Chineesen t'onswaerts te trecken (...)."

fol. 510v.: The land, as we see it, gives the impression that it could be turned into a very beautiful fertile land. It is full of game like deer, pigs, serows, pigeons, partridges, pheasants and the like. And the waters teem with fish. The natives are crude barbaric people who live without any laws or civil order. Still it seems that they do have a religion, for they observe holidays and abstain from labour on days of rest. They walk about totally naked and also fight against each other. Upon our arrival here they showed friendship and amiability to the Lord Governor and offered their service and help as well, which is the reason why the Lord Governor also sent a junior merchant to live among them, for the purpose of luring the trade in deerskins away from the Chinese and towards us in due time (...).

(The villages appear to be eager to assure themselves of the protection of the Company and to turn this to their own ends in their internal strife. The Company gives them equal and impartial treatment, as a precaution against Chinese influence.)

10. Missive Governor Martinus Sonck to Governor-General Pieter de Carpentier. Tayouan, 5 November 1624.
VOC 1083, fol. 41-48. Extract.

fol. 46v.: "Sijn de inwoonders van Saoulang ende Sincan, welcker negriën ons naest leggen, bij ons affgecomen ende hebben ons hare vrientschap aange-booden, door intercessie van dewelcke die van Backalouwangh, daerdoor 't voorleeden jaer eenich volck van ons dootgeslagen ende 't fort in brant te steecken getracht is. Onse vrientschap meede vergunt hebben. (...) Wij hoopen haer harten mettertijt t'eenemael, de Chineesen te ontrecken, alsoo 't een volck tot veranderinghe geneegen schijnt te weesen. Ieder van hun is te naeste bij evenveel meesters; willen onder geen een hooft staen. Voeren gestadich inlantschen oorlooch ende die de meeste hoofden weet te haelen, 't welck meest bij laegen ende listen, doch die heeft onder haer het meeste seggen. Haere vrientschap sal met geschencken, ende vreesen van onse macht gevoet ende onderhouden moeten werden, waerdoor noch veele vrientschap alhier verhoopen te becomen.

De Chineesen sijn uijttermaeten jeloers over onse residentie alhier, ende soecken alle quaet tusschen de inwoonders ende ons te rockenen, doch wij verhoopen dat ons niet seer hinderlijck sullen kunnen weesen.

fol. 47: In 't schrijvens deses sijn eenige van de principaelsten van Bacca-lawan bij ons gecomen ende versochten selve onse vrientschap, die sij seyden dat wij haer door die van Saoulang toegeseyt hadden, alsmeede dat wij eenige Hollanders in haer negri wilden senden, gelijck wij in Saoulang ende Sincan gedaen hebben. 't Welck haer toegeseyt is. Ende sij weeder na Baccalawang met een cleene vereeringe vertrocken, om de inwoonders van haer negri van onse goede genegentheijt 't haer- waert te verwittigen. Wij verhoopen naar 't hem tot noch toe laet aensien, dat dese plaetse de Compag-nie dienstcher als Pehou sal weesen.

Om de inwoonders van deese omliggende negries te meer tot ons te trecken, ende vermits de inwoonders sulcx aen ons selffs versochten, hebben aldaer een ondercoopman met noch twee andre persoonen in Saoulang metterwoon gesonden. Die van Baccalawan hebben meede eenich volck versocht, 't welck onses oordeels dienstich sal weesen dat geschiede."

fol. 46v.: The people of Soulang and Sincan, which are settlements in our neighbourhood, have come to us and have offered us their friendship. Through their intercession we also bestowed our friendship on the people of Baccaluan who last year had killed some of our people and had tried to set fire to the fort.

(...) We hope to win their hearts away from the Chinese once and for all some day, because they seem to be a people inclined to change.

Each one of them is about as much in charge as anybody else. They do not want to be ruled by leaders. They are constantly embroiled in internecine strife and it is the man who is able to collect the most heads (which is generally done by ambush and ruses) who has the most authority. Their friendship will have to be nurtured and maintained by presents and by fear for our power. This way we hope to win many more friends here.

The Chinese are extraordinarily jealous of our settlement here and they seek to stir up strife between us and the natives, but we hope they will not give us too much trouble.

fol. 47: While I was writing this down some of the prominent men of Bac-caluan came to see us and asked for our friendship of their own accord, which they said we had promised them through the villagers of Soulang. They also asked us to send a few Dutchmen over to their village as we had done in Soulang and Sincan. This was promised. And they returned to

Baccaluan with some small presents to report to the inhabitants of their village on our good intentions towards them. We hope, which would seem to be the case, that this place will be of better service to the Company than Pehou. In order to draw the inhabitants of these surrounding villages closer to us and since the inhabitants have asked for this themselves, we have sent a junior merchant with two other persons to settle in Soulang. The people of Baccaluan asked for some people too, which we think would be useful to comply with.

11. Missive Governor Martinus Sonck to Governor-General Pieter de Carpentier. Tayouan, 12 December 1624.
VOC 1083, fol. 49-54. Extract.

fol. 53v.: "De inwoonders genegentheijt van dit eylant schijnt t'onswaerts te vermeerderen. Voordeesen hebben wij die van Saoulang, Sincan ende Baccalauwan, in haer dorpen op hare instantie doen besoecken ende in teecken van vrientschap een cleene vereeringe gedaen. Die van Mattau sijn eenige daegen geleden bij ons geweest ende hebben mede onse vrientschap versocht, die wij haer toegeseyt hebben. Om met dese inwoonders alsmede de Chineesen te recht te geraecken, sullen eenige van 's Compagnies jongens de taele van dit lant dienen te laeten leeren, alsmede de Chineesche taele leeren spreecken ende begrijpen, waerin wij eenige jongens met den eersten sullen laeten oeffenen.

Dit lant schijnt seer vruchtbaer te weesen, derhalven sullen een partije met coques, orangie-appelen, limoenen ende andere vruchtboomen beplanten, alsmede met waterlimoenen ende andere eerdtvruchten besayen.

Mettertijt souden wel genegen weesen, soo 't met wille van die van Sincan geschiede, ofte in, ofte ontrent haer dorpen een reduyt te leggen, om alsoo met ontsach ende mime de inwoonders van Sincan alsmede van de omleggende dorpen t'onswaerts te trecken, den handel van de hertevellen te becomen ende in sonderheijt om de inwoonders van dit eylant mettertijt onder de gehoorsaemheyt van de Hoog Mogende Heeren Staeten der Vereenigde Nederlanden te brengen.

fol. 54: Tegenwoordich sijn hier ontrent hondert vischersjoncken om te visschen, die alhier groote menichte van Chinesen gebracht hebben, die te landewaerts in gereijst sijn om het hertenvlees ende vellen op te coopen om naer China te vervoeren."

fol. 53v.: The inhabitants of this island seem to grow more attached to us. Some time ago we paid visits to the people of Soulang, Sincan, and Baccaluan in their villages at their own request and we gave them small presents as a token of our friendship.

The people of Mattau came to us a few days ago and asked us for our friendship, which we bestowed on them. In order to get along with these natives and the Chinese, we shall see to it that some of the Company's boys learn the language of this land and also learn to speak and understand the Chinese language. We shall have some boys practise as soon as possible.

This land seems to be very fertile, therefore we will start a plantation with coconut palms, orange, lime and other fruit trees and sow it with watermelons and other root vegetables.

In due time we would be inclined, albeit with the consent of the people of Sincan, to lay out a redoubt either in or in the vicinity of their villages, thereby winning the inhabitants of Sincan and the surrounding villages to our side by authority and mime, to obtain the trade in deerskins and, in particular, in due course to bring the inhabitants of this island under the authority of the High and Mighty States General of the United Netherlands.

fol. 54: At the moment about one hundred fishing-junks are here to catch fish and they have already brought hither a large multitude of Chinese, who have gone inland to buy the meat and skins of deer to transport to China.

1625

12. General Missive.
VOC 1082, fol. 175v. Extract 27 January 1625.
FORMOSA, p. 45.

"Omtrent Tayouan leggen in 't landt verscheijden bewoonde vlecken. Daer van de inwoonders dagelijck aen 't fort comen, yeder versoeckende om 't eerst onse vrientschap. De Chineesen die gewoon sijn met dit volcq te handelen, sijn seer jaloers over onse residentie aldaer, ende doen vast haer best om d'inwoonders tegen ons op te rockenen, en van ons te trecken. Daer vallen jaerlijck nae men verstaet, omtrent 200 000 hertevellen, abundatie van gedroogt hertevlees en vis, en verscheijden andere lijfftochten, mitsgaders veele goede vruchten. In somma 't is een gewenschte plaetse, soo de Chineesen handel maer volgen wil, gelijcq wij daer seer goede moet toe hebben."

There are various populated settlements in the neighbourhood of Tayouan. Their inhabitants come to the fort daily, each one vying to be first in asking for our friendship. As they have a tradition of trading with these people, the Chinese are very envious of our residence there and try everything to incite the inhabitants against us and lure them away from us. Rumour has it that every year approximately 200,000 deerskins, an abundance of dried venison and fish and several other victuals, as well as many delicious fruit can be found there. Summing up, it is a pleasing, desirable place, if only the Chinese trade would follow, which we are optimistic about.

(Various Formosan villages proclaim themselves allies of the VOC.)

13. Missive Governor Martinus Sonck to Governor-General Pieter de Carpentier. Tayouan, 19 February 1625.
VOC 1085, fol. 228-233. Extract.

fol. 230v.: "Vrientschap van d'onse met de Tayouanners."
"Verscheijden dorpen, verstaen wij, dat doorgaens op dit eylant sijn met die van Mattau (alwaer ontrent 2000, Saoulang alwaer ontrent 1000, Baccalauwang alwaer ontrent 1000 ende Sincan alwaer ontrent 400 weerbaere mannen sijn), sijn (met ons) in vrientschap getreeden. Verscheijdene andere cleender

dorpen die met den andere in vrientschap sijn, leggen mede hier ontrent: *Tomeete, Sincang, Baccalauwang, Thomolokang, Teopang*, waerin ieder 150 à 200 weerbaere mannen sijn. Dese hebben mede onse vrientschap versocht, waerom in haer dorpen sullen doen besoecken ende eenige slechte cangans schencken.

fol. 231: In Sincang ben op den 15 Januari selffe geweest om de nieuwe vrientschap te vermeerderen, ende die te aensienelijcker te maecken (...).

Plaetse gecocht om te bouwen in 't gebiet van Sincan op Lequio. (...) ende heb alle de principalen van 't dorp alhier ontbooden, die op den 20e Januarij wel 70 persoonen sterck bij ons verscheenen syn, van de welcke ick naer vrientlijck onthael, voor 15 cangans gecocht hebbe sooveel lants als tot behoeve van de Compagnie aldaer van doen hebben. Ende is alsoo met goet contentement weeder van hier vertrocken. Is deurgaens een minnelijck volck ende wel mede omme te gaen voor diegeene die haer humeuren kennt ende sich daernaer een weijnich weet te accommoderen, waerin men haer voor 't eerst wat toegevallen moet weesen, alsoo het haer om een buijck vol rijs, een vaem cangans ofte een pijp toeback te doen is.

(...) hebbe met goetvinding van de raet op 't vastelant in 't gebiet van Sincang een bequaeme plaetse aen een rivier van varse waeter verkoopen om aldaer Compagnie Comptoir te houden (...) en wij verhoopen dat voorsz. een gepopuleerde stadt sal worden.

fol. 231v.: Dese plaetse ende 't gansche lant is zeer vruchtbaer ende van seer goeder nature, overvloedich van wilt als herten, steenbocken, verckens, alsmede fesanten, haesen etc. Heeft mede ontrent het begrip van voorsz. plaetse een tamelijck groot binnenwaeter daer veel visch in ront ende is door-gaens vol schoone rivieren, daerenboven omcingelt met een seer vischrijcke zee. Sulcx het bij toeloop van volck binnen weijnige jaeren daertoe (Godt ten voorsten) sal cunnen gebracht worden, dat wij allen toevoer van eetbaere waeren uijt andere quartieren derven ende des Compagnies dienaers als meede onse taefel met weynigh oncosten onderhouden sullen cunnen.

fol. 232v.: Uwe Edele gelieve herrewaerts eenige paerden met saedels ende thoomen te senden, alsoo deselve alhier groot ontsach ende in tijden van noot een groot behulp souden geven, alsoo wij daermede boven de inwoonders ende andere vijanden int velt domineeren souden."

fol. 230v.: *(In the margin:)* Friendship between our people and the Tayoua-nese.

Several villages on this island which are usually, as we understand, on the side of the people of Mattau (who each number about 2000 able-bodied men, Soulang, and Baccaluan each having about 1000 and Sincan about

400), have made friends (with us). Several other smaller villages which are allied to the others are also in the neighbourhood, being Tomeete, Sincang, Baccaluan, Thomolokang, Teopang, each having 150 à 200 able-bodied men. These people have sued for our friendship as well and that is why we will visit them in their villages and give them some coarse cangans.[16]

(On 15 January, Governor Sonck visited Sincan in order to improve and substantiate the new bonds of friendship with the villagers.)

fol. 231: *(In the margin):* Land has been bought to build on in the area of Sincan on Liqueo.[17]

(...) On 20 January I summoned all the principals of the village to come to the castle. A total of 70 people appeared and after having welcomed them, I bought as much land from them, as needs the Company for the price of 15 cangans. And they all departed from here in a good mood. Generally speaking they are very aimiable people and easy to get along with if you know their moods and are able to accommodate yourself to them a little, for you should meet their wishes first, their main object being a bellyful of rice, a fathom of cangans, or a pipe of tobacco.

With the consent of the Council I bought a suitable plot on the side of a fresh river near Sincan to set up a trading office for the Company, which we hope will grow into a populous town.

fol. 231v.: (...) This place and the entire country is very fertile and blessed with excellent nature, abundant in game like deer, serows, swine as well as pheasants, hare, etc. Near the limits of the place in question it also contains a fairly large inland lake with a multitude of fish swimming in it and everywhere it is teeming of limpid rivers, and what is more, it is surrounded by a sea abounding in fish. It is such that with more people settling here within a few years (with God's help), it can be brought to a point where all of us will not be in need of food imports from other quarters and will be able to sustain the Company's employees and also our table with little cost. (...)

fol. 232v.: Would Your Honour be so kind as to send over some horses with saddles and bridles because these would give us great authority and would be of great help in times of emergency, because we will be able to tower high above the natives and the other enemies in the field.

14. Missive Governor Martinus Sonck to Governor-General Pieter de Carpentier. Tayouan, 3 March 1625.
VOC 1085, fol. 234-236. Extract.

fol. 236: "Uwe Edele gelieve met het toecomende mousson herrewaerts te senden eenige bequaeme oppercooplieden en ondercooplieden ende assistenten, om des noodich wesende alhier te mogen gebruijcken alsmede 2 à 3 predicanten ofte voorleesers van bequaem ende goet leven, opdat de naeme Godes alhier verbreydt, ende de barbare inwoonders van dit eijlant tot het getal der Christenen gewonnen mochten worden. (...)"

fol. 236: Would Your Honour graciously consent to send over some able senior and junior merchants and assistants during the next monsoon, to serve us here as we are in need of them. And also two or three ministers or readers who are competent and well taught so that the name of the Lord will be spread in these parts and the barbaric inhabitants of the island may be numbered among the Christians (...).

15. Message Governor Martinus Sonck. Tayouan, 9 April 1625.
DRB, pp. 144-146. Extract.

"Per resolutie van den 15^{en} Januarij 1625 resolveerden d'onse de logie vande sandtplaete op de vaste cust van Formoso te renoveren. Item daer een stadt aff te steecken, ende daer een colonie van Chinesen, Jappanders &^a te stabilieren. Den toeloop der Chinesen was t'sedert 't verlaten van Pehou op Formoso seer vermenichfuldicht. Dese plaetse op Formoso hadden d'onse inde jurisdictie van Sincang, met consent vande ingelande begrepen, ende hadden dit landt van die van Sincang gecocht voor 15 cangangs. Verhaelt redenen waerom goet vonden 't comptoir vande santplate te renoveren. Dese begrepen plaetse hadde aen d'een seijde een versche rivier, was seer vruchtbaer landt ende rijck van wilt vhee ende vischrijcke binnen wateren, item becingelt met een vischrijcke see soodat aenden toeloop van Chinesen ende Jappanders niet en twijffelen.
Sonck meent de Comp^{ie} dienst soude geschieden soo daer eenige Battavische huijsgesinnen gesonden wierden, die gelimiteert souden wesen in wat waren dat souden vermogen te handelen. Hiermede soude des Comp^{es} capitael verstreckt konnen werde, de Chinesen van andere plaetsen gediverteert, nae Taijouwan gelockt, ende den vijant alsoo vanden Chineschen handel alleng-

skens gepriveert werden, insonderheijt als de particuliere van vermogen waren met haer eijgen vaertuijgh te vaeren.

In 't lant van Formoso ontrent onse begrepen stadt waren verscheijden dorpe ende vlecken als onder andere:

Mattau: konde uijtmaecken ontrent weerbaare mannen	2000
Soulangh	1000
Baccalauwangh	1000
Sinckan	400

Met dese voorsijde dorpen waren d'onse in vrientschap, daer laegen noch verscheijden dorpen ontrent ijder van 150 à 200 mannen, die mede onse vruntschap versochten. 't was al te saemen een mannelijck volck, ende wel om mede omme te gaen voor degeene die haer humeuren kendt, ende sijn licht te paeijen met een buijck vol rijs, een vadem cangang, een pijp toebacq &ª.

Ider van dese inwoonders is bijkans even veel meesters; sij willen onder geen een hooft staen, voeren gestadich inlandschen oorloch en die de vroomste inden oorloch is, heeft 't meeste gesach, haer vrientschap sal met ontsach ende schenckagie onderhouden moeten werden.

Nae men verstaet, soo wast op Formoso schoonen rijs, ende soo veel als de inwoonders van doen hebben, de wijven ploegen, saeijen ende garen, ende de mans oorlogen.

De Chinesen waeren vrij jalours van onse compste op Formoso, sochten d'inwoonders tegen ons te verwecken, omdat sij vreesden dat wij haer in den vellen, vleijsch ende visch handel inde wege souden sijn.

Nae men verstaet, vallen daer jaerlijcx 200 000 hartevellen, groot abundatie van gedroocht harte-vleesch, waervan men in rederlijcke quantité souden konnen gedient werden.

De voorschreven inwoonders insisteerden seer om van ons volck in haere dorpen te hebben. In Soulang hadden d'onse gesonden een ondercoopman met twee andere persoonen tot hem, in andere dorpen souden van gelijcken doen."

(*And on August 26, 1624, we dismantled the whole box and dice in Pehou and went to Tayouan:*)

By Resolution of January 15, 1625, we decided to rebuild the settlement on the sandbank on the mainland of Formosa. And to mark out a town there and establish a settlement of Chinese, Japanese etc. The influx of Chinese has multiplied greatly since we left Pehou.

Our people took the measurements of this place, situated on the island of Formosa falling within the jurisdiction of Sincan, with the consent of the

inhabitants and they bought this piece of land from the people of Sincan for 15 cangans. Reasons are given why we thought it best to erect a new office on the sandbank. The plot is bordered on one side by a limpid river, has very fertile soil and teems with game, animals and inland lakes abundant with fish, and is also surrounded by a sea abounding in fish, so that there is no doubt the Chinese and Japanese will come.

Sonck is of the opinion that it would be useful for the Company if some families were to be sent over from Batavia, who would be allowed to trade in a limited range of goods. This would strengthen the Company's finances, and lure the Chinese to Tayouan from other places and thus the enemy would be slowly deprived of the Chinese trade, in particular when the merchants are allowed to trade for themselves with their own vessels.

In Formosa there are several villages and hamlets near our town-to-be, including:

Mattau with able-bodied men	about 2000
Soulang	1000
Baccaluan	1000
Sincan	400

Our people have struck friendships with these villages. Some more villages are situated there, each of about 150 to 200 men, which have also asked for our friendship. It was altogether a fine people and easy to get along with if you know their moods and they are easy to please with a belly full of rice, a fathom of cangan, a pipe of tobacco etc.

Each of these natives is the equal of the other, they do not want to be ruled by a leader. They are embroiled in internecine wars most of the time and the bravest man in war enjoys the most authority. The friendship with them will have to be maintained by our authority and by gifts.

As we understand good rice grows in Formosa and as far as the inhabitants are concerned: the women plough, sow, and spin and the men make war.

The Chinese, very jealous of our arrival in Formosa, have tried to incite the natives against us, because they are afraid we might stand in their way by trading skins, meat, and fish. As we understand every year 200,000 deer-skins, a great abundance of dried venison and dried fish is produced, with which we can be supplied in a reasonable quantity.

The inhabitants mentioned above are highly insistent that they have our soldiers posted in their villages. Our people have sent a junior merchant

accompanied by two other persons to those in Soulang and will do the same in other villages.

(Governor Martinus Sonck died on 17 September 1625. Senior Merchant and Commander Gerrit Frederickz. de Witt took over as Interim Commander of the VOC post on Tayouan.)

16. Missive Commander Gerrit Fredericksz. de Witt to Governor-General Pieter de Carpentier. Tayouan, 29 October 1625. VOC 1087, fol. 385-396. Extracts.

fol. 389v.: "(…) 3 persoonen in Wancan (…) zijnder van vremde ofte onbekende inwoonders die het geheele landt doorloopen, in een cleyn vers reviertge, soo se gingen water haelen, dootgeslagen ende een dappere gequest. (…)

fol. 391v.: Wat belangst d'inwoonders van Paccan ofte Formosa, bij ons bekent, als namentlijck die van Soulangh, Sinckan, Backeluan, Mattau ende haer omleggende dorpen, daer sijn tot noch toe in goede vrintschap mede. Zij comen ons dagelijcx besoecken ende sijn met een pijp toeback ende een weynich cangan te contenteren. Daer mede oock onderhouden moeten worden, hoe sij het maecken der reduyten zullen nemen, zal de tijt leren. Uwe Edele vermaent oock off dese luijden niet tot vrijwillighe contributie van eenighe subsidien soude te brengen wesen ende soo dat niet vallen wilde, off daer middel zij, haer door ontsagh daertoe te brengen. (…)

fol. 392: Eerstelijck zijn sijluijden gewoon van de Chinesen uyt haer wooningen ende vaertuych te nemen, sulcx als haer wel gevalt. Soo de Chinesen hun daertegen stellen, nemen zij al wat de Chinesen hebben ende snijden haer het hayr aff, dat hier dagelijcx gebeurt. Dit heeft Capiteyn China veel cangans gecost: soo zij tot eenighe vrijwillighe opbrengingen te brengen ware geweest, hij soude het wel gedaen hebben. Elck bij de haren is evenveel meester, sodat niet weten met wie dat men te houden heeft. 't Minste dat haer in haer quaet doen tegen gesproocken ofte yets misdaen werdt, soo dreygen zij alles in brandt te steecken, wat hier ontrent staet; zulcx dat het luyden sijn die geen reden gebruijcken, maer eijgen gewoonte ende hooft volgen.

Ten tweede om met ontsach haer daer toe te brengen, zal mijns oordeels tot dien eynde alleen niet geraden wesen te geschieden, doordien zij niet hebben: zij soecken alleen haer dagelijcx broot. Die bij haer voor rijck en machtich gehouden werden, hebben ten hoogste 100 à 150 cangans. Maer om haer in

haren moetwil ende woestheijt wat te temmen, sou het onder correctie seer
geraden wesen, dat men met ontsach van volck haer in hare dorpen gingh
besoecken. Ende om daertoe juste redene te hebben, dient soo een tijt waer-
genomen, dat als yemant van hare dorpen de Compagnie off in haren stadt
yets groots misdoet (gelijck in Wancan daer drij van d'onse sonder reden
doot gesmeten hebben, doch dit waren lantloopers en hebben niet cunnen
vernemen van wat dorpen dat se waren), als dan soude de andere dorpen
siende des Compagnie's macht haer door vrees vandien lichtelijck onder
subjecten begeven. (...)

fol. 393: Eenighe der geseyde inwoonders zijn hier bij ons geweest, wilden dat
men haer een joncq met zijn toebehooren en ingeladen goederen zouden
weder geven. Naer veele onderrechtinghe hebben haer met 40 stucx cangans
om vreedes wille afgeseth."

fol. 389v.: (...) In Wancan three men have been beaten to death and one man
has been severely wounded while fetching water from a small fresh water
river, by strange or unknown natives who wander throughout the whole
country. (...)

fol. 391v.: Regarding the inhabitants of Paccan or Formosa who are known to
us, being those from Soulang, Sincan, Baccaluan, Mattau and their surroun-
ding villages, we have been on good terms with them up to now. They
come to visit us daily and are easy to please with a pipe of tobacco and
some cangans. Time will tell how they will accept the construction of a
redoubt.

*(The High Government in Batavia had proposed that the government of
Tayouan persuade the Formosan villagers to paying a financial contribu-
tion:)*

Your Honour also suggests that these people could be brought to donate a
voluntarily contribution and that if that would not happen, there would be a
way to pressurize them as to make them pay some taxes to the Company.
(...)

*(Shortly before his death Governor Sonck had put forward the following
objections:)*

fol. 392: In the first place these people are in the habit of taking away from
the houses and boats of the Chinese whatever takes their fancy. And when
the Chinese object to this, they take away whatever the Chinese possess and
cut off their hair. This happens here daily and has cost the Captain China
many cangans. Had he been able to induce them into producing any volun-

tary revenue he would have done so, but each of them is equal to the other, so you do not know to whom you should turn to. Whenever they have done wrong, are contradicted or are committed the slightest injustice, they threaten to set fire to everything in sight. They are irrational people who follow their own customs and inclinations.

Secondly, to force them into payment by inspiring awe is in my opinion not to be recommended, because they have nothing to give. Their only care is to collect their daily bread. The people they consider to be rich and powerful have 100 to 150 cangans at most. But in order to tame them somewhat in their wilfulness and ferocity, it would perhaps be a good idea to visit them in their villages with an impressive number of soldiers. And in order to have a good reason for doing so, we must keep a close watch to see if someone from their villages misbehaves badly towards the Company or in their towns (like in Wancan where three of our people were murdered without any reason - but these inhabitants were vagrants and we have not been able to find out from which villages they came), in that case the other villages, seeing the Company's power, would from fear readily submit.

(Three months ago ten inhabitants of the village of Soulang crossed the sea to the Chinese coast with Chinese pirates. They captured four small junks loaded with sugar, which they landed shortly after at Wancan and then loitered in the estuary of the river of Mattau. At the beginning of September 1625, after Governor Sonck had despatched two Chinese junks manned by Company soldiers, these junks sailed into the river and the Chinese fled inland with the natives. During the operation one of the pirate junks loaded with sugar and its crew fell to the VOC as prize. The Company could not do much more with them.)

fol. 393: Some of the abovementioned natives came here. They wanted us to return a junk with its tackle and cargo to them. After many admonitions we sent them off with 40 cangans for the sake of peace.

(The Company's junks Packan and Orangie have clashed with Chinese pirates in the River Mattau.)

17. Missive Commander Gerrit Fredericksz. de Witt to the captains of the junks *Packan* and *Orangie* in Wancan. Tayouan, 20 December 1625. VOC 1090, fol. 184. Extract.

fol. 184: "Seedert is op heeden Ue. schrijvens van de 19e dito ons ter hant gestelt, daer uyt verstaen 't rencontre dat in 't opvaeren van de revier van Mattau jegens de Chineese zeerovers gehadt hebt maer, vermits de paelen bij ditto Chineesen in de engte der reviere gestelt, bij haere joncken met d'onse niet hebt connen commen, als mede door beduchtinge dat de inwoonders van 't dorp Mattau de Chineesen helpen. (...)"

fol. 184: Your letter of the 19th has been given to us today. We understand that you clashed with the Chinese pirates in the River Mattau, but you could not approach their junks because of the poles put up by those Chinese in the narrows of the river and also from fear that the inhabitants of the village of Mattau would go to the aid of the Chinese (...).

1626

18. General Missive.
VOC 1086, fol. 5. Extract 3 February 1626.
FORMOSA, pp. 49-50.

> "Met d'inwoonders van 't lant hielden d'onse noch goede correspondentie
> ende vrientschap, niet soo seer om de proffijten, welcke daervan te verwach-
> ten staen, als om d'selve niet te vijant te crijgen, sijnde doch een ongeregelt,
> woust, quaetaerdich, luy ende begerich volck, daer niet dan bij lancheyt van
> tijt ende degeneratie van haeren bedurven aerdt iets goets van te verhoopen
> is."

We are on good and friendly terms with the inhabitants of the place, not so
much because of the expected profits as by not turning them into enemies,
as they are a disorderly, fierce, malicious, lazy, and greedy people, of
whom something good can only be expected after a very long time and
through the disintegration of their depraved nature.

*(Since September 1625, three Chinese pirate junks have been moored in the
mouth of the River Mattau; their crews were harassing the villagers. In
March 1626, Chinese pirates invaded the village and they have even lodged
in the houses of the inhabitants. The Company stations the junk the Orangie
and 20 soldiers near the river.)*[18]

**19. Missive Commander Gerrit Fredericksz. de Witt to Governor-
General Pieter de Carpentier. In the Chincheo River, 4 March 1626.
VOC 1090, fol. 176-181. Extract.**

> fol. 177v.: "Met de inwoonders van Paccan staan wij noch wel. Die van
> Mattau alwaer men door de revier van Wanccan can aencomen hebben drie
> Chinese roovers voor haer dorp ende in hare huijsen gelogiert gehadt. Dit
> lieten wij hun weten dat niet doen en soude, maer deselve van daer drijven.
> Ondertussen hebben wij de joncke *Orangie* met 20 coppen voor de revier op
> de wacht geleyt en dat zij bij gelegentheyt de roovers soude aentasten,
> waartegen hun de roovers zich zoo dapper gestelt hebben dat de onse de
> wijck mosten nemen. Dit heeft onder de inwoonders van alle de andere

dorpen een groote vervlaeuwinge gebracht dat de Chinesen de Nederlanders verjaegen ende machtich waren. Waernaer goet gevonden is de joncke *Packan* met 40 coppen de joncke *Orangie* te hulpe te stieren. Ondertussen hebben die van Mattau ons laeten weten soo wij de roovers vandaer begeerden, dat wij se wel mochten vandaer drijven, sij en souden ons niet tegen staen. Ende alsoo in 't opvaeren van de revier ontrent onse joncken seer veel inwoonders verthoont hebben, sulcx dat d'onse niet en wisten of sij hen wilden als vrienden of vijanden stellen.

fol. 178: De inwoonders van Mattau hebben in 't dorp Sincan eenige huijsen, ten tijde als alle het volck meest in 't lant waren, geplundert. Onder alle het huijs daer de Compagnie twee jongeren gelogeert heeft, meede met al de cleederen van de jongeren. Daerover die van Sincan seer bij ons quaemen doleren en versochten, dat men haer met eenich volck wilde helpen, sij wilde de Mattauers gaen bevechten. Dit hebben haer afgeraden ende belooft daer inne te sullen versien ende dat hunne geplunderde goederen soude weder gegeven worden.

De goederen hebben sij weder ter hant gesteld, maer op Tayouan en dorsten sij niet comen, waerover eeniche hoofden van andere dorpen andermael derwaerts gesonden hebben, dat sij bij ons soude comen haer verantwoorden, hetwelck sij door twee der principaelen gedaen hebben. (...) naer haer lantsmaniere al wanneer sij met iemant versoenen twee verckens. Seyde wat 't plunderen in Sincan belangde, dat het door eenige jongelingen geschiet ware sonder kennisse van de principaelen ende dat sij deselve naer haer custum gestraft hadden.

Wat het herberge van de zeerovers belangde, die waeren daer met geweldige hant gecomen en conde haer niet vandaer houden. Soo wij niet en begeerden dat sij daer comen souden, sij mochten wel vandaer gaen, sij souden daer niet tegen sijn. Dese twee hebben wij wel onthaelt en geseyt dat sij met de andere principaele hoofde bij ons comen soude, wij wilden met haer als dan in haer dorp comen besoecken ende eenige cangans vereeren, gelijck wij aen andere dorpen die onse vrienden sijn gedaen hebben."

fol. 177v.: We are still on good terms with the inhabitants of Paccan. Those of Mattau whom one can reach via the Wancan river have had three Chinese pirates before the village and have been lodging them in their houses. We told them we would not have it and that they should drive them out. In the meantime we dispatched the junk *Orangie* with a crew of twenty to guard the river and to attack the pirates, were the opportunity to present itself, but the pirates fought so bravely that our men had to retreat. This has led to a watering down of relations with all the other villages because the Chinese

put the Dutch to flight and showed their power. Hereupon it was agreed to send the junk *Packan* with forty men to assist the junk *Orangie*. In the meantime the people of Mattau have let us know that if we want the pirates out of there we would be welcome to chase them away. They would not oppose us. While we were sailing up the river, many inhabitants (of Mattau) showed up around our junks, so that our people were in doubt as to whether they were intending to behave as friends or foes.

(Escalation of the animosity between Mattau and Sincan.)

fol. 178: The inhabitants of Mattau plundered several houses in the village of Sincan at a time when most of all the people were in the fields. Among these houses was the one where the Company has lodged two young men and all their clothes were gone. The people of Sincan came to us and complained sorely about this and asked for the assistance of some of our people so that they could make war on the Mattau people. We discouraged them from doing so and promised to look into the matter, as well as to arrange for the return of their stolen goods.

(The principals of the other villages were summoned to assemble by order of the VOC and it was agreed that the people of Mattau had to present themselves at Fort Zeelandia and that this would also be an opportunity to make peace between Mattau and Sincan and to negotiate the restitution of the goods stolen from Sincan.)

(...) The goods have been given back but the people from Mattau did not dare to come to Tayouan. That is why we sent some headmen of other villages to their place for the second time to tell them to come and to account for this behaviour. This they did by sending two of their prominent men (...)

According to their custom, when they make peace with someone [they bring with them] two pigs. Referring to the plundering of Sincan they said it was the work of some youngsters without the consent of the notables and that they themselves had punished them according to their custom.

And with regard to the sheltering of the pirates, these had entered their settlement by force and they had not been able to fend them off. If we did not want the pirates to come there, these could be dislodged, and they would not oppose this.

We entertained these two envoys well and told them to come to us with the other principal chiefs and that thereupon we would accompany them to visit

them in their own village and bestow on them a couple of cangans, like we had offered to other friendly villages.

20. Missive Governor-General Pieter de Carpentier and councillors to Senior Merchant Gerrit Fredericksz. de Witt. Batavia, 3 May 1626. VOC 853, fol. 76-82. Extract.

fol. 81: "d'Ingesetene van 't Eylandt Formosa sult soo veel t'onswaerts te trecken ende tot onse devotie te brengen als bij gevoeglijcke middelen geschieden kan. Zeer wel heeft Ued. gedaen het crackeel tusschen die van Mattau ende Sinckan met interposite authoriteijt vereffent te hebben. De taecken dienen daer soo beleijt dat men soo veel aanhang becoome, daermede men de moetwillige 'Negris' tot ontsach ende obediëntie kan dwingen, om alsoo allenskens sonder beswaringe van de Compagnie 't gesach ende heerschappij door middel van d'Ingesetenen selfs t'onsewaerts te trecken, gelijck wij niet en twijffelen soo daerinne van tijt tot tijt discretelijck gehandelt wordt, wel sal connen geschieden."

fol. 81: You should attract the inhabitants of the Island of Formosa to us and win their devotion if this may be possible by decent means. Your Honour has done very well to have smoothed out the quarrel between the people of Mattau and Sincan by interposing your authority. The tasks involved should be carried out in such a way that as many allies as possible are won over, by which means the malicious villages can be forced into respect and obedience, because this is the only way in which, without hardship to the Company, the respect and rule of the inhabitants can be drawn in our direction, which (should it from time to time discretely be taken in hand) will undoubtedly take place.

21. Missive Commander Gerrit Fredericksz. de Witt to Governor-General Pieter de Carpentier. Tayouan, 15 November 1626. VOC 1090, fol. 196-206. Extract.

fol. 201v.: "(...) waerop oorloch gevolgt is. De drie cleyne dorpen Teopan, Tatepoan en Tibolegan die onder Sincan sorteren sijn met die van Sincan tegen de Mattauwers ende Backeluwanders (die haer van haer dorpen quamen bezoecken) uitgevallen, maer ziende zij te swack waren bennen in Sincan retireert. (...) Dit nu soo eenige dagen durende, sijn die van Sincan

en de drie cleyne dorpkens bij ons affgecomen en versochten assistentie ofte dat sij hare dorpen wilden verlaten en naer 't geberchte vluchten.

(…) lieten wij die van Mattau en Backeluwan dickwils weten, zij zouden vrede maken off wij souden ons de saecke t'eenemaele aentrecken. Echter hieuwen zij niet op, maer besprongen de andere seer manhaftich eerst met hasegayen, daernaer met schild en swaert. Hackten malcanderen aen hutspot met soo een couragie dat te verwonderen was. Veele zijnder van beyde de zijden gequest geworden ende vier zijnder gebleven van de vijantszijde. De onse nu daer weijnich dagen geweest zijnde, vonden niet geraetsaem daer langer te blijven, maer den crych tot een eynde te maecken ende lieten den vyant aenseggen wilden zy vrede maecken, dat zulcx terstont doen zouden ofte anders wilden ons in 't velt verthoonen, dat zy zeyden te willen ver-wachten. D'onse zijn flucx jegens haer uytgetogen, maer zij namen terstont de wijck ende mochten 't gehuyl vande cogels niet verdragen ende bleven zeer verwondert als zij zagen datter een vande haren liggen bleef sonder te zien waerdoor. Niet lange daer naer zijn zij bij d'onse gecomen ende vrede begeert, waer over eenige hoofden van alle de gemelte dorpen bij ons hier gecomen zijn ende hebben tusschen den anderen vrede gemaeckt ende die van Mattau ende Backeluwan hebben tot een pene opgeleyt twintich ver-ckens, die (fol. 202) zij goetwillich zijn comen brengen ende zeyden haer voortaen gerust te zullen houden. Dese genoechzaem gedwongen vrede heeft niet lange geduert, maer hebben den anderen in't velt comende qualijcken bejegent ende de Sincanders groote overlast gedaen, daer over zij zeer claechden.

Geleden drie weecken ben perzoonelijck met 60 coppen met de gewoonlijck jaerlijcke schenckagie naer bovenen gegaen. De Soulangers daer eerst qua-men, hebben ons zeer onthaelt en houden goede correspondentie, de Mattau-wers en de Backeluwanders deden door vreese sulcx mede. Hier hebben wij hun vermaent ende gelast sij souden met de Sincanders en andere dorpen goede vrientschap houden en een ieder ongemolesteert laten, ofte wij wilden sulcke overlast en quaetdoenders straffen. Daerop swoeren zij naer hare maniere onse willen te zullen doen. De Sincanders daertegen zijn ses dagen daernaer comen clagen dat die van Mattau een out man, in't velt zijnde, 't hooft met de handen affgehouwen hebben. De Mattauwers hebben hun bij onse tolck in Soulangh verontschuldigt, seggende dat geschiet te zijn van een broeder bij die van Sincan in de oorloch terneder geslagen en dat hij al naer 't geberchte gevlucht was. Hierop lieten wij de Mattauwers roepen, maer se zijn tot noch toe niet affgecomen. Wat hier noch uijt groeijen wil moet de tijt leren. (…)

fol. 204v.: d'Inwoonders van Formosa ofte Packan kennen geen Godt nochte sijn gebodt, maecken oock geen werck van de zon ofte maen, hebben geen beelden nochte besondere uijtmuntentheden daer zij superstitie off maken, sulcx dat zij lichtelijcken tot den Christen-gelove te brengen zoude wesen. Haer tale is wel te leren, onse tolck heeft noch geen twee jaren in Soulangh gewoont en heeft se lange gekent. (...)

fol. 205: Zij hebben oock geenige wetten daernaer zij leven en slaet den eenen den anderen doot, met hunne middelen 't sij 20 ofte wat meer cangans (wat bij hun veel is) cunne zij versocht werden. Geenich hooft en willen zij sijn, ieder is genoechzaem evenveel. De oudste doene zij alleen eere en dat de cloeckste voorvechter is, heeft de grootste aanhanck."

(The Formosan villages knew no mutual peace. Inhabitants of Mattau and Baccaluan had attacked and robbed Sincan, situated close to Tayouan, several times:)

fol. 201v.: (...) thereupon war broke out. The three small villages under the control of Sincan, Teopan, Tatepoan, and Tibolegan joined with the Sincandians to make a sally against the people of Mattau and Baccaluan (who came to their village), but seeing that they were too weak in numbers they drew back to Sincan (...). This having lasted several days, the people of Sincan and the three small villages came to us and asked for assistance. Were we not to do so, they would leave their villages and flee to the mountains.

(It was very inconvenient to the Company that enmity flourished between the various villages. The Dutch had done their best to give the Sincanese and their allies as much support as possible and in the meantime to woo them to make peace with their enemies.)

(...) We told the people of Mattau and Baccaluan several times to make peace or we would take matters into our own hands once and for all. Yet they did not stay their hand, but assailed the others very bravely first with assegays and thereafter with shields and swords. They hacked each other into a hodgepodge with astonishing courage. Many were wounded on both sides and four were killed. Our people having spent a few days there, decided it would be advisable not to stay any longer but to put an end to the war and to tell the enemy that if they wished to make peace, they should do this immediately unless we should ourselves take the field. This, they said, they were willing to face. When our men quickly showed themselves, they took to flight immediately, unable to stand the whine of the bullets. They stood

amazed when they saw that one of them remained lying without seeing what had caused this. Not long after this they came to us and sued for peace, to which end several notables from all the villages mentioned came to us here. They have made peace with each other and those of Mattau and Baccaluan have had a fine of twenty pigs put upon them, which (fol. 202) they willingly brought hither saying that in the future they would keep the peace. This compulsorily concluded peace did not last long but the others with evil intentions have taken the field and caused the Sincandians great problems, about which they complained. The last three weeks I personally have gone inland with sixty men to present the annual gifts. The people of Soulang where we came first welcomed us and maintained good relations. Cowed by fear the people of Mattau and Baccaluan did the same. Here we have warned and charged them that they should maintain friendship with the Sincandians and with other villages, or we shall punish such harassment and its perpetrators. Thereupon they swore in their way that they should obey us: Six days later the Sincandians came to complain that the people of Mattau had beheaded an old man who was out in the fields. The people of Mattau apologized to our interpreter in Soulang, saying that it was perpetrated by one whose brother had been smitten in the war with Sincan and that he had fled into the mountains. Hearing this we summoned the people of Mattau, but so far they have not ventured forth. Time will tell what is going to happen next. (...)

fol. 204v.: The inhabitants of Formosa or Paccan live without God's commandments, do not worship the Sun or the Moon, do not have images or specially conspicuous features to which they attach superstition or magic, so that they may be easily nudged towards the Christian belief. Their language is easy to learn. Our interpreter has been living in Soulang for less than two years and has already been acquainted with it for quite a while. (...)

fol. 205: What is more, they do not have any laws at all to live by and when somebody kills another person, within their means they can be fined to 20 or more cangans (which is a lot to them). They do not aspire to be leader, they are all satisfied with being equal. They honour only the oldest and he who is the bravest warrior has the larger following.

1627

22. Memorandum for Pieter Nuyts, on his departure as Commander of the fleet destined for Tayouan and as ambassador on a mission to the _Keijser_ (_Shogun_) of Japan. Batavia, 10 May 1627.
VOC 854, fol. 51-60. Extract.
Duplicate: VOC 1092, fol. 80-90.

> fol. 52: "den vijant van Manilha verleden Zuyder mousson anno 1626 aen't noordereynde van Formosa gecomen ende op zeecker cleen eylandeken genaempt Kelangh Tamsuy niet verre van 't groot eylant gelegen plaetsen geïncorporeert ende een drij puntich fort op den hoeck van 't Eylandeken begreepen heeft (…)."

fol. 52: (_It is certain that:_) last southern monsoon (the year 1626) the enemy from Manila arrived on the northern end of Formosa and has incorporated a certain small island named Kelangh Tamsuy, situated not far from the large island and has built a triangular fort on the corner of the small island. (…).

(In June 1627 Governor Pieter Nuyts and the Reverend George Candidius had arrived on the island. The Company was still embroiled in the internecine squabbles of the Formosans and found itself more firmly entrenched in the camp of the opponents of Mattau and Baccaluan.)

23. Missive Governor Pieter Nuyts to Governor-General Pieter de Carpentier. Tayouan, 22 July 1627.
VOC 1092, 398-401. Extract.

> fol. 401: "De Sinckanders en Soulangers hebben ons behoorlijcke reverentie comen doen, maer de Baccalauanders ende Mattauers sijn noch scrupuleus. Soo niet paresseren, sullen op ons retour deselve personelijck selfs eens moeten besoecken."

fol. 401: The people of Sincan and Soulang have paid us satisfactory honour. But the people of Mattau and Baccaluan are still circumspect. If they do not show up, we shall have to visit them in person on our return from Japan.

(Before Pieter Nuyts could take up office on Formosa, he was under instructions first to proceed, with Senior Merchant Pieter Jansz. Muyser, on a diplomatic mission to the court of the 'Emperor', in fact the Shogun, in Edo (Tokyo). On his way to the capital he was informed by the head of the VOC factory in Hirado that a delegation of sixteen Sincandians had arrived in Nagasaki as 'ambassadors' from Formosa on the orders of 'Phesodonne', Suetsugu Heizō, the Regent of Nagasaki. They had been kidnapped and brought to Japan to bring tribute to the Shogun and thus the sovereignty over the island of Formosa was to be handed over to the Shogun. The shrewd political move was intended to take all the wind out of the VOC's sails on Formosa and to settle the island under the Japanese sphere of influence.)

24. Journal of the voyage to the Shogun and Councillors of Japan by the Ambassadors Pieter Nuyts and Pieter Muyser. Tayouan and Japan, 24 July 1627-4 March 1628.
VOC 1095, 449-508. Extracts August 1627-February 1628.

fol. 449v.: [2, 3, 4 August 1627] "Op dato verstonden oock, dat de 2 joncquen uyt Tayouan in Nangesacqui waeren gearriveert; dat Yaffioye[19], capitein van de joncq van Fesodonne, ettelijcke inwoonders van de dorpen van Formosa steelsgewijs hadde met hem gebracht ende dat Fesodonne deselve meende boven voor den Keyser te brengen. Tot wat eynde is alsnoch onbekent; apparentelijck niet om d'onse eenige deucht ofte vrientschap te doen (...)."

fol. 452: [6 September] "(...) hebbende derselver ouders ende huisvrouwen wijs gemaeckt gemelte persoonen soude niet langer als voor 10 dagen met hun in zee gaen om buyt ende eere te soecken, alsdan souden die wederom bestellen. Ende alhier (in Japan) maecken de luyden wijs dattet gesanten sijn van dat landt, gedeputeert aen den Keyser alhier (...)."

fol. 457: [4 October] "(...) want gemelte luyden al over 4 jaren hadden getracht de souverainiteyt van haer lant aen haren Keyser op te dragen ende daerom waren sij nu oock eygentlijck gecomen, waerent dat wij dan seyden datse uytgestoolen ende onse onderdanen ofte slaven waren.

fol. 457v.: (…) waeruyt niet anders can beslooten worden ofte dese luyden sijn onse onderdanen, niet vermogende sonder consent een voetstap buytten haer landen te gaen (…).

fol. 457v.: [5 October] "Want de Keyser en de Raden wilden van sulcx niet hooren spreken, derhalven rechtuyt seyden wij waren geen ambassadeurs, maer opgeraept ende versamelt van (fol. 458) eenige coopluyden, om door onse geschencken 't stuck van Teyouan bij Sijne Majesteyt wegens sijne onderdanen te defenderen. 't Was al 5 jaeren geleden dat men de Tayou-wanders verwacht hadde ende dat die nu eygentlijck waren gecomen ende niet gestolen maer expres quamen om Sijne Majesteyt 't lant op te dragen."

fol. 495v.: [25 November] "Des morgens vertrock Phesodonne mette Sinckanders naer Edo. Wij verstonden dat hij geprotesteert hadde gemelte luyden niet in prejuditie van ons op te leyden, maer simpelijck om die voor den Keyser te stellen, als rariteyt aen Sijne Majesteyt te vertoonen ende alsoo wederom af te brengen ende naer Teyouhan te senden. Doch of sulcx waerachtich is blijven wij in twijffel (…)."

fol. 505: [5 February 1628] "(…) Phesodonne (…) hadde moeten bekennen dat deselve Sinckanders buyten weten van ymandt van d'onse uytgevoert waren geweest, daerom beslooten was bij de raetsheeren dat geen ambassadeurs ofte gesanten conden sijn (…)."

fol. 506: [16 February] "Aengaende de luyden van Sinckan meende hij [de Heer van Hirado][20] hadden audiëntie gehad ende mosten nootwendich op wech sijn om af te comen.

fol. 507v.: Missive van de Heer van Hirado Matsura Figenno Camij aan kapitein Pieter Muyser. Edo, 19 December 1627. " 't Volck van Teyouhan hebben wij niet gesien, waerom oock van hunne affaire niet connen schrijven (…)."

fol. 508: Missive Tacotta Kakusemedonne[21] aan kapitein Pieter Muyser. Edo, 19 December 1627. "De Sinckanders met Phesodonne sijn hier aengecomen. Soo wij verstaen spreken gants niet in der Hollanders nadeel. Alleenlijck hebben sij vertoont, alsoo geen hooft ofte gouverneur hebben, sulcken één alhier in Japan comen soecken, sulcx loopt hier de sprake."

fol. 508v.: [1 March 1628] "Belangende Phesodonne mette Sinckanders, waren alsnoch niet daer gecomen, maer worden verwacht, nevens sijne groote Japanse joncq.
[2 March] (...) arriveerde Phesodonne alhier. De luyden van Sincan waren in Nangoia ende conden door harden windt niet voorts comen."

fol. 449v.: (2, 3, 4 August) Today we heard that the two junks from Tayouan had arrived in Nagasaki; that Jaffioye, the Captain of Phesodonne's junk, has secretly brought with him a number of inhabitants of the villages of Formosa and that Phesodonne was intending to take them to the Shogun. To what purpose is still unknown, obviously not to cultivate any credit or friendship with our people.

fol. 452: (6 September) [The Japanese] convinced the parents and wives [of the kidnapped people] that the people mentioned above would go to sea with them for no longer than ten days, with the purpose of seeking booty and honour, whereafter they would return them home. And here [in Japan] they convince the people that they are representatives of that land, sent to the Shogun of this country as envoys.

fol. 457: (2 October) [Because the Japanese believe] that these people had been trying to transfer the sovereignty over their land to their Shogun for no less than four years and that this was in fact the reason why they had come, we said they had been kidnapped and that they were our subjects or slaves.

fol. 457v.: (4 October) The only conclusion is that these people are our subjects, unable to set foot outside their territory without our consent. (...).
fol. 457v.: (5 October) Because the Shogun and his councillors did not want to hear a word of it, without palaver they said that we were not ambassadors, but were picked up and collected from among a few merchants, with the purpose of bringing, by means of our presents, the matter of Tayouan to His Majesty's attention so that he might forbid his subjects [to go there]. Five years ago they had already been expecting the Tayouanese and now these had finally come; indeed, they had not been kidnapped but came expressly to transfer the land to His Majesty.

fol. 495v.: (25 November) In the morning Phesodonne left for Edo with the Sincandians. We heard he pretended that he was not going to present these

people in a way which would prejudice us, but simply intended to exhibit them to the Shogun, to show them as a curiosity to His Majesty and afterwards to bring them back and send them to Tayouan. But we doubt whether this is true.

fol. 505: (5 February 1628) Phesodonne (...) had to confess that these Sincandians had been taken out without any of our people knowing about this, therefore the Councillors concluded that they could not be ambassadors or delegates.

fol. 506: (16 February) (...) Concerning the people of Sincan, the Lord of Hirado, Hizen-no-kami, thought that they had been received in audience and consequently should be on their way back.

(Letters of Japanese officials of December 1627, quoted by Nuyts in his journal:)
fol. 507v.: (Missive of Matsura Hizen-no-kami, Lord of Hirado to Pieter Muyser. Edo, 19 December 1627). (...) We did not see the people of Tayouan, therefore we are not able to write about them.

fol. 508: (Missive Yokota Kakuzaemon to Pieter Muyser. Edo, 19 December 1627). The Sincandians have arrived here in the company of Phesodonne. We have understood they do not speak disparagingly of the Dutch at all. They have only stated that because they do not have a head or governor of their own, they have come to look for such a man here in Japan, so rumour has it there.

fol. 508v.: (1 March 1628) As far as Phesodonne and the Sincandians are concerned they have not yet arrived but are expected together in his large Japanese junk.
(2 March) (...) Phesodonne arrived here. The people of Sincan were in Nagoya and were not able to proceed because of strong winds. (...)
(End of the Journal of Pieter Nuyts.)

25. Missive of Cornelis van Neijenroode to Governor Pieter Nuyts. Hirado, 28 August 1627. VOC 1094, fol. 141-142. Extract.

fol. 141v.: "Met de jonquen van Phesodonne sijn gecomen 16 persoonen van Sincan, die sij 's nachts voor haer vertrecq met een groot rumoer aen boort hebben gecregen. De capitain van de joncque seyt sij versocht hebben om mede naer Japan te mogen vaeren om de Keyser te groeten ende soo sij 't geweygert hadden, mochten daernaer andere jonque gecomen sijn, die deselvers mede gebracht hadden, soude het hem dan sijn hooft gecost hebben. Dan dit is maer een doecxken voor 't bloeijen. Sij geven uyt dat een van dese swarten een Heer van dat landt Formosa is ende dat die compt Sijne Mayesteit begroeten. Sij sijn bij Phesodonne die haer reedt ende cleedt ende schenckagie prepareert om haer voor den Keyser te verthoonen."

fol. 141v.: Sixteen people from Sincan have arrived on Phesodonne's junks, whom they succeeded in getting on board with great uproar the night before their departure. The Captain of the junk said they had asked to sail to Japan with him to hail the Shogun. If they had been refused and if another junk had come afterwards and had taken them, it would have cost him his head. This is no more than a trumped up excuse. They pretend that one of these *blacks* is an Overlord of this land called Formosa and that he comes to salute His Majesty. They are staying with Phesodonne who gives them clothes and provisions and is preparing the tribute for the presentation to the Shogun.

26. Missive Senior Merchant Cornelis van Neijenroode to Governor Pieter Nuyts. Hirado, 5 September 1627. VOC 1094, fol. 188-189. Extract.

fol. 188v.: "Belangende 't geene hier passeert den 15e van d'ander maent sal Phesedonne mette Sinccanders naer boven reysen. (...) (fol. 189) Heel Nangisacki is vol van dese Sinckanders. D'eene seyt den overste van haer het landt de Keyser wil presenteeren, andere dat sij willen versoucken een Japander tot haer overhooft (...)."

fol. 188v.: As far as the local affairs are concerned, Phesodonne will travel on the fifteenth of the next month to Edo with the Sincandians. (...) The entire city of Nagasaki is buzzing about these Sincandians. Some say their leader

wants to offer the land to the Shogun, others that they want to ask a Japanese to be their Overlord (...).

27. Missive Governor Pieter Nuyts to Governor-General Jan Pietersz. Coen. Miyako (Kyoto), 7 September 1627.
VOC 1094, 165-168. Extract.

fol. 167v.: "Uwe Ed. condt dencken wat een schelmstuck Phesedonne en Yafioyodonne, sijn schipper, met het overbrengen der 16 persoonen ofte wilden vuijt Formosa in den sin hebben. Besluyten buyten twijffel daeruijt de souvraijniteijt aen Sijne Mayesteit sullen offereren. Ende ben beducht, soo Sijne Mayesteit sulcx aenvaert, voor ons cantoir ende volck in Firando ende voor ons selver (fol. 168) alhier boven."

fol. 167v.: Your Honour can imagine what knavery Phesodonne and Yafioyodonne, his skipper, have in mind by bringing the sixteen people or savages from Formosa.
No doubt they plan to offer the sovereignty to His Majesty. And if His Majesty accepts it, I do fear for our office and our personnel in Hirado and for ourselves here.

28. Missive Governor Pieter Nuyts to Commander Gerrit Frederikz. de Witt and Council. Miyako (Kyoto), 7 September 1627.
VOC 1094, 168-170. Extract.

fol. 168v.: "Het impertinent vertreck van de Japanse joncken verwondert mij niet meer als alle hare andere ghehoudene proceduren aldaer, maer seer qualijck is bij U Edele gedaen, dat die niet voor haer vertreck behoorlijck sijn gevisiteert, souden dese onse 16 ondersaeten niet raptivelijck wechgevoert hebben, maer noch qualijcker dat onse ordre in 't seinden van 't schip *Heusden* om onser ende der Japanders sijde in de riviere Chincheu, gelijck U. E. expresselijck gelast hadden, niet achtervolcht hebt."
fol. 169: "Wat Yaffioye met de 16 gerapineerde inhabitanten costi intentioneert, is ons noch niet heel vast bewust."

fol. 168v.: The impertinent departure of the Japanese junks does not surprise me any more than all the other stratagems staged there, but Your Honour's behaviour is very censurable, namely that you failed to search these junks

properly before their departure, so they would not then have snatched away
our sixteen subjects. But what is even more disgraceful is that you did not
comply with our order to send the ship the *Heusden* for the silk for us and
for the Japanese into the Chincheu River, as we had expressly ordered Your
Honour.

fol. 169: As yet we have not the slightest idea what Yaffioije has in mind
over there for the sixteen kidnapped inhabitants.

29. Missive Pieter Nuyts and Pieter Muyser to Governor-General Pieter de Carpentier. Miyako (Kyoto), 7 September 1627.
VOC 1094, fol. 171-173. Extract.
Duplicate: VOC 1092, fol. 420-423.

fol. 172: "In Firando noch sijnde, verstonden aldaer 't arrivement van de 2
Japanse joncken uijt Tayouan in Nangesacqui. Oock mede hoe dat d'eene,
namentlijck die van Phesedonne, 16 inwoonders van Sinckan hadde met ghe-
bracht. Denselve Phesedonne uytgevende, dat deselven in ambassade aen den
Keyser quamen ende hunne presenten met brachten. Derhalven hij hunlieden
dede cleeden ende in alles toestellen, sendende een expressen op aen de
Rijcxraden, versouckende dat die luijden mochten boven gebracht ende voor
den Keijser gestelt werden. Sij hadden oock, voor soo wij verstonden, groote
clachten over onse proceduren in Tayouan te doen. (...) Maer alhier in
Meaco sijnde, hebben ten deele uijt een coopman van d'ander joncque van
Toiseredonne, maer principaelijck uyt d'avisen op gisteravondt vuyt Tayouan
ende Firando per 't schip *Heusden* ontfangen, gantschelijck vernomen, de
gemelte 16 inwoonders van Sinckan sijn genouchsaem raptive bij den
Capiteyn van gemelte joncque van hunne ouders ende vrouwen met geno-
men, onder pretecxt van voor 10 daghen in zee te vaeren om eer ende buijt
op hunne vijanden te haelen, deselve belovende binnen den voornoemde tijdt
hunne gemelte ouders ende vrouwen wederom thuijs te brenghen.

't Sijn onnosele, slechte luijden, die bij maniere van sprecken van goet ofte
quaet weten. Ghelijck wij genouchsaem bij de ootmoedighe requeste bij ge-
noemde ouders, vrouwen ende andere inwoonders van Sincan aen de Heer
Commandeur de Wit gepresenteert connen sien, al sulcken rapten ende vals-
cheijt souden wij oock lichtelijck, alst daertoe compt, aen Sijne Mayesteit
ende raden remonstreeren ende hem oirdeel daerover versoucken. Ten
minsten wij sullen die moeten wederom eijschen ende als onze ondersaeten,
die bedrieghelijck uyt haer landt gestoolen sijn, in onse bewaeringhe ende

protextie nemen, om deselven ter plaetse haer residentie wederomme te stellen.

Wat sijder eijgentlijck met in sin hebben, connen wij alsnoch niet verstaen. Eenighe seggen dat Phesedonne uyt gheeft, dat eenen van die luijden is een principael Heer van Formosa ende compt om den Keyser de reverentie te doen. Andere meenen 't zijn gesanten, die comen over de Hollanders claghen ende den Keyser homasie te doen, hem 't landt opdragende, diergelijck. Maer seker is dat Phesodonne versocht heeft met hunlieden boven te comen. Heeft haer ghecleedt ende presenten van hertevellen toe gemaeckt om die aen de Mayesteit te presenteeren."

fol. 172: While we were still in Hirado we heard of the arrival in Nagasaki of the two Japanese junks from Tayouan. Also that one of them, namely Phesodonne's junk, had brought sixteen inhabitants of Sincan. This Phesodonne alleged that these people came as envoys to the Shogun and brought their gifts with them. Therefore he had these people clothed and equipped with everything and he sent an express letter to the Councillors of the Shogun asking permission to take these people to Edo and present them to the Shogun.

As far as we have understood it they also wanted to raise serious complaints about our actions in Tayouan. (...)

But here in Miyako we have understood the whole story, partly from a merchant of the other, Toiserodonne's[22], junk, but mainly from information received yesterday from Tayouan and Hirado via the ship the *Heusden*, that these sixteen inhabitants of Sincan in question were secretly snatched away from their parents and wives by the captain of the junk mentioned, under the pretext of sailing out to sea for ten days to gain honour and to loot their enemies, by promising them to bring them home to their parents and wives within the stated time.

They are simple, ignorant people who do not know good or evil as it were. As we are quite adequately informed by the presentation of the humble request by their parents and wives and other inhabitants of Sincan to Commander De Witt, we may also easily raise objections against all such furtiveness and dishonesty with His Majesty and the councillors, should it come so far, and ask him for his judgement. At least we will have to demand their return and since they are our subjects who have been illegally kidnapped from their own land, take them under our protection and under our tutelage in order to restore them to their place of residence there.

What they actually plan to do with them we are not able to ascertain at present. Some people say that Phesodonne claims one of these men is an important Lord of Formosa who has come to pay his respects to the Shogun. Others think they are envoys who have come to make complaints about the Dutch and pay homage to the Shogun, transferring the land to him, things like this. But it is certain that Phesodonne has asked to go to Edo with them. He has clothed them and prepared presents of deerskins to be presented as gifts to His Majesty.

(The Japanese merchants complain about the Dutch politics in Formosa. The letter continues with an enumeration of Japanese complaints about the conduct of the Company.)

30. Missive Senior Merchant Cornelis van Neijenroode to Governor Pieter Nuyts, Hirado, 28 September 1627.
VOC 1094, fol. 190-192. Extract.

> fol. 191: "Altoos heeft hij de presenten, die van de Sinckanders ontfangen hadde, als 200 cattij getweerende sijde ende diverse stuckgoederen wederomme tot Phesedonne gesonden."

(The Japanese court was uncertain about the identity of the Formosans. The secretary of Kawachi-no-kami, one of the councillors, who asked about these 'Ambassadors of Tangasen', was told by an interpreter that they were not ambassadors, but 'stolen people'. Then the councillor himself began to see the light:)

fol. 191: Soon he sent back to Phesodonne the gifts he had received from the Sincandians, as these consisted of 200 catty of twilled silk and several piece-goods, excusing himself very sincerely that he had accepted these the other day.

31. Missive Pieter Nuyts and Pieter Muyser to Governor-General Pieter de Carpentier. Edo, 7 October 1627.
VOC 1094, fol. 175-176. Extract.
BESCHEIDEN, Vol. VII 2, p. 1170.

> fol. 175v.: "Opp gisteravondt laet ons de Heer van Firando weten dat alles (fol. 176) wat de papen genoteert hadden, den Keyser gerapporteert was ende dat over het veranderen der brieven, oftewel eer te seggen dat wij

gesanten sijn van de Heer Gouverneur Generael in plaets van Hollantse
ambassadeurs ofte legaten, het gantsche hoff soo ontstelt is. Veel meer dat
wij hier uytgeven dat de goede inhabitanten van Formosa, die nu 5 jaeren
lanck versocht hebben Sijn Mayesteit haer landt op te draghen, nu die
gecomen sijn, verdacht worden gemaeckt uyt Tayouan ghestolen te sijn. Dat
men disputeert off wij 't leven daervan sullen bringhen ofte niet. Den Keyser
nempt alles seer qualijck ende heeft de 16 wilden vrij paerden ende volck,
als ons gedaen is, met sijn pas gegeven ende worden dagelijcks boven ver-
wacht.

fol. 176: (…) de Heer van Firando heeft ons rondtuyt laeten weten dat soo wij
levendich willen blijven, van Tayouan niet en vermanen, anders niet alleene
wij maer oock sijne Edele hier moeten den buijck snijden (…).

Seer qualijck heeft den Commandeur de Wit gedaen, als hem voor datum
gereprocheert hebben, de joncquen ongevisiteert heeft laeten vertrecken ende
dat per *Heusden* nochte *Westcappel* niet 5, 6 die der wilden spraecke connen
vertolcken herwaerts heeft ghesonden, opdat wij, soo 't ons toegelaeten
werde, met haer mochten spreken. Den standt van Tayouan werdt van over-
vloedighe swaericheden gemineert."

*(October 1627. At the Court in Edo, where they arrived on 19 September
1627, Nuyts and Muyser were taken for two ambassadors sent by 'the King
of Holland'. They corrected this misunderstanding by saying they had not
come directly from Holland; Holland does not have a King: In fact they
were Dutch ambassadors sent to Japan by the Governor-General of the
Netherlands Indies, who resided in Batavia.)*

fol. 175v.: The Lord of Hirado informed us yesterday evening that all of the
notes the priests had taken were reported to the Shogun and that the entire
Court was very upset about the change in the letters, that we state that we
are envoys of the Lord Governor-General instead of Dutch ambassadors or
envoys. And even more because we claim that the good inhabitants of
Formosa, who over a period of five years have asked to transfer their land
to His Majesty, and now have come, have been kidnapped from Tayouan.
And there is a discussion whether our lives will be at stake or not.

The Shogun takes everything very much amiss and has issued the sixteen
savages horses and servants, and a pass like he did to us, and they are
expected there [in Edo] any day.

*(After eight days in Edo, Nuyts and Muyser still had not achieved anything
and their letters and gifts were refused. They hoped that the Shogun would*

*ask for more detailed information from Tayouan in order to make a more
balanced decision about who is right or wrong, but unfortunately he himself
did not get the best information. The Daimyō of Hirado appeared to be the
main obstacle:)*

fol. 176: (...) The Lord of Hirado informed us frankly not to mention Tayou-
an if we want to stay alive or else not only we, but also His Honour here,
would have to slit his belly.[23]

Commander De Witt did a stupid thing, for which we have already rebuked
him, by letting the Japanese junks leave without searching them, and he did
not send over five or six men with the *Heusden* or the *Westcappel* who
could translate the language of the natives, so that we, if we were so per-
mitted, might be able to speak with them. The situation of Tayouan is beset
with a great many dangers.

32. Missive Senior Merchant Cornelis van Neijenroode to Governor Pieter Nuyts. Hirado, 15 October 1627. VOC 1094, fol. 192-193. Extract.

> fol. 192v.: "De Sinckanders sullen met Phesodonne oock binnen 2 à 3 dagen
> volgen. Sij sijn ontbooden te comen als ambassadeurs ende sullen overal
> vrijgehouden werden, gelijck die van Corea, dat veelen een seer vremdt
> naerduncken geeft ende doeter veelen Phesodonne noch veel meer als te
> vooren vreesen.
> fol. 193: (...) Ende men verstaen hier nu de Sinckanders door last van Sijne
> Mayesteit ofte sijne Bonghoijs als ambassadeurs te hove ontboden werden.
> Dat tegens haer ofte sijn doen te spreken, oock tegens het welgevallen van
> Sijne Majesteit soude gesproocken sijn. Daer is geantwoordt, op 't geene ick
> geseyt hebbe, dat het volck is dat uyt Tayouan gestoolen is, dat men wel 1
> à 2 persoonen soude connen steelen ofte tot yets bepraeten, maer niet 16 à
> 18 persoonen."

fol. 192v.: Within two or three days the Sincandians will follow with Pheso-
donne. They have been summoned to come as ambassadors and will be
treated as guests everywhere, just like the people of Korea, which makes
many people suspicious and makes Phesodonne even more fearsome to them
than he was before.

fol. 193: (...) And now rumour has it that, by order of His Majesty or his
bonghoijs[24], the Sincandians have been summoned to the Court as ambas-

sadors, and that to speak critically of them or his actions would run counter to the goodwill of His Majesty. On my remarking that they are people who have been kidnapped from Tayouan, their answer is that it might have been possible to kidnap or lure one or two persons, but certainly not sixteen to eighteen people.

33. Missive Pieter Nuyts to Cornelis van Neijenroode. Edo, 16 October 1627.
VOC 1094, fol. 178. Extract.

> fol. 178: "Dat de Japanders de inhabitanten van Formosa hebben uyt Tayouan, buyten der wilden kennisse ende vrij wille, vervoert. (...) Dat voorsz. wilden bij Phesodonne sijn aenvaert, gecleet, gefourieert, gespijst, gedisiplineert ofte onderwesen ende vooral schenckagiën geprepareert."

(It is now dawning on the Court:)
fol. 178: That the Japanese have transported the inhabitants of Formosa from Tayouan without the consensual knowledge and the free will of the natives. (...) That the natives in question were received, clothed, supplied, fed, disciplined or taught and above all provided with [tribute] gifts [for the Shogun] by Phesodonne.

34. Missive Pieter Nuyts and Pieter Muyser to Cornelis van Neijenroode. Edo, 4 November 1627.
VOC 1094, 178-179. Extract.

> fol. 178: "De Heer van Firando drijft openbaerlijck den spot met ons, is ordinaris twee mael 's daegs droncken ende van 4 reysen dat wij 't ver-soucken becomen eene audiëntie voor hem."

fol. 178: The Lord Hirado mocks us openly, is usually drunk twice a day and [only] one out of every four times that we ask for an audience, we are received.

35. General Missive.
VOC 1091, fol. 11. Extract 9 November 1627.
FORMOSA, p. 65.

"Met de inwoonders van Sinckan hielden d'onse goede correspondentie; sij hadden in haer vleck een huys voor ons gemaeckt, daerinne thien Nederlanders t'haerder assistentie tegen d'inwoonders van Soulang ende Mattau lagen, omme derselver incurssiën ende rooveryen op onse vrunden van Sinckan te beletten."

Our men were on good terms with the inhabitants of Sincan. In their small village they had built us a house, in which ten Dutch soldiers were lodged ready to assist against the inhabitants of Soulang and Mattau, in order to prevent their incursions and plunderings against our friends in Sincan.

36. Missive Cornelis van Neijenroode to Pieter Nuyts. Hirado, 16 November 1627. VOC 1094, fol. 152-153. Extracts.
Duplicate: VOC 1094, fol. 194-196.

fol. 194: "Daer isser genouch die alles wat wij begeeren genouch weten ende breet genouch vertellen, maer niemandt en wil daer eenighe attestatien van verleenen, soo seer wert Phesodonne gevreest. (...)

fol. 195: Heel Nangesacqui is wel bekent, dat de Sincanders door ordre van Phesodonne gheforieert sijn ende herberghe daer sij thuijs hebben gelegen. Dat hij haer met cleedere voorsien heeft, jae gelt om in 't hoerhuys te gaen gegeven heeft. Alle dese dinghen seggen de luyden wel, maer durven daervan niet onderteekenen. Sooveel de Sincanders aengaet, daer is niemandt noch groot noch cleijn in die quartieren, die iets tegens haer sal derven attesteeren. (...)

De Heer van Firando heeft weynich authoriteijts ofte gesach bij de grooten ten hove ende is oock te twijffelen off hij al cloeck genouch is. Dese raden hier willen niet seggen dat sij aen sijn verstand twijffelen, maer excuseren hem dat hij veel te doen heeft (...)

fol. 196: (...) soo veele de Sinckanders belanght, daer willen sij weynich mede te doen hebben off per avontuere sien sij weynich mouwen daeraen weten te setten."

fol. 194: There are enough people who are well aware of all that we want and who recount it accurately enough, but nobody wants to bear testimony to it, so great is the fear for Phesodonne. (...)

fol. 195: The entire population of Nagasaki is very well aware that the Sincandians have been given provisions and a place to stay on Phesodonne's orders. That he has provided them with clothes and even has given them money to visit the whore-house. People gossip about all these things, but are not brave enough to sign proof of it. As far as the Sincandians are concerned no one, old or young, dares to bear testimony against them in those quarters.

(...) The Lord of Hirado has little or no authority or influence with the important people at the Court, quite apart from which it is doubtful whether he is enterprising enough. These councillors here do not want to say that they have their doubts about his intellectual wherewithal, but make excuses for him saying he is a very busy man (...)

fol. 196: (...) As far as the Sincandians are concerned, they want as little as possible to do with them nor do they know how to handle the matter.

37. Memorandum by Governor Pieter Nuyts on the mission to the Court of the Shogun and the position of the VOC in Japan, written upon his return to Tayouan. Hirado, 1 December 1627.
VOC 1094, 160-161. Extract.

> fol. 160: "Het quade tractement van de Japanse coopluyden ofte veeleer 't impessement in de Chinese handel door den Commandeur de Wit (soo sij voorgeven) in Tayouan aengedaen, maer bysonder het overbrenghe der 16 inhabitanten van Sinckan, neffens de te doene opdracht van Formosa aen Sijne Mayesteit."

(Nuyts' report to Senior Merchant Cornelis van Neijenroode in Hirado about 'the state of the Company affairs' in Japan speaks of a deteriorating relationship with the Japanese authorities. He believes this is the direct result of:)

fol. 160: (...) the bad treatment of the Japanese merchants or perhaps more the obstruction of the Chinese trade imposed in Tayouan by Commander de Witt (as they claim), but in particular due to the transportation of the sixteen inhabitants of Sincan and the future presentation of Formosa to His Majesty.

1628

38. General Missive.
VOC 1092, fol. 3. Extract 6 January 1628.
FORMOSA, p. 67.

p. 67: "Om d'onse in Japan in d'hoochste indignatie ende swaricheyt te breng-
en, heeft hy [Jaffioye] van Teyouhan secretelijck met behendicheyt wechge-
voert sesthien naturelle van 't dorp Sinckan, ende dat door inductie van een
van de haren, *Dijcka* genaempt, welck onse natie niet gunstich is, maer altijt
groote correspondentie met de Japanders gehouden heeft. Dese maeckte
vijfthien andere jongelieden wijs, dat met de Japanders op een advantagie
souden uytgaen om hooffden te haelen ende binnen thien daegen weder-
keeren. In plaetse van op den rooff uyt te gaen, heeft Jaffioyo dese Sinckan-
ders in Nangesaque gebracht ende aldaer uytgegeven, dat het ambassadeurs
van 't eylandt Formosa sijn. Den heer van den capiteyn Jaffioyo, Phesedonne
genaempt, heeft deze luyden als gesanten toegemaeckt, geschencken voor
den keyser geformeert ende voor haerlieden by syne Majesteyt audientie
versocht, voorgevende, dat aldaer comen om den keyser te besoecken ende
versoecken dat haer gelieve een regent te geven, alsoo de harde regieringe
der Hollanders niet connen verdragen ende veel clachten daerover hadden te
doen, waermede het schijnt de Japanders de soverainiteyt van Teyouhan ende
Formosa aen haer (trachten) te trecken.
Soo haest den commandeur de Witt 't vervoeren van voorsz. 16 Sinckanders
gewaer wierdt ende het disseyn van de Japanders vernam, heeft hy aen
d'onse in Japan gesonden schriftelijcke clachte van de vrunden van voorsz.
Sinckanders, hoe dat haer volck van de Japanders gestolen en de buyten haer
kennisse vervoert waren, ernstelijcken versoeckende dat gelieven souden te
produceren, dat weder by haer thuys mochten comen: met welcke actie
verhoopt werdt, dat het valsch voorgeven van Phesedonne ende synen
capiteyn Jaffioyo genouchsaem wederleyt sal werden. Doch vreesen evenwel
voor groote swaricheyt, alsoo by des keysers raden dies niettegenstaende
geresolveert was, dat de Sinckanders als ambassadeurs te hove souden reysen
ende verhoort werden, met gelijcke eere als d'onse, welcke in Edo wel
aengecomen waren. Doch 5en October passato hadden noch geen acces by
den keyser ofte raden gehadt, maar wierdt ondervraecht wat actie van
souverainiteyt op Teyouhan pretendeerden ende wat te claegen hadden over
de lieden die daer quamen om den keyser reverentie te doen ende de sourve-
rainiteyt van haer landt op te draegen, daerop geen antwoord heeft ontbroo-

cken: doch wierd soo niet aengenomen, off d'onse vernamen dat haere pertyen mede vrunden te hove hadden. D'uytcomsst sal den tijt leeren."

(The same story, the way it was told in the letter from Batavia to Amsterdam:)

With the intention of arousing a state of seething indignation in our men in Japan and causing them trouble, he [Jaffioye] has skilfully by stealth kidnapped from Tayouan 16 natives from the village of Sincan, through the collusion of one of these, by the name of *Dika*, who does not favour our nation but has always had a close relationship with the Japanese. He induced 15 other young boys to believe that were they to go out with the Japanese to try their luck to get a few heads, that they would be back within ten days. Instead of going out for plunder Jaffioyo transported these Sincandians to Nagasaki, and having arrived there, announced they were ambassadors of the Island of Formosa. Skipper Jaffioye's lord, by the name of Phesodonne, dressed these people up as ambassadors, organized gifts to be given to the Shogun and asked an audience of His Majesty for them, pretending that they had come all the way to visit the Shogun to ask for a (Japanese) regent, because they could not tolerate the harsh regime of the Dutch and wanted to lodge many complaints about this, through which the Japanese seem to have tried to seize the sovereignty over Tayouan and Formosa for themselves.

As soon as Commander De Witt became aware of the transportation of these 16 Sincandians and had discovered the plan of the Japanese, he sent to our men in Japan the complaints written by the friends of these Sincandians to our men in Japan: how their people had been kidnapped and carried away without their knowledge, that they requested emphatically that efforts should be undertaken to bring them back home with them. By taking this action, it is hoped that the lies of Phesodonne and his skipper, Jaffioye, will be contradicted.

However, we do fear some trouble, because it has already been decided by the Council of the Shogun that the Sincandians, being ambassadors, would travel to the Court and be heard with the same respect as our men, who had arrived at Edo. But on the fifth of October last our ambassadors had not yet gained access to the Shogun or the Council but were questioned how they dealt with the question of Dutch sovereignty over Tayouan and what their objections were to the people who had arrived to honour the Shogun and to dedicate their country's sovereignty to him. To this they were not short of

answers. But these were not accepted as such, because our people heard that their side also had advocates at Court. Time will tell the outcome.

39. Missive Senior Merchant Cornelis van Neijenroode to Governor-General Jan Pietersz. Coen. Hirado, 17 February 1628. Extract.
BESCHEIDEN, Vol. VII 2, pp. 1224-1233.

> p. 1233: "De Sincanders hebben van den Keijser tot een schenckage becommen, nevens eenige rocken, 600 schuijten off 2580 taijl silvers ende een joncq omme te vertrecken, den tolck 20 diergelijcke schuijten silvers. Fesidonne is mede een joncq vereert ende, soo sijn volck voorgeeft, sal hij selver mede gaen om aldaer possessie van Keijsers wegen in Sincan te nemen. De rechte sekerheijt hiervan sullen niet connen vernemen voor hij selver affcommen sal sijn."

p. 1233: From the Shogun the Sincandians have received as gifts, apart from several Japanese gowns, 600 bars of silver being 2580 tael[25] and a junk on which to leave, while the interpreter received 20 such bars of silver. Phesodonne is also honoured with a junk and according to his people he himself will go with them to take Sincan into possession in the name of the Shogun. But we will not know this for sure until he arrives there in person.

40. Missive Pieter Nuyts to Governor-General Jan Pietersz. Coen. Tayouan, 28 February 1628. Extract.
BESCHEIDEN, Vol. VII 2, pp. 1233-1248.

> p. 1242: "Hier comende verstaen, dat de request door de Sincanders aen den Comandeur De Wit niet vrijwillich maer door inductie ende aanporren van uytgemaecte Chinesen is gepresenteert, sulcx dat wij meynen niet steelschewijs maer voluntairlijck vervoert zijn. Want corts naer ons arrivement sijn de hoofden van de 4 naeste dorpen Sincan, Bacluan, Mattau, Soulangh bij ons comen, met een botte arrogantie een jaerlickse erkentenisse naer gewoonheyt, omdat in haer landt resideren, ons afvorderende. Hebben haer (sijnde van natueren praggers ende bedelaers) geantwoort, dat sij ons een huys in elck dorp, als die van Sincan voordesen gedaen hebben, souden maken, waervoor cangans souden genieten ende daer beneffens dan sien, wat vorders in den sin hadden (...).
> p. 1243: 't Waere goet, dat wij in elck dorp 10 a 12 soldaten conden leggen. 't Soude ons niet alleene van dien cant buyten alle peryckel stellen, maer het

volck wat menschelycker, tot ons gemeensamer ende daer beneffens van langerhant de souverainiteyt t'onswaerts maken."

p. 1242: When I came here I understood that the request [to retrieve their kin from Japan] made by the Sincandians to Commander de Witt had not been presented voluntarily but at the instance and instigation of some shrewd Chinese, in such a way that we believe that they sailed away not furtively but voluntarily. Because shortly after we arrived [in Formosa] the heads of the four villages nearby, Sincan, Baccaluan, Mattau, and Soulang, came to us, demanding from us with brusque arrogance a yearly allowance as customary, because we were staying in their land. We replied to them (since they are grumblers and beggars by nature) that they should build a house for us in every village, just like the people of Sincan had done earlier, which would earn them some cangans and we for our part would see what else was in their minds.

p. 1243: It would be a good thing if we could station ten to twelve soldiers in every village. On the one hand it would not only safeguard against all dangers, but would also render the people somewhat more lenient and closer to us. In addition, it would in the long run reap us sovereignty.

41. Missive Governor Pieter Nuyts to Governor-General Jan Pietersz. Coen. Tayouan, 23 March 1628.
VOC 1094, fol. 118-119. Extract.

fol. 118: " (...) bij desen wat betere tijdinge als we in onse voorgaende (missiven) uijt conjecturatien voorsagen ende vreesden, adviseren namentlijck dat des Compagnies stant in Japan geen last en schijnt te lijden. Ende naer connen, soo uijt gemelte Sr. Muysser als particulieren aen ons affgesondene missiven verstaen, soo wij terugge niet waeren ghehouden ten soude niet geschieden, sij hebben genoechsaem berou van 't gepasseerde daervoor.

De slechte gestalte onser inhabitanten van Sincan, daervan men seer hooge voor Sijne Majesteit hadde voorgegeven, de cleijne apparentie ende schijn van de te doene opdracht deeses lants, maer voornamelijck onsen vlijt die in haer te onderrichten ende onse ingesetene te denigreren, aengewent te hebben (...). Naer het hem vertoont soude onder 't stuck der Sincanders noch heel yets verborgen connen schuijlen, doch niet ten aensien van den Keijser, maer van Phesodonne sijn opticul, want 't is zeker en gewis dat sij van Sijne Majesteit geen audientie gehadt hebben."

fol. 118: (...) Hereby some better news than we had foreseen and feared from conjectures in our previous letters, i.e. we are informed that the Company's state of affairs in Japan does not seem to have suffered any damage. And as we can understand from letters sent to us by the aforementioned Mr Muyser and by private persons had we not been held back it would not have happened, they sufficiently repent all that has happened.

The poor picture presented by our inhabitants of Sincan, who had been much boasted about to His Majesty, the paltry evidence and probability of the putative mandate of this land, but above all our diligence which we showed in instructing them and in downgrading our subjects have averted disaster (...). To all appearance there could still be something concealed behind the affair of the Sincandians, but not so much from the Shogun's point of view, but from Phesodonne's point of view, because it is a sure thing that they have not been admitted to the Shogun.

(In April 1628 Japanese junks sail to Tayouan to return the Sincandians to their village.)

42. Missive Governor-General Jan Pietersz. Coen to Governor Pieter Nuyts. Tayouan, 18 May 1628.
VOC 1095, fol. 254.
BESCHEIDEN, Vol. V, p. 265.

fol. 254: "Wat aengaet de souveraijniteyt van Teyouhan ofte 't eylant Formosa, welck de Japanders schijnen te pretenderen uijt crachte van d'opdracht, die eenige Jappanders seggen dat 16 personen vant dorp Sinckan (steelsgewijs van Teyouhan vervoert) aen de Keyser van Japan aenbieden, in Teyouhan sal U Edele in geenderlij manieren 't recht welcke de Compagnie daertoe compt ende tot noch toe gebruijckt heeft, aen geen natie ter werelt cederen (...). Laet die Sinckanders haer selven in 't dorp Sinckan regeren, gelijck gewoon sijn. Dat de Keyser van Japan in Japan sulcken souveraijniteijt gebruijcke als Sijne Majesteijt daertoe compt, in Teyouhan heeft hij niet te pretenderen (...).

fol. 254v.: Wij sien wel, soo den Keyser van Japan de souvereyniteyt van Teyouhan op 't vals voorgeven sijner ondersaten in opdracht van d'opgemaeckte 16 Sinckanders in ernst begeert aen te nemen (...)."

fol. 254: Regarding the sovereignty over Tayouhan or the island of Formosa, which the Japanese seem to claim by virtue of the mandate some Japanese say that sixteen people of the village of Sincan (transported secretly from Tayouhan) offer to the Shogun of Japan, Your Honour in Tayouan must not in any way surrender to any nation in the world the right which is due to the Company and which it has exercised up to now. (...) Let those Sincandians govern themselves in the village of Sincan as they are used to. Let the Shogun of Japan exert such sovereignty in Japan as is His Majesty's good right. He has nothing to lay claim to in Tayouhan.

fol. 254v.: (...) We will see if the Shogun of Japan seriously wants to accept the sovereign power over Tayouhan based on the false pretences by his subjects at the behest of the sixteen Sincandians who were set up.

(A letter by Jan Pietersz. Coen, in BESCHEIDEN, Volume V, pp. 146-168, mentions what happenend in the months of May and June 1628:)[26]

p. 146: "Van Japan sijn den 27 Mey in Teyouhan aengecomen 2 Japanse joncken met 470 coppen. Op de secrete advertentie, welck de Gouverneur Nuyts, Van Nieuroode ende d'Heer van Firando bequam als waerschouwinge, die sekere Chinesen met de Japonders comende, deden van de verme(te)le proposten die Jaffioye, capiteyn van dese joncken, van hem liet gaen met andere vordere inditiën van quaet voornemen meer, resolveerde sijn Edele dese Japanders t'ontwapenen omme de quade disseynen, welcke mochten hebben, voor te comen. Den Edele Nuyts constringeerde den capiteyn aen lant te comen, hielt hem 5 à 6 dagen in versekeringe, totdat consenteerde de joncken te laten visiteren ende haer wapenen aen landt te brengen, gelyck geschiede.

(...) Den Edele Nuyts, alsnoch verstoort wesende (na 't schijnt), dat door toedoen van deese luyden (die selffs in haer dorp niet bestaen connen, maer van sijn Edele gemainteneert ende voor hare vyanden beschermt werden) soo grooten affront in Japan geleden hadde ende de Compagnie groote moeyte ende kosten aengedaen was, heeft dese Sinckanders in boeyen gesloten ende de vereringe van den Keyser in Japan bekomen (dat weynich importeert) affgenomen, 't welck voorsz. Jaffioye ende sijn geselchap seer verdroot."

p. 146: On May 27, two Japanese junks with 470 men on board arrived in Tayouan from Japan. In pursuance of the secret notice which Governor Nuyts received from Van Neijenroode and the Lord of Hirado as alerting him to a warning given by a couple of Chinese travelling with the Japanese

on the presumptuous proposals which Jaffioye, the captain of these junks, made along with some other hints of evil intentions, His Honour decided to disarm these Japanese to anticipate any wicked plans which they might have in mind.

The Honourable Mr Nuyts ordered the captain to come ashore, held him in captivity for five or six days until he consented to the junks being searched and their weaponry brought ashore, which was duly carried out.

(...) The Honourable Mr Nuyts, annoyed (as it seems) that the machinations of these people (who cannot even survive in their own village, but are supported and protected against their enemies by His Honour) had led to so great an affront in Japan and had caused untold trouble and damage to be afflicted upon the Company, has put these Sincandians in irons and has confiscated the gifts they had received from the Shogun of Japan (which were really nothing valuable), all of which vexed the aforesaid Jaffioye and his company.

(On 29 June 1628, under pretence of taking leave, a group of Japanese visited Pieter Nuyts in his lodge, in an angry mood because of the delay and the fear of starvation. Nuyts was present with his young son Laurens, an interpreter and ten to fourteen Company servants. The Japanese seized him, and tied him to a chair. In the skirmishes which followed two VOC soldiers were killed outside and a few others wounded. Several Japanese were shot dead.

After this, while still holding the hostages, the Japanese framed five demands. The Council consented after eight days and paid a heavy ransom.[27] Nuyts was freed and the Japanese left with several hostages among whom his young son.)

43. Missive Governor Jan Pietersz Coen to Frederick Hendrick, Prince of Orange. Batavia, 18 March 1629. Extracts.
BESCHEIDEN, Vol. V, pp. 166-169.

p. 166: "In June 1628 is in Teyouhan een notabel acte gebeurt. Teyouhan is een onbewoonde plaetse aen 't eylant Formosa. (...) (p. 167) Omme d'onse vandaer te crygen ende by den Keyser van Japan odieus te maken, hebben seeckere Japonders anno 1627 stilswygende 16 naturale van 't dorp Sinckan naer Japon vervoert. Sinckan is een dorp omtrent een mijl van ons fort gelegen, waervan d'inwoonders haer onder protextie van d'onse begeven

hebben ende van d'onse tegen d'inwoonderen van andere dorpen, haere vyanden, beschermt werden, (...)."

p. 166: In June 1628 a remarkable event has occurred in Tayouan. Tayouan is an uninhabited place on the island of Formosa. (...) With the intention of chasing us away from here and of putting us in an odious light with the Japanese Shogun, certain Japanese secretly transported sixteen natives of the village of Sincan to Japan in the year 1627. Sincan is a village at a distance of about a mile from our fort. Its inhabitants have put themselves under our protection as a defence against their enemies, the inhabitants of other villages.

(Coen proceeds by explaining the past events in Japan, stressing the fact that the Sincandians failed to make any sort of good impression and that the Shogun did not appear to be interested in affairs outside his empire anyway. In the year 1628 two Japanese junks with soldiers and the Sincandians reappeared in Tayouan. Coen describes Nuyts' hostile attitude and actions, the obstruction of Japanese trade in Tayouan and the outcome: the detention of Pieter Nuyts.)

44. Missive Governor-Genereal Jan Pietersz. Coen to Governor Pieter Nuyts. Batavia, 26 June 1628.
VOC 1095, fol. 293-304. Extract.

fol. 303v.: "De predikant Candidius claecht ons bij sijne brieven dat hem sijn toegeseyde rantsoen bij U Edele vermindert, gelijck mede die clenicheden die hem voordese toegestaen sijn geweest uijt te reijcken aen eenige inwoonders van 't dorp Sinckan, daer sijn residentie houdt, om deselve t'onswaerts te trecken."

fol. 303v.: In his letters the Reverend Candidius complains to us that the allowance agreed on has been cut down by Your Honour, as well as those gratuities which used to be granted to him for distribution among some inhabitants of the village of Sincan, where he resides, with the purpose of winning them over to our side.

45. Governor-General Jan Pietersz. Coen to the Reverend Georgius Candidius. Batavia, 26 June 1628.
VOC 1095, fol. 304.

(The letter deals with the conflict about the reduction to Candidius's financial means, which had flared up between the reverend and Governor Nuyts, stressing that this should be settled.)

46. Demand by the Japanese presented to Governor Pieter Nuyts. Tayouan, 2 July 1628.
VOC 1096, fol. 128-129. Extract.

> fol. 128: "Ten tweeden d'elff inwoonders van Sincan, waervan ghijlieden secht vier wechgelopen te sijn, die wij t'haren woonhuijsen zullen soecken ende vernemen ofte het soo is (...)."

(Second demand by the Japanese who held Pieter Nuyts hostage:)
fol. 128: In the second instance concerning the eleven inhabitants of Sincan, of whom you say four have run away. We will try to find those four in their houses and see if it is true.

47. Missive Reverend Georgius Candidius to Governor-General Jan Pietersz. Coen. Sincan, 20 August 1628.
VOC 1096, fol. 199-202. Extracts.
BESCHEIDEN Vol. VII 2, p. 1365; ZENDING, Vol. III, pp. 36-43.

> fol. 199: "De inplantinge Christelicker religie, onderwijsinge in het salich-makende gelove, uitroyinge heijdenscher superstitiën, affgoderijen ende ongeregeltheden wil alhier (tot onsen grooten leetwesen) onder de Sinckanders tegenwoordich weynich voortgang meer hebben. De beletselen hiervan zijn principalijck dese:
> Eerstelick der Japonners aencomste met de Sinckanders, die voor een jaer met haer naer Japon sijn getrocken. Want van dier tijt aen, in den april voorleden, is der Sinckanders herte tegen ons verandert en verbittert geworden. Want als de Japonners met de Sinckanders alhier op de reede quamen, eer zij aen lant mochten comen ofte ververschinge van water ende ander goet aen boort crijgen (door reden den Edele Heer Gouverneur bekent) sijn al eenige dagen voorbij gelopen; 't welck de Sinckanders seer qualick genomen als begerende eensdeels haer volck, die se nu langh niet gesien, aen landt

ende alsoo thuijs te hebben, anderdeels vresende dat haer nu eerst eenich ongeval op de reede soude mogen overcomen, geen verversinge hebbende, want daer waren alreede vijff van haer gestorven.

Daernae, als d'Edele Heer Gouverneur met de Japonners geaccordeert ende de Sinckanders in der Hollanders handen zijn overgelevert, in boijen gesloten ende in onse schepen bewaert geworden was gants Sinckan, anders niet aen te sien, als een leeuwe dien sijn jongen ontstolen sijn: veel schreijen, kermen, scheltwoorden was te hooren; begosten te dreijgen, principalicken mij, als leggende alleen onder haer met een jongen. Ick schreef sulcx aen den Edele Gouverneur, die terstont acht soldaten met een corporael naer boven sonde en liet mij daerbij weten, soo ick mij gantschelicken niet en betroude, dat ick aff soude comen. Ick bleeff noch, maer richtede doen weijnich uyt.

Ondertusschen hebben de Japonners de logie ingenomen, den Edele Heer Gouverneur met sijn soontie gevangen; dese gevanckenisse noch duerende. Hebben 4 van de principaelste Sinckanders haere boijen in stucken gebroocken, sijn des nachts heijmelick overboort gesprongen, aen lant geswommen ende alsoo in Sinckan wederom gecomen, niet veel goets van de Hollanders seggende.

Eijndelick soo is ons volck met de Japonners veraccordeert, d'Edele Heer Gouverneur onder seeckere conditiën weder los gelaten worden. Onder andere conditiën was oock dit eene, dat de Sinckanders, die noch in de boijen saten, souden vrijgelaten, hen hare goederen allegaer die se in Japon hadden gecregen ende van ons affgenomen waren, soude weder gerestitueert werden.

Dese Sinckanders nu aldus gelargeert sijnde, sijn met een menichte van Japonners, die se geconvoijeert ende begeleijt hebben, boven naer haer dorp Sinckan getrocken. Hebben feest gehouden ende groote vrolickheijt bedreven, prijsende ende lovende de Japonners, als van dewelcke zij seer heerlick ende mangnificq soo in Japon als op de reijs zijn getracteert geworden, veel schenckagiën, gelt ende goet ontfangen hebben, (fol. 199v.) daerentegen verachtende ende met leelicke coleuren affschilderende de Hollanders, als van de welcke zij qualick ende onbeleeffdelick bejegent waren (naer haer seggen) ende 't gene zij van de Japonners gecregen van ons ontnomen ende ontstolen was. Hebben alsoo hiermede der inwoonderen herten ende gemoederen van ons affgewendet, ontstolen ende verbittert.

Dit is het eerste beletsel, 't welck mij van april voorleden tot noch toe is in den wech gestaen ende eensdeels noch staet, te weten het quade contentament dat se in ons hebben om bovengemelde reden.

Het ander ende principale beletsel zijn hare leraressen, eenige oude wijven die se noemen *Inip*, die mij contrarie in allen dingen leeren ende in 't minste

niet en willen toelaten, dat oock het cleijnste tittelken van hare superstitiën, affgoderijen ende ongeregeltheden zoude gederogeert ende affgedaen werden. Veele onder haer hebbe ick alrede soo verre gebracht, dat se hare gebeden tamelick connen ende antwoort weten te geven op de vraechstucken eenen mensche tot sijner salicheijt van noode ende deshalven bequaem souden wesen om gedoopt te werden. Ja, bekennen oock, bij mij sijnde, dat haere leraressen maer leugenen leeren en dat mijne leere goet ende warachtig is, maer de practic en willen se daervan niet thonen.

Ick was vastelicken gesint eenige te doopen ende met dit schip de namen derselven als de eerstelingen der geestelicke vruchten alhier in Sinckan aen sijn Edele over te senden. Maer 't en heeft noch niet willen lucken, want hoewel de uitterlicke wetenschap aengaende sij bequaem waren om gedoopt te worden, soo heeft mij nochtans niet goed gedocht haer te doopen, 't en ware dat se vantevooren niet alleen belooffden alle hare affgoderie, superstitiën ende ongeregeltheden aff te leggen, maer oock eenen tijt lang sich daerinne te oeffenen tevooren, alsoo dat ick sien mochte dat de wercken met de confessie overeen quamen. Hebben sij sulcx niet willen doen, want sij deeden hare offerhanden noch, van verckens, visch, vleesch, ousters, rijs, stercken dranck ende evenals vantevooren voor herten- ende verckenshooffden. Sij reguleerden sich ende deden alle hare wercken noch naer haer droomen, naer het vliegen ende gesang der vogelen ende diergelicken ontallicke dingen.

Ende alwaer 't oock dat ick noch door reden haer soo verre mochte brengen dat se zulcke superstitiën ende affgoderijen nalieten, soo zoude ick se nochtans niet connen persuaderen ofte daertoe brengen dat se de kinderkens niet en souden dooden. Want sulcx soo gemeijn bij haer is, als bij ons het kinderdoopen, te weten van personen die noch over haer 30, 33, 35 jaer niet en sijn gecomen. Sij dragen haren roem daervan wanneer se veel gedoot hebben; gelijck mij verscheijden vrouspersonen bekent hebben, dat de eene 8, de ander 12, de ander 15 alreede gedoot hadden. Jae, hare leeraerssen leeren haer, dattet sonde ende schande soude wesen deselve niet te dooden, waerom sij dan oock selven geroepen ende gehaelt werden om deselve te dooden. Ende genomen dat se alle haere superstitiën ende affgoderijen verlieten ende dese meer dan beestelicke wreedsaemheijt aen haren kinderen noch oeffenden (want sonder een scherpe wet ende straffe sullen sij 't niet laeten), soo zoude ick se niet connen noch mogen doopen.

fol. 200: Dese nu ende diergelijcke ongeregeltheden, gelijck oock hare superstitiën ende affgoderijen, en willen se door mijn simpel seggen ende leeren alleen niet nalaten om dese redenen: eerstelick, seggen se, is dese costuijme van outvaders tot outvaders ons nagelaten die wij niet en willen te niete

doen. Ten anderen, onse leeraerssen die dagelicx met de Goden spreecken die weten 't recht ende leeren ons sulcx, gelijck oock onse oudsten. Ten derden, indien wij sulcx onderlieten souden wij in schande ende verachtinge geraken bij onse lantsluijden. Ten vierden, onse Goden souden op ons quaet wesen, mogelick geen rijs geven ende de vijanden ons op den hals stieren, die ons verjagen ende doot slaen souden.

Hier hebben zij noch andere superstitie, want van der Japonners aencomste aff, dat is in den avril, en hebben sij geen goet ooge op ons. Sij meijnen dat wij haer van haren godtsdienst soecken aff te trecken, omdat de goden op haer vergramt souden worden. Hierom soo hebben se mij voorgeslagen dat ick één huijs alleen soude onderwijsen ende dattet selve huijs zijne wetten ende manieren soude verlaten ende de onse aennemen. Indien nu de goden 't selve huijs segenden, veel rijs ende andere goederen gaven ende sulcx twee, drie jaer achter malcander, soo wouden se onsen godtsdienst oock aennemen. Sij comen bij mij om mij te beproeven, willen hebben dat ick wonderwercken doe, regen ende wint maecke ofte weder verdrijve, toecomstige dingen voorsegge ofte tgene geschiet openbaren. Ende dewijle ick sulcx niet en can doen, verachten sij mij, seggen dattet haere leraerssen doen connen.

Dit is het tweede beletsel, te weten hare leraerssen met hare leugenen.

Het derde beletsel tot noch toe is geweest, datter geen seker hooft onder dese natie is, met dien ick in den naem van de gantschen volcx wegen spreken conde. Een yder doet wat hem belieft. Leere ick vandaech ijmant, deselve gaet morgen in 't velt; comt altemets in een maent qualick weder thuijs. Sijnder eenige die mij gewillich hooren ende comen bij een deel die mij niet en willen hooren, soo verbreken ende verderven sij meer in een ure als ick in thien opgebouwt hebbe. Ick behoorde aen haer gerecommand(eert) te werden, dat se naer mij souden luijsteren. Hebbe sulcx versocht aen de Edele Heer Gouverneur naer 't vertreck der Japonners, dewelcke haer omlaeg ontboden, maer sij en wouden niet bij hem comen, vresende om oock in de boijen geset te werden. Hebbe sulcx een tijt lang daernaer weder aen hem versocht, dewelcke belooft met mij te willen boven trecken om met haer selven te spreecken, maer ('t schijnt datter wichtiger saecken sijn voorgevallen) is met de vloote naer de cust van China vertrocken.

Dit is oock het derde beletsel, te weten disordre ende geen recommandatie.

Dit nu aldus sijnde, ick weijnich aldus uitrichtende ende (indien datter geen ander middel soude aengewent werden) weijnich hope om ijet uit te richten siende, soo isset dat ick den 1... augustij ben omlaech getrocken bij den Edele Heer Gouverneur; hem allerding hoe het stonde geseijt, om raet

gevraecht wat verder hierin te doen soude wesen, dewelcke mij geantwoort dat hij geen raet en wiste.

Ick seijde hem mijn goetduncken, hoe dat ick meijnde dattet soude connen lucken, te weten, dat eerstelick hare leraerssen moste verboden werden niet meer te leeren noch hare affgoderijen te bedrijven; het volck niet meer naer hen moste luijsteren, noch sich naer haere voorige leeringen moesten reguleren, maer dat se naer mij moesten hooren

fol. 200v.: ende haer leven daernaer aenstellen.

Ten tweede datter moeste ordre in het leeren gestelt werden, 't welck op dusdanige maniere bequamelick soude connen geschieden. Het gantsche dorp Sinckan is affgedeelt in 14 deelen ofte quartieren. Indien nu belast wierde, datter alle dage 2 quartieren, des morgens vroechs de manspersonen, des achtermiddachs de wijven van deselve 2 quartieren, ontrent negen tot 12 uren toe alle de kinders van 't gantse dorp mosten comen om te leeren, soo soude het gantse dorp alle seven dagen eens connen onderwesen werden ende de kinderen, daer de meeste hoope op is, alle dage. Ende dit en soude haer niet veel verhinderen in haer arbeijt, want het soude elck mensch alle seven dagen maer twee uren costen. Ende dit soude al met soeticheijt geschieden ende doch eenen dwang causeren op dusdanige maniere.

De Mattauers ende Backelouers sijn bittere vijanden tegen het dorp Sinckan. Souden hetselve voor 2 jaren verbrant, alle de inwoonders verjaecht ende dootgeslagen hebben, 't en waere dat de Hollanders sich haer hadden aengenomen, hen met ontrent 100 musquettiers secours gedaen ende alsoo de Mattauers ende Backelouers in de vlucht geslagen. Dit dorp Sinckan is tot noch toe in der Hollanders bescherminge genomen ende sonder dese bescherminge en soude Sinckan geen maent staen.

Nu tegenwoordich vresen de Sinckanders van de Hollanders ofte dat se van haer selven souden verjaecht werden (om de saecken tusschen de Japonners ende haer gepasseert), want sij voordesen door een roep die onder haer uitgestroijt was, dat de Hollanders haer souden verjagen, alle haer beste goet naer 't geberchte toegevlucht hebben, ofte al waer 't dat sij haer geen quaet en souden doen, dat se al evenwel haer niet meer souden willen beschermen. Indien nu de Edele Heer Gouverneur dese bescherminge haer vernieude ende seijde dat hij voortaen altijt haer patroon ende beschutter soude willen wesen, bij aldien sij ons hierinne souden willen gehoorsamen, onse wetten ende manieren aennemen ende soo niet, dat sij 't om der religie wille niet meer en vermochte te doen, ick meijn vastelicken zij souden wel luijsteren ende gehoor geven. Het can altoos niet schaden: willen sij 't doen soo is alle dinge wel, ende willen sijt gantschelicken niet doen ende wij begeren al evenwel haere vrientschap, soo can ick van daer gelicht ende weder omlaech

genomen werden ende sij sullen even degeene wesen, die se van te vooren
waren.

Hierop antwoorde de Edele Heer Gouverneur dat hij 't doen woude als 't
schip naer Batavia vertrocken was. (...)

Dit is aldus cortelicken den toestant der kerckelicken saecken in Sinckan.
(...)

Mijnen tijt is toecomstige verlossinge geëxpireert, wensche hertelicken om
grote redenen verlost te wesen. Ick hebbe alle de gebeden, gelijck oock de
vraechstucken eenen mensche tot sijner salicheijt nodich om te weten, in de
Sinckansche spraeck overgesettet, gelijck oock een dictionarium vergadert
van alle 't gene ick tot noch toe gehoort hebbe. Het soude goet wesen datter
een predicant gesonden wierde, wiens tijt noch lang duerde ofte die gesint
was om altijt te blijven, om mij te verlossen. Ick sal hem al mijn Sinckan-
sche schriften overlaten, dat, soo het alhier deugen wil, hij metterhaest met
haer te recht raecken sal."

fol. 199: The implanting of the Christian faith, teaching of the sanctifying
faith, the eradication of heathen superstition, idolatry, and irregularities is
no longer making much progress here among the Sincandians nowadays,
which we very much regret.

The chief impediments are these:

In the first place, the arrival of the Japanese with the Sincandians who had
accompanied them to Japan a year ago. Since that time, last April, the
Sincandians have changed their attitudes towards us and have grown embit-
tered.

Because when the Japanese arrived here in the roads with the Sincandians,
several days had already passed by before they had even received permissi-
on to come ashore or take on board fresh water and other things (for
reasons well-known to the Honourable Lord Governor). This the Sincan-
dians took very ill, partly because they were longing to see their own kin-
folk, whom they had not seen for a long time, ashore and consequently at
home, partly because they feared that some calamity might now befall them
in the roadstead, since they did not have fresh food or drink, because five
of their kin had already died.

Afterwards, when the Honourable Lord Governor had come to terms with
the Japanese and the Sincandians were turned over to the Dutch, then
clapped in irons and taken into custody on our ships, the entire village of
Sincan gave a wretched performance, like a lion whose whelps are taken

from her: the air was vent by much weeping, moaning, and abusive language. They began to threaten especially me, being the only one living among them just in the company of a boy.

I wrote of this to the Honourable Lord Governor who promptly sent up eight soldiers and a corporal and who also let me know that if I did not feel completely safe, I should come back. Nonetheless I did stay on, but did not accomplish much.

In the meantime, the Japanese had taken possession of the lodge, captured the Honourable Lord Governor with his young son. While this imprisonment still continued, four of the most important Sincandians have broken their shackles and have secretly jumped overboard during the night. Swimming ashore they have returned to Sincan, inveighing quite a deal against the Dutch.

Eventually our people came to terms with the Japanese and the Honourable Lord Governor was released under certain conditions. One among these conditions was that those Sincandians who were still in chains would be released and that their jumble of goods, which they had received in Japan and were taken away by us, be returned again.

Having thus been released, these Sincandians went up to their village of Sincan escorted and accompanied by a whole group of Japanese. They celebrated and made merry, praising and glorifying the Japanese, saying that they had been treated very well and wonderfully both in Japan and during the voyage home and that they had received many gifts, both money and goods, (fol. 199v.) but on the other hand despising and picturing the Dutch with odious colours, saying they were treated badly and rudely by them (as they claimed) and that the goods they had received from the Japanese had been taken away and stolen by us. By saying this they have estranged, led astray, and embittered the hearts and minds of the inhabitants towards us.

This is the first impediment, which formed an obstacle for me and partly still continues to do so since last April up till now, i.e. the bad feelings they have towards us for the reasons mentioned above.

The other and principal impediments are their female teachers, some old women whom they call *Inibs*, who teach everything which is in contradiction to what I teach and who in no way whatsoever will allow even the smallest tittle of their superstitions, idolatry, and irregularities to be derogated and belittled.

I have already brought many of those people so far that they know their prayers fairly well and are able to give an answer to the questions a person needs to know on the way to his salvation and who therefore would be fit to be baptized. They even confess when they are with me that their instructresses teach them only lies and that my preaching is good and true, but they do not want to put it into practice.

It was my firm intention to baptize some of them and to send Your Honour with this ship their names as the first fruits of spiritual cultivation here in Sincan. But I have not yet succeeded, for although they are fit to be baptized as far as external knowledge is concerned, nevertheless it did not seem right to me to baptize them, since they not only have to promise in advance to do away with all their idolatry, superstition, and irregularities, but also have to put this into practice for some time beforehand, so I shall be able to see that the deeds corresponded to the confession.

They were not willing to do so, for they were still preparing their offerings of pork, fish, meat, oysters, rice, strong drinks just as before in front of skulls of deer and pigs. They regulate and still proceed in their actions according to their dreams, the flight and singing of birds, and similar countless things.

And should I ever be able to bring them so far by reason that they abandoned such superstitions and idolatries, still I would not be able to persuade them or bring them to the point that they would not kill the babies. Because that is as common among them as the baptizing of babies is with us, that is to say by people who are not older than thirty, thirty-three or thirty-five years old. They garner fame when they have killed many fetuses, as several women confessed to me, one already having killed eight, the other twelve, another fifteen. Yea, their female teachers even instruct them that it would be a sin and a shame not to kill their babies, which is the reason why they themselves are called upon and fetched to perform the killings.

And given that they would leave behind all their superstitions and idolatries and would still practice this more than beastly cruelty with their children (for without a severe law and punishment they will not break the habit), I could not or should not baptize them.

fol. 200: These and similar irregularities, as well as their superstitions and idolatries, they are not willing to leave behind just because of my telling and teaching them, for these reasons:

In the first place, they say, 'this custom has been handed down to us from our ancestors and we do not want to revoke it'. Secondly, 'our female teachers who speak daily with the gods know the customary law and teach us accordingly, as do our elders'. Thirdly, 'were we to abandon such a habit we would be shamed and despised among our fellowmen'. In the fourth place, 'our gods would be angry with us, possibly not give rice, and send enemies against us, who would chase us away and kill us'.

Here they have yet another superstition, because since the arrival of the Japanese, that is since April, they do not look kindly upon us. They believe that we intend to turn them away from their religion, and the gods will be angry with them. Therefore they suggested to me that I should teach only one house, which house would discard its rules and customs and adopt ours. Should the gods now bless this house, give plenty of rice and other products, two or three years in succession, then they would accept our religion. They come to me to put me to the test, want me to perform miracles, make rain or wind or dissipate the same again, tell the future, or explain what is happening. And since I cannot do such things they hold me in contempt, saying that their priestesses can do this.

This is the second impediment, namely their female preceptresses with their lies.

The third impediment so far has been the fact that there is no certain leader among this nation, with whom I would be able to speak on behalf of the entire people. Everyone does what pleases him best. Should I teach someone today, tomorrow he will be gone into the fields, and sometimes does not come home again within the month. When there are a few who listen to me tractably, the moment they come into contact with a certain group of people that does not want to listen to me, they destroy it and spoil in one hour more than I have built up in ten.

I ought to be commended to them, so they would listen to me. This I asked of the Honourable Lord Governor after the departure of the Japanese, who summoned them to come over, but they did not want to come to him, out of fear they might also be clapped in irons. I asked him this once again some time later and he promised to come to the village with me to talk to these people, but (there seem to be more important matters taking place) he has left for the Chinese coast with the fleet.

This also is the third impediment, that is disorder and no commendation.

This being a fact, I am in a situation to accomplish little and (if no other remedy is forthcoming) I do not have much hope of accomplishing anything. Therefore on August (...)[28] I went to see the Honourable Lord Governor. I told him how matters stood and asked his advice about what further things should be done, to which he replied that he did not have any solution.

I told him how we in my opinion might succeed, that is that in the first place their female teachers should be prohibited from either teaching or practicing their idolatry. That the people should no longer listen to them nor should they comply with their old teachings, but that they had to listen to me (fol. 200v.) and direct their lives according to my teachings.

In the second place that a kind of order should be imposed in the teaching, which could easily be organized in the following way:

The entire village of Sincan is divided into fourteen parts or quarters. Now were orders to be given that every day two quarters had to come to be taught, early in the morning the men, late afternoon the women of the same two quarters and from nine to noon all the children of the entire village, then the whole village would be taught once in every seven days and the children, on whom most hope is placed, every day. And this would not impede them in their labour, for it would cost every person only two hours in seven days. And all this should be done by gentle persuasion, but yet some pressure should be exerted in the following way.

The inhabitants of Mattau and Baccaluan are bitter enemies of the village of Sincan. They would have burnt this village down two years ago, driven out and beaten to death all the inhabitants, had not the Dutch concerned themselves with them. They came to their aid with a hundred musketeers and chased away the inhabitants of Mattau and Baccaluan. This village of Sincan has been under the protection of the Dutch ever since and without this protection Sincan would not exist for one more month!

But nowadays the Sincandians live in fear of being driven out by the Dutch themselves (because of what happened between them and the Japanese); recently they have taken all their best belongings to the mountains, prompted by a rumour spread among them that the Dutch were going to chase them away, or that even if they were not going to harm them, they would no longer grant them protection.

Were the Honourable Lord Governor now to renew this protection and tell them that he would always be their patron and protector were they to obey us and accept our laws and customs, but were they to refuse, that they ought

not do it for reasons of religion, I am convinced they would listen and obey. In any case it can do no harm: if they want to do it, all is fine and if they refuse point-blank to do it and we still want their friendship, I can be withdrawn from there and recalled and they will just as much be the same people as they were before.

To this the Honourable Lord Governor replied that he was willing to comply after the ships had left for Batavia (...).

This is in brief the state of matters of the Church in Sincan (...).

(Candidius closes his letter with the information:)

Post Scriptum:

My time for replacement has expired and I deeply wish to be replaced for serious reasons. I have translated all the prayers as well as the questions a human being needs to know on the road to his salvation in the Sincandian language, and I also have compiled a dictionary of everything that I have heard so far.

It would be a good thing to send a minister to take my place, who would stay for a long time or who would indeed be willing to stay forever. I shall leave him all my Sincandian notebooks, so if things work out well here, he will find his feet with them in a short period of time.

48. General Missive.
VOC 1094, fol. 1-47. Extract 3 November 1628.
FORMOSA p. 73.

fol. 5: "d'Onse, vresende dat hierdoor groote swaricheyt voor de Compagnie soude mogen ontstaen, namen voor des Compagnies recht ernstelick voor te staen; seyden dat deze Sinckanders geen ambassadeurs waren, maer dat se van den capiteyn van de jonck van Phesodonne steelswijs van Teyouhan vervoert ende als ambassadeurs opgemaect waren.

Het schijnt, soo d'onse van dese Sinckanders ende van de souverainytijt van Tayouhan geswegen hadden, dat by den keyser wel audiëntie becomen ende goet affscheyt vercregen souden hebben, maer alsoo d'onse door Quinos-quedonne, één van des keysers raden, ende twee domestique priesters van syne Majesteyt seer nauw geëxamineert wierden, van waer zy quamen, wie haer gesonden hadde, van wie de brieven geschreven waren, van waer de schenckagie quam ende wat sy meer quamen doen als syne Majesteyt te begroeten ende van ontfangen weldaden te bedancken, is rontuut door d'onse verclaert, dat syne Majesteyt wilden clagen, dat den capiteyn van de joncke

van Phesedonne sekere inwoonders van Sinckan, onse onderdanen, steelsge-
wijs van Tayouhan hadde vervoert ende Phesedonne uutgaff, dat die als
ambassadeurs aen syne Majesteyt gesonden waren ende dat daerover recht
wilden versoucken, daerby allegerende wat recht ende souverainiteyt in
Teyouhan pretenderen. De rijcxraeden d'intentie van onse gesanten aldus
vernomen hebbende, wierd daer nae selfs verweten dat geen ambassadeurs
waren, maer dat eenige cooplieden haer opgeraept ende gesonden hadden om
voor geschencken 't stuck van Tayouhan by syne Majesteyt jegens syne
onderdanen te defenderen; item dat haren generael niet dan een dienaer van
cooplieden is, ende nadat 37 dagen getraineert waren, wonderlijcke veel na
de qualiteyt van d'heer generael ende de plaats van Batavia gevraecht was,
wierde d'onse eyntlijck aengeseyt, dat met haere geschencken van Edo weder
souden keeren ter plaetse daer vandaen gecomen waren, alsoo geen Batavia,
noch gouverneur-generael kenden (doch de vier metalen stucken heeft d'heer
van Firando in Osacca doen blyven), sonder dat syne Majesteyt off oock
yemant van de rijcxraden hebben mogen spreecken. d'Onse menen dat voor-
nemelijck door toedoen van d'heer Firando met dese affront affgewesen sijn,
maer wy achten datter by de raetsheeren naer praetext gesocht is om d'onse
aff te wysen, de tijt aen te sien ende de reputatie van den keyser, haeren
heere, geheel te mainteneren. Per nevensgaende journael sullen U Ed. sien
hoeveel datter met dese ambassaetschap in Edo te doen is geweest.

fol. 5: Our men [Pieter Nuyts and Pieter Muyser] fearing that heavy diffi-
culties might well beset the Company, decided to stand up earnestly for the
Company's right, explained that these Sincanese were not ambassadors, but
that they had been stealthily transported from Tayouan by the skipper of
Phesodonne's junk and had been dressed up as ambassadors.
It seems that had our men remained silent about these Sincanese and the
sovereignty over Tayouan, they might have been admitted to the presence of
the Shogun and might have been granted a proper farewell, but when our
men were interrogated at great length by Quinosquedonne, one of the
councillors to the Shogun, and by two of His Majesty's personal priests
(being asked whence they came, who had sent them, who had written the
letters, from where the gifts had come and what more they had in mind than
to honour His Majesty and thank him for his benevolence), they had
declared very frankly that they wanted to make a complaint to His Majesty
about the fact that the skipper of Phesodonne's junk had transported certain
inhabitants of Sincan, our subjects, from Tayouan by stealth and that Pheso-
donne had lied saying that these had been sent to His Majesty as ambassa-

dors and that we wanted justice to be done, alluding to the authority and sovereignty to which we lay claim in Tayouan.

When the councillors of the Shogun had thus understood the intentions of our representatives, it reached such a pitch that afterwards our men were reproached themselves that they were not ambassadors, but that some traders had picked them up and sent them over to bring the issue of Tayouan to the Shogun's attention to defend it against his subjects by using gifts; and also (the reproach) that their General was no more than a servant of traders. And when 37 days had passed, in which amazingly many questions were asked about the quality of the Lord Governor-General and the role of Batavia, our men finally received the order to leave Edo and return with their presents to the place whence they had come, because neither Batavia nor the Governor-General were known to them (but the four metal pieces of ordnance had to stay in Osaka by order of the Lord of Hirado), without having been able to speak to His Majesty or to anyone of the councillors of the Shogun. Our men think that it was mainly by the machinations of the Lord of Hirado that they were dismissed in such an insulting way, but we feel that the councillors were using this as an excuse to repudiate our men, to wait a while and to keep the reputation of the Shogun, their Overlord, unblemished. Your Honour will see from the journal appended what a to-do there has been with this representation at Edo.

(Following are costs and the announcement that Nuyts and Muyser themselves must pay for all the extra expenses they had added to look all the more impressive at the Court of the Shogun.)

49. Discourse by the Reverend Georgius Candidius. Sincan, 27 December 1628. Rijksarchief Utrecht, Family Archive Huydecoper, R. 67, no. 621.[29]

"Dit eylandt (segge ick), tot hetwelcke Godt de Heere gelieft heeft mij te senden om den inwoonderen der selver plaetsen het Evangelium van Christo den Salichmaker te vercondighen, is geleegen 22 graeden bij noorden de linie. Heeft in sijn begryp ontrent 130 mijlen, is vol dorpen ende seer volckrijck. Hebben niet een, maer veele ende verscheyden spraken. Hebben geenen coninck, heer ofte overhooft die se regeert ende dien se onderworpen sijn. Leeven niet in vreede ende pays met den anderen, maer voeren continueelen oorlogen, een dorp tegen het ander. Is rijck van veel schoone visch ende vischrijcke rivieren; is vol van herten, wilde verckens, reetjes, steen-

bocken, haesen, conijnen, dassen, wilde katten, veele hoenders, patrijsen, duijven. Heeft oock groote beesten, als koeyen ofte perden, die mede hoorens dragen seer dick ende met tacken, welcker vleesch seer lieffelyck ende smaeckelijck is om t'eeten; werden van de inwoonders *Chuang* genoemt. Dese sijnder bij groote meenichte in 't geberchte. Het heeft oock tijgers ende een ander groot gedierte, dat se op haere spraeck *Tumei* noemen. Is van gestalte als een beyr, doch wat grooter, welcker vellen in groote estime gehouden werden. Het landt aen sich selver is seer vet ende vruchtbaer, doch wordt weynich bebout ende besaeyt. Het geboomte is meestal wildt, doch sijnder oock eenich geboomte die vrucht brengen, dewelcken van de inwoonders met grooten smaeck werden gegeeten, maer van onse natie souden se niet willen geproeft werden. Anders soo sijnder oock te vinden geimber ende caneel. Men seyt oock datter silver- ende goutmijnen souden wesen, 't welck de Chinesen besocht ende de bethooninge daer van in Japan souden gebracht hebben; doch hebbe 't selve niet gesien ende is van onse natie noch niet daer op geattenteert.

Dit is in 't generael van 't gansche eylant, welcker costuymen, manieren, religie ende spraecke mij niet int geheel bekent is. Dieshalven sulcx maer met een woordt aenroerende, jae verbij, ende begeve mij tot de particuliere plaetsen, welcker spraeck, manieren ende costuymen, gelijck oock haere religie, mij bekent is, om u daer van te onderrichten. Deese plaetsen dan sijn acht in 't getal: *Sinckan, Mattau, Soulang, Backeroan, Tafalan, Tifalukan, Teopang ende Tefurang*. Deese acht plaetsen hebben een ende deselve maniere, costuymen, religie ende spraecke, doch weynich verschillende. Waervan de seven liggen inde leechte naer de zeecant toe ende connen alle seven van ons fort aff te voet binnen twee daghen doorreyst werden ende den selven tweeden dach gemackelyc weeder int fort comen. Het achtste dorp Tefurang leijt in 't geberchte, drie dagen reysens in 't heen ende wederom comen van ons fort.

De inwoonders van deese plaetse sijn wilde, rouwe ende barbarische menschen om aen te sien. De mannen sijn meestendeel lang van statuer, sterck van lijff ende leeden, als halve reusen. Hebben een couleur tusschen swart ende bruyn, gelijck den meestendeel der Indiaenen, doch niet heel swart als de Caffers. Loopen somerstijden gansch naeckt, sonder eenige schaemte te hebben, noch sonder die *membra qua natura ipsa vult tecta* te bedecken. De wijven daerenteegen sijn meestendeel cleyn ende cort van statuer, doch heel vet ende starck. Hebben couleur tusschen bruyn ende geel. Gaen gekleet ende hebben natuerlycke schaemte, behalven wanneer sij sich wasschen, 't welck sij 'sdaechs twee reysen met warm waeter doen, des morgens ende des

avondts, buyten haere huysen. Alsdan sullen se niet licht voor den voorbij-
gaenden man beschaemt wesen.

Dit volck is den meestendeel seer vriendelyck, getrou ende goethertich.
Sullen onse natie naer haer vermeugen met cost ende dranck seer vriendelyck
onthaelen, soo se maer niet al te veel comen ende gheen onbeleeftheyt
gebruycken. Sullen niet licht yet ontwenden ofte steelen, jae, vreemt goet
gevonden hebbende, sullen 't weder thuys brengen, daer se meynen daert
behoort, vuytgenomen 't dorp *Soulang*, 't welck seer van diverije ende
struyckrooverie beschuldicht werdt. Sijn seer getrou teegens degeene, daer
se mede in vriendtschap ofte in verbont staen. Niet verradich, jae, souden
selve liever willen sterven ofte all ongemack lijden, eer se andere door haer
verraedt int verdriet souden brengen. Hebben goet verstandt ende memorie
om een dinck licht te begrijpen ende t'onthouden. Doch hoewel alle de
Indianen seer beedelachtich sijn, soo hebbe ick nochtans door gantsch India
geen beedelachtiger ende in 't eyschen onbeschaemder ende stouter als dese
natie gevonden. Al wat se sien en schaemen sij sich niet om het selve te
eyschen ende te begeeren. Doch connen met weynich gepaeyt ende te vrede
gestelt werden.

Haer principaele neering ende hanteeringhen is, het velt te bouwen ende rijs
te saijen. Ende hoewel se velts genoech hebben, 't welck goet, vet ende
vruchtbaer is, jae, soo veel oock dat deese seven dorpen met haere velden,
indien se gebout waeren, noch hondertduysent man souden connen voeden,
soo is nochtans, dat se niet meer bouwen ende saeyen dan dat se selven tot
haerder onderhout noodelycken van doen hebben, jae, altemets noch te cort
comen. De wijven bouwen meest het veldt ende doen de swaerste arbeyt.
Ende om het velt te bouwen, soo hebben se geen paerden, ossen ende ploe-
gen, maer hacken 't al met houweelen om, 't welck dan veel tijdt vereijscht.
Wanneer de gesaijde rijs voortspruyt ende op d'een plaetse dick, op d'ander
dun voortcomt, soo isset, dat se den selven rijs verplanten, 't welck oock
met veel moeiten geschiet. Den rijs, wanneer hij rijp is, gebruycken sij
geene sickelen om den selven aff te snijden ofte saijsen om aff te maijen,
maer hebben een ander seecker instrument als een mes, waermede zij halm
voor halm een spanne onder sijn aijre affsnijden.

Deesen rijs alsoo affgesneeden, vergaderen sij bij maelcanderen in haere
huysen, sonder vuyt te dorschen ofte te stampen, totdat se hem tot haere
nootdruft van doen hebben. Alsdan stampen se voor elcken dach soo veel als
se effen op moghen, twelck oock der wijven werck is. Des avonts hangen se
twee ofte drie bondekens over het vier om te droghen. Des anderen mor-
gens, ontrent twee uren voor den dach, staen de wijven op, stampen den rijs

ende maecken hem claer voor den selven dach. Also continueeren sij dage-
lijcx, jaer vuyt jaer in, ende maecken niet meer claer als voor eenen dach.
Sij sayen oock noch drie andere slach ofte soorte van vruchten, waer van sij
t'een *pting*, t'anderen *quach*, het derde *tavau* noemen, niet ongelijck onse
vaderlantsche milien. Noch hebben se twee andere soorten, niet ongelijck
onse vaderlantsche boontjes. Sij hebben oock noch drie ander soorten van
wortelen die se planten, dewelcke sij in plaetse van broodt eeten; met
dewelcke sij sich soude connen onderhouden, alwaer 't oock, dat se geen
broot, rijs ofte andere vruchten en hadden. Geimber, suyckerriet, waterla-
moenen planten sij oock, maer niet meer als voor sich selven van doen
hebben. Benannis, clappus, limoenen van verscheyden soorten, gelijck oock
pijnang, hebben se in groote abundantie. Sij hebben oock noch eenige
weynighe andere fruijten, dewelcke niet veel te beduijden hebben ende die
ick in onse taele niet can vuytspreecken.
Dit is hetgeene dat se van haere velden ende thuijnen haelen, tot haer lijffs
onderhoudinghe van nooden.
Wijn ofte eenighe andere stercke drancken, die in andere quartieren van
India vuyt den boomen getapt werden, en hebben se niet, nochtans hebben sij
eenen anderen dranck, die van crachte soo sterck ende van smaeck soo
lieffelyck is ende soowel droncken maeckt als Spaensche ofte Rijnsche wijn
soude wesen ofte maecken. Den welcken de wijven op deese maniere
bereyden ende toerusten: sij nemen rijs, dien se op de walmte setten ende
gewalmt sijnde, stampen sij den selven in eenen rijs block, totdat hij deech
is. Dan neemen se meel van rijs, kaeuwen 't selve in den mondt ende dan
spouwen sij 't weder vuyt in een potje, totdat se ontrent een pint nats
hebben. Alsdan doen sij 't selve onder den deegh, kneeden ende wercken den
deegh daermeede, totdat hij soo fijn wordt als een backersdeegh om broot
daervan te backen. Dit kausel is in plaetse van suerdeesem. Dit gedaen
sijnde, doen sij den deegh in een groote pot, gieten waeter daer over, laetent
staen tot ontrent twee maenden. Dan isset een schoonen, lieflijcken, starcken
ende dronckenmaeckenden dranck, 't welck ondertusschen coockt als nieu-
wen most in een vadt. Hoe langer dat sij se laeten staen, hoe beter ende
starcker den dranck wordt. Hij can wel duijren een, vijff, thien, twintich,
dertich jaeren, dan is hij eerst op sijn best. Wanneer se van deesen dranck
opschaften, soo schijntet tweederley dranck te wesen. Want het bovenste is
soo claer als een hel, claer fonteyn water, maer het onderste is soo dick als
een breij, twelck sij met leepelen pleegen te eeten, ofte, indiense 't willen
drincken, moeten se waeter daerin gieten, want van dickigheyt cannet niet
gedroncken werden. Wanneer se in haere velden gaen, neemen sij van dat
dicke een pot ofte bamboes vol ende een bamboes vol waeter, 't welck hen

voor cost ende dranck den selven dach verstrecken mach. Maer van het bovenste claerste neemen sij maer een cleyn weijnich, 't welck hen dan is tot versterckinge ende tot vroolickheijt ende niet tot verslaginge des dorsts. Den meestendeel van haer rijs consumeeren sij in desen dranck te maecken.

De wijven, wanneer se met haeren velden ofte rijs niet besich sijn, vaeren oock met haeren schampans vuyt om visch, crabben ende garnael te vanghen ende oesters te haelen, 't welck sij naest den rijs voor haere beste ende principaele cost houden. De visch souten se in met schobben, ingewandt ende een tijdt langh gestaen sijnde, eeten sij se op met vuyllicheyt ende alles. Als sij se vuyt de potten weeder vuythaelen om te eeten, can men se altemets voor wormen ende maden qualijc sien. Doch sij en hebben geen arch daerin ende schijndt hen leckere ende delicate cost te wesen.

De mannen gaen ondertusschen meestendeel leegh, principael de jonghe, starcke kerels van 17, 20, 22, 23 etc. jaeren. Doch de ouden van 40, 50, 60 etc. jaeren sijn meest met haere wijven in haere velden, bij nacht ende bij daech. Hebben een cleyn hutjen, daer se in rusten ende slaepen. Comen altemets in twee maenden qualyck eens int dorp, ten sij datter feestgehouden wert. De anderen helpen altemits de wijven in de velden, doch weynich. Haer meeste werck dat se doen, is jagen ende backeleyen.

Haer jagen is driederley: met stricken, hasegeyen ende met pijl ende booch. Met stricken is weder tweederleij. Eenighe stellen se in de bosschen ende in de paggers, daer se weeten dat de herten ende wilde verckens met meenichte comen. Dan omsingelen se deselve ende jagen se alsoo in de stricken, ende dese stricken sijn van rottangh ofte bamboesen gemaeckt. Andere stellen se in de paden of op het vlacke velt ende claeren 't aldus: sij slaen eenen starcken bamboes diep in de aerde daer een touw voor aen vast is ende diep in de aerde sijnde, buygen sij den selven voor over, maecken 't onder met cleyne houtjens vast, spreyden daer over den strick vuyt, decken 't met een weynich aerde toe ende als de herten (die bij twee-, driehonderd en, jae duysenden in haere velden lopen) den selve aenroeren, snapt het op ende hout het hert ofte vercken in een voet vast staende. Dan comen se ende doorschieten hem met een hasegey. Op dese maniere worden der jaerlijcks veel duysenden gevangen.

Met hasegeyen claeren sij 't aldus: het gantsche dorp, ofwel twee ofte drie dorpen, gaen met maelcanderen vuyt. Elck heeft twee ofte drie hasegeyen. Nemen met sich honden, die dat wilt opjagen. In 't velt gecomen sijnde, verdeijlen sij sich van maelcanderen; begrijpen altemits in een zirckel wel een heel ofte halff mijl velts; gaen dan op maelcanderen toe. Al dat wilt in desen zirckel begrepen can niet ofte swaerlick ontvlieden, want als hij een hasegey in 't lijff (heeft), is (hij) soo goet als gevanghen. De hasegeyen daer

se de harten mede schieten, bennen dusdanich: den steel is ontrent een manslengte van een bamboes. Heeft een belleken daeraen gebonden met een langh touw, welck touw voor oock aen 't ijser vast is. Het ijser heeft drie ofte vier tacken om datter in 't hert soude blijven steecken ende niet weder vuytvallen. 't Selve ijser is niet heel starck in den steel ingemaeckt, omdat, het hert geraect sijnde, den steel soude vuytvallen ende naeslepende door ruychte het hart in sijn loopen verhinderen, totdat hij ofte meer geraect ofte niet verre soude loopen, totdat het sich verbloedt hadde. Het belleken werdt tot dien eynde daeraen gehangen, opdat men altijt can hooren waer het hert heenen loop. Op dese maniere worden oock bij meenichte gevangen.

Met pijl ende boogen claeren sij 't aldus: een man alleen, ofte twee, drie, al eevenveel, gaen in 't velt ende daer se eenen trop herten sien, loopen denselven nae (want sij bijcans soo hart als herten connen loopen), schieten een pijl voor, den anderen naer, totdat se eyndelijck geraeckt hebben. Op dese maniere schieten se oock niet weynich.

Maer ghij sult vraegen, bij aldien se sooveel herten op deese drie manieren schieten, waer se met alle het vlees blijven? Sij en eeten 't niet, maer vercoopen 't aen de Chinesen voor cleetjes, sout ofte eenighe andere barang barang. Selden dat sij een voor sich houden. Het ingewandt houden sij ende eeten 't met vuylicheyt en alles op. Ende wanneer se veel hebben, souten sij 't met vuylicheyt ende alles in ende dunckt haer sulcx een welsmaeckende cost te wesen. De herten, soo haest sij se geschoten hebben, noch warm sijnde, snijden sij een stuck daer van ende eeten 't alsoo rouw op, dat het bloedt de wanghen affloopt. De jongen die sij in de hinden vinden, het sij dat se volwassen ofte onvolwassen sijn, eeten sij oock met huijt ende met haer ende met alles op. Dit is een van de principaelste wercken dat de mannen doen.

Het ander is, dat se vuytgaen tegens haere vijanden te backeleijen, 't welck sij op soo danighe manieren claeren: wanneer sij nieuwen oorloghe een dorp aendoen, seggen sij den pays vantevooren op ende waerschouwen maelcanderen. Alsdan consenteeren 10 of 20 off 30 off soo veel haer lust, gaen ofte vacren met een schampan naer de plaetse toe. Ontrent de plaetse gecomen sijnde, wachten sij tot in de nacht, opdat se niet gesien ende verraden soude werden (want haer meeste backeleijen maer een verraet is). Alsdan bij nacht gaen se in des vijants velden, sien of se yemandt souden vinden in haere velthuysen. Want, gelijck boven geseyt, soo slapen de oude luyden meest in haere velden. Vinden se ymant, het sij out off jong, wijff off man, dien slaen se doot, smijten hem 't hooft aff, met handen ende voeten, jae neemen altemets wel t'geheele lichaem meede in stucken gecapt. Naerdat haer veel sijn, een yder wil wat daervan hebben, om weder thuys comende daermeede

te proncken. Ende naer de gelegentheyt van de plaetse ofte des peryckels, want alsij met meenichten vervolcht werden, neemen sij maer 't hooft, ofte, bij aldien dit haer in 't vluchten soude beletten, snijden sij alleenlijc het haer daervan aff ende salveeren sich met de vlucht. Ofte, bij aldien se niemant in den velde vinden, gaen se naer het dorp toe, sien haer beste cans vuyt, overrompelen een huys, slaen alles doot in 't huys dat se vooreerst int doncker vinden ende dan met der haest met het hooft, handen ende voeten op den loop, eer den alarm in 't dorp wort.

Somwijlen beurt het wel dat se maer het haer van des dootgeslagenen hooft nemen ende vluchten eer se overvallen werden. Want als se in een huys in-breecken, connen sijt soo stil niet claeren ofte den een ofte de anderen wort wacker, dewelcke dan dadelycken een moort-geschreij maeckt ende alsoo in een omsien het gantsche dorp in de waepenen sijnde, op deselve plaetse vergadert. Somwijlen slaen sij wel een ofte den anderen op soodanighe ma-nieren doot, maer moeten daerover ontloopen eer se hooft ofte haijr crijgen. Somwijlen verwonde se maer. Somwijlen richten se oock niet vuyt, door dien het doncker is ende 't volck in 't huys sich versteecken. Somwijlen werden se oock verrast ende selffs doot geslagen. Altemets comen se oock wel, maecken alarm, locken het volck vuyt tot ontrent de plaetsen, daer haere champans liggen. Dan slaen se ende vechten mannelijcken tegens maelcanderen, soo lange ofte dat se overmant werden ofte dat se doode ofte gequetste crijgen. Dan neemen se de vlucht, want als een van haer volck doot geslagen is, wordt het soo hooch bij haer genomen, als bij ons wanneer een gantsch leeger geslagen ofte in de vlucht gedreven is.

Haere waepenen, daer se haere vijanden mede bevechten, sijn hasegeijen (doch een ander slach als daer se de herten mede schieten, want dese en hebben geene tacken, hebben geen touw, hebben oock geen beltie daeraen. Sij sijn oock vast in den steel, soodat se niet connen vuytvallen), schilt ende swaert. De schilden sijn heel langh ende breet, soodat se daerachter connen schuylen sonder gesien te werden. Haere swaerden, die se gebruycken, sijn heel cort ende seer breet. Gebruycken oock corte Japansche houwers in haere oorloghen, pijl ende booghen.

Somwijlen treckt wel oock een geheel dorp ofte spannen oock wel twee ofte drie dorpen tesaemen. Trecken bij daech tegen een ander plaetse om hetselve opentlijck te bevechten. In haere oorloogen en hebben se geen seecker Capi-teijnen ofte hoofden, dien se onderdaenich sijn ofte naer wiens seggen sij luijsteren. Maer soo daer yemandt is, die voordesen veel hoofden heeft gecreegen, wanneer den selven lust heeft om te backeleyen, can lichtelyken 10 ofte 20 mannen crijgen, die met hem vuytgaen ofte vaeren om te backe-leijen. Ende dese wordt quasi voor een hooft gehouden, want de gantsche

actie van den selven den naem crijcht, als wanneer se een hooft crijgen. Al isset dat desen persoon met sijn handen 't feyt niet gedaen heeft, nochtans wordt hij gesecht een hooft gecreegen te hebben.

Sij gebruycken oock listicheeden ende bedroch. Listicheeden, wanneer se met 5 ofte 6 champans, dat is met 50 ofte 60 mannen, vuytvaeren om te backeleijen. Soo laeten sij bij nacht de meeste van 't volck op d'een sijde van 't dorp aencomen ende aldaer schuylen. Op d'ander sijde van 't dorp comen de anderen des morgens vroech aen, vuyt de zee dat sij 't sien, maecken alarm. Dan meynen die in 't dorp datter anders gheen vijant en is, comen tegens dien vyant aen, laeten 't dorp meest leech. Ondertusschen comen die op d'ander sijde invallen, slaen doot 't geene haer voor eerst voorcompt. Ende als sij een ofte twee hoofden hebben, nemen se weder de vlucht tot haere champans, vergaderen bij de anderen, meynen groote victorie begaen te hebben.

Somwijlen claeren 't in die dorpen, die lantwaerts ingelegen sijn. Comen met weynich aen 't dorp, maecken eenen alarm, locken 't volck vuyt, vechten een tijdt langh, totdat se overmant werden; alsdan vluchten se. Ondertusschen comen die op de beurs, die se in *Insidie* achter haer gestelt hebben ende bespringen se dan tegelijck van achter ende van vooren. Sij claeren 't oock alsoo, wanneer se des nachts een huys in een van haere vijandts dorpen bij nacht willen overvallen, setten sij de weghen allenthalven vol voetangels, opdat den vijant haer vervolgende daerdoor inne loopen. Ondertusschen houden sij eenen openen wech voor haer, die ongebaent is. De voetangels maecken sij van een seecker hart riet ende maecken se niet gelijck onse natie, dat men met de voeten soude daerintreeden, maer maecken se ontrent een elle lanck ende setten se niet steyl op, maer setten se wat vooroverhangende naer de plaetse, daer de vyant moet van daen comen. Als dan den vijandt haer achtervolcht, loopt hij met de scheenen daerin, want sij gantsch naeckt ende bijcans soo strenge als een hert loopende, quetschen sij sich ten hoochsten, soodat se haer te vervolgen gedwongen werden om naer te laeten.

Sij sien oock altemets door opentlijck bedroch haeren vijandt te overrasschen door schijn van vrientschap, gelyck sulcx daer in mijnen tijden alhier gebeurt is. Daer is een seecker eylant ontrent 13 mijlen van dit onse *Ilia Formosa* gelegen, genaemt in haere spraeck *Eugiu*, twelck onse natie *'t Gouden Leeuwsch Eylant* noemen, omdat voordesen 't schip Den Gouden Leeuw aldaer woude verversinghe haelen, de inwoonders den coopman, schipper met eenich volck meer doot sloegen. Dit eylant heeft oorlogh met de inwoonders van dit ons eylant ende laeten geen vreemde natie op haer eylant comen. De Chineesen comen altemets om aldaer te handelen, maer moghen aen landt niet comen; blijven in haere joncken sitten, dan comen die van 't

landt bij haer, dicht bij haere joncken, reijcken maelcanderen de goederen toe, die se willen verruylen. Met de rechter handt geeven sij 't één, met der slincker neemen sij 't ander ende laeten haer goet niet vuyt de handen, totdat sij 't ander alreede weder vast hebben. Vertrouwen maelcanderen niet. Onlangs ist gebeurt, dat deese inwoonders van ons dorp Soulang, in 't getal 60, sijn met de Chineesen naer toe gevaeren, hebben sich in Chinees habijt verthoont, sich gelaeten, alsof se met haer eenighe goederen verruylen wouden. Als een van dit voorgenoemde eylandt wat te dicht bij quaeme, sijne goederen daer reyckte om met haer te ruylen, hebben sij hem bij den arm gevadt, in haeren jonck getrocken, in stucken gecapt ende met grooter victorie vandaer wederom naer huys gevaeren. Dusdanich sijn haere oorloghe.

Wanneer se nu van haere vyanden een hooft crijgen ofte alleen 't haijr daervan ofte een hasegeij ende thuys comen, soo isset datter groot feest, juychen ende jubileeren hierover, in 't gantsche dorp bedreeven wordt. Het hooft neemen sij eerstelijcken, gaender meede door 't gansche dorp toonen 't; singen liedekens ter eere van haere affgoden, door welckens hulps sij meenen sulx vercreegen te hebben. Waer se comen, worden seer heerlijcken ontfangen ende bennen seer wilcom. Van den besten ende stercksten dranck die sij hebben, wordt haer opgeschaft. Dan nemen sij 't hooft, brengen 't op de kercke van die, die 't gecreegen hebben (want elck 15 ofte 16 huysen een besonder kercke heeft), coocken 't aldaer in eenen podt totdat het vlees heel versiet ende affvalt, dan laeten 't droogen. Begieten het selve van haeren besten starcken dranck. Slachten een vercken ter eeren van haere affgooden. Houden groote (op haere manieren) gasterijen. Deese victorie duert wel 14 continueele dagen aen maelcanderen.

Alsoo claeren sij 't oock, als sij maer wat haijr van den vijandt ofte eenighe wapenen gecreegen hebben. Deese hoofden, haijr, arm, beenen ofte stucken van eenich gebeente worden in grooter estime ende wardij bij haer gehouden, als bij ons silver, gout, perlen ofte eenich costelyck gesteente. Als een huys brandt, sullen sij voor eerst alles laeten staen, dit alleen bergen. Degeene, die soo danich hooft hebben gecreegen, worden seer ontsien ende geeert, jae bijkans veerthien dagen is niemandt soo stoudt, dat hij haer opentlyck soude derven aenspreecken. Dit is oock de maniere, hoe se met haere overwonnene vijanden leven.

Deese seven dorpen en hebben gheen gemeen hooft, die se regeert, maer elck dorp is voor sich selven. Ende elck dorp wederom heeft oock gheen particulier hooft, die 't absoluijt seggen ofte gebiedt over haer heeft, nochtans soo hebben se quasi eenen Raedt, de welcke bestaet vuyt 12 mannen. Deesen quasi Raet wordt alle twee jaeren verandert ende vercooren van

persoonen, die ontrendt 40 Jaeren ende 't gelijck van een ouderdom sijn. Hoewel dat se van getalle den jaeren niet en weten, noch niemant bekent is hoe lang dat hij geleeft heeft, nochtans isset, dat sij 't wel onthouden welcke in een dach, maent ofte jaer gebooren sijn. Wanneer desen Raedt nu sijn twee jaeren vuyt gedient heeft, laet een ygelyck van dese persoonen hem 't haijr op het voorhooft ende op beyde slaepen ofte op beyde sijden van 't hooft vuyt plucken, 't welck een teecken is, dat se raetspersoonen geweest ende wederom daervan ontslagen sijn. Alsdan worden wederom nieuwe raetspersoonen vercooren, van één ende 't selve ouderdom. Deser digniteyt nu ofte authoriteyt is niet soodaenich, dat 't gene sij goet vinden ofte besluyten van anderen soude moeten aengenomen ende geapprobeert werden.

Haer ampt bestaet daerinne, dat soo wanneer eenige swaericheijt voorcomt sij bij maelcanderen vergaderen, daervan spreecken wat daarinne te doen soude wesen. Dit gedaen sijnde, doen sij het gantsche dorp op één van de grootste kercken vergaderen. Stellen de saecke voor; spreecken pro ofte contra wel een geheele halve ure aen maelcanderen, naer 't vereysch van de saecke. Als den eenen moede is ofte vuyt gesproocken heeft, vervangt hem de ander ende soecken alsoo door veele reedenen het volck te persuadeeren, tot 't geene sij goet gevonden hebben. Houden oock goede ordre daerinne, want als den eenen spreeckt, sullen de andere alle gaen swijgen ende luysteren, al waeren se oock bij veel duysenden. Haere eloquentie ende welspreeckentheyt is soodanich, dat ick ten hoochsten daerover ben verwondert geweest, wie niet meyne *Demostenem* in woorden rycker ende vloijender geweest te hebben. Als sij nu vuytgesproocken, beraetslaegen het volck daerover met maelcanderen. Willen sij 't doen, 't geene voorgestelt is, 't is wel; willen sij 't niet doen, 't is oock wel, niemant wordt gedwongen. Een elck dwingt het overdencken vanden profijt ofte schade, die vuyt dese voorgestelde saecke soude connen voortcomen. Haer ampt is oock veerder, wanneer haere leeraressen yet belasten, daerop te letten, dat het selve in 't werck gestelt werde; item te verhinderen 't gheene waerdoor sij meynen dat haere affgoden souden vergramt werden. Wanneer sij nu sich te buyten gaen in yet dat haer affgoden aengaet, oft in yet, dat niemant particulierlijck, maer het algemeyn belangt, soo hebben dese 12 raetspersoonen daerin yet te seggen ende straffen haer. Doch niet met gevangenissen, boijen, ofte eenighe andere lijffstraff, veel weyniger met de doot, maer ofte om een cletje, ofte een hertevel, ofte wat rijs, of een pot van haeren starcken dranck, doch elck naer 't vereysch der saecken.

Daer sijn seeckere tijden in 't jaer, ontrent drey maenden, dat se moeten heel naeckt loopen. Ende sulcx daerom, indien dat se niet geheel naeckt loopen (seggen se), soo souden haere goden hen geen reegen geven ende soude

alsoo de rijs op 't velt verderven. Bij aldien nu dese raetspersoonen yemandt vinden met een cleetje gaen, hebben sij de macht hem 't selve cletje aff te neemen, ofte om twee hertevellen, ofte om rijs, dranck ofte yet anders te straffen. Hierom isset dat den Raet des morgens ende des avonts, soo wanneer het volck in 't velt gaet ofte wederom compt, op de weegen gaen sitten daer 't volck voorbij moet, om te sien ofte eenige waeren, die cletjes hadden, om deselve aff te neemen ende te straffen. 't Welck ick hebbe selve gesien, op de reyse gaende van Sinckan naer Mattauw. Onderweegen ben ick Mattauers ontmoetet, die van haeren velden naer huys gingen. Onder dewel-cken eene was, die een cleetje om 't lijff hadde. Dewelcke van veere de raetspersonen sach sitten, badde mij, dat ick toch sijn cleetje woude soo langh nemen, totdat se den Raedt voorbij waeren, anders soude hij gestraft werden. Ick nam het ende als ick bij de raetspersoonen quame, toonde ick 't selve cleetje ende seyde, dat het yemandt van dit volck, bij mij sijnde, toebehoorde. Sij wouden met gewelt van mij hebben ofte weeten wien het toebehoorde. Ick weygerden hen sulcx, ging voorbij. Dicht aen 't dorp gecomen sijnde, gaff ick 't den eygenaer wederom, dewelcke betoonde hem groote vrientschap van mij ghesciet te wesen.

Daer sijn wederom seecker getijden, dat se wel cleetjes moegen dragen, maer geen sijden. Bij aldien dese raetspersoonen nu ymandt vinden, die sijden cleetjes ofte rocken draecht, dien neemen se se aff ofte straffen se in yet anders. Wanneer op seeckere feestdagen de wijven om te proncken tesaemen comen ende één van haer schijnt ofte teveel cleetjes aen te hebben ofte aen haere cleetjes hooverdije te bedrijven, worden sij oock van dese raetspersoonen gestraft ofte in aller presentie 't geene sij meenen al te hoovaerdich soude weesen, in stucken gesneeden.

Deese raedtspersoonen hebben oock eenen seeckeren tijdt, daer se sich van eenige saecken onthouden moeten. Ontrent dien tijdt, wanneer den rijs halff gewassen is, soo mogen sij haer niet droncken drincken; gheen suycker, pijssang ofte eenich vet eeten. Ick vraechde, waerom sij dat deeden. Gaven mij ter antwoordt, bij aldien sij dat souden doen, soo souden de herten ende wilde varckens in haer rijs velden comen ende deselve verderven. Ende als sij sulckx niet houden ende obseerveren, comen sij in cleynachtinge bij 't volck. Dit is oock aengaende haere reegeringe.

Wetten van dieverey, dootslach, overspel en hebben se niet, noch werden oock publicken niet gestraft. Elck wreeckt sich selven, naerdat hij meent hem ongelijck gesciet soude weesen. Wanneer ymandt yet steelt ende 't selve notoor ende openbaer wordt, soo gaet degeene dien 't ontnomen is met sijn vrientschap in 't huys van dien, die 't hem ontnomen heeft, haelt er soo veel goet vuyt naerdat hun goet dunckt ofte met den anderen veraccordeert. Wilt

het den anderen niet toelaten, soo haelt hij 't met den swaerde ofte met gewelt: vergadert al sijn volck ende vrinden ende doet hem particuliere oorlooch aen. Alsoo oock wanneer imandt eenen anderen in oneerlijcker conversatie bij sijn vrouw gevonden, gaet hij in des selven huys, haelt twee ofte drie varckens vuyt sijn stal ende dit is voor de straffe van overspel. Alsoo oock wanneer ymandt wordt doot geslagen ende 't selve comt vuyt, moet hij vluchten, anders soude hij oock van des dootgeslaegene vrienden doot geslagen worden. Ondertusschen handelen de vrienden met maelcanderen, presenteeren soo veel varckens, herttevellen etc., totdat se de vrienden tevreeden gestelt hebben. Dan comt den dootslager wederom.

Hoewel dat bij dese natie eygentlyck noch minder, noch meerder, noch knecht, noch heer is, maer al eevenveel sijn ende dieshalven oock in haere spraeck den naeme van heer ofte knecht niet en hebben, soo is 't nochtans dat se maelcanderen groote eere ende cortesie aendoen op haere manieren. Welcke eere sij maelcanderen aendoen, niet omdat den eenen in meerder aensien, dignyteyten, statie ofte ryckdom soude weesen als den anderen, maer ten aensien van het ouderdom. Wanneer se maelcanderen op de straeten ontmoeten, sal degeene die jonger is een weynich vuyt den wech gaen ende den geenen die ouder is den rugghe toekeeren, totdat hij voorbij is. Al is 't oock saecke dat se met maelcanderen spreecken, soude hij sich al eevenwel niet omkeeren soo lange totdat hij voorbij is. Wanneer een ouderen aen een jongeren yet belast, sal hij 't hert niet hebben om hetselve te weijgeren, al soude hij hem oock twee, drie, vier mijlen om een bootschap ofte om yet anders stieren. Wanneer in een geselschap oudere sijn, sullen degheene die noch wat veel jonger sijn sich niet durven verstouten om te spreecken. Wanneer se maeltijden houden ofte om te drincken bij maelcanderen vergaederen, sullen se eeten ende drincken eerst aen de outste geeven, sonder eenige insicht van andere qualiteyten te hebben. Dit van haer gouverne ende eerbiedinge, die se maelcanderen toedraegen.

Laet ons nu oock sien, hoe se sich verhouden in haeren houwelycken staedt ende bij haere dooden. Belangende den houwelycken staet, den selven mach niet yederman naer sijn believen aengaen, want de mans seecker tijdt hebben, op dewelcke sij dan eerst mogen trouwen, 't welck is ontrent het twintichste ofte eenentwintichste jaer. Ende hoewel sij gheen reeckeninge van jaeren houden, soo weten sij 't nochtans wel t'onthouden welck ouder off jonger is. Degheene die in een maent, halff ofte heel jaer gebooren sijn, die reeckenen sij tesaemen ende houden deselve van één ouderdom, twelck sij in haer spraeck *Saât cassiuwang* noemen. Deese nu tot haere tijdt gecomen sijnde, mogen trouwen, maer degheene die van het selve *cassiuwang* niet en sijn, maer noch daeronder sijn, die en moghen niet. Dit onderhouden sij met

mercken alsoo successivelicken: van haere jonckheyt tot ontrent het 16 ofte 17 jaer en meugen se het hayr niet langer laeten wassen als dat effen de ooren bedecken mach. Ende laeten sich vraij scheeren, gelyck onse natie, die 't haer lang totaen de ooren laeten wassen. Doch sij en hebben gheen scheer nochte scheermes. Aen plaetse van een schaer gebruycken sij een parang; leggen onder het haijr een hout ende snijden 't alsoo op het hout met de parrang af. Het cleyne haer dat en sneyden se niet met een schermes aff, maar plucken 't vuyt, tot den welcken eynde sij een cooper ofte iser instrument hebben. Sij gebruycken oock tot dien eynde een draet van een bamboes, den welcken sij dobbel nemen. Doen het haer in de midden daervan, drayen om ende trecken alsoo het hayr op dusdaenige manieren vuyt. Op deese manieren trecken sij oock het haijr aen den baert ende op andere plaetsen des lichams vuyt, want sij gheen hayren op deese plaetse mogen lijden. Dit is de wet van de mannen.

Want de wijven laeten se trouwen soo vroech sij meijnen deselve tot het houwelyck bequaem te wesen. Sij laeten oock haer haijr wassen, sonder eens het selve aff te snijden.

Van het 17 jaer ontrent laeten eerst de mannen 't hayr op het hooft wassen soo lang het wil, gelyck de Chineesen, ende als se weder langh haijr hebben, dan beginnen se te vrijen ende te trouwen.

Welck trouwen aldus geschiet: wanneer een jongman sin in een dochter crycht, stiert hij sijn moeder, suster, nichte ofte ymant anders van de vrienden, vrouwen sijnde, in 't huys daer de dochter is die hij begeert, met goet gewoonlijck bij haer aen een vrouw te geeven. Versouckt de dochter tot het houwelijck van de vader, moeder, vrienden, voor den vrijenden jongman; toont de goederen. Is dat de dochter, vader, moeder, vrienden tevreeden sijn, soo blijft het gegeven goet daer ende het houwelyck is claer, sonder andere ceremonien te gebruycken ofte bruyloftsfeest te houden. Ende de toecomende nacht mach hij bijslapen.

Het goet dat gegeven werdt, is verscheijden: den eenen heeft meer als den anderen ende alsoo geven se oock naer advenant. De alderrycksten geeven 7 ofte 8 rockjens; sooveel cleetjes om 't lijff; 300 ofte 400 armringhen, die sij van bamboesen vlechten; 10 ofte 12 vingerringen van metael ofte van witte hertehoorens gemaeckt (ende is elck ringh soo groot als een eij, diens beyde hoecken afgesneeden ende het middel naer advenant den hoecken gelijck gemaeckt is. Bennen soo breet, dat se bijcans een lidt aen den vinger bedecken. Welcke ring sij tot een cieraet een aen elck van haere vingeren dragen aen een root snoertje van hontshaijr gevlochten. Wanneer se deese ringhen aenhebben, staen de vingeren van groote der ringen soo veer van maelcanderen als sij connen, oock tot weedoen toe, 't welck leelick staet,

maer wordt bij haer voor een cieraet gehouden); 4 ofte 5 gordels om 't lijff, van grooven lijwaet; 10 of 12 andere cleetiens, die sij *na(x)aho* noemen, van hontshayr gemaeckt; 20 of 30 cangans ofte Chinesche cleetjes, daer één voor ⅜ reael can gecocht werden; een grooten bos hontshayr dat een man genouch daeraen te dragen heeft, twelck sij in haer spraeck *Agammamiang* noemen ende wordt voor heel costelijck bij haer gehouden; een cieraet op 't hooft, bijcans als een bisschopshoet van stroo ende hontshayr vray gewrocht; 4 ofte 5 paer coussen van hertevellen, noch onbereyt, dewelcke sij maer van een rouw hertevel affsnijden ende dan om 't been vast binden.

Sooveel sullen wel de alderryckste voor eerst geeven ende oock niet meer, 't welck op 't hoochste soude beloopen 40 realen, als 't een Duytschman coopen soude.

Maer andere die niet ryck sijn, geeven 300 ofte 400 armringen van bamboesen; 2 ofte 3 rockjes ende oock soo veel cleetjes om 't lijff. 't Welck in alles maer soude beloopen reaelen, op 't hoochst drie. De middelmatighen geeven wat meer, soo veel haer goetdunckt ende soo veel sij connen t'samen brengen.

Dit nu aldus gegeven ende geapprobeert sijnde, mach hij des anderen nachts bijslapen. Ende sij houden niet de maniere, dat dan het wijff bij den man compt in een bijsonder huys te woonen, maar het wijff blijft in haer huys woonende, eet, drinckt, slaept aldaer ende de man in sijn huijs. Maer des nachts comt de man in 't huys van de vrou. Moet heymelyck incruijpen, als een dieff bijcans, mach niet bij het vuer ofte de keerse comen, moet daede-lycken stilschwygens op de koij leggen sonder te spreecken. Indien hij toubback ofte yet anders begeert, mach hij 't niet eyschen, maer hoest een weijnich, twelck als sijn vrou hoort, coemt sij bij hem, brengt hem 't geene hij van doen heeft ende gaet dan weder bij het ander volck. Als 't volck al wech is, comt sij dan bij hem op de koy liggen. Sij hebben op haere koyen geen bultsack ofte kussens. Aen plaetse van een bultsack leggen se op een hertevel; aen plaetse van kussens leggen se een hout onder 't hooft. Haer coyen maecken sij van bamboesen op; leggen daerop een planck ende op de planck een hertevel. Ofte leggen maer op de vloer neder een hertevel ende liggen daerop. Des anderen dachs wederom vroech voor den dach moet den man weder op staen, heymelyck wech gaen sonder te spreecken (als de kat vuyt 't hoender hock) ende mach des daechs niet wederom in 't huys comen.

De vrouwe heeft met haer volck ende geslachte haer eygen velden die sij bouwen ende daervan leeven ende also altijdt bij maelcanderen in een huys sijn ende eeten. De man wederom op d'ander sijde met sijn volck ende sijn geslachte, heeft wederom sijn eygen velden; blijft, werckt ende eet also in

sijn eygen huys. De vrouw en sorget voor den man niet, noch den man voor de vrouw, maer elck huys sorcht voor sich selven. De man werckt des daechs in sijn velden, de vrouw in de haere ende comen bij daech niet licht bij maelcanderen, tensij dat se maelcanderen op een heijmelijcke plaetse alleen bescheijden. In 't preesentie van 't volck sullen se niet licht met maelcanderen spreecken in 't openbaere. Doch gebeurt het wel, dat de man des dachs oock bij sijn vrouw in 't huys sal comen, maer dan moet niemandt anders t'huys weesen als de vrouw. Ende van te vooren, eer hij derft ingaen, moet hij yemant stieren; laeten vraegen aen de vrouw, dat haer man buyten sij, off hij soude mogen binnen comen. Dan comt de vrouw voor eerst buyten. Wil se hem binnen hebben, soo brengt se hem binnen; soo niet, soo laet se hem weder deurgaen.

Wanneer se kinderen crijgen, blijven de kinderen bij de moeder 't meest in huijs; doch wanneer se twee, drie jaeren of ouder sijn, comen sij oock veel bij de vaders.

Doch vooreerst en crijgen se geene kinderen. Want haere wet, maniere ofte costuyme is soodanich, dat se vóór haer 35, 36, 37 jaeren gheene kinderen mogen laeten voor den dach comen. Dieshalven, wanneer se bevrucht sijn, dooden se de vrucht in 't lijff, 't welck sij aldus claeren: sij roepen een van haere leeraressen die, gecomen sijnde, leggen se op de koy ofte ergens anders op neder; dan douwen ende perssen se soo langh, totdat de vrucht affgaet, 't welck geschiet met grooter smerten alsof se 't kint levendich ter werelt brachten. Ende dit en doen se niet alsoff se gheen natuerlycke liefde tot haeren kinderen souden hebben, maer dewijle soo geleert worden van haere leeraressen. Ende het soude hen voor een groote sonde ende schande bij haere natie toegereeckent worden, bij aldien se haer kinderen op de beurs soude laeten comen. Dieshalven veel lijffsvrucht op dese maniere vernielt wordt, want mij selven verscheydene bekent hebben, dat se 15, 16 soo affgedreven hebben ende dat se tegenwoordich met het 17 swanger gaen, 't welck sij wilden laeten op de weerelt comen.

Wanneer se nu tot ontrent 37, 38 jaeren gecomen sijn, dan laeten se eerst de kinderen, sonder in moeders licham te dooden, des weerelts licht aenschouwen. Ende als se ontrent 50 ofte daer ontrent jaeren oudt sijn, mogen se eerst bij haer wijven woonen.

Dan vertrecken de mannen vuyt haeren huysen ende van haer geslachten ende comen inwoonen bij haere vrouwen, 't welck dan op het laetste bijcans van haer leeven is. Ende dan sijn se niet veel thuys, maer den meestendeel nacht ende dach in 't velt. Maecken een cleyn hutjen, daer se 's nachts in slaepen.

Dit haer trouwen nu is niet soodaenich, dat se souden gehouden wesen altijdt bij haere vrouwen te blijven tot aen 't eynde van haer leven, sonder van deselven te scheijden ofte deselve te verlaeten. Maer bij aldien se gheen sin ofte gheen behaeghen in deselve hebben, moegen sij se verlaeten ende een ander trouwen. Doch wanneer se gantsch gheen andere reeden hebben als dat se gheen sin meer in haer hebben, moeten sijt goet aen haer gegeven bij haer laeten blijven. Maer isset dat se eenighe andere reedenen hebben: als dat de vrouw heeft overspel begaen ende met anderen boeleert, ofte den man geslagen, ofte diergelijcken yet anders bedreeven, mach hij al sijn goet aen haer gegeven wederom haelen. 't Gheene wij nu seggen van den man effen 't selfde is oock geoorloft de vrouw. Dieshalven het altemets wel gebeurt dat sooveel maenden in een jaer comen, sooveel vrouwen sij repudieren ende andere trouwen.

Sij houden oock dese maniere, dat se niet twee ofte meer, maer één vrouwe trouwen. Hoewel datter eenighe sijn die oock twee vrouwen hebben, maer 't selve is heel raer ende wort bij haer selven niet voor wel gedaen gehouden. Doch bennen se groote hoerenjagers. Al hebben se vrouwen, sullen sij 't al eevenwel niet laeten om met andere wijven te bouleeren; doch in 't geheijm, sonder dattet haere eijgene vrouwen ofte de mannen van andere vrouwen sulcx te weeten crijgen. Sij houden oock desen gebruyck dat se in haere vrientschap niet sullen aen maelcanderen trouwen, jae, tot in de vierde linie toe. Sij hebben oock deese manieren, dat se niet sullen lijden ofte verdragen, dat ghij haer soudet vragen van de vrouwen haeres geslachts, in presentie van ander volck, hoe se vaeren, of se moij ofte leelick sijn. Ghij soudet oock vuyt jockernije niet derven seggen, dat ghij haer soudet willen vrijen ofte trouwen; sij worden over sulck seggen hooghelijck beschaemt. Die mannen die getrouwt zijn (hebben wij gehoort), woonen niet in bysondere huysen met haere wijven, noch en slaepen in haere en geene huysen niet, maer gaen bij haere vrouwen in huys slaepen. Het ander mans volck, 't welck niet getrouwt is ofte getrouwt sijnde ende bij haere wijven niet en slaepen, hebben aparte plaetsen int dorp daer se slaepen. Elck 12 off 14 huijsen hebben haere bysondere kercken, in dewelcke sijn koyen gemaeckt, op dewelcke alle de mans, oock tot de 4 jaerige kinderen, moeten slaepen. Niemandt van de mannen, ongetrout sijnde, mach in huysen slaepen. Elck moet sich op de kerck vervougen.

Dese natie hebben schoone ende groote huysen. Soo schoon ende seltsam van geboute ende verciersel, dat ick diergelycken in gantsch Indien niet en hebbe gesien. Al van bamboesen, sonder solder, met vier deuren: Oost, West, Suyd, Noord. Somwijlen oock met 6, 2 in 't Oosten ende 2 in 't Westen,

besuyden ende -noorden elck één. Bouwen deselve op een hooghe plaetse, die se van cley, ontrent een manshoochte, hebben tesaemen gedragen.

Haere vercierselen, binnens- ende buytenshuys, sijn herten- ende varckens-hooffden. 't Gheene sij in huys hebben sijn eenige cleetjes, die se van de Chineesen ruylen voor rijs ende herte vleesch; item hertevellen, die se gebruycken in plaetse van silver ende gout, 't welck sij niet en hebben ende een hertevel wordt voor ⅛ reael gereeckent. Haer huysraet is houweelen om in 't veldt mede te bouwen, hasegeyen, swaerden, schilden ende bogen om mede te jaegen ende tegens haere vyanden te gebruycken. Doch den besten en costelycksten cieraet in haeren huysen, die sij hebben ende achten sijn dootshoofden, haijre ofte beenen, die sij van haeren vyanden gehaelt hebben. Haere vaten, daer se eeten in opschaften, sijn vuyt gehouwene houten, gelijck als een troch daer men verckens in t'eeten geeft. Haere drinckvaten sijn aerde potten ofte bamboesen. Haere vaten, daer se in coocken, sijn aerde potten ende pannen. Haere cost, behalven den rijs, is meestal heel vuyl ende stinckende. Haeren dranck is voor degeene die niet heel vijs zijn, goet gesondt ende wel smaeckende.

Deese natie hebben geene rust- ende vierdaegen, maer alle dagen sijn bij haer eeven gelijck. Doch hebben se seecker algemeijne feestdagen, op dewelcke sij tesaemen comen. Bennen vroolijck, maecken goet chier, trecken op op haere kercken, danssen, springen ende doen wonderlijcke verthooningen.

Haere wijven comen oock te voorschijn, op het costelyckste (in haer manieren) opgepronckt, wonderlycke fatsoen van habijt ende cleederen, dewelcke ick noch soude beschrijven, soo ick die maer in Duytsch conde vuytspreecken ende den tijdt niet in noodelycker dingen te besteeden waere. Haere meeste costelyckheyt die se hebben, worden van hontshayr gemaeckt. Want gelyck wij in onsen landen schapen hebben om de wolle daervan te haelen ende laecken ende alsoo cleederen daervan te maecken, hebben sij aen plaetse honden, dien se jaerlycx het hayr vuytplucken, hetselve tesamen draijen, root verven ende dan haere cleederen daermede te vercieren. 't Welck bij haer sooveel is als goude ofte silvere passementen ofte costelycke coorden bij ons.

Als se nu sterven, begraven se maelcanderen niet, gelijck wij ende den meestendeel des weerelts doen. Noch sij verbranden se oock niet, gelyck de Mallabaren ende Gentiven op de cust van Cormandel, maer naerdat se noch veel ceremonien aen hem gedaen hebben, 't welck is gemeijnelyck den tweeden dach naerdat hij doot is. Soo leggen se den dooden op een stellagie, 't welck sij in haere huysen van cleijne gespoudene bamboesen, ontrent 2 ellen hooch van de vloer, opmaecken. Binden hem daerop vast met handen ende voeten,

maecken een vier niet recht onder, maer neffens den dooden, ende laeten hem alsoo droogen. Dan houden se dootfeest, slachten verckens, oock tot neegen toe, naerdat eens ideren middel vermach, vreeten ende suypen op haeren maniere niet weynich. Veel volck van 't dorp comen bij dese doode kijken. Want soo haest imant doot is, wordt voor desselven huys een trommel geslaegen, dewelcke van een vuijtgehouwen boom gemaeckt. Ende daer se de trommel hooren, vergaderen 't volck op deselve plaetse ende weeten datter imant daer gestorven is.

Elck van de vrouwen brengen een pot met dranck mede ende wel gedroncken hebbende, danssen de vrouwen voor des dooden huys. Maer een wonderlycke maniere van dansen: sij hebben groote vuytgehouwe trochen, van groote boomen, bijcans als een oostersche kist, wat langer noch ende breeder; deese keeren se om ende daerop danssen se. Dat geeft een geluyt, want se van binnen hol sijn. Ende op eenen trogh sijn twee reijen van vrouwen, die maelcanderen den rugh toe keeren; op elcke reye 4 of 5 vrouen die dansen. Int danssen en springen se, noch en huppelen, noch en loopen niet, maer verroeren beyde de armen ende voeten een weynich ende danssen also soetjens om den troch rontom. Ende als deese moede sijn geworden, sijnder andere die se vervangen. Dit danssen duyrt ontrent twee vuijren. Dit is haer dootfeest.

Ondertusschen leyt de doode droogende tot den neegenden dach, 't welck bijcans eenen onlydelycken stanck in 't huys causeert, doch wordt alle daghen eens schoon gewaschen ende gereynicht. Den negenden dach nemen sij hem weder aff van dese stellagie, winden hem in een matje, maecken een ander stellagie in 't huys, wat hooger, behangen 't rontom met cleetjes als een paveljoen ende leggen den dooden daer op. Ende houden weder dootfeest gelyck in 't eerste. Op deese tweede stellagie nu blijft hij leggen tot in 't derde jaer, alsdan nemen se hem weder aff (doch daer en is anders niet meer aen als been) ende begraven hem in huys. Ende houden weder feest, doch en danssen niet.

Dit is cortelycken, hoe se met haere dooden leeven.

Noch een van haere maniercn moet ick alhier verhaelen, die in haere sieckte gebruyckelyck is in 't een van deese 7 dorpen, genaemt *Teopang*. Wanneer se yemant hebben die heel sieck is ende groote pijn heeft, maecken se hem een strick om des hals, haelen hem hooch op alsof se hem souden wippen, laeten dan hem weder nedervallen om alsoo hem van sijn pijn te verlossen ende aen den doot te helpen.

Laet ons nu oock besien haere religie, om der welcker ick ben daer gesonden om de selve te veranderen ende het waere Christelycke gelooff in te brengen. Hoewel dat se op dit gantsche eylant gheen schryften ofte boecken hebben,

nochtans niet een mensch is van haere natie (wij en spreecken van de Chinesen niet, die vuijt China comen daer woonen, die schriften soo wel als wij hebben, die een ander spraeck ende religie hebben), die een letter schrijven ofte leesen can, soo is 't nochtans dat se eene gedaente van religie hebben, van ouders tot ouders mondelycken overgeleevert.

Van het beginsel der weerelt, noch dat deselve een eyndt hebben sal, en weeten sij gantsch niet, maer meynen dat deselve van eeuwicheyt geweest sij ende dat se noch in eeuwicheyt duijren sal.

De onsterffelyckheyt der sielen is bij haer bekent, waerom sij dan desen gebruijck hebben: dat wanneer ijmant sterft, soo maecken sij voor desselven huijs een cleyn stellagie hutjenswijse, besteecken hetselffde rontom met groente, maecken veel ander ciraet daeraan, laeten vier vlaggen -op elck hoeck een- daervan aff wayen. Binnen in het selve hutjen stellen sij eenen grooten calibas met versch waeter, leggen een cleyn bamboesken daerbij, om water vuijt de calibas daermede te scheppen ende meijnen dat de siele des verstorvenen mensche dagelicx come in het selve hutje om sich aldaer te baeden ende te wasschen. Dit wordt bij allen dooden onder haer natie gedaen, maer niet den hondersten van haer selven weet waerom het geschiet. Meynen dat het soo behoort ende dattet de maniere ende costuyme aldus sij. Dencken aen de verstorvenen sielen niet. Doch den heel ouden luyden ist bekent ende die hebben mij daer van onderrichtet.

Sij weeten oock van eene belooninge ende straffe der sielen naer desen leeven, waervan de oude luijden veel weeten daervan te verhaelen. Sij seggen, bij aldien een mensche in deesen leeven sich niet wel comporteere, naer sijn sterven daer sij een groote gracht van vuylicheyt, daer hij in moet quellen. Maer die sich wel dragen, die comen over de gracht, alwaer een heerlyck, playsant leeven is. Over deese vuyle, diepe gracht, segghen se, daer sij een brugghe gemaeckt, heel smal, van bamboesen, daer de sielen der verstorvenen moeten overgaen. Diegeene nu, die sich wel gedraegen hebben, connen daer over gaen ende alsoo in *Campum Elijsium*, in dat belooffde lant, comen. Maer diegeene die sich niet wel gedraegen hebben, wanneer se willen overgaen, draeijt de brugge om (seggen se) en vallen alsoo in dese vuyle gracht, daer se in grooter pijn ende quellinge moeten lijden. Doch dit is oock heel weijnigen onder haer bekent; meyn niet dat onder hondert een gevonden soude connen werden, die daervan wetenschap heeft.

De sonden nu, om dewelcker willen sij dese pijn moeten lijden, en sijn niet sonden in onse Thien Gebooden off in de Wet Gods verbooden, maer sijn andere seecker versierselen, die se selffs versieren, van geender waerden: als dat se tot seeckere tijden moeten geheel naeckt loopen; dat se tot seeckere tijden wel moghen cleetjes draegen, maar niet van sijde; dat se geene

kinderen voor het seven- ofte achtendertichste jaer mogen voor den dach laeten comen; dat se, tot seeckere tijden gheen huysen moghen bouwen ofte hout vergaderen om te bouwen; dat se op seeckere tijden geene oesters mogen haelen; dat se sonder op haere dromen off op haer vogelgesang gelet te hebben niet en mogen vuijt gaen vechten off yets sonderlinghes beginnen ende diergelycke veel andere ongeriemde dingen meer. Al te langh om hier te verhaelen, 't welck wij tot andere tijden sullen doen, wanneer wij *Ex professo* onse *ergon* daervan sullen maken.

Doch eenige uyterlycke sonden, ons verbooden, achten sij oock voor onge-oorloft: als liegen, steelen, dootslaen. Ende hoewel se eygentlyck geen *juramentum* hebben, soo is 't nochtans, dat se aen plaetse van een eedt te doen een strootje met maelcanderen breecken, 't welck haer aen plaetse van een eedt sweeren is ende 't welcke sij iniolabel houden. Dronckenschap wordt bij haer voor gheen sonde geachtet. Want sij veel van droncken drincken houden, soowel de wijven als de mannen ende noemen deselve maer vrolyckheyt te weesen. Hoererye ende overspel wordt oock voor gheen sonden gehouden, sooveer het maer heymelyck mach geschieden. Want het is een seer hoerachtige ende libidieuse natie; doch souden niet licht aen een Duijtschman tot oncuysheyt connen bepraet worden. Jae, sij seggen, als ick haer over 't stuck van hoererij bestraffe, datter haere goden behaegen daerin hadden. Daerom isset, al weeten 't de ouders, dat haere kinderen hoereeren (sooverre het maer niet in 't openbaer geschiet), sij sullen daerover lachen ende hen 't selve niet verbieden. Want de manspersoonen en derven niet trouwen, gelyck boven geseyt, tot ontrent het 21 jaer, maer op hoereeren werdt niet geleth.

Van eene verrijssenijsse des lichams en weten se oock niet. Sij bekennen niet eenen Godt, maer hebben veel ende verscheyden goden, die se aenroepen ende hen offerhande doen. Doch twee van de principaelsten hebben se, die se 't meest aenroepen ende hen offerhande doen: den eenen woont in 't Suyden ende heet *Tamagisangach*; die maect de menschen ende maeckt se schoon ende fraij. Wiens huysvrouw, de goddinne, woont in 't Oosten ende heet *Tekarukpada*. Wanneer het dondert in 't Oosten seggen se dat deese goddinne met haeren man spreeckt ende hem bekijft, waerom hij gheen reegen en geve. Sulck haer stemme dan hoort haer man ende niet langh daernae sendt hij reegen. Deese goddinne met haeren man worden 't meest gedient ende wordt hen 't meest geoffert, principael van de vrouwen.

Daernaest hebben se eenen anderen godt, die woondt in 't Noorden, genaemt *Sariasang*; die deucht niet veel. Wanneer den godt *Tamagisangach* de men-schen schoon maeckt, maekt hij se weder leelijck, vol pockdaelen ende dier-gelycken. Deesen roepen se aen, dat hij haer geen quaet doen sal ende

bidden de anderen godt *Tamagisangach* tegen deese *Sariasang*, dat hij hem bekijven ende bestraffen soude. Want desen is den oversten godt ende heeft het meest te seggen. Sij hebben weder twee andere goden, die sij aenroepen wanneer se vuyt oorloghen gaen: de eene Heer *Tacafulu*, den anderen *Tupaliape*. Deese worden meest van de mannen aengeroepen ende gedient. Sij hebben oock noch veel andere goden, die se aenroepen ende dienen, al te lang om te verhaelen.

Alle andere natie, die ick noch hebbe gesien, hebben haer papen, priesters ende leeraers, dewelcke mansvolck sijn, die 't volck onderrichten ende dan opentlycken dienst aen haere goden doen. Maer dese natie alleen hebben wijven, die se *Inibs* noemen. Den opentlycken dienst nu, die se nu aen dese gooden doen, bestaet in tweeën: één in aenroepinge, 2 in offerhanden, dewelcke doch alle bijden tesaemen behooren. Want wanneer se deese opentlycken dienst doen, brengen sij vooreerst offerhanden: slachten vercken, offeren een deel daervan; brengen gewalmte rijs, pynang, meenichte van dranck offeren se haer gooden op. Dit doen se principaelyck op haer kercken voor harten- ende verckenshooffden. Dit gedaen sijnde, staet één ofte twee van haere leeraerssen op, roepen haere goden aen met een lange sermoen. Onder het aenroepen gebeurt het, dat se de oogen in 't hooft verdraijen, vallen neder op de aerden, schreeuwen jammerlick; alsdan verschijnen haere goden. Deese leeraerssen leggen op de aerde als doode menschen, connen niet weder opgerechtet worden, oock bij vijff, ses persoonen niet. Tot eyndelick comen se weeder bij sich selven, sitteren ende beeven ende bennen in grooter benautheyt. Alsdan sijn hen haere goden verscheenen, die se aengeroepen hebben. Het omstaende volck ten deele schreijt ende weent. Ick hebbe selff aengesien, maer noijt haere goden ofte wat haer verschijnt connen vernemen. Dit ontrent een ure geduyrt hebbende, climmen haere leeraerssen op het dack van de kercke ende staen op beyde hoecken één; hebben weer lange oratien tot haere goden. Eyndelyck neemen sij het cleetjen aff, dat sij om 't lijff hebben, toonen aen haere gooden haere schamelheyt, cloppen met de handen daerop, laeten waeter brengen, wasschen het gantsche lichaem, aldus naeckt staende in 't presentie van al het volck. Doch de meeste omstanders sijn wijven, dewelcke sich ondertusschen soo vol suypen, dat se qualyck staen ofte gaen connen. Het is een werck dat grouwelyck is om aen te sien, doch hebbe haere goden ofte eenige spoockerij daerbij noyt connen verneemen.

Dit is een dienst die in 't openbaer op haere kercken geschiet.

Elck huys heeft oock sijne eygene plaetsen, daer se dese goden elck in 't particulier aenroepen ende hen offeren. Maer alsser eenige swaericheyt voorhanden is, worden haere *Inibs* in huijs geroepen om desen dienst te doen, 't

welck dan geschiet met veel ceremonien ende phantasien. Het ampt van deese *Inibs*, ofte leeraerssen, is oock: gluck ende ongeluck, regenweer ende schoon weer voorseggen, onreyne plaetsen heyligen, de duyvelen vuytbannen (want onder haer veel duyvelen sijn, gelyck sij seggen). Deese *Inibs* bannen se vuyt met grooten getier ende geroep, dragende bloote Japansche houwers in de handt, iagen de duyvels soo langh naer, totdat sij eyndelyck in 't waeter moeten springen ende sich verdrencken. Sij setten oock allenthalve op de straeten ende weegen offerhanden voor dese affgoden, die ick tot meenighe reijse toe hebbe om verde gesmeeten.

Dit is aldus cortelicken de maniere, costuymen ende religie der inwoonderen op dit eylant Formosa, tot dewelcke, als ick ben gecomen, hebbe groote neersticheyt gedaen om haere spraecke te leeren, om alsoo met den eersten haer van het Christelyck gelooff te onderrechten. Hebben al soo verde gebracht, datter op verthien daegen voor den Christdaagh in 't jaer 1628 hondert ende twintich waeren, die haere gebeeden conden ende op de principaelste articulen onses Christelycken gelooffs vraij wisten te antwoorden. Doch om seeckere redenen noch niemant van deselve gedoopt. Sijnde bij haer geweest in alles ontrent 16 maenden. Hoope Godt de Heere sal dit werck seegenen ende een heerlicke gemeynte hem in corten aldaer colligeeren ende vergaederen. Vale!

Datum, Sinckan op 't eylandt genaempt *Formosa*, 27e December Anno 1628."

This island (I say), to which the Lord has seen fit to send me to preach the Gospel of Christ Our Saviour to the inhabitants of these places, is situated north of the equator at latitude 22. It is some 130 miles in circumference, contains many villages and is very populous. The people speak not one but many different languages and they do not have a king, lord, or chief to govern them and to whom they are subject. They do not live in peace and good harmony with one another, but are continually at war, one village against the other.

It abounds in fine fish and rivers teeming with fish and it is full of deer, wild boar, roes, serows or wild goats, hares, rabbits, badgers, wild cats, a wealth of poultry, partridges, and doves. It also has large beasts, similar to cows or horses, which moreover possess very thick horns with tines. Their meat is very pleasant and tasty to eat. The natives call these animals *Chuang*. They live in a great multitude in the mountains, which also house tigers and another large animal, which they call *Tumei* in their language. It has the form of a bear, but is a bit bigger. Its pelt is highly valued.

The land itself is very rich and fertile, but it is scarcely cultivated or sown. The trees mostly grow wild, but there are some fruit-bearing trees as well, from which the natives eat with great relish, but which would not go down well with our nation. Apart from these ginger and cinnamon can also be found. It is said that there may also be silver and gold-mines and that the Chinese have visited them and have taken samples of this to Japan. But I myself have not seen this and it has not yet been brought to the notice of our people.

This is a general idea of the whole island, the customs, manners, religion and language of which have not yet been completely revealed to me.

That is why I only touch upon it with a single word and even pass it over, turning myself to the particular places, of which the language, manners, and customs as well as their religion are known to me, in order to tell you about them. Well, these places are eight in number: *Sincan, Mattau, Soulang, Backeloan, Tafalan, Tifalukan, Teopang, and Tefurang*. These eight places share the same manners, customs, religion and language, showing only small variations. Seven of them are situated in the open countryside along the coast and all seven can be reached from our fort on foot within two days and the return to the fort can easily be achieved on the second day. The eighth village, Tefurang, is situated in the mountains, a roundtrip from our fortress taking three days.

In appearance the inhabitants of these places are savage, rude, and barbaric people: the men are generally tall and sturdily built, like semi-giants. Their colour is halfway between black and brown like most Indians, but not as dark as the skin of the Kafirs. In summertime they walk about stark-naked, without any shame and without covering up those *membra qua natura ipsa vult tecta*[30]. The women, on the other hand are generally small and short of stature but very plump and strong. Their colour is halfway between brown and yellow. They wear clothes and have a natural feeling of shame, except when they wash themselves, which they do outside their houses twice a day, in the morning and in the evening with warm water. At that moment they will not easily be embarrassed by a man passing by.

Generally speaking these people are very friendly, faithful and good-hearted. They will treat our nation in a very friendly fashion to food and drinks as much as they can, as long as these do not come to visit them too often and are not rude in their behaviour.

They do not readily take away or steal anything. What is more, when they have found somebody else's property, they will return it to the place where they think it belongs. (This is not the case with the village of *Soulang*, which is often accused of theft and robbery.) They are very loyal to those with whom they live in amity or with whom they have allied themselves. They are not treacherous, yea indeed would rather die or suffer any hardship than inflict sorrow upon others because of their treachery. They have a sound mind and a good memory, understanding and remembering things easily. But although all Indians are very beggarly, I have not discovered a people more beggarly and more shameless and impertinent in their demands in all the Indies than this one. They are not ashamed to demand and desire whatever they see, but although this is so they can be soothed down and appeased with only a very little bit.

Their main occupation is the cultivation of the fields and the sowing of rice. And although they possess plenty of good, rich, and fertile soil (so much even that these seven villages would be able to feed another hundred thousand people with the produce of their fields were they cultivated), nevertheless they do not cultivate or sow more than they need themselves for their daily subsistence, indeed they even run short of supplies now and then. The women generally cultivate the field and perform the heaviest tasks. And to work the fields they do not have horses, oxen, or ploughs but hoe the field with mattocks, which is very time-consuming. When the sown rice sprouts thickly in one place and thinly in another, they must replant this rice, which involves a great deal of labour. When the rice has ripened, they use neither sickles to cut it, nor scythes to mow it, but they have another kind of instrument resembling a knife, with which they cut off stalk after stalk at a span[31] below its ear.

When this rice has been thus cut, they collect it in their houses without threshing or pounding it until they need it. They then pound every day just as much as they can eat, which is also the duty of the women. At night they hang two or three sheathes to dry over the fire. The next morning, about two hours before daylight, the women rise and start pounding the rice and prepare it for the same day. This way they go on ceaselessly, day after day, year after year, and they prepare no more than they need for one single day. They also grow three other kinds of fruit: the first of these they call *pting*, the second one *quach,* and the third one *tavau,* which is not unlike our native millet. And they have two other kinds, not unlike our beans back

home. They also have three other kinds of tubers which they plant and which they eat instead of bread. They could live on these if they did not have bread, rice or other fruits. They also grow ginger, sugarcane, and watermelons, but no more than they need for themselves. They have banannas, coconuts, lemons of all kinds as well as betel nut in great abundance. They also have a few other fruits of no great importance, which I cannot possibly pronounce in our language. This is what they gather from their fields and gardens for daily life.

They do not posses wine or any of the other strong drinks which are tapped from trees in other regions of India they do not possess, but they do have another drink that has a similar potency, sweet in flavour and as intoxicating as Spanish or Rhenish wine. The women prepare and furnish this drink in the following way: they take rice and smoke it. After having smoked it, they pound it in a ricemortar until it is turned into a dough. After this they take rice flour, chew it in their mouths, and spit it out again into a little bowl, until they have about a pint of liquid. After that they add it to the dough, knead it and mix it into the dough, until it is as fine as a baker's dough for baking bread. This spittle is used instead of yeast. Having done this, they put the dough into a large pot and pour the water over it, then leave it to stand for about two months. By then it has become a pleasant, fine, strong, and intoxicating beverage, now fermenting like new must in a vat. The longer they leave it to stand, the better and stronger the drink becomes. It can age one, five, ten, twenty, or thirty years before it reaches its peak. When they serve this drink it seems to consist of two parts; because the upper part is as limpid and clear as fountain water, but the lower part as thick as porridge they usually eat it with spoons or if they want to drink it they have to add some water to it, for it cannot be drunk because of its thickness. When they go into their fields they take with them a jar or bamboo full of the thick stuff and a bamboo full of water, which may serve them as food and drink for that particular day. But from the upper clear part they take only a little. It serves them as refreshment and cheers them up, but not as a thirst quencher. They consume most of their rice in producing this drink.

When the women are not occupied with their fields or with the rice, they also go out on their sampans[32], in order to catch fish, crabs, and shrimps and to collect oysters. They consider this to be their best and most important food next to rice. They salt the fish including scales and entrails and after

it has been standing for a long time, they eat them with filth and all. When they take the fish out of the jars to eat them, sometimes you can hardly see them because of all the worms and maggots. But they do not care and it seems as if it is delicious and delicate food to them.

In the meantime, the men stay idle, especially the young, strong fellows of 17, 20, 22, 23 and more years old, but the older men of 40, 50, 60 and more years spend most of the time, day and night with their wives in the fields. They have small huts where they can rest and sleep. Sometimes they hardly come down to the village but once every two months, unless there is a celebration going on. The others sometimes assist the women in the fields, but not often. Their principal occupations are hunting and fighting.

They hunt by using three methods: with snares, with assegais, and with bows and arrows. With snares again two methods are possible: they either set some up in the bush and in the thickets, wherever they know that deer and wild boar are coming down in herds. Then they surround them and chase them into the snares like that. These snares are made of rattan or bamboo. Or they put up other snares on the paths or in the open field, fixing them in the following way: they hammer a strong bamboo to which a rope is tied to the front into the ground and when this is fixed deep into the soil they bend it forward tying it down with little twigs, then install the snare over it covering it up with a little soil.

When the deer (which are running around in their fields in two or three hundreds or even thousands) touch this, it snaps up and the deer and swine are brought to a standstill, their feet caught fast. They then close in and spear them with assegais. Many thousands are caught in this way every year.

With assegais they arrange it like this: the entire village (or two or three villages) go out together, each man carrying two or three assegais. They take along dogs to hunt the game. Having arrived in the field, they split up and stand in a circle, sometimes covering a whole or a half mile of the field, then close in on each other. All the animals enclosed by this circle cannot escape or only with the utmost effort. For when one is hit by an assegai it is as good as caught. The assegais with which they spear the deer are like this: the shaft is made out of bamboo approximately the height of a man. A small bell is tied to it by a long rope and this rope is also tied to the iron point in front. The iron point has three or four barbs so that it sticks into the deer and does not fall out again. This iron point is not very firmly

attached to the shaft, so that after the deer has been hit the shaft will fall off and prevent the deer from running away by dragging behind it through the bush, until the deer is either hit once more or is unable to go any further because of loss of blood. The small bell is attached to it so that one can always hear in which direction the deer is running. By this method they are also caught in great numbers.

Their technique with bow and arrows is as follows: a man alone, or two, three, does not matter, go into the field and wherever they see a herd of deer they go after it (for they can run almost as fast as deer), shoot one arrow in front and another one behind it, until they end up hitting the deer. In this way they also shoot quite a number.

But what you will ask do they do with all the meat, if they capture so many deer with these three methods?

They do not eat it but barter it with the Chinese for piece-goods, salt, or any other trifles. They hardly ever keep any for themselves. They do keep the entrails though and eat these with filth and all. And when they have a fair number, they salt them with filth and all inside and consider this to be a tasty meal. They cut off a hunk from the still warm deer, as soon as they have shot them, and eat it raw so that the blood runs down their cheeks. They eat the young fawns they find inside the hinds (both fully grown and in foetal state), whole with skins and hairs. This is one of the principal occupations of the men.

The other occupation is going to war against their enemies, which they do in the following ways. Before they declare war against a village, they officially break the peace and warn each other. After that 10, 20 or 30 men or as many as feel like it consent to go (on foot) or sail by sampan to the place. Having arrived somewhere near the place they wait until the night has fallen so they will not be seen and betrayed (for most of their fighting is done by betrayal). Then they go into the fields of the enemy by night and look to see if they can find anybody in their field huts. Because, as mentioned above, the old people usually spend the night in their fields. When they find someone, be they old or young, woman or man, they kill that person without any niceties, chop off the head, hands and feet, sometimes even take the whole body cut into pieces with them. Because they are many, everybody wants a piece to show off upon returning home.

And depending on the place or the danger, because if they are chased by a number of people they only take the head, or should this hinder them in the

escape, they only cut off the hair and save themselves by fleeing. Or, if they do not find anybody in the field, they go to the village, look for the best chance, enter a house by surprise, beat to death whomever they happen to come upon in the dark in the first house and scurry away hastily with the head, hands and feet, before the village is alarmed. Sometimes they take only the hair of the victim and flee before they are themselves attacked. For when they break into a house they cannot possibly manage to do so stealthily without waking up someone, who will immediately start screaming murder so that in no time at all the entire village will take up arms and converge on the spot. Sometimes they kill someone in this way, but clear out before getting hold of the head or the hair. Sometimes they only inflict wounds and sometimes they simply do not accomplish anything, because of the dark and because people in the house are hiding themselves. Sometimes they themselves are assaulted by surprise and even killed. It also happens that they arrive, raise alarm, and lure the people to somewhere near the place where their sampans are moored, where they then engage each other and fight manfully until they either lose the fight or suffer casualties or wounded. They then flee, for they take the death of one of their people as seriously as we take the defeat or rout of an entire army.

Their weapons for assailing the enemy are assegais, but different from the ones they use to spear the deer, for these ones do not have barbs, do not have a rope, and do not have a little bell.

They are also firmly attached to the shaft so that they cannot fall out, and a shield and a sword. The shields are very long and broad so that they can hide behind them without being seen. The swords they use are very short and very broad. They also use short 'Japanese broadswords' in their wars, plus bows and arrows.

It will sometimes happen that an entire village (or a conspiracy of two or three villages) sets out by day to another place to attack it openly. They do not have particular captains or chiefs in their wars whom they serve or whose orders they obey. But if there is anybody who has earlier collected many heads and is disposed to fight, he can easily get 10 or 20 men to join him to set out or sail out to fight. And this man is taken as a leader, for the whole expedition is named after this man when they get hold of a head. Although this person himself may not have accomplished it with his own hands, he nevertheless gets the credit for getting hold of a head.

They also use ruses and deceit. Ruses, when they sail out on five or six sampans, which means with 50 or 60 men, to fight. They direct the majority of these men to one side of the village by night and keep them hiding there. The rest of them arrives on the other side of the village early in the morning, from the sea so that the villagers see them, and they raise alarm. The villagers then think that there are no other enemies and attack them, leaving the village behind them empty. In the meantime, those hiding on the other side attack and kill whomsoever they come upon. As soon as they have got one or two heads they escape to their sampans and join the others, thinking they have won a great victory.

Sometimes they accomplish this in villages lying inland. They arrive in the village with a few men, make some noise, lure the people out, fight for some time, until they are overpowered, whereupon they flee. In the meantime, the men holed up *in Insidie*[33] come on stage and they assault the villagers both from behind and head on. They also act in this way: when they want to attack a house in one of their enemy villages by night, they place mantraps all over the paths with the purpose of luring the enemy into these during the pursuit. But in the meantime they keep one untrodden, unbeaten track open for themselves.

They make mantraps out of a certain hard reed and not in the fashion of our nation by which you get clamped in them with your feet, but they make them about an ell long and do not place them upright, but install them inclining a little forwards in the direction of the place from which the enemy will come. As soon as the enemy begins to chase them, he will run into it with his shins, because they are totally naked and run almost as fast as a deer. They will injure themselves severely, so that they are forced to give up the pursuit.

Once in a while by deceit they also manage to surprise their enemies, by pretending to be friends, as has happened during my stay here. There is a certain island situated at approximately 13 miles from our *Ilha Formosa*, named *Eugiu*[34] in the local language, which is called by our people *Golden Lion Island*, because some time ago, when the ship *The Golden Lion* wanted to fetch fresh water there, the islanders killed the merchant, the skipper, and a few other crew members. This island lives in a state of war with the inhabitants of this (our) island and does not allow any foreigners on to their island.

The Chinese come to visit the place once in a while in order to trade, but they are not allowed to come ashore. They stay in their junks and the natives come to them, approach their junks and pass up the merchandise they want to barter. With the right hand they give one thing and with the left hand they take another one. And they do not let go of their merchandise before they have grabbed something else. They do not trust each other. A while ago it happened that the inhabitants of our village of Soulang, 60 in number, sailed to them with the Chinese. They were all dressed up in Chinese clothes and pretended to be willing to barter a few goods. As soon as an inhabitant of the abovementioned island came a little too close offering his merchandise for barter, they took him by the arm, dragged him into their junk, cut him to pieces and returned home from there in great triumph. This is what their wars are like.

When they have obtained an enemy head or only its hair or an assegai and return home, there will be a big party, cheers and jubilation in the entire village because of it. They carry the head before them, show it all over the village, and sing songs in honour of their idols, by whose help they consider they have captured it. Wherever they arrive, they are very well received and are most welcome. Some of the best and strongest drink they have is served to them. They then take the head and bring it to the 'church'[35] of those who obtained it (because for every 15 or 16 houses there is a special 'church'), boil it there in a vessel until the flesh is cooked away and falls off, then let it dry. They pour some of their best strong drink over this skull.

They slaughter a pig in honour of their idols and hold large (at least for them) banquets. This victory celebration will last for 14 days on end.

They also act this way when they have obtained only a tuft of hair from the enemy or a few weapons. They hold these heads, hair, arms, legs or parts of the bones in great esteem and high value, just like we value silver, gold, pearls or any precious stone. When a house is on fire they will save this first. A person who has secured such a head is very much respected and honoured and, what is more, no one would have the nerve to speak to him openly for almost fourteen days. This also is the way in which they behave towards their vanquished enemies.

These seven villages do not have a common leader to rule over them, but every village is a unit in itself. And every village in its turn does not have its own specific leader with absolute say or command over them, but they

do have a sort of council consisting of 12 men. This so-called council is res-
huffled every two years. New persons of the same age-group of around 40
years are chosen for it. Although they have neither any idea of the counting
of the years nor does anyone know how old he is, nevertheless they do
remember who was born on what day, in which month or year. When this
council has run its two-years term, each of its members has the hair on the
forehead and both temples or on both sides of the head plucked out, which
is a sign that he has been a member of the council and that he has been
dismissed. New councillors are then chosen again from one and the same
age. The dignity or authority of these men is not such that whatever is
approved of or decided upon by them must be accepted and approved by
others.

It is their task to hold a meeting when something serious comes up, to
discuss what to do. After this meeting they organize a general meeting of
the entire village in one of the biggest 'churches'. They raise the matter for
discussion, talk about the pros and cons for half an hour continuously,
depending on the matter. If someone tires or has finished, someone else
replaces him and by this they try to persuade the people using many argu-
ments until the matter is approved. They keep good order in this, because
when someone is speaking, the others will all be silent and listen, even
though they are there in their thousands. Their eloquence and talent for
orating are such that I was extremely surprised by them and I think Demos-
thenes himself could not have been more eloquent and more fluent with
words. When all the speeches are finished, the people discuss the problem
in order to make a decision. If they are willing to go along with the sugges-
tion, fine. If they are not willing, it is also fine, no one is forced. Every-
body should reflect for himself what gains and losses might result from the
matters in question.

Their task also requires taking care of the execution of all the demands
made by the priestesses[36]. Likewise to impede whatever they think might
anger their idols. Whenever they misbehave in something regarding their
idols or in something that regards no one in particular but the public inte-
rest, these 12 councillors have their say in this matter and punish the
miscreant not by imprisonment, chains or any other corporal punishment, or
even less so by the death penalty, but by fining him a piece-good, a deers-
kin, some rice, or a jar full of their strong drink, all this depending on the
case.

During a certain time of the year, a period of about three months, they have to walk about totally naked. The reason for this is that were they not to walk about totally naked (as they say) their gods would not give them rain and as a consequence the rice in the fields would be ruined. So when these councillors discover somebody dressed in a piece of cloth, they have the power to take the garment away or to fine him to two deerskins or rice, liquid or something else. This is the reason why the members of the council sit down on the roads in the morning and in the evening when the people are going to the fields or returning from them, just there where they pass by, in order to check if there are any people wearing clothes and, should this happen to be the case, to take these off and to impose a fine.

I have seen this for myself when I was travelling from Sincan to Mattau. En route, I met a few people from Mattau, who were returning home from their fields and one of them was wearing a piece of cloth. When from a distance he spied the councillors sitting there, he begged me to take care of his garment until they had passed the council to prevent him from being fined. I took it and when I came to the councillors I showed them the piece and told them it belonged to one of the people going with me. They wanted to take it away from me by force or to be informed to whom it belonged. I refused to tell them and passed by. Approaching the village I returned it to the owner, who let me know I had done him a great favour.

There are times as well when they are indeed allowed to wear clothes as long as these are not made out of silk. When these councillors happen to come upon someone wearing a silk loin cloth or skirt, they take it away or fine him something else. When the women assemble on certain feast days to show off their appearance and one of them seems either to wear too many clothes or to take too much pride in wearing them, she will also be punished by these councillors or whatever the councillors judge to be too frivolous will be cut to pieces in the presence of all the villagers. There also is a certain period of time when these councillors have to abstain from a few things. It is around the time that the rice is half-grown that they are not allowed to get drunk or to eat sugar, bananas, or any fatty food. I asked why they did this and they replied that were they to do so, the deer and wild boar would come into their ricefields and ruin these. And if they did not comply with and observe their duty, they would no longer be respected by the people.

This too is concerning their government.

They neither have laws for robbery, manslaughter, or adultery, nor are these punished in public. Each person takes his own revenge to the degree he thinks he has been offended. When someone has stolen something and this becomes notorious and well known, the one who has been robbed goes into the house of the thief with his friends and takes away as many things as they think right or is approved of by the other one. If the other does not permit it, he takes away the things using swords or by force, assembling all his fellow-villagers and friends and starts a private war against him. The same thing happens when someone sees another man involved in criminal conversation with his wife. He enters the house of this man, takes away two or three pigs out of his pigsty as punishment for the adultery. The same thing happens when someone is killed and it is discovered. The murderer has to escape or else he too would be killed by the friends of the dead man. In the meantime, the friends negotiate with each other, offer as many pigs, deerskins etc. until they have satisfied the victim's friends. Then the killer will come back.

Although no one among these people is lower or higher, servant or master, all being of the same level and therefore not having words for master or servant in their language, they nevertheless show great respect and courtesy to each other in their own way. The respect they show to each other is not because one person should be of a higher prestige, dignity, standing or wealth than the other, but is because of difference in age. When they meet in the streets, the younger person will go out of the way a little and will turn his back on the older person until he has passed. Even should they speak to each other, he would not turn around until the latter had passed.

When an older person entrusts a younger person with something, the latter will not dare to refuse, even if he were sent on an errand or the like two, three or four miles away. When older people are present in a group, those who are much younger will not dare to speak. Whenever they take meals together or come together for a drink, they will give the food and drink first to the oldest one, without paying any attention to other qualities.

Thus their government and the respect they pay to each other.

Let us now also observe their customs regarding marriage and death. As far as marriage is concerned, nobody is allowed to get married as he pleases, because the men may not marry until a definite time, which is around the age of twenty or twenty-one. And although they do not count the years, they nevertheless remember quite well who is older or younger. They consider

those born in the same month and the same half or whole year to be of the same group and the same age, which they call *Saât cassiuwang* in their language. When this group has reached the age, they are allowed to get married, but those who are not of the same *cassiuwang* but below, are not allowed.

They distinguish the stages by marks: from their early youth until their sixteenth or seventeenth year they are not allowed to grow their hair any longer than to just above the ears. And they have their hair cut nicely like our nation, who has its hair grown down to the ears. But they do not have scissors or razorblades. Instead of scissors they use a parang. They put a piece of wood under the hair and cut it on the wood with the parang just like that. They do not cut off the small hairs with a razor but they pluck them out, for which purpose they have a copper or iron instrument. For this purpose they also use a splinter of a piece of bamboo, which they fold double. They put the hair through the middle, twist it and this way pull out the hair. This is also how they pull out the hair of the beard and of other parts of the body, because they cannot stand having hair growing in these places. This is the law of the men.

Because they allow the women to marry as soon as they are thought fit for marriage, they also let their hair grow without ever having a hair cut. Not until the age of seventeen do the men let the hair on their heads grow as long as possible, just like the Chinese, and when their hair is long again they begin with courtship and marriage.

This marriage goes like this: when a young man fancies a young maiden he sends his mother, sister, cousin, or somebody else of his female friends to the house of the maiden he fancies with presents, usually given to a woman. She asks for the permission of the father, the mother, and friends for the young suitor to marry the daughter and shows them the dowry. If the daughter, father, mother, and friends approve, the presents remain there and the marriage is settled, without performing any other ceremonies or celebration of a wedding day. And the next night he may sleep with her.

The presents that are given are various. Some people possess more than others and thus give accordingly. The richest people give: 7 or 8 skirts and the same number of items of garments, 300 or 400 bangles, which they plait from bamboo, 10 or 12 rings made of metal or white deer-horns (and every ring is as big as an egg with both points cut off and the middle part evened off just like the points. They are so broad that they almost cover a finger-

joint. This ring, which is threaded on to a red string made of dog's hair, they wear as an ornament on every one of their fingers. When they wear these rings, the fingers are kept as far apart as possible because of the size of the rings, even though it hurts. It looks ugly but they see it as an adornment), 4 or 5 waistbands made of coarse linen, 10 or 12 other piece-goods made of dog's hair, which they call *na(x)aho*, 20 or 30 cangans or Chinese piece-goods, one costing ⅜ real a piece, a big tuft of dog's hair enough for one man to carry, which they call *Agammamiang* in their language and which they consider to be very valuable, an ornament for the head, almost like a bishop's mitre, nicely made out of straw and dog's hair, 4 or 5 pairs of leggings made of deerskins, still uncured, which they simply cut from an unprepared deerskin and then tie around the legs. All this the richest people will give but not more, which would cost 40 reaels at most were a Dutchman to buy it. But others who are not rich give: 300 or 400 bracelets made out of bamboo, 2 or 3 skirts and the same number of garments, which would amount to only 2 reals altogether, or three at most. The average people give a bit more, as much as they think is right and as they are able to raise.

So when this has been given and has been approved, he may spend the night with her. But it is not their habit that the wife then comes to live with the husband in a house of their own, but the wife stays living in her house (eating, drinking and sleeping there) and the husband stays in his. But at night the husband comes into the house of the wife. He must enter secretly, almost like a thief and is not allowed to approach the fire or the candles. He must lie down on the bed immediately without saying a word. If he wants to have some tobacco or something else, he is not allowed to ask for it, but he coughs a little. When his wife hears this, she comes to him and brings him what he needs and returns to the other people again. After the people have left she comes to lie down with him on the bed.

They do not have straw mattresses or pillows on their beds. Instead of on a mattress they lie down on a deerskin. Instead of pillows they put a piece of wood under their heads. They construct their beds from bamboo, put a wooden board on top and lay a deerskin over the board, or they simply put a deerskin on the floor and lie down on that.

Early the next morning, before dawn, the husband must rise and slink away without speaking a word (like the cat from the henhouse) and he is not allowed to come back to the house during the day.

The wife has her own fields to cultivate and provide a living, sharing with her kin and other women, so that they are always together in a house and eat together. The husband, on the other hand, has his own fields with his kin and fellow men and this way stays, works and eats in his own house. The wife does not take care of her husband, nor does the husband take care of his wife, but each house(hold) looks after itself. The husband works in his fields during the day and so does the wife in hers. And they do not easily get together during the day, unless they meet each other alone in a secret place. They will not often talk to each other in public in the presence of other people. Yet it can happen that the husband will come to his wife in the house by daylight, but in that case nobody else but the wife should be at home. And before he dares to enter he must send someone to tell his wife that he is standing outside and to ask her whether he is allowed to come in. The wife then first comes outside and if she wants him inside she will lead him inside. If not, she lets him pass on again.

When they have children, the children usually stay with the mother in her house, but once they are two, three or more years old, they often go to the fathers as well. But for the time being they will not have children. Because their law, manners, or customs are such that they are not allowed to produce any children before they are 35, 36, or 37 years of age. Therefore when they are pregnant they kill the foetus in their body. This is done as follows: they call one of their priestesses, who when she arrives makes them lie down on the bed or some place else. They then push and press until the foetus is released, which causes more pain than giving birth to a living baby.

They do not do this out of lack of natural feelings of love for their children, but because this is what is taught by their priestesses. And were they to bring their children into the world, they would have to bear the imputation of this being a great sin and a disgrace. That is why many foetuses are destroyed in this way. For several women confessed to me that they had aborted 15 or 16 foetuses and that they were now pregnant with the 17th, which they were going to deliver.

Only when they have reached the age of about 37 or 38 years do they let the children see the light of day without killing them in mother's womb. And not until they (the men) are about 50 years of age are they allowed to live with their wives.

(In the manuscript in the margin is written:) About inheritance.

At that point the men leave their homes and their fellow men to live with their wives, which happens almost at the end of their lives. And they are not often at home, but in the field most of the time day and night. They build a little hut where they sleep at night.

This marriage of theirs is not such that they should be compelled to stay with their wives forever till the end of their lives, without separating from them or leaving them. But if they do not want or like them, they may leave them and marry someone else. But if they have no other reason at all than that they do no longer like her, they must leave behind the bride price which they have given to her. But if they have any other reason: such as if the wife has committed adultery and flirts with other men or has beaten the husband or committed a similar wrongdoing, then he may get back all the things he gave to her.

What we now say about the husband's rights counts for the wife too. That is why they sometimes reject and remarry as many women as there are months in a year.

It is also customary with them to marry not two or more, but only one woman. Although there are some men who have two wives, but this is very rare and is not considered proper conduct by them. Still they are great whoremongers. Although having their own wives, they will not pass up a chance to commit adultery, but in secret, so that their own wives (or the husbands of the other women) will not find out. They also have this custom, namely that they will not marry within their lineage, not even in the fourth generation. They also behave in the following way, they would not tolerate or suffer that in the presence of others you would make enquiries about the women of their family, how they are, if they are good-looking or ugly.

Nor should you dare to say mockingly that you would like to court or marry her. They would be extremely embarrassed by remarks like that. Men who are married (as we have heard) do not live together with their wives in separate houses nor do they sleep in their own houses, but they go to sleep in the houses of their wives. The other men, unmarried or married but not sleeping with their wives, have separate places in the village where they sleep. Every 12 or 14 houses have their special 'churches', where beds to sleep on have been built for all the men and the children up to four years old. None of the unmarried men is allowed to sleep in houses. They all have to call at the 'church'.

This nation has fine and big houses, so beautiful and original in structure and decoration as I have never seen in the Indies. They all are made from bamboo, without an attic, but with four doors: east, west, south, north and sometimes with six: two east and two west and one each facing south and north. They build them on an elevated place which they have piled up with clay to approximately the height of a man.

Their decorations inside and outside the house are heads of deer and boars. What they keep in the house are some piece-goods bartered with the Chinese for rice and venison; also deerskins, which they use instead of silver and gold - which they do not have - and a deerskin is worth ⅛ real. Their utensils are matlocks for cultivating the field, and assegais, swords, shields, and bows for hunting and for use against their enemies. But the best and most precious treasures they keep and value in their houses are the skulls, hair, or bones obtained from their enemies.

The vessels they use for serving food are hollowed out pieces of wood, like a trough for feeding pigs. Their drinking-vessels are earthenware pots or pieces of bamboo and their cooking-vessels are earthenware pots and pans. Their food, apart from the rice, is often very dirty and smelly. Their drink, at least for someone not very choosy, is healthy and tasty.

This nation does not observe days for rest and celebrations, but every day is the same for them. But they do have certain days of public festivals, when they come together, make merry and are of good cheer. They go to their 'churches', dance, jump up and down and engage in all kinds of wonderous presentations. The women also appear, dressed up in their way in their best apparel, in an amazing style of dress and clothes, which I would describe too if only I could find the Dutch expression for it and if I did not have to spend my time on more useful matters. The most precious objects they have are made of dog's hair. Just as we in our country have sheep which we shear for wool to make fabrics and clothes, they have dogs instead, whose hair they pluck out every year, spin and dye red, in order to decorate their clothes with it. To them this is the same as gold or silver trimmings or costly cords are to us.

When they die they do not bury each other in the same way as we and the majority of the world do. Nor do they cremate their people like the inhabitants of the coast of Malabar and the Jentives of the Coromandel Coast do. But after performing many ceremonial observances (generally on the second day after the person has died), they lay the dead on a bier which they

construct out of small, split bamboos in their houses, about 2 ells in height from the floor. On this they fasten the corpse by tying hands and feet, and light a fire not directly under the corpse, but beneath it and thus let it desiccate.

Thereupon they hold a celebration for the dead, slaughter pigs (sometimes as many as nine depending on the person's means) and gorge and guzzle in their own way no mean quantities of food and drinks. Many villagers come to see the deceased, because when somebody has passed away, a drum made from a hollow tree is beaten in front of his house. And on the very place where they hear this drum the people come together knowing that someone has died there. Each woman takes along a jar full of liquor, and having drunk a fair amount they start dancing in front of the house of the deceased. But they dance in an extraordinary way: they use large hollow troughs, made out of big trees, almost like an oriental chest but even a bit longer and wider. They turn these upside down and dance on them, which makes a noise because they are hollow inside. On each trough there are two rows of women dancing with their backs turned towards each other, each row consisting of four or five women. They do not jump, hop, or walk while dancing, but move both arms and feet slightly and this way dance slowly all around the trough. When these dancers are tired there are others who replace them. This dancing takes about two hours. This is their ceremony for the dead.

In the meantime, the corpse lies there drying until the ninth day, which causes an almost unbearable stench in the house, although it is washed and cleaned once a day. On the ninth day they take it off this bier again and wrap it in a mat. They build another bier in the house, somewhat higher than the first one and cover it on all sides with pieces of fabric like a pavilion and put the corpse on top of it. They hold another celebration for the dead like the first one. The corpse will stay on this second bier into the third year, when they take it down again (although not more than a skeleton remains) and bury it in the house. And again they celebrate but this time they do not dance. This in short is how they deal with their deceased.

Here I must mention yet another of their customs, one which concerns illness and is customary in one of these seven villages, called *Teopang*. When they have someone amongst them who is very ill and suffers great pain, they put a cord around his neck and pull him up high as though they

were going to hang him, then drop him to deliver him from his pain and send him to the other world.

Now let us have a look at their religion, on account of which I was sent there with the purpose of changing it and introducing the true Christian Faith. Although on this entire island they have no written records or books, and although there is not a single person in their nation who is able to read or write a single letter (we do not include the Chinese who, having come from China to live here, have a writing like we have but have a different language and religion). Yet they do have some form of religion, handed down orally from one generation to another. They know nothing of the creation of the world nor that it will come to an end, but they think it has existed for eternity and will last forever.

They have knowledge of the immortality of the souls, which is the reason why they have this following custom: when someone has died, they build a small platform in front of his house in the form of a miniature hovel, attach foliage all around it, decorate it with many other ornaments and place four waving flags on it, one at each corner. Inside this little house they place a large gourd full of fresh water and put a small piece of bamboo next to it to scoop out water from the gourd, because they think that the soul of the deceased will come every day into this miniature house to bathe and wash. They do this for all the deceased of their nation, but not even one per cent of them knows why it is done. They just think that this is proper and that manners and customs should be thus, but do not think of the souls of the dead. But the very old people are acquainted with the meaning and they have instructed me in it.

They also know of the reward and punishment of souls in the Hereafter, about which the elderly people have much to tell. They say that, if someone does not behave well in this life, a wide and filthy trench will await him after death, in which he must suffer torments. But those people who behave well will be able to cross the ditch where a delightful and pleasant life awaits them. They say that spanning this filthy and deep ditch there is a very narrow bridge made of bamboo, which has to be crossed by the souls of the dead. Those who have behaved well will be able to cross it and reach the Elysian Fields, the promised land. But when those who have not behaved well try to go over it, the bridge will topple over (they say) so that they fall into the dirty trench, where they will have to suffer great pain and torment.

But this too is known to only a very few among them. I do not think that among a hundred people one could find even one who has knowledge of this story.

The sins for which they have to suffer this pain are not the sins in our Ten Commandments or sins forbidden by the Law of God, but are other sorts of fanciful inventions which they themselves make up and which are of no importance. For instance, that they have to walk about totally naked at a certain time, that they are allowed to wear clothes at a certain time as long as they are not made of silk, that they are not allowed to bear children before their thirty-seventh or thirty-eighth year, that they are not allowed to build houses or to collect timber at certain times, that they are not allowed to collect oysters in a certain season, that they are not allowed to go out to fight or to start something special without paying attention to their dreams or to the singing of the birds and many more of these absurd things. It is too long a story to account here and we will do that some other time when it will be our work *Ex professo*[37].

But some manifest sins, forbidden to us, they also consider unlawful: such as lying, stealing, and killing. And although they do not really have a *juramentum*[38], it is nevertheless the case that instead of swearing an oath they break a piece of straw. This is their form of swearing an oath and is considered inviolable. Drunkenness is not considered a sin by them, because they like to get drunk, both women and men, and they call it merriment. Neither fornication nor adultery are considered sins, so long as they are committed in secret. It is a very lascivious and libidinous nation indeed, but they would not easily be talked into committing an unchaste act with a Dutchman. Yea, when I scolded them about their fornication, they said that their gods were pleased with it. That is the reason why the parents, although they are aware of the fact that their children are promiscuous (as long as it does not occur in public), laugh about it and do not forbid it. As mentioned above, the men do not dare to get married before their 21st year, but there is no control over fornication.

About a resurrection of the body they do not know either. They do not recognize one God, but they have many different gods whom they invoke and worship with offerings, but they have two principal gods whom they invoke most and to whom they make offerings. One of them lives in the south and is called *Tamagisangach*. He is the creator of mankind and makes the people good-looking and beautiful. His wife, the goddess, lives in the

east and her name is *Tekarukpada*. When there is thunder in the east, they say that this goddess is talking to her husband and is scolding him for not sending rain. Her husband then hears her angry voice and sends rain shortly after. This goddess and her husband are worshipped the most and to them most offerings are made, mainly by the women. Apart from them they have another god, by the name of *Sariasang*, who lives in the north. He is a good for nothing! When the god *Tamagisangach* makes people beautiful he makes them ugly again, with pockmarks and such disfigurements. They invoke this god not to harm them and they pray to the other god *Tamagisangach* for protection against this *Sariasang*, so that he may scold and punish him, because the former is the supreme god and he is in charge. They have two more gods whom they invoke when they go to war: one is the Lord *Tacafu-lu*, the other one is *Tupaliape*. These two are invoked and honoured mostly by men. They also have many more gods they invoke and honour, too many to speak of.

All other nations I have seen so far have male clerics, priests and teachers, to teach the people and to perform public services to their gods. But only this nation has women, whom they call *Inibs*.

The public worship for these gods consists of two parts: the first is the invocation and the second is the offering, but both belong together. Because when they hold a public service they first bring offerings: they slaughter pigs and sacrifice some of them. They bring in smoked rice, betel nut and a great quantity of liquor and they offer it to the gods. This is done mainly in their 'churches' in front of the heads of deer and boars.

After this, one or two of their priestesses will stand up and invoke their gods in a long sermon. During the invocation they roll their eyes and they fall down to the ground, wailing pathetically. Thereupon their gods appear. These priestesses lie on the ground as though dead and they cannot be stood upright, not even by five or six people. Then finally they come to their senses, shivering and trembling and very much out of breath. Then the gods they invoked have appeared to them. Some of the people standing around are crying and sobbing. I have witnessed it myself, but have never seen their gods or whatever appears to them.

After one hour the priestesses climb on to the roof of the 'church' and stand one at each corner. Again they hold a long oration to their gods. At the end they take off the loincloth they are wearing, revealing their private parts to their gods and tapping on them, and order water and wash their entire

bodies, standing there naked in the presence of all the people. But the majority of those standing by are women, who in the meantime have been drinking so extensively that they can hardly stand or walk. It is a horrible scene to watch and I have never been able to discover their gods or any magic. This is a service that is held in public in their 'churches'.

Each house also has its private places for invoking and worshipping these gods in particular. But when something serious is at hand, the *Inibs* are called to the house to perform this service which then takes place with much ceremonial pomp and imagination. The office of these *Inibs* or priestesses also includes the forecasting of fortune and misfortune, of rain or good weather, the blessing of unholy places and the exorcizing of devils (for there are a lot of devils around they say). These *Inibs* exorcize them with great fury and shouting, brandishing uncovered Japanese broadswords in their hands. They chase the devils for such a long time that these must finally jump into the water and are drowned. For these gods they also place offerings in the streets and on the roads, which I have knocked over more than once.

This in short are the way of life, the customs, and the religion of the inhabitants of the isle of Formosa. When I came here, I was very diligent in learning their language in order to teach them the Christian Faith at once. I have already come so far that a fortnight before Christmas Day of the year 1628 there were one hundred and twenty natives who could say their prayers and who were able to answer properly the most important articles of our Christian Faith. But none of these has been baptized as yet for certain reasons.

I have been with them for about 16 months altogether. I hope that our Lord will bless this work and that an honest following will come together and meet.

Farewell, Sincan on the island called *Formosa*, 27 December of the year 1628.

49a. Continuation of the Discourse by Reverend Georgius Candidius, with the answer to the question of Governor Pieter Nuyts if the Christian faith could ever be implanted in the inhabitants of the island. Without a date, probably written somewhat later than the *Discourse*.[39] Rijksarchief Utrecht, Family Archive Huydecoper R. 67, no. 621.

"Naer corte verhaelinge der costuymen, manieren ende religie der inwoonderen des eylants genaemt Formosa gevraacht sijnde van den Ed. Hr. Gouverneur deser plaetsen Pieter Nuyts, wat mijn dacht ofte de Christelijcke religie bij haer soude connen ingeplandt ende aengenomen werden? Ende op wat manier sulcx best ende bequaemst soude connen geschieden? 't welck niet hebbe connen noch sullen weygeren; ende is dit mijn gevoelen:

(…) Dese natie heeft noch universael noch particulaer hooft, naer wien se moeten luysteren ende dieshalven elck particulier persoon in dit cas doen mach 't geen hem gelieft.

(…) Dese natie heeft noch schrijften noch boecken van hare religie, gheen beroemde ofte cloecke voorstanders om voort te planten. Hebben maer eenige wijven tot priesterssen die alsoo weynich weten als den geheelen rest. Waerom haere religie heedendaechs maer eene opinie ofte gewente is, om sus ofte soo te doen. Ick achte dat haere religie binnen den tijdt van 60 jaeren soo vervallen is, dat sij nu gants nieu ende verandert is ende houdet daer voor dat sij noch in 60 jaeren wederom, al waeren wij Christen oock nie bij haer, gants veranderen ende dese nu staende onglijck sijn sal. Ende dit daerom, om dat se gheen schriften hebben ende omdatter niemant schrijven ende haer gevoelen opteeckenen ende naer derselve opteeckeninge voortplanten can. Want heele oude luyden mij veel anders onderricht, als nu heeden gelooft ende van haer geëert wordt.

(…) Ick wil hebben ende soeck eene natie, dier wille men soude connen buyghen ende trecken tot onse religie om haer waerdicheyt selfss wille, niet om eenige andere vuyterlicke bijvallende dingen ofte profijte willen. Dit sijn de inwoonders opt eylant *Formosa*, met desen en staen wij met gheen soodaenich verbondt. Haere wille soude om de weerdicheijt selve van onse religie tot ons connen gebooghen werden, gelyck alreede de proeve daervan gedaen is, datter binnen de tijdt van 16 maenden alreede 120 sijn gevonden ende onderweesen worden, soo jongh als out, dier wille bereijt was om tot onsen gevoelen te buyghen.

(…) Tot noch toe gediscureert ende met reeden beweesen sijnde, waerom ick achte dat op *Ilia Formosa* de principaelste Indiaensche gemeynte soude connen vergadert ende gecolligeert werden, come tot het ander, waerom ick achte, dat dese gemeynte, die op *Ilia Formosa*, met der tijdt soude connen

weesen herlijcker ofte alsoo herlijck als eene gemeynte in't vaderlant soude worden.

In't Vaederlandt soo meenich huys soo menich gevoelen bijcans inde religie, jae altemets soo meenich volck in een huys sijn, soo meenich verschil is in haer geloove. Dese natie van een ofte eenighe getrouwe ende orthodoxe leeraeren onderricht sijnde, souden een ende t'selve gevoelen hebben.

In't Vaderlandt, al wilde men haer dwaelingen uytroyen, sij hebben schrijften in dewelcke deselve ingeprint sijn, uyt dewelcke sij ende haere naecomelingen in valscheyt connen onderrechtet werden en can alsoo niet gesuyvert werden. Deese natie heeft geen schriften, daer se haere (…) ende affgoderyen haere posteriteyt soude connen overleeveren ende in dewelcke haere naecomelinghen souden connen onderrichtet werden. Aen plaetse soude men haer connen leeren leesen ende schrijven, ende alsoo onse religie in t'cort verwaeten ende hen leeren, uyt den welcken sij eenstemmelijcken van een ende t'selffde souden connen onderrichtet werden ende alsoo uyt eene mondt Godt aenroepen, met een hert, sinne ende ceremonien Hem dienen ende eeren. (…)

Dit is aldus cortelijcken mijn gevoelen ende opinie over de mogelijckheyt der invoeringe der religie op het eylant genaemt *Formosa*.

Dewijle gheen republick sonder reegeerder ende wetten can bestaen ende dese plaetsen noch hooft noch wetten hebben, soo moeste den magistraet hier reegeerende dese 7 dorpen hulpe ende beschherminge aenpresenteeren, bij sooverre sij sich sijner ordinanten, wetten ende manieren wilde onderwerpen ende aen deselve gehoorsamheyt bethoonen. Want sonder wetten ende obidientie sal 't veel tijdt vereyschen, eer alles met simpele persuasie sal connen uytgeroyt werden.

Maer off sij niet en wilden, sult ghij vraegen? Soo sij niet en wilden moste men haer dreijgen. Maer off sij naer gheen weygeren vraegen? Moesten de dreijgementen int werck gestelt werden. Maer bij aldien sij vluchten naer 't geberchte toe? Neen, dat sullen noch en connen sij niet doen. Bij allegaer aldien men een van dese 7 dorpen alleen soude willen dwingen, souden se mogelijck vluchten, een deel naer 't geberchte, den anderen deel soude in de andere ses dorpen gaen schuylen, maer bij aldien sij alle seven over eenen cam geschooren weerden, souden se niet vluchten. Maer off se sich teweer stellen ende ons oorloge aendeeden? Om dit te verhinderen moeste men in elck dorp 2 ofte 3 van de principaelste hebben, daer men vrientschap mede hielde, die 't volck licht naer haeren wille souden locken. Doch ick en meijne niet dat se sich teweer stellen, want sij vreesen al te seer voor de *Hollanders*."

Having been asked by the Honourable Governor of this place, Pieter Nuyts, for a short account of the customs, habits, and religion of the inhabitants of the island called Formosa, if I believed the Christian faith could be implanted in them and could be accepted? And in what way this could be done at best? This I could not and will not refuse. And this is how I feel about it.

This nation has no general or particular leader whom they must obey and therefore each private person may act as he likes in this respect.

This nation has no scriptures nor books of their religion, has no famous or brave leading men to propagate it. They have only a few women as priestesses who know just as little as all the others. Which is the reason why their religion nowadays is only an opinion or habit about doing this or that. I suspect that every sixty years their religion falls into decay, that now it is completely renewed and has been altered and I presume that in another sixty years, even without us Christians being around, it will again have changed completely and will have become different from the current one. That is because they have no records and because nobody can write and mark down his beliefs and spread them after written records. Because very old people told me things totally different from what is believed and honoured by them nowadays.

I want to find and get hold of a nation where the mind of the people can be bent and drawn towards our religion because of its intrinsic quality, not because of some other external unimportant things or because of profit. Well, this is the case with the inhabitants of the island of Formosa, to whom we are not bound by such ties. Their minds could be bent towards us for the very value of our religion, as has already been demonstrated by the fact that within a period of 16 months already 120 people, young and old, who are willing to turn to our views, have been found and are being preached to.

Up to this point having given arguments and reasonable proof of why I assumed that at *Ilha Formosa* the main Indian congregation could be gathered and assembled, I come to the other point, that is why I assume that this congregation at *Ilha Formosa* could in due time become more glorious or as glorious as a congregation in our country.

Back home in our country as many houses as there are there, there are almost as many feelings about religion, yea, as many people as there are in a house, as many differing opinions on their beliefs they hold. But if this

nation were taught by one or several faithful and orthodox teachers, they would have only one and the same feeling.

Back home in our country, if you want to stamp out heresies, the people have published writings in which those ideas are printed, from which the falsehoods can be taught to them and their offspring and therefore there is no purification. This nation has no writings, by which they could transmit their (...)[40] and idolatry to posterity and by which their offspring could be taught.

Instead we could teach them to read and write and thus pass on our religion in a limited sense and preach to them, so that they would be taught unanimously one and the same doctrine and thus invoke God in unison, serve and honour Him with one heart, mind, and ceremony.

This is in short my feeling and opinion on the possiblity of the introduction of the Faith into the island called *Formosa*.

Since no state can exist without a governor and laws and these places have neither leader nor laws, the magistrate in charge had to offer help and protection to these seven villages as far as they were willing to obey his orders, laws, and customs. For without laws and obedience it will take a long time before everything will be stamped out by simple persuasion.

But what if they do not want it, you may ask yourselves? If they do not want it we must threaten them.

But what if they do not even think about a negative answer? Then the threats must be carried out.

But what if they flee into the mountains? No, they will not and cannot do that. On the whole, if you would want to use force on one of these seven villages alone, they would possibly flee, some part into the mountains, some would hide in the other six villages, but if all seven were treated in the same way, they would not flee.

But what if they defend themselves and declare war on us? To prevent this we should find two or three of the principals in every village with whom to be friends, who could coax the people gently to their view. But I do not think they will defend themselves, because they stand in great awe of the Dutch.

1629

50. Missive Reverend Georgius Candidius to Governor-General Jan Pietersz. Coen. Sincan, 1 February 1629.
VOC 1096, fol. 197-198. Extracts.
ZENDING, Vol. III, pp. 44-48.

fol. 197: [Nuyts] "heeft haere principaelsten oock met eten ende drincken wel onthaelt ende daerbij noch 30 canganges ofte cleeties gegeven, niet uyt sijn maer uyt mijn naeme, seggende dat Candidius haer deese cangangs vereerde, omdat se neerstich naer hem souden luijsteren, hem gehoorsaem weesen ende naer sijn leere haer leven aenstellen. Het effect hiervan is geweest, (fol. 197v.) dat se naer 't vertreck des Heer Gouverneurs seer diligent sijn geweest om mij te hooren.

(...) soo dat ick alleen niet meer sufficant sijnde. Hebbe eenige van de bequaemste inlanders met mijn jongen, dien ick de gebeeden geleert, tot assistentie moeten gebruycken.

Naerdat de Heer Gouverneur voor dese reyse vertrocken, is hij binnen weijnich dachen met een partij volck weder naer Sinckan gecomen om eene Sinckander met namen *Dika*, hooft van degeenen die voor een jaer veel quaets in Japan aengericht hebben (om reden den Heer Generael bekent), gevangen te nemen. Maer alsoo hij ontsprongen ende in der Sinckanders huysen schuijlde en sij nochtans hem in gener (fol. 198) hander manieren wouden openbaeren ofte op de beursch brengen, wat belofte ofte dreygementen oock gedaen werden.

Ende dewijle oock noch 10 andere van sijn maets in Sinckan waeren, die met hem in Jappan geweest hebben, hadde de Heer Gouverneur een quaet achterdencken ende vonde goet, dat ick haer voor een tijdt langh verlatende met sack ende pack met hem omlaech weder naert fort soude trecken ende hij haer den peijs op ende den oorloch aen soude seggen, bij aldien se deze *Dika* binnen ses dage niet op de beursch souden brengen. Twelck geschiet is.

Ondertusschen geduerende deese 6 dagen noch hebben se al haer goet uijt Sinckan gevlucht ende hebben gaen schuijlen in bosch ende ruijchten. Naer 't verloop deeser ses dagen, als *Dika* niet op de beursch gebracht wierde, is den Heer Gouverneur selven weder met een tamelick getal van volck naer booven gecomen om, soo se noch niet en wilden *Dika* voor den dach brengen, haer dorp in brandt te steecken. Naer boven comende was noch goet noch volck meer int dorp te vinden, behalven eenige oude mannen.

Dit siende den Heer Gouverneur, dat se alreede gevlucht ende dat se van
haer leven mogelicken niet en souden wederom comen, heeft hij sijn voorne-
men verandert, met hen op haer maniere weeder veraccordeert, tot straffe
opgeleijt: 30 verckens, elck huijs tien bondelkens rijs te geeven, een nieuw
huijs voor de Hollanders te bouwen ende dat se de elff huijsen der geenen
die in Jappan geweest hebben, souden ruijneeren ende onder voete werpen.
Twelck sij hebben gecon(ten)teert, waerop den Heer Gouverneur weeder met
sijn volck vertrock.

Den 26e januari anno 1629 ben ick weeder op den nieuws, op 't ernstich
versoeck ende aenhouden der Sinckanders, met consent van den Heer
Gouverneur naer boven getrocken om in ons heilich, heerlick ende wel-
begonnen werck te continueren.

Maer vinde groote veranderinge, want een grooten deel der geenen die
gevlucht sijn, binnen noch niet wederom gecomen. (fol. 198v.) Een deel willen
niet wederom comen. Die der noch sijn, bennen bevreest om bij mij te
comen. Sij en betrouwen niet meer, hebben quaet achterdencken. Sal deesen
eersten maent noch weijnich uijtrechten, doch hoope ende hebbe goede moet
door vriendelickheyt haer weeder aen te locken.

Dus staen de saecken in Sinckan tegenwoordich. Ben seer bevreest dat op de
coemste van de Jappanders dit nieuw begonnen wercke in Sinckan weeder
eenen grooten aenstoot sal moeten lijden (...).

(...) verlange seer om groote reeden naer mijn moederlant."

*(Nuyts had visited Candidius in Sincan in order to commend the preacher to
the villages. Under threat of punishment the governor ordered them to heed
Candidius and follow his commands. Should they obey, the Company would
offer them protection.)*

fol. 197: [Nuyts] has entertained their notables, also with food and drink and
thereby also presented 30 cangans or cloths, not in his own but in my name,
saying that Candidius honoured them with these cangans because they listen
to him with attention, are obedient to him and order their lives according to
his teachings. The effect of this has been (fol. 197v.) that after the departure
of the Lord Governor, they have been exceedingly attentive in listening to
me.

*(Candidius scarcely had time to draw breath, because a crowd gathered
constantly before his door, eager to learn. At night these were they who*

worked in the fields during the day and during the day came those who had no work outside the village.)

So that I no longer suffice on my own. I have had to use some of the ablest natives with my boy, whom I have taught the prayers, as assistants.

(The result was that at the winter solstice of 1628, there were 110 persons who knew the prayers and could answer the principle questions about a Christian life. At the beginning of 1629, Nuyts once more arrived to lend Candidius his support and to hear the prayers as examiner, as well as motivating the villagers to obey their teacher.)

After the Lord Governor had left this time, he returned to Sincan within a few days with a group of people to take into custody a Sincandian by the name of *Dika*, the leader of the people who in the past year had perpetrated a lot of mischief in Japan (for reasons known to the Lord Governor-General).

But he escaped and was hiding in one of the houses of the Sincandians and these (fol. 198) had absolutely no thought of betraying him or bringing him out, whatever promises or threats were made.

And because ten other companions who had been to Japan with him, were in Sincan as well, the Lord Governor was suspicious and he agreed that I leave them with all my belongings for a certain time and travel back to the fort with him. He would denounce peace and declare war, if they did not deliver this *Dika* within six days. Which has been done.

In the meantime, during these six days, they fled with their belongings from Sincan to safety and they went into hiding in the forest and the rough country. After the six days had expired and *Dika* still had not been delivered, the Lord Governor himself came over again with a fairly large group of soldiers to set fire to their village should they not reveal *Dika*. But when he arrived in the village there was not a thing nor a person to be found, except for a few old men.

When the Lord Governor saw that they had already fled and that they might not return again for the rest of their lives, he changed his plans and came to terms with them again in their own way, imposing as sanction: thirty swine, ten bundles of rice to be given by every household, a new house to be built for the Dutch, and he said that they should destroy and crush under their

feet the eleven houses of those villagers who had been to Japan. Which they agreed to do, upon which the Lord Governor left again with his soldiers.

At the urgent request and insistence of the Sincandians, I travelled to the village again on 26 January with the Lord Governor's permission to proceed with our sacred, pious, and auspiciously begun labour.

But I came upon great changes, because as yet a large part of the villagers who had fled away had not returned. (fol. 198v.) Some of them do not want to return. Those who are still here are afraid to approach me.

They no longer trust me and are suspicious. I shall not be able to accomplish anything this first month, but I do hope and I am confident of winning them again by kindness.

This is how matters are in Sincan nowadays. I am very much afraid that this recently started project in Sincan will suffer a great blow again after the arrival of the Japanese.

(In a postscript Candidius asks to be released: 'I am homesick for my homeland'*, and to be replaced by a competent person who is prepared to marry a local girl or to stay here for a long time.)*

51. Missive Governor Pieter Nuyts to Governor-General Jan Pietersz Coen. Tayouan, 4 February 1629.
VOC 1096, fol. 118-119. Extract.

fol. 119: "Candidius blijft noch in Zincan, maer ontmoet ons met soo veel swaricheden, dat aen sijn werck despereeren. 't Principaelste dat hij versoeckt ende nodich tot verder progres oordeelt is, dat men de luijden met wetten ende straffen moet dwingen naer hem te luijsteren ende wij comen geen straffen inbrengen ofte sal met groot perijckel van onsen staet alhier gemenght sijn. U Edele Heer Gouverneur Generael gelieve ons te ordonneeren wat in dese saecke sullen doen. Dese luijden moeten ende behooren meer door goede exempelen als leringen onderwesen te werden. Voor ons wij meenen hij maer tijdt consumeert ende gagie sonder dienst treckt. Wij hooren in een jaer namlicx drie predicatien. Hier in 't fort can altijt sekeren dienste doen, want een rouwen hoop volcx hebben beter bekeringe (als hebbende den smaeck des Christendoms) als de Zincanders noodich.

't Is bij haer een gebruyck dat de vrouwen voor 40 jare ofte daeromtrent geen kinderen mogen voortbrengen, daeromme deselve, bevrucht sijnde, continuelijck in haer lichaem ombrengen. Candidius sal met sijn honderden tselve haer niet ontwennen. Wat Christenen connen dat gewesen. De nature grouwelt selffs hier aff, dat de Heer Gouverneur Generael aen de ingesetene

onser natie te trouwen licentieerde. Wij estimeren door den civilen omme-
gangh meer als leeringe souden avanceeren, doch soude oock sijnen tijdt
vereijsschen ende soude de Compagnie mettertijdt jaerlicx goede quantiteyt
van menschen uyt dit eyland trecken."

fol. 119: Candidius stays in Sincan but raises so many difficulties that we
despair of his mission. The principal action that he requires and judges to be
necessary for further progress is that the people must be forced to listen to
him by laws and punishment, but if we come to inflict punishment, this will
only greatly endanger our affairs here. May Your Honour the Governor-
General tell us what to do in these matters. These people must and ought to
be taught by good example rather than by teaching. As far as we are con-
cerned we believe that he wastes time and earns money without doing his
duty. As a matter of fact, we hear of only three preachings in one year. He
can always perform his duty here in the fort, where a wild and rough bunch
of people is more in need of evangelization (as they already are accustomed
to the Christian Faith) than are the Sincandians.

It is their custom that women are not allowed to produce children before the
age of forty or so, which is the reason why they always kill them in their
bodies when they are pregnant. Not even with the aid of a hundred [of his
confraters] will Candidius be able to discourage this. What kind of Chris-
tians would they make! Nature itself even abhors the fact that the Governor-
General has allowed the inhabitants to marry men of our nation.

We estimate that we would make more progress by social contact than by
teaching, but this would also take its time and would in due time enable the
Company to draft a great deal of people from this island annually.

**52. Brief Account by Pieter Nuyts to be presented to the Governor-
General and Council in Batavia and to the VOC-Directors in Amster-
dam, from which it can be ascertained if the expenses incurred by the
Company for the benefit of the continuation of the trade with China and
Japan actually contribute to annual profits or if they could better be
used for the development of trade in other places. Tayouan, 10 Febru-
ary 1629.**
VOC 1098, fol. 391-397. Extracts.

fol. 391v.: "(...) het landt heeft extraordinarie hooge schoone bergen; d'in-
woonders goetaerdich, maer seer luij, bedelachtich, doch met weynich te

contenteren. Wert besaijt bij ider huysgesin niet meer als voor een jaer nodich hebben. Daer valt wat suyckerriet, gember ende weynich terrestre vruchten, weynich geboomte ende noch silvestre. Anders, wanneer gebout werde, is 't lant fertijl ende seer goet. Wij sullen, om ons propoost niet te interrumperen, bij andere gelegentheijt daer aff als van haere manieren seggen.

fol. 393: "Wat hier te betrachten staet: Ten derden (…), is te beduchten dat d'inwoonders en de Chinesen hier in 't lant woonen, jegens onse natie sullen ophitsen, sonder welckers vruntschap niet en connen continueren, ofte sullen de garnizoenen en de navale machten moeten beswaert ende geaugmenteert werden."

fol. 391v.: (…) the country has extraordinarily high and beautiful mountains. The natives are good-natured but very lazy, beggarly but easy to satisfy. Each family cultivates only the land for the needs of one year. Some sugar-cane, ginger, and not many tubers grow there, some trees and some sylvan glades. But when it is cultivated, the land is fertile and very good. Because we do not want to interrupt our story, we will discuss this as well as about their customs some other time.

(Nuyts concluded that, from the moment Zeelandia was settled, the Company had faced two major difficulties on Formosa: the presence of its old enemy the Spanish on the northern tip of the island and the activities of the Japanese.)

fol. 393: *(In the margin:)* What needs to be done here.
(…) In the third place (…) there is fear that the natives and the Chinese who are living here in the place will turn against our nation, but we cannot continue without their friendship or the garrisons and the naval powers will have to be strengthened and enlarged.

53. General Missive.
VOC 1096, fol. 10-17. Extract 10 February.
FORMOSA, pp. 77-78.

fol. 12: "Dese joncken brachten mede 't volck van 't dorp Sincan, welck de capiteyn Jaffioye verleden jaer steelswijs hadde vervoert, ende in Japan uytgegeven waren voor ambassadeurs, die den keyser de souverayneteyt van

Teyouhan ofte 't eylant Formosa quamen opdragen ende een regent versoe-
cken. Den Ed. Nuyts, alsnoch verstoort wesende (na 't schijnt), dat door
toedoen van deese luyden (die selffs in haer dorp niet bestaan connen, maer
van sijn Ed. gemainteneert ende voor hare vyanden beschermt werden) soo
grooten affront in Japan geleden hadde ende de Compagnie groote moeyte
ende kosten aengedaen was, heeft dese Sinckanders in boeyen geslooten ende
de vereringe van den keyser in Japan bekomen (dat weynich importeert)
affgenomen, 't welck voorsz. Jaffioye ende sijn geselschap seer verdroot.
De Japanders dese ophoudinge niet connende verdragen, meenden (so
namaels seyden), dat ons volck voorhadde [hen] te doen sterven, waerover
resolveerden in de voorbaet te wesen. Den 29en Juny is voorsz. capiteyn
Jaffioye met eenige geconjureerde in des Compagnies huys, buytten 't fort
Teyouhan staende, by de gouverneur Nuyts gegaen omme affscheyt van sijn
Ed. te nemen. Hy was alleen in de camer met sijn soontjen, een tolck ende
10 à 14 cooplieden. Na lange onderlinge discoursen heeft voorsz. Jaffioye,
cappiteyn van de Japanders, met sijn geselschap den gouverneur Nuyts gevat
ende met coorden, na de Japanse maniere, wel vast geknevelt. Verscheyde
Japanders die omtrent 't huys versteken waren, 't rumoer hoorende, spron-
gen met haer geweer voor den dach, sloegen twee Nederlanders doot,
quetsten eenige, daerby oock een van de haere 't leven liet. Uyt het fort
wierden in een schuyt, die na de joncken voer, eenige Japanders
dootgeschooten, maer op 't huys is niet geschoten om den gouverneur Nuyts
by 't leven te houden. d'Eerste furie over sijnde, wierd de Japanders van die
van 't fort aengeseyt, dat den gouverneur Nuyts ontslaen souden, ofte dat
met groff geschut op haer souden schieten. De Japanders antwoorden dattet
huys noch den gouverneur niet wilden verlaten, voordat gecontenteert ende
versekert waren vry te mogen vertrecken. Den gouverneur Nuyts aldus in
haer gewelt hebbende, stelden de Japanders d'onse 5 articulen voor. (…)
Ten tweeden de elff Sinckanders, welcke als gesanten van Japan hadden
wedergebracht ende van d'onse in de boeyen waren geslooten, met 2
Chineese tolc[ken].
Ten derden, de schenckagie die de keyser van Japan voorsz. Sinckanders
gegeven heeft, ende door den gouverneur Nuyts haer benomen was. (…)
Dit gedaen sijnde, souden d'heer Nuyts ontslaen.
Niettegenstaende dese Japanders den gouverneur Nuyts in des Compagnies
huys gevangen hadden onder 't gewelt van ons fort ende de schepen, ende
dat d'onse met onthoudinge van eten ende drincken de Japanders hadden
connen constringeren den gouverneur Nuyts in vryheyt te stellen, heeft den
raedt van Teyhouan goetgevonden, nadat Nuyts acht dagen gevangen was
geweest, de begeerte van dese Japanders te vollen t'accorderen, onaengesien

hoe ongefondeert hare pretentie sy ende hoe qualijck haer versoeck, behoudens d'eere ende reputatie van onse natie, geaccordeert cost worden, en dat omme in Teyouhan, seyt den raedt, hantdadicheyt, ende in Japan meerder swaricheyt voor te comen."

(In the General Missive the events around the arrival of the two Japanese junks at Tayouan in April 1628 are mentioned again:)

fol. 12: These junks brought along the people from the village of Sincan, who had been carried away by stealth by the captain, Jaffioye, last year and who had been passed off as ambassadors who came on a mission to present the sovereignty of Tayouan or the island of Formosa to the Shogun and to request a regent. The Honourable Mr Nuyts, still being annoyed (so it seemed) that he, through the agency of these people (who could not even survive in their own village without His Honour's support and protection against their enemies), had suffered such a great affront in Japan and that so many troubles and great expense had befallen the Company, had ordered these Sincandians to be put in chains and the gifts they had received from the Shogun, which were really nothing valuable, be confiscated, all of which aroused the ire of the aforesaid Jaffioye and his company.

The Japanese, who could not tolerate being delayed, thought (as they declared afterwards) that it was the intention of our people that they would die of starvation, against which they resolved to take pre-emptive action. On June the 29th, under pretence of taking leave, Captain Jaffioye accompanied by some conspirators, came to the Governor's house which is situated outside the walls of Tayouan fort. Nuyts was present with his young son, an interpreter and ten or fourteen Company servants. After having conversed together for a long time, the captain of the Japanese, Jaffioye, together with his company, had seized Governor Nuyts and tied him to a chair in 'the Japanese fashion'. Upon hearing the noise, several Japanese who were hidden near the house emerged with their weapons, killing two VOC soldiers and wounding a few others. Some Japanese who sailed to the junks in a small boat were shot dead from the fort, but from there they did not dare to fire on the house itself from fear of killing Governor Nuyts. After the first fury had abated, the message from the fort to the Japanese was unequivocal: if they would not let Governor Nuyts go, they could expect to be fired on by the heavy artillery. Upon which the Japanese replied that they would not leave the house and set the Governor free before they were

guaranteed a free withdrawal and before the Company had complied with five demands.

(The Japanese promised to release Governor Nuyts if these demands should be complied with. The second demand concerned the release of the eleven inhabitants of Sincan, who were put in chains after they were brought back to their village from Japan as ambassadors; and the third one ordered that the gifts, which they had received from the Shogun, should be returned to them. After eight days, very much to the dissatisfaction of the High Government in Batavia, the Tayouan Council resolved to give in to all five demands. The council motivated its resolution by saying that this would restore the damaged relationship between the Company and Japan and would prevent similar problems to occur in the future.)

(Coen, Bescheiden, Volume V, pp. 146-168). (See: May and June 1628 for Governor General Coen's account of the return of the Sincandians from Japan and of Nuyts's wrongdoings.)

54. Instruction for Governor Hans Putmans and Council of Tayouan. Batavia, 24 April 1629.
VOC 1097, fol. 146-154. Extracts.

fol. 151: "(…) mits haer soo weijnich redenen van clachten gevende als eenichsints doenelijck was, opdat de vruntschap met den Keyser van Japan ende de commertie aldaer geconserveert mocht blijven ende alsoo d'onlusten hierover van tijt tot tijt toenamen. Ende sekere Japanders anno 1627 onderstonden, apparent door toedoen van de Portuegesche vijanden, met 16 naturelle die steelswijse van 't dorp Sincan vervoerden ende als ambassadeurs opmaeckten, den Keyser van Japan wijs te maken dat Sijne Majesteit de souverainiteyt van Teijouhan opgedragen was (…).

fol. 151v.: In plaetse van middel te gebruycken die geen voorder onlusten gaven noch schijn van offentie aenbrachten, heeft de Heer Nuyts de Capitein van de twee Japanse joncqe gedwongen aen sijne Edele over te leveren de Sinckanders, die weder van Japan brachten, die in Japan als ambassadeurs waren geëert ende van de Keyser beschoncken. Heeft haer in boeyen geslooten, des Keysers geschenken affgenomen ende die aen d'een en d'ander geschoncken. Waertoe Sijne Mayesteit dese affrontie gedaen, wat dienst conde de Compagnie daeraen geschieden? (…)

fol. 153: Alsoo d'inwoonders van 't dorp Sinckan door toedoen van de voorz. Japanders van d'onse seer vervreemt sijn. Met behendicheyt ende clenicheijt

hebben de gemoederen tot haer getrocken ende tegen d'onse seer verbittert sijnde, de brutaliteijt van dit volck daerenboven soo groot dat de predicant Candidius bijcans geen hoope schijnt te hebben om haer te siviliseren ende totte Christelijcke religie te brengen. Desen flauwheyt bedroeft ons te vernemen, de wijle daertegens sien, dat een deel Japonders, die bijcans soo brutael zijn als de Zinckanders, haer met soeticheijt tot haeren wille hebben weten te crijgen ende daermede soo groote quaet tot nadeel van de Compagnie te wesen hebben gebracht (...).

(...) omme de herten van voorz. inwoonders van 't dorp Sinckan ende andere naest gelegen plaetsen meer t'onsewaerts te trecken ende tot de Christelijcke religie te brengen, biedt Dominee Candidius daertoe de hant, helpt sijn Edele daer U Edele hulpe van noode mocht hebben ende gebruyckt daertoe (fol. 153v.) noch soo veele andere persoonen meer als geraden vinden sult. Soeticheyt ende vriendelijckheyt meenen wij dat meest gebruyckt dient; daer hardichheijt ende straffe vereyscht wort, laet die spaersaem ende met discretie gebruycken.

Soo eenige van d'onse genegen mochten worden om haer in den echten staet met vrouwspersoonen van Sincan ofte andere plaetsen te vereenigen, weest daer niet tegen, maer laet haer vereenigen. Alsoo verhoopen, dat het van middel wesen sal daermede des Heeren zegen te meer becomen sullen."

(Governor-General Coen briefs the new Governor of Tayouan, Hans Putmans, on the tense political situation as far as Japan is concerned.)
fol. 151: *(About Tayouan's sovereignty:)*
(...) on the understanding that we gave them as little reason for complaint as possible, so that the friendship with the Shogun of Japan and the trade over there would be maintained, but agitation about it accumulated in time.

And in the year 1627, apparently by the machinations of the Portuguese enemies, certain Japanese in the company of sixteen natives (whom they had transported secretly out of the village of Sincan and had dressed up as envoys) had the nerve to make the Shogun of Japan believe that the sovereignty over Tayouan was dedicated to His Majesty (...).

(...) Instead of using means which would obviate any further trouble or look provocative in any way, Mister Nuyts forced the captain of the two Japanese junks to hand over to His Honour the Sincandians whom they had brought back from Japan, who had been honoured in Japan as envoys and had received gifts from the Shogun. He has clapped them in irons, has confiscated the Shogun's gifts and has donated these to some people here and there. Why offend His Majesty, what good could this do the Company?

(The crew of the two Japanese junks carrying the Sincandians, deprived of provisions and angry because of shortage and hunger, raided the shore and Nuyts's house with two hundred men. In the fight they were soon scared away by the Company's muskets. With the hostage-taking of Nuyts and the conditions which the Japanese were able to extract from the VOC for release, all the prestige which the Company had been able to build up with the aboriginal population was lost.)

fol. 153: So the inhabitants of the village of Sincan have been very much estranged from us by actions of these Japanese. With stratagems and little things the Japanese have drawn them over to their side and what is more, now that they are in a bitter mood towards our people, the insolence of these people is so great that the Reverend Candidius seems to have lost almost all hope of civilizing them and leading them to the Christian Faith. We are sad to hear of this set-back, while on the other hand we see that some of the Japanese, who are almost as insolent as the Sincandians, have managed to woo them into their power with sweet words and have harmed the Company a great deal.

(...) in order to win the hearts of these inhabitants of the village of Sincan and neighbouring places more to our side and towards the Christian Faith, do give the Reverend Candidius a helping hand, assist His Honour for which Your Honour [in turn] might need help and use as many more persons for it as you think is necessary.

We believe that sweet words and kindness must be used in the most instances, where toughness and punishment are necessary, use it seldom and with discretion.

If any of our men are inclined to join in matrimony with women of Sincan or other places, do not oppose it, but let them get married. This way we hope to gain God's blessing more and more.

55. Missive Governor-General Jan Pietersz. Coen to the Reverend Georgius Candidius. Batavia, 24 April 1629.
VOC 1097, fol. 163-164. Extract.

fol. 163v.: "(...) tot een medehulper in de dienste Godts ende niet omme in U Edele's plaetse te treden, gaet met sijne Edele (Gouverneur Putmans) dominee Robertus Junius.

't Sal ons bedroeven soo U Edele 't goede begonnen werck nalaet omme de menschelijcke passie ende genegentheyt vol te doen; 't ware beter dat noyt

van sijne geboortplaetse ware vertrocken dan dat sonder merckelijcke vrucht van sijn arrebeijt naer te laeten weder derrewaerts keere. De Japonders, dat immers mede rouwe, brutale menschen sijn, hebben haer persoonnagie met dese Zinckanders alsoo weten te spelen, dat tusschen ons ende de Japonse natsie groote questie geresen is."

(Announcement to Candidius of the coming of a second minister the Rev. Robertus Junius, who will endeavour to decrease the Japanese influence on the Sincandians.)

fol. 163v.: (...) as an assistant in the service of God and not as a substitute for Your Honour will come His Honour Robertus Junius.

We would be grieved should Your Honour abandon work begun so propitiously in order to assuage human feelings and desires. It would be better never to have left his place of birth than to return home again without leaving any visible result of his labour. The Japanese, indeed uncivilized and insolent people, have made use of their reputation with these Sincandians in such a way that grievous troubles have arisen between us and the Japanese nation.

56. Original report of Pieter Nuyts to the Amsterdam Chamber. Tayouan, 4 August 1629.
VOC 1098, fol. 321-386. Extracts.

fol. 327: "De Gouverneur Putmans 't gouvernement van Tayouan overgenomen hebbende, sal datelijc trachten de saecken aldaer soo te belijden, dat des Compagnies standt ende affairen ten besten dienste van de Compagnie redresseere ende verbetere (...) Daer is niets te redresseren, wat is dit anders als mij verdacht gemaeckt!" (...)

fol. 354: "Als ambassadeurs sijn dese wilden niet erkent. Van de souveraijniteijt te cederen aen de Keijser is noijt een eenich woordt vermaent, maer wel dat hij lant mochte connen bebouwen. De Keijser, wat meer is, heeft die noijt willen sien. Hebben oock noijt audiëntie gehadt nochte versocht, veel minder soude haer landt, soo het Sijne Majesteijt schoon gecedeert werdt, willen aenvaerden, 't welck die de Zincanders vervoert hebben oock wel oordeelen conden. Maer ter contrarien, wetende dat sij met soo een opgemaeckte presentatie geen eere (fol. 354v.) behaelen souden, nochte oock niet (...) veel minder bij den Keyser aenvaert werden, hebbe die 16 wilden tot hun eygen profijt medegevoert, aengesien hier groote fastidiën in den handel leeden ende 't voorgaende jaer hadden moeten overblijven ende haer d'or-

dere van den Commandeur onderwerpen, waerinne groote tegenheyt beco-
men hadden."

*(Nuyts's apology to the Amsterdam Chamber. It is obvious that he is out-
raged by the fact that he has been heavily criticized and adds arguments in
his defence:)*

fol. 327: 'After having taken over the government of Tayouan, Governor
Putmans will immediately try to represent things there in such a way that he
will redress and improve the condition and business of the Company to the
utter benefit of the Company' (...) There is nothing to be redressed! What
else is this than to cast suspicion on me! (...)

fol. 354: There has not been any acknowledgement of these savages as
envoys. There has never been a word spoken about giving sovereignty to the
Shogun, but only that he might cultivate the land. What is more, the Shogun
never desired to meet them. They never had an audience, nor indeed asked
for one, much less would His Majesty want to accept their land, even were
it ceded to him properly, of which even the men who transported the
Sincandians were well aware. But on the contrary, knowing that they would
neither be given any credit for such a staged presentation (fol. 354v.) nor
would they be received by the Shogun (...), they have transported these
sixteen savages for their own benefit, because they had suffered great disad-
vantages in the trade in Tayouan and the year before had to stay over and
accept orders from the commander, about which they had developed a great
dislike.

*(fol. 358v.- fol. 364) (The blame for all the obstinacy from the Japanese was
now put on Pieter Nuyts. After all it was he who had offended the Shogun
himself by robbing the Sincandians of their presents and he had been indif-
ferent to the provisioning offshore of the Japanese ships on which the Sinca-
ndians had come home. On several occasions he had put the Company in a
position of 'disreputation' not in the least on 28 June 1628, by allowing
himself to be tied up in his own home by thirty Japanese.)*

57. Original missive Pieter Nuyts to Governor-General Jan Pietersz. Coen. Tayouan, 14 August 1629.
VOC 1098, fol. 406-431. Extract.

fol. 414v.: "Doch vinde ick [Nuyts] aen de Edele Heer Generaal door sijne Edele [Sonck] dit geschreven [19 February 1625]: 'In Zincan ben ick op 15 januarij geweest om de nieuwe vrundtschap te vermeerderen ende des te aensienelycker te maecken ende insonderheijt om met minne van haer voet op 't vastelandt te krijgen'. Ende een weynich lager: 'Ick hebbe voor 15 cangans van haer soo veel landts gecocht als voor des Compagnies ommeslagh nodich hebben, 19 februari 1625, onder stont Martinus Sonck'.

Nochtans sijn bij mij verscheyden acten van souveraijniteijt gepleeght, soo in 't verbodt datter geen hartevellen sullen uijtgevoert werden, soo in 't uijtstellen in verscheyden dorpen dat gheen Chineesen sullen mogen woonen, in Zincan, Baccaluan, Matau, Solangh, Teopan, Tifalucan en Tafacan, sonder mijne permissie. Welcke passen aldus luijden: N.N. werdt toegestaen in N. en Z. voor den tydt van drij maenden te mogen woonen, mits hem onderwerpende alsulcken ordere als den Gouverneur Generael vanwegen den Nederlantschen Staet in India ofte sijnes Edeles gesubstitueerden, den Gouverneur in Zeelandia resideerende, voor desen goetgevonden heeft ofte naermaels stellen sal."

(In this apology Pieter Nuyts also deals with the justification of the Dutch sovereignty over the island of Formosa, for which he refers to the first Governor Martinus Sonck.)

fol. 414v.: So I find this document written to the Honourable Lord General by His Honour [Sonck] on 19 February 1625: 'I visited Sincan on 15 January in order to improve and substantiate the new bonds of friendship and in particular to obtain a foothold on the main island with their approval'. And a little further down: 'For fifteen cangans I bought as much land from them as we need for the business of the Company', 19 February 1625, signed Martinus Sonck.

Again several deeds concerning sovereignty have been executed by me, such as for instance a ban on the export of deerskins, and the announcement of the regulation in various villages that no Chinese may live without my permission in *Sincan, Baccaluan, Mattau, Soulang, Teopan, Tifalucan, and Tafacan*. The permit of this kind states as follows: N.N. is granted permission to reside in N. and Z. for a period of three months, provided that

he is subject to all instructions announced to him now or in the future by the Governor-General of the Dutch State in the Indies or his Honour's deputy, the Governor residing in Zeelandia.

58. Extract letter Georgius Candidius. Tayouan, 14 September 1629. VOC 1100, fol. 5.
BESCHEIDEN, Vol. VII 2, p. 1804.

fol. 5: "Wanneer ick insye ende aenmercke den groote ijver ende sorge, die sijne Edele voor de zalicheyt deser heijdenen heeft ende de veelvoudige moeijte, arbeyt ende swaricheden, die ick om harentwille gehadt ende verdrage ende de gewenste effecte ende vruchte alreede daervan gesyen ende genoten ende nu van verre aenschouwe, den miseraebele ende beclaechlijcken toestant derselven soo en can ick niet voorbij, ofte ick moet menichvoudige ende overvloedige traenen storten. Want de sorge ende arbeyt, die wij gedaen ende gehadt, is apparent meest verloren gegaen. De hope om sulcx te restaureren, wort ons geene of heel cleijne gethoont.

Ons volck tot 70 toe, is van de Mattauwers ende Backeloanners aen een van haren zijrivieren vermoort. Dit geschiet sijnde, zijn sij datelijck naer Zincquan getrocken, meijnende den Gouverneur noch daer te vinden ende oock niet beter met hem te leve, maer hij een halff ure omtrent vantevoren gewaerschouwt zijnde, is 't ontcomen.

't Gene nu dat se aen de Heer Nuydts niet hebbe connen volbrengen, hebben zij aen onse huijsen ende beesten gebroocken.

fol. 5v.: Want sij d'Heer Nuydts in Zinckan, gelijck oock mijn huys (van de Zinckanders selffs gebouwt) daer ick in woonde en leerde, in brant gesteeken ende tot aschen verbrant. Daernaer zijn se oock noch verder voortgevaeren totaen *Sacam*, alwaer des Compagnies beesten, bocken, gansen ende peerde waeren. Hebben veel van dezelven dootgeschoten, de huijsen met 't goet dat daerinne was, koeijen-, paerden- ende bockestallen, met drij paerden noch levendich, verbrant.

Die van *Sulang* hebbent oock niet veel beter geclaert, want sij eenen seeckeren Jan Harmanszoon, sieckentrooster, die de Heer Nuydts den 2e april in Sulang geleijt om de spraecke te leeren, met noch eenen jongen ende een bootsgesel eeven op denselven dach oock vermoort.

De Zinckanders bennen noch vrunden met ons, met noch drij andere cleijne dorpjens, soo men tot noch toe niet anders en weet. De Zinckanders comen noch altemet eens aff, maer weijnige ende selden. Van al de andere dorpen compt niemand af."

(The Reverend Candidius did not get permission to leave Formosa from the High Government in Batavia:)

fol. 5: When I realize and take into consideration the great fervour and care His Honour shows for the salvation of these heathens and the manifold efforts, work, and troubles that I have endured and still endure for their sake and the required effect and results that I have so far seen and savoured (and now see from a distance), I cannot ignore the miserable and deplorable state of these people without shedding a flood of abundant tears, because the troubles we have had and the work we did has clearly come to nought for the most part. We have very little or no hope of restoring this.

Almost 70 of our men were killed by the Mattau and Baccaluan villagers in one of their tributary rivers. After this act the natives immediately went to Sincan, thinking they might find the Governor there, whom they also preferred to see dead. But he had received a warning about half an hour before and escaped.

But what they were not able to perpetrate on Mister Nuyts they wreaked on our houses and animals.

fol. 5v.: Because they set fire to and burnt to ashes Mr Nuyts's house in Sincan as well as my house (built by the Sincandians themselves) in which I have lived and preached. After this they went on to Saccam, where the Company's livestock, goats, geese, and horses, is kept. They shot dead many of them and burnt down the houses with all that was inside, the cowshed, the stable, and the goatshed, with three horses still alive.

The people of Soulang have not behaved any better, because on the same day they also killed a certain Jan Harmensz., visitor to the sick, whom Mr Nuyts had introduced in Soulang on 2 April to learn the language, and another boy and a sailor on the same day.

As far as we know the people of Sincan are still our allies, with those of three other small villages. The Sincandians sometimes come to us, but hardly ever and seldom. From all the other villages nobody ever comes down.

59. Original missive Governor Hans Putmans to the Amsterdam Chamber. Tayouan, 15 September 1629.
VOC 1098, fol. 33-38. Extracts.

fol. 33v.: "Ontrent acht daeghen voor ons arriveren alhier was (door last van de Hr. Nuyts) gemelte [koopman Jacob] Hooman in compagnie van den

ondercoopman Carel Basseliers, den vendrich Spangnaert, sargeant Crama, vier corporaels, veerthien adelborsten ende de beste soldaten, zijnde het principaelste ende beste volck tegenwoordich alhier in garnizoen liggende, tesamen 63 coppen sterck, naer seecker dorp hier te lande liggende ghenaempt Mattau gesonden, omme eenen Chinees genaempt *Sachataija*, opperhoofd van seeckere joncke, die hij ten rooff geëquipeert ende bij d'onse tevooren leedich sonder volck becomen was, met vier bassen, eenighe piecken ende sabels (also d' roover hem in Matau voornoempt onthielt volghens 't oude gebruijck), te gaen haelen.

In Matau comende sijn d'onse aldaer van de swarten ofte wilden volgens ghewoonte wel onthaelt, doende hun excuse dat gemelte roover *Sachataija* in 't geberchte met sijn geweer ende volck gevlucht was. Soodat d'onse onverrichter saken hun op den wech om weeder te keeren hebben begeven ende wierden geconvoijeert uijt courtoysie volgens 't oude gebruijck van outsher (naer 't voorgeven van de swarten). Zestig van voorsz. dorp *Matau* in dit wederkeeren comende ontrent een cleijne mijle van 't voorsz. dorp aen een reviere, die d'onse moesten passeeren, hebben ghemelte swarten onder decxel van vrundtschap aen d'onse gepresenteert eerst hun geweer ende daernaer hunne lichaemen (also ditto reviere seer diep was) over te draeghen, dwelck d'onse, gheen achterdocht hebbende, consenteerden. Ende sijn also van diversche swarten, die in de ruychten ter wederzijden van de reviere in embuscade laghen, (ontwapent sijnde) zeer moordaedich altsaemen vermoort, uijtghesondert eenen Chineesen tolck ende een swarte slaeff die 't ontliepen. Hetwelck niet alleen een groote verswackinge in 't garnisoen alhier, maer principaelijcken in de voortplantinghe der Christelijcke religie sal geven, daerenboven sullen d'oncosten van de taeffel alsmede het sieckenhuys jaerlijcx veel grooter vallen, vermidts het landt ende de jacht van herten, haesen als andersints daegelijcx hierdoor gemist moet werden.

In somma vonden alles in een seer troubleusen standt, als U Edele uijt desen noch breeder sullen connen verstaen. (...)

fol. 35v.: " 't Is seker dat de Hr. Zonck hier een misslach heeft begaen; 't waere beter geweest dat ter plaetse daer het fordt tegenwoordich light maer een redoute ende packhuijs stondt, (fol. 36) ende het fordt daer nu de redoute licht waere geweest. Want bij sooverre den vijandt dese plaetse incorporeert (...) soo sijn wij genouchsaem voor altijt belegert en sullen gheen scheepen noch joncken uijt noch in connen crijghen.

Derhalven hebben wij goetgevonden gemelte redoute met een punt aen de landtzijde te verstercken ende ontrent 8 à 9 voet rondtsom te verhooghen. (...)

fol. 38: "Den aenwas ende toeloop van veele Chineesen in Taijouan, die ons bij d'Edele Heer Generaal gerecommendeert werdt, sal vooreerst seer qualijc connen geschieden.

Ten eerste, door d'onbequaemheijt der plaetse ontrent het fordt, daer de Chineesen tegenwoordich woonen.

Ten anderen, doordien geen vrouwen onder haer sijn hebbende, die uijt China alsmede uijt 't landt Formosa seer qualijck ofte gheen te becomen zijn. Ende ten derden, vermidts hier tot noch toe seer weijnich gelt (anders als 't ghene dat weghen de Generale Compagnie vuijtgegeven werdt) omme gaet.

Soo veel als aengaet de plaetse, is anders niet als een cleijne spatie van zandtduijnen, daer niet gesaijt ofte gewonnen can werden; tensij hetselve aen d'oversijde van 't vastelandt Formosa gedaen werdt, dat door de swarten, gelijck nu met die van seeckere dorpen genaempt Mattau, Zoulang ende andere bij gelegenhe in oorloge sijnde, geheelijcken gedestrueert ende de huysen, alsnoch cordts gebeurt is, altesamen in de brandt gesteecken, de Chineesen het haer affgesneeden, veele gequest ende alsoo gants vruchteloos gemaeckt werdt.

Om hetwelcke voor te comen (soo men den aanwas ende toeloop van Chineesen in Taijouan wil voeden), dienen ten minsten twee redouten aen d'oversijde op 't vastelandt van Formosa gelecht, waermede onse macht verspreijt ende wij veel verswackt souden werden. Ten waer d'Edele Heer Generael conde verstaen men het guarnisoen alhier soo veel versterckte, dat ditto redouten daervan behoorlijc beset conden werden, 't welck vooreerst vreese niet sal connen geschieden, want eer het fort ende de redoute buijten naer behooren beset can werden, dient ons vooreerst toegesonden niet min als 150 cloecke soldaeten.

Wat aengaet het tweede, soo dient middel gevonden omme slavinnen, 't sij dan Javaensche, Balische ofte andere, herwaerts gesonden omme deselve onder de Chineesen te vercoopen. Maer dienen vooreerst tot een preuve niet boven 't getal van 20 à 30 hier gesonden, opdat, kinderen daerbij crijgende gelijck natura dat leert, daerdoor bewoghen moghen werden hunselven neder te setten ende op Taijouan haere vestplaetse te nemen.

Comende het derde, dient vooreerst, mijns bedunckens, onder correctie gecontinueert, dat eenighe joncquen alsmede vrije luyden die sulcx versoucken, licentie vergunt werden om herwaerts te comen, midts dat de thienden soo van uijt- als incomen betalen. Alsmede soot mogelijcken waere in te voeren dat hunne goederen alleen in Taijouan ende niet in Chincheo ofte andere plaetsen sullen venten ende vercoopen, waerdoor de Chineesen met hunne coopmanschappen op Taijouan getrocken, aengelockt om haersel-

ven daer neder te setten ende alles in aenwas soude connen gebracht wer-
den."

fol. 33v.: About eight days before our arrival here, on the orders of Mr Nuyts
this already mentioned [Merchant Jacob] Hooman in the company of Junior
Merchant Carel Basseliers, Ensign Spangnaert, Sergeant Crama, four cor-
porals, fourteen cadets, the rest soldiers, being the most outstanding and
best men stationed here in the garrison nowadays, altogether 63 men strong,
were sent to a certain village situated here in this area called Mattau, in
order to fetch a certain Chinese by the name of *Sachataija*, the skipper of
a junk (which was deserted by him when he went looting and which had
previously fallen into our hands empty without crew), with four naval guns,
several pikes and sabres (because the pirate was skulking around in this
village of Mattau, as usual).

Upon arrival in Mattau our people were well received as always by the
blacks or savages, who apologized and said that the pirate in question,
Sachataija, had fled into the mountains with his weapons and his men. So
that our people went away in order to return with nothing achieved and they
were politely escorted as was the old custom (according to what the blacks
told us). When on their way back from this village of Mattau 60 of our men
had arrived at a distance of less than a mile from this village at a river that
our men had to cross, the blacks in question under the guise of friendship
offered our men to carry them to the other side, first their muskets and then
their bodies (because the river in question was very deep), to which our
men agreed without having any suspicion.

And thus (disarmed) they were killed in a most brutal way by various
blacks, who were lying in ambush in the scrub on both sides of the river, all
of them apart from a Chinese interpreter and a black slave who escaped.

This will not only cause a great weakening in the garrison, but mainly in the
spreading of the Christian Faith and what is more, the annual sum of
expenses for food as well as for the hospital will turn out to be much
bigger, as we must do without the daily work on the land and the hunting
for deer, hare, and other animals because of this.

All things considered we found everything in a very troubled state, as Your
Honour may understand from a broader report.

*(Ex-Governor Nuyts was also blamed for the death of the soldiers, as he was
the one who had sent them out. The new governor, Putmans, was an energe-*

tic man, who lost no time in making a proposal for the improvement of the fort in the same letter.)

fol. 35v.: There is no doubt that Mr Sonck has made a mistake here. It would have been better if only a redoubt and warehouse had been built on the very place where the fort is now situated and that the fort had been built where the redoubt is now situated. Suppose the enemy conquers this area, we will be besieged forever and will not have a chance to get ships or junks in or out. Therefore we have decided to strengthen the redoubt in question on the landside with a ravelin point and to heighten it all around by about eight or nine feet.

(Putmans also discussed the problems encountered in encouraging Chinese migrants to settle in Tayouan.)

fol. 38: The increase and influx of many Chinese into Tayouan, which the Honourable Governor-General has recommended to us, is unlikely to take place.

In the first place because of the unsuitability of the area around the fort where the Chinese live nowadays.

In the second place because there are no women among them and it is hardly possible or not possible at all to get them from China or from the island of Formosa.

In the third place, because there is until now very little money in circulation here (other than the money that is spent by the General Company).

As far as the living-area is concerned, it is no more than a small aperture between the sand dunes where nothing can be sown or harvested. Unless it is laid out on the other side of the bay on the mainland of Formosa, which has been completely destroyed by the blacks, because we happen to be at war with the people of certain villages named Mattau, Soulang and others. All the houses were recently set to fire, the hair of the Chinese was cut off, many were wounded and [the land has] been totally laid waste.

In order to prevent this from happening again (if you want to stimulate the increase and influx of Chinese into Tayouan), at least two redoubts will have to be built on the other side on the mainland of Formosa, by which our authority will be extended but our position will be much weakened, unless the Honourable Lord General would agree to reinforce the garrison to such

a degree that these redoubts could be properly manned, which I fear may not be done for a while yet, because in order to man the fort and the redoubts properly, no less than 150 brave soldiers should be sent.

Regarding the second point, we have to find a way to send over female slaves, from Java, Bali or elsewhere, to sell them to the Chinese. But they should be sent over here in a trial number of no more than 20 to 30 to begin with, so that the Chinese, siring children with these women in accordance with nature's law, may be encouraged to settle for that reason and make Tayouan their home.

Coming to the third point: I believe that for the time being, the practice of giving out 'permits to sail' to some junks and also to the free merchants who apply for them must be continued, provided that they pay duties upon arrival and departure. And also if possible the proviso should be introduced that they may peddle and sell their goods only in Tayouan and not in Chincheo or elsewhere, as a result of which the Chinese, once having been drawn to Tayouan with their products, will be tempted to settle there and increase their numbers.

(Jan Pietersz Coen, the Governor-General in Batavia, died on 29 September 1629. It took some time before the news reached Tayouan. Putmans writes to Coen a week later:)

60. Missive Governor Hans Putmans to Governor-General Jan Pietersz. Coen.
VOC 1098, fol. 39-43. Extract.

fol. 40: "Den 23 deses sijn de Bandanesen tot 19 in 't getal wechgeloopen, doch hope dezelven in 't corte weder te crijgen.

Wij hebben datelijc in alle de dorpen boden gesonden, bij soverre sij paijs willen, gelijck sij voorgeven, dat sij de Bandanesen die in hunne dorpen verschijnen datelijc terugge senden ofte dat wij anders genootsaeckt zouden sijn die te comen wederhalen. Temeer geven wij gelooff dat zij ons de Bandanesen sullen wederom sturen, omdat eene van de matroosen van onse gebleven wanckans op een stuck van 't roer voor Choelonch te lande gekomen ende van de swarten was aengehaelt. Dewelck van de Chinesen verstaen hebben een bode aen die van Choelonch gesonden. Ende hun aen laten seggen dat wij seer verwondert waren dat sij eene van ons volck daer hielden, naerdemael zij paijs versochten."

fol. 40: On 23 September the Bandanese slaves, up to 19 in number, ran away but we hope to recover them soon.

We immediately sent messengers to all villages to inform them that if they want peace as they pretend to, they should send back straight away all Bandanese who appear in their villages or else we would be forced to fetch them. We do believe that they will send the Bandanese back to us, because one of the sailors on our shipwrecked wancans washed ashore at Choelonch on a piece of the rudder and was well received by the blacks. When we heard this from the Chinese, a messenger was sent to the people of Choelonch, to let them know that we were very surprised that they were keeping one of our people in their midst, while they were asking for peace.

61. Dagregister Zeelandia.
VOC 1101, fol. 389. Extracts 8, 10 October 1629.
DRZ, Vol. I, p. 2.

"Den 8 dito. Heeft de heer gouverneur op Saccam weder een plaatse tot op-bouwinge van een huys doen begrijpen ende afsteecken, ten eynde weder het velt veylich mochte gebruycken, niet van de wilde soodanich perijckel te loopen als wel voor dato geschiet was.

Den 9 dito. Quam alhier een inwoonder van Sincan ons uyt last van den raadt aldaer, genaempt op haerlieder spraacke *Tackatackusach*, aendiende, hoe ontrent de 500 soo Baccalouanders als Mattauwers opgetrocken waeren ende omde de zuydt hun versterckte, geïntentioneert zijnde bij avondt een aenval op 't voorseyde nieu begonnen huys te doen, niet begerende wij daer weder zoude metselen ende wijders oock een aenslach met verraadt op 't fordt te doen.

Den 10 dito. Wierdt den raadt door d'Edele heer gouverneur voorgehouden, oft men deses dreygementenshalve het begonnen huys op Siaccam weder woude raseren, alsoo seer weynich volck tot desselfs besettinge connen gelecht werden, 't soude 't garnisoen grootelijcx geswackt werden. Waerop bij den hartenvangst als om steen, calck etc. daar te branden seer gedienstich was ende niet wel conde geëxcuseert werden, met d'heer gouverneur goetge-vonden heeft met het opbouwen van 't huys voort te vaeren ende soo defen-cijff te maacken, dat met weynich volck daerop volcomentlijck voor den wilden aenval bestandt zij. (...)

Op dato 16 voorseyt verthoonde haer onse bij het voorseyde huys omtrent de 400 à 500 wilde, doch sijn buyten scheut gebleven. Den sergant met 8 à 9 musquettiers, sich te landewaerts begeven hebbende omme 3 à 4 wiltschutten

in te haelen uyt vreese van de wilde mochten aengestast werden, is dapper-
lijck van de wilde vervolcht ende met meer als hondert pijlen ende assegayen
naargeschooten, doch niemandt van d'onse gequest geworden. Hebben voorts
den geheelen dach ontrent 't huys gehouden sonder eenich vorder attent."

October 8: At Saccam the Lord Governor ordered a new site on which to
build a house to be measured and marked out so as to make use of the plot
of land again safely and not to run the risk of being attacked by the savages
as was the case before.

October 9: An inhabitant of Sincan came here to announce that by order of
their council, called the *Tackatackusach* in their language, about 500
inhabitants from Baccaluan as well as from Mattau had gone out to fight and
were regrouping on the southern side, with the intention of attacking this
recently started house by night, because they did not want us to build there
again, and also to attack the fort by treason.

October 10: The suggestion was made by the Honourable Lord Governor to
the council whether in consideration of these threats the house already
started could better be demolished again, since very few soldiers could be
spared for its defence and in the case of defeat and because the garrison
would be greatly weakened. The council paid careful attention to this and it
took into consideration how important the location was, useful for deer-
hunting as well as making bricks and mortar, and that it could not be
missed. And in conjunction with the Lord Governor, the council decided to
proceed with the construction of the house and to build it so strong that,
with a small number of soldiers in it, it would be able to resist attacks by
the natives completely. (...)

On the 16th of this month 400 to 500 natives appeared near the house in
question, but they stayed out of shooting-range. The sergeant who had gone
inland with eight or nine musketeers in order to call back three or four
game-hunters for fear that they might be attacked by the natives, was
fiercely pursued by the natives and targeted by more than a hundred spears
and assegais, but none of our men was harmed. We had them around the
house for the rest of the day without any more attacks.

62. Dagregister Zeelandia.
VOC 1101, fol. 389-390. Extract 5 November 1629.
DRZ, Vol. I, p. 3.

"Den 5 dito. Is een soldaet, liggende op 't nieuw gemaeckte huys op Siaccam ende om eenich wilt te schieten uytgegaen sijnde, van 4 à 5 Mattauwers dootgeslaagen, 't hooft affgesneden ende medegenomen, (fol. 339) daer sij groote superstitie mede bedrijven ende groote feeste omme houden, als hebbende eene treffelijcke victorye over hunne vijanden (daer wij nu alomme van haerlieden voor verclaert sijn) gehadt."

November 5: A soldier stationed in the newly-constructed house at Saccam, who had gone out to shoot some game, was beaten to death by four or five villagers from Mattau and decapitated, his head they took with them. With it they indulge into considerable superstition and they celebrate because of it, as if they have won an outstanding victory over their enemies (which is what they declare us to be far and wide).

63. Dagregister Zeelandia.
VOC 1101, fol. 390. Extracts 6, 7 November 1629.
DRZ, Vol. I, pp. 3-4.

"Den 6 en 7 dito. Hebben de wilden hun omtrent het voorseyde huys op een hoochte stijff een musquetscheut lengte van daer met omtrent hun 30, gewapende met schilden, assagayen, pijl ende booch, verthoont, makende eenige bravades met schieten ende hunne schilden om 't hooft te laaten gaan, doch onder scheut van 't huys niet gekomen. 't Schijnt, sij met partijen 't landt bewandelen ende met verraet eenich vordeel op d'onse soucken te behaelen. Des avonts verstonden, twee Chineesen, die met weynige cleetgens naar de dorpen te vercoopen waeren uytgegaen, van de wilde bij de wech mede dootgeslagen waaren, dat ten hoochsten te verwonderen is, vermits alle toevoer van cleeden, sout ende andere nootlicheden van deselve moeten becomen ende sonder deselve niet wesen mochte leven connen. Hebben noyt voor desen, daer men van gehoort heeft, eenich Chinees leet gedaen, veel min gedoodt, sulcx oock dat soodanich in hunne dorpen sijn gemenichvuldicht, dat het getal de naturelle selffs bijcans excedeert, in vougen dat te besluyten is, de verbittertheyt haerder gemoederen gantsch groot moet zijn, temeer geen resistentie van ons becomen, jae laaten hun, naar uyt alle acte connen speuren, vastelijck voorsta[en], wij haer sellfs vreese ende niets in

wederwraacke dorven bieden ende is te verwachten, nochte de gemoederen tot ons versachten, voor ende alleer haeren trotsigen ende arrogantschen hoogmoet bij middel van uytterste gewelt ende totale ruyne van menschen ende dorpen ter neder gesmeten sal sijn ende alsoo vanselffs onse vrunt-sc[hap] weder comen versoucken; sonder des is oock naar alle apparentie niets goets, maer veeleer meerder verbitter[t]heyt der gemoederen van deselve t'onswaerts te verwacht[en]."

November 6 and 7: The natives have shown up on a hill near the aforesaid house at the distance of about a musketshot, about 30 of them, armed with shields, assegais, bows and arrows. Shooting off a few arrows and banging their shields around their heads out of bravado, but they did not come within shooting-distance of the house. It seems they wander about the land in groups and try to gain some advantage over us by treachery. In the evening we heard that two Chinese, who had gone out to the villages to sell a few piece-goods, were also killed on the road by the natives, which is very amazing because they have to get all their supply of piece-goods, salt, and other necessities from them and cannot exist or live without them. They never ever harmed a Chinese before as far as we know, let alone killed one, but on the other hand these have swelled so much in numbers in their villages that their number almost exceeds that of the natives, from which should be concluded that their feelings must be very bitter, all the more so because they do not meet with any resistance from us. Yes, they even purport, as can be understood from what is going on, that we are afraid of them and that we have no means to seek vengeance in our turn. And it is to be feared that as long as this continues we may not expect any friendship from them, nor will we mellow their feelings towards us, if their overween-ing and arrogant haughtiness is not crushed by means of extreme violence and the complete destruction of people and villages, so that they will come to sue for our friendship again of themselves. Without this it is obvious that nothing good, but instead only more bitterness in their feelings towards us, is to be expected.

64. Resolution. Tayouan, 17 November 1629.
VOC 1101, fol. 424-437. Extract.
ZENDING, Vol. III, pp. 49-50.

"Oordelen de beste middelen, die voor eerst, ja voor al aengewendt connen
werden, om deselve te civiliseeren ende subject te brengen, een totale ruyne
aen persoon, goederen etc. der ghene die principale autheurs van dese
moordt ende andere dagelycse geuseerde insolentiën geweest waaren,
namentlijck die van Mattauw ende Baccalouan; hoopende hier door haer
soodanige vreese en schrik sal aencomen, dat eerlangen sullen commen ons
het hooft inden schoot te leggen en onse vruntschap op het vierrichste te
versoucken. Dat zoo sijnde, was weynich te twyffelen ofte soude voorders
dan soo geciviliseert en ons onderdanich gemaeckt connen worden, dat der
christelijcke regligie voortplantinge door Godes genade een gladder voort-
ganck zoude nemen als voor desen gedaen hadden, daer anders naar alle
apparentie met vruntschap niets goets van haerlieden verwachten, veelmin
voorderinge tot de Christenheyt te hoopen hadden. Weshalve by den raadt
naar rijpe overweginge goet gevonden en geresolveert is, soo haest de
Jachten uit China alhier weder verschijnen, datmen 't dorp Baccalouan,
sijnde wel het swacste van volck, niet boven de 300 coppen sterck, alleen-
lijck sal aentasten om by dat middel te sien ofte weder tot onse devotie ende
civilisatie soude connen gebracht werden."

(...) We are of the opinion that the best methods to be employed first and
above all in order to civilize and subject them are the complete destruction
of the person, goods etc. of those who have been the principal perpetrators
of this murder and of other insolence inflicted daily, meaning the people of
Mattau and Baccaluan. By this we hope to frighten and alarm them in such
a way that before long they will shortly come to submit to us and sue for
our friendship ardently. If this was a fact, it would be beyond doubt that
they would be made so civilized and submissive that the propagation of the
Christian Faith would by the grace of God proceed more smoothly than
before, whereas otherwise most likely we could not expect anything good
from them in friendship and even less could not hope for any progress in
conversion to Christianity.

Therefore it has been agreed and decided by the council after careful
consideration that, as soon as the yachts from China appear again, only the
village of Baccaluan, which has the smallest fighting population, no more

than 300 heads strong, will be attacked in order to see if by that method it could be brought back into our religion and civilization.

65. Dagregister Zeelandia.
VOC 1101, fol. 390v. Extract 23 November 1629.
DRZ, Vol. I, pp. 4-5.

"Den 23 dito. Sijn omtrent 230 gewapende mannen, soo soldaeten, als vaerent volck naer Baccaluan vertrocken omme 't selve, volgens resolutie op 17 deser gearresteert, door vier en sweert te ruïneren, die des volgende daechs sijn geretourneert, hebbende ettelijcke menschen gedoodet ende 't meerendeel van 't dorp verbrandt, daer in fure van d'onse 3 à 4 sijn gequetst geworden, soodat alleene den bottelier van 't jacht *Slooten* perijckel van leven te verliesen mede gemengt is."

November 23: About 230 men, soldiers as well as crew, left for Baccaluan in order to destroy it by fire and the sword in accordance with the Resolution of the 17th of this month and they returned the next day, having killed several people and burned most of the village, during which three or four of our people were wounded, but to an extent that only the steward of the yacht *Slooten* is in danger of losing his life.

66. Dagregister Zeelandia.
VOC 1101, fol. 390. Extract 28 November 1629.
DRZ, Vol. I, p. 5.

"Den 28 ditto. Item is heden naer Sincan vertrocken d'heer gouverneur Putmans, geaccompagneert van omtrent 50 soldaeten om weder een plaatse tot opbouwinge van een huys aff te zien alsmede een plaatse, omtrent een quartier uyr gaens van daer op de riviercandt, om een redout op te werpen tot een rendevous voor d'onse, wanneer uit Sincan moest wijken, alsoo Sijn E. van meyninge was dominum Candidium weder met eenige soldaeten, gelijck voor den oorlooch, aldaer te leggen omme de Christelijcke religie onder de inwoonders te excerceren, alsoo verhoopte, de gemoederen der ingesetenen van Baccaluan t'onswaerts getrocken connen werden, temeer alreede bewijs daervan aen ons hadden laten blijcken; hebben die van Mattauw onse (fol. 391) vruntschap door twee Chinesen wegen haeren raadt afgesonden, doen versoucken ende die van Baccaluan door dien van Sincan haere beste crijchswapenen ons doen overleveren, tot een teycken wij haer

verwonnen ende in ons gewelt gebracht hadden, daeromme voortaen oock betoonen wilde, wij haere overhooffden waeren ende onse genade ende ongenade haer onderwerpen. Des volgenden daechs is d'heer gouverneur weder met 't gantsche gevolgh hier gecomen, sijnde van de inwoonders volgens hunne costume wel getracteert geweest hebbende de plaatse tot een huys ende redoutes opbouwinge affgesien."

November 28: Today Governor Putmans left for Sincan accompanied by approximately 50 soldiers in order to inspect another site for the construction of a house, as well as a place on the riverbank about a quarter of an hour from there where a redoubt can be built to serve as a rendez-vous for our people if they have to leave Sincan, since His Honour is planning to have the Reverend Candidius reside there again with a few soldiers, just as before the war, in order to practise the Christian Faith among the inhabitants and since he hopes that the sentiments of the inhabitants of Baccaluan may be drawn towards us, the more so as they have already given us evidence of this. The people of Mattau sued for our friendship through two Chinese sent by their council and the people of Baccaluan by the handing over of their best weapons of war to us through the Sincandians, a sign that we had conquered them and brought them under our power and therefore they henceforth wanted to show that we were their masters and they were subject to our mercy and displeasure.

The following day the Lord Governor returned here with his complete retinue and he has been received well by the inhabitants according to their customs. He inspected the places where a house and a redoubt will be built.

67. Dagregister Zeelandia.
VOC 1101, fol. 391. Extract 2 December 1629.
DRZ, Vol. I, pp. 5-6.

"Den 2 december. Sijn de ingesetenen van de dorpen Baccaluan ende Mattauw op Siaccam gecomen ende van daer door een gecommitteerde aen d'heer gouverneur doen versoucken, ofte liber ende ongemolesteert bij Sijn E. op Teyouan mochten verschijnen omme van vrede te tracteeren etc., 't welck haer is geaccordeert ende derhalve dominum Candidium gesonden om haer te haelen. Dewelcke hier comende, sijn met drij cherge van musquetterij als vrunden ontfangen ende ingehaelt ende naer onderlinge discourssen

naervolgende conditie voorgehouden omme die naer te comen, sou anders onse vruntschap sochte te verwerven ende genieten.

Eerstelijck, dat sij alle de hoofden ende gebeente van d'onse, bij haer in 't masacreren verovert, sullen restitueren.

Ten tweeden, van gelijkcken alle de wapenen.

3). Een jaarlijcse eerkentenisse.

4). De Chineese cabessa van Baccaluan, met namen Hoystee, die geafirmeert wert een groot instigateur tot dit feyct geweest te sijn.

5). In onse handen te leveren sooveel jonge persoonen als van d'onse vermoort hebben omme daermede te handelen als d'E. heer generael op Battavia te raaden vinden sal.

6). In ostage te setten sooveel persoonen als van d'onse in haere respective dorpen, gelijck voor dato in Sincan gewoon waeren geweest te doen, mochten gelecht werden, ten eynde segoure daer mochte frequenteren.

Op welcke voorseyden poincten naervolgende te presteren belooft hebben, namentlijck:

1). Alle de hooffde ende gebeente van d'onse te sullen restitueren.

2). Alle de wapenen.

3). Een jaerlijckse erkentenisse.

Tot de rest hebben niet connen condescenderen ende alsoo d'heer gouverneur van meyninge was eerstdaechs naer China te reysen, heeft haer uytgestelt tot zijne wedercompste omme interim haer volcomen tijt van beraidt op de resterende poincten te doen hebben.

Des avondts sijn sijlieden weder vertrocken, belovende haeren raadt sulcx te willen aendienen ende, soohaest de heer gouverneur weder van China quam, weder aff te comen."

December 2: The inhabitants of the villages of Baccaluan and Mattau came to Saccam and through an envoy they requested the Lord Governor that they could present themselves before His Honour at Tayouan freely and unharmed in order to make peace. This was agreed and therefore the Reverend Candidius was sent to fetch them. After their arrival here they were greeted and received like friends with three salvoes of musket-shots. And after some discussion, the following terms were presented to be taken into account if they wanted to gain and profit from our friendship.

1). In the first place, that they will return all the heads and bones of our men obtained by them in massacres.

2). In the second place, the same thing with all the weapons.

3). An annual tribute.

4). The Chinese cabessa[41] of Baccaluan by the name of Hoytsee, of whom it is confirmed that he was a great instigator of the events [should be handed over].

5). To be handed over to us as many young persons as they had killed of our young men, with the intention of doing with them whatever the Honourable Lord General will think advisable.

6). To keep hostage as many people as we have in their respective villages, as we used to do formerly in Sincan, in order to go in and out safely.

With regard to these points they promised to effectuate the following, which is:

1). To return all the heads and bones of our men.

2). The same with all the weaponry.

3). An annual tribute.

We were not able to reach agreement on the other points and the Lord Governor, who is planning to go to China one of these days, has postponed discussing them and in the meantime allows them time for reconsideration of the remaining points until his return.

In the evening they left again promising to present this to their council and to return as soon as the Lord Governor comes back from China.

68. Original Missive Pieter Nuyts to the Amsterdam Chamber. Batavia, 15 December 1629.
VOC 1098, fol. 319-320. See also: General Missive, VOC 1097, fol. 51.
FORMOSA, p. 92.

> "In somma, den standt in Tayouhan mocht wel beter wesen. In Japan is apparent groote misnoegen; den Spaingnaert dreycht Tayouhan; die van Mattauw hebben meest alle de beste soldaten van 't fort vermoort ende de rovers houden de cust van China onveyl, soodat sonder negotie sitten; d'Almogende, verhoopen wij, sal daerin ten besten van de Compagnie versien".

(December 15, The half-yearly letter from Governor-General and Council at Batavia to Amsterdam refers to the murder of fifty-two good soldiers and experienced officers on a river north of Tayouan. This murder by Mattau villagers could have been prevented had the troops been less careless.)

In conclusion, the situation at Tayouan could be better. In Japan there clearly exists a lot of dissatisfaction. The Spaniard menaces Tayouan. Those from Mattau have killed most of the best soldiers of the fortress, and the pirates disturb the peace at the coast of China so that we are without trade; The Almighty, we hope, will show Providence to the Company.

1630

69. Dagregister Zeelandia.
VOC 1101, fol. 396-397. Extracts 1, 2, 3, February 1630.
DRZ, Vol. I, pp. 15-16.

"Den 1, 2, 3 februario. (...) D'heer gouverneur Putmans in Teyouan zijnde, heeft met de overhooffden van Baccalouan ende Mattauw een accoordt van vrede voor den tijt van 9 maenden getroffen onder naervolgende conditiën, namentlijck:

2). Ten [eerste en] tweede sullen die van de voorseyde dorpen restitutie doen van alle de hooffde ende gebeente alsmede het geweer ende alles wat in 't masacreren van d'onsen becomen hebben.

Ten derden sullen die van de voorseyde dorpen jaerlijcx gehouden sijn op denselven dach van 't jaer, dat sij de verradische ende trouweloose moordt aen d'onse begaen hebben, tot erkentenisse van haere misdaet uyt ider dorp aen 't casteel te leveren een groote soch ende beer.

4). Dat sij sonder eenich tegenseggen sullen consenteren, dat alle Chineese in haere dorpen ofte daeromtrent woonachtich om de drye maenden eens t'elcken een nieuw hoofdbriefken comen haelen.

5). Dat sij in geenderley wijse eenige zeeroovers sullen vermogen met victualie, ammonitie van oorloge ofte andersints te stijven, veel min in haere dorpen ophouden ende eenige huysvestinge te geven.

6). Ende laasten sullen die van Mattauw ende Baccalouan, opdat alles onverbreeckelijck ende bondich naergecomen werden, uyt ijder dorp twee van hunne principale kinderen als ostagiers ons ter handt te stellen, waertegens weder gelijck getal van d'onse in haere dorpen sullen gelecht werden."

February 1, 2, 3: The Lord Governor Putmans residing in Tayouan concluded a peace treaty with the heads of Baccaluan and Mattau for a period of nine months on the following terms:

2). In the [first and] second place, the inhabitants of the abovementioned villages will return all the heads and bones as well as weapons and everything else they laid their hands on in the massacre of our men.

3). In the third place, the inhabitants of these villages will be obliged to deliver annually, on the same day of the year that they committed the treacherous and perfidious murder of our men, a large sow and boar from each village to the castle as an acknowledgement of their crime.

4). That, without raising any objection, they will consent to all Chinese living in or near their villages to come and obtain a new 'head tax' permit, once in every three months.

5). That in no way they will try to support any of the pirates by giving food, ammunition for war or other provisions, let alone have them in their village and lodging them.

6). And finally in order to guarantee the infrangible and concise observance, the inhabitants of Mattau and Baccaluan must hand over as hostages two of the principal children of each village, for whom a same number of our soldiers will be posted in their villages.

70. Missive Reverend Georgius Candidius to Governor-General Jacques Specx. Tayouan, 27 March 1630.
VOC 1100, fol. 6.

fol. 6: "(...) want in mijn absentie (sijnde den meestendeel Heer Nuyts bij haer) groote ongeregeltheden en schandaelen streckende tot naedeel ende verwerpinge van 't geene ick haer geleert aldaer begaen sijn. Waere te wenschen, soo het geoorloft is om qualijck te wenschen, dat se van geringe stanspersoonen geschiet waren. Doch ick sal mijn devoir doen om deselve weder wech te nemen ende dit kercklijcke voorgenomen werck door de hulpe Godt te vorderen. Haer toeschijnt hoochlijck van noode te zijn, datter politicque wetten (want sij sonder wetten leven) gestelt wierde ende dat de overtreders op eenige maniere gestrafft ende alsoo onder subjeckt ende dwanck gebracht wierde, want sonder dit schijnt het lancksaem voortganck te willen nemen. Ick en can niet meer doen als haer leeren ende, soo sij niet en willen luijsteren naer 't geen ick haer leere, hen de toecoemende straffe Godts vercondigen.

Maer veel sijnder, dewelck veeleer door vreese van menschelijcke als van goddelijcke straffe tot haeren schuldigen plicht connen gebracht werden.

Belangende het dooden van haere kinderen, dat ick maer een articul noeme, meijne vastelijck, soo daer een straff op geset wierde, dat degeene die daer haere kinderen dooden drij groote verckens (want sij malcanderen in 't verongelijcken op soodaenige maniere met eenige verckens aff te nemen straffe) tot boete moeste geven, dat sij 't éér soude laeten als off ick haer over sulcx quaet dach ende nacht den (fol. 6v.) tijtelycke ende eeuwigen torn Godts vercondichde. Daer waeren twee dochters in een huijs, allebijde in de kennisse der Christelijcke reliegen tammelijck onderwesen, dewelck, als ick verstonde dat se allebijde swanger waeren, hebbe bij haer in huijs gecoome.

Haer vermaendt, alle redenen gebruyckende, dat se haere kinderen niet en soude dooden. Maer sulcx niet conne vercrijgen: hebben se allebeyde gedoot ende wech gesmetten.

Wat can ick meer daertegen doen? Met droffenisse moet ick sulcx voor mijn oogen sien ende can 't niet remedieeren daer sij 't van vrese van tijtelijcke straffe wel souden laeten. Ende Godt gave dat hetselvige een kint niet van Christus ende hooge affcompst waere. Ende sulcx dan alle haere ongeregel- theeden ende affgooderijen.

Dit van de religieuse saecken belangende deese inwoonderen. Hoe dat se tegens ons gesint sijn, is mijn gevoelen dat se noch niet goedts in de schilt voeren.

(...) Die van Mattauw maecken sich heel vast eenen dubbelen pagger ende die van binnen vol clij, rontsoms haer dorp met eenen loopgraeve met noch veel halve maenen, soodat ick uit dese ende diergelijcke dingen daegelijcx affneme, dat se niet veel goedts in den sin hebben."

fol. 6: (...) Because in my absence[42] (when Mr Nuyts was with them most of the time) considerable irregularities and scandals occurred, being a disgrace to and repudiation of all that I taught them. I wish, if indeed one may wish ill of people, that these were perpetrated by people of less good standing. But I will not shirk my duty in eliminating this evil and then proceed with this committed Christian work with God's help. In their case it seems most urgent to enforce political laws (for they live without any laws), to punish the offenders in one way or another, by so doing bringing them under authority and discipline, because without this it seems there would be little progress. I can do no more than teach them and proclaim to them God's appropriate punishment if they are not prepared to listen to what I teach them.

But there are many who are more likely to be called to account for their guilt by fear of human rather than by fear of God's punishment.

Regarding the killing of their children, which I call only a fraction of the problem, I am strongly of the opinion that when it comes to punishment, those of them who kill their children would sooner abandon the habit if they were fined to give away three large pigs (because after an offence they punish each other in this manner: by taking away a few pigs), than if day and night (fol. 6v.) I proclaimed God's temporal and eternal wrath about such wrongdoing.

There were two daughters in one house, who both had a fairly good knowledge of the Christian Faith. When I heard that they were both pregnant I went to their house. I warned them, using all possible arguments, not to kill their babies. But I failed in the attempt. They killed them both and threw them away.

What else can I do against it? With grief I must witness this before my very eyes and I cannot redress it, but they might refrain from it for fear of temporal punishment. And I wish to God that this child neither was of high ancestry nor did belong to Christ the Lord.

And these were all their irregularities and idolatries.

These then are the religious matters regarding these natives. Concerning how ill-disposed they are towards us, it is my feeling that they are still up to no good.

(...) The people of Mattau are building a very sturdy double palisade, banked up with clay on the inside, all around their village with a ditch with a fair number of crescents, so that I conclude daily from this and similar things that they have nefarious plans.

71. Dagregister Zeelandia.
VOC 1101, fol. 441. Extract 17 April 1630.
DRZ, Vol. I, pp. 27-28.

"17 ditto. Is d'heer gouverneur Putmans ende compagnie weder teruggekeert, zijnde op 15 stantij van hier vertrocken omme in 't dorp Zincan een bequame plaets tot opbouwen van 't voorgenome huys af te sien alsmede om bequame wegen ende toegangen, zoo te voet als te paarde, naar de dorpen Zincan, Zoulang, Bacaluan ende Mathau te bespeuren, opdat, in toecomende des van noode zijnde yts op deselve te attenteren, met minder gevaer in voornoemde dorpen ofte ijder desselfs soude mogen comen. In Zincan comende, verstont Sijn E., dat die van Zoulang, Bacaluan ende alle andere omliggende dorpen fol. 441: in Mathau waeren vergadert om tegens die van Tierasan te vechten, weshalven Sijn E. resolveerde wijders met sijn geselschap, bestaande in 15 à 16 soldaaten als andere persoonen, naer oudt-Bacaluan te rijden, sijnde de weerbaarste manschap als voorn. naer Mathau verreyst, omme te zien ofte aldeaer niet seeckere Chinees, Hoytche gena[emt], cabessa van Bacaluan zijnde, die gesustineert wert inventeur van de moort aan de 63 onser natie, jongst bij die van Mathau ende Bacaluan begaan, geweest te zijn, mitsgaders een van de jongste gevluchte Bandanese, zich aldaer onthoudende, in stillicheyt soude connen verraschen. Doch voor

't huys van de voornoemde Chinees in Bacaluan comende ende onder schijn van daer te willen eeten, naer hem vragende, wierde geantwoort, dat mede naer Mathau in de vergaderinge was ende is Zijn E. alsdoen, sonder te bethoonen dat gemelte cabessa sochte, van daer gereden. Haer verder naer den Bandanees vragende, zeyde, dat hem in haer nieuw dorp, onlangs bij haer gebouwt ende omtrent 2/3 mijl van het oude gelegen, onthielt. Zijn E. derhalven naer voornoemde plaetse rijdende, heeft aldaer belast, dat sij den Bandanees souden voor den dach brengen ofte Zijnne E. wilde haer nieuwe werck terstont aen brandt steecken ende, als het oude dorp voor desen was geschiet, ter ruyne brengen. Waarover soo verbae[st] sijn geworden, dat terstont eenige uyt haere hebben gesonden om den Bandanees, die sij seyden uyt vischen was, te haelen ende wederkeerende brachten sijn vischtuych, maer hijselve was het ontcomen, doch egter beloofden hem binnen 2 à 3 dagen aen Sijn E. ter handt te stellen op pene van de gedreychde straffe onderworp[en] te sijn. Ende is Sijn E., alsdoen geheel bequame paden om in 't noordermouson soo te voet als te paerden te gebruycken, jae langs desel-ve, sonder af te stijgen, tot in Bacaluan ende Mathauw connende comen, die voor dat onbekent waeren geweest, gevonden te hebben, weder herrewaerts gekeert.

19 ditto. hebben die van Bacaluan alhier gebracht ende aan ons ter handt gestelt den gevluchten Bandanees, hebbende sichselfs, apparent uyt vreese voor straffe, swaerlijck verwondet."

April 17: The Lord Governor Putmans and troops returned, having left here on 15 March in order to inspect a place in the village of Sincan suitable for the construction of the planned house and to explore roads and entries to the villages of Sincan, Soulang, Baccaluan and Mattau suitable for men on foot and for horses, so that, were these needed in the future, by paying attention to such things they might be able to approach these villages or one of them with less danger.

Upon his arrival in Sincan, His Honour was informed that the inhabitants of Soulang, Baccaluan and all the other surrounding villages were assembling in Mattau preparing to fight against the inhabitants of Tirosen. Therefore His Honour decided to ride on to old Baccaluan, with his company consisting of 15 or 16 soldiers and other persons. The best fighting men and His Honour travelled on to Mattau in order to see if a particular Chinese by the name of Hoytche, cabessa of Baccaluan (who is under suspicion of being the instigator of the killing of 63 of our nation, which was committed recently by inhabitants of Mattau and Baccaluan) and also one of the recent fugitive

Bandanese who was staying there, could be taken by surprise. But when they arrived at the house of this Chinese in Baccaluan and asked for him, pretending they wanted a meal, the reply was that he had also gone off to the meeting in Mattau. So His Honour left the house without letting them know that they were looking for this man, the cabessa. When they continued on their way asking about the Bandanese, they said that he was residing in their new village which had been built near them recently and situated approximately two-thirds of a mile from the old one. Therefore, His Honour went to this place and ordered them to hand over the Bandanese or His Honour would immediately set fire to their new work and destroy it, in like manner as had happened before to the old village. They were so amazed by this that they straightway sent a few of their men to fetch the Bandanese whom they said was out fishing, and when they returned they brought back his fishing-tackle, but he himself had escaped. However, they promised to hand him over to His Honour within two or three days on penalty of being subject to punishment.

And His Honour returned again after he had found very suitable paths to use on foot and on horseback in the northern monsoon, by which he even managed to come all the way to Baccaluan and Mattau without dismounting once.

The inhabitants of Baccaluan have brought the fugitive Bandanese here and handed him over to us, who clearly from fear of punishment had severely wounded himself.

72. Dagregister Zeelandia.
VOC 1101, fol. 441. Extract 13 May 1630.
DRZ. Vol. I, pp. 28-29.

"13 ditto. Arriveert alhier met d'joncque *Zincan* den stuerman Blacq, op 9 deser vertrocken zijnde, hebbende de custe deses bezuyden Teyouan tot aen Tampzui mitsgaders 't Goude Leeuwseylant bezichticht, rapporte[rende] gemelte eylandt, sooveel in 't omseylen hadde cunnen bemerc[ken], vol boomen ende vruchtbaer was. Hadde daer twee persoo[nen] ende op veele plaetse roock sien opgaen, doch geen vaertu[ych] vernomen als twee vlotte van bambousen, daer d'inwoonde[rs] mede waeren vischen. Hadde aen de noordwestzijde van 't eylandt, omtrent een half musquetscheut van 't landt, 26 vadem waters."

May 13: The pilot Blacq, who left on the 9th of this month, arrived here on the junk *Zincan*. He has inspected the coast of this island south of Tayouan down as far as Tampzui and also the island called *the Golden Lion* and he reported that this island, as far as he had been able to detect sailing around it, was full of trees and fertile. He had seen two persons and smoke rising at several places, but had not seen any ships other than two rafts made of bamboo from which the natives were fishing. On the north-west side of the island, about half a musket-shot distance from the coast he had drawn 26 fathoms of water.

73. Dagregister Zeelandia.
VOC 1101, fol. 443v. Extract 8 July 1630.
DRZ. Vol. I, p. 33.

"8 ditto. Is d'heer gouverneur Putmans met eenige soldaeten naer dorp Sincan vertrokken omme aldaer een bequame plaetse tot opbouwinge van 't geordonneerde huys voor domine Candidius ende bijwesende persoonen af te zien."

July 8: The Lord Governor Putmans left for the village of Sincan with a few soldiers in order to inspect a place there suitable for the construction of the house planned for the Reverend Candidius and the people with him.

74. Resolution. Tayouan, 10 July 1630.
VOC 1101, fol. (...).
ZENDING, Vol. III, p. 52.

(The Tayouan Council had decided to build a stone house at Sincan for the Reverend Candidius.)

75. Interrogation Corporal Jan Barentsen, of Delft, and Lancer Juriaen Smith, of Strasbourg. Tayouan, 27 July 1630.
VOC 1100, fol. 13-14.

fol. 13: "Vraag 3. Of de Heer Nuyts met een partije soldaten niet naer Sinckan is vertrocken omme Dycka, inwoonder aldaer, als overste der Sinckanders in Jappan geweest zijnde, gevancklick te nemen ende gemelde Dicka ontvlucht. Ende oft sijn huys door last van gemelde Heer Nuyts niet

is geplundeert, een Japons waepen ende pieck daeruit genomen, de res-
teerende goederen aen stucken geslaegen ende daernaer neffens andere
huysen niet is onder de voet geworpen ende geraseert ende andere Sin-
ckanders bij voorn. Heer Nuyts niet sijn gedreygt (…)?

Antwoord: Seggen jae. (…)

fol. 13v.: Vraag 4: Ofte gemelte Heer Nuyts in Sincan voornoemt niet bij een
heydensche vrouw, *Poeloehee* genaempt, op haere huys is getrout en tot
schenckagie aen haer niet heeft gegeven goede laeckense baeytgens, cleet-
jens, dongris, enckelde damasten ende andere goederen, midtsgaeders een
silveren croon bij de Sinckanders uit Japon gebracht, alsmede een ketting van
gemunt silver met halve reaelen en quartjens, onderaen een geheel reael van
8 hangende (…)?

Antwoord: Segge jae. Van *Poeloehee* selff verstaen hebbe, dat de Heer
Nuyts getrouwt was ende dat alle goederen haer van de Heer Nuyts gegeven
haer wel hebben sien draegen, uitgenomen de croon, maer dat de croon ten
verscheyde reyse te haeren huyse in een canaster hebben sien leggen.

Vraag 5: Off geduyrende dat sij gevragders met eenige soldaeten in Sincan
lagen niet hebben gezien, dat voorn. Hr. Nuyts dickwils in 't voornm. dorp
quam ende aldaer 5 à 8, 10 à 14 daegen, jae somtijts 3 wecken bleeff bij
haer in 't huys gelogeert sijnde ende off niet gemenlijcke des avons na *Poelo-
hee's* huys ginck ende smorgens niet de haene crajde wanneer de Sinckanders
van haere vrouwen opstaen, niet weder bij haer gevragders in sijn loegement
quam?

Antwoord: Segge jae, ende dat gemenelijck met den tolck Jan Houtang alleen
na *Poeloehee's* huys ginck, sonder ander volck bij hem te willen hebben.

fol. 14: Vraag 8: "(…) dat voornoemde *Poeloehee* bij de Heer Nuyts swanger
is geweest ende haer vrucht, wesende een soontgen, verdaen en omgebragt
heeft?

Antwoord: Seggen jae, ende dat degeene van *Poeloehee*, haer moeder ende
suster neffens andere vrouwen die daer bij ende present sijn geweest,
verstaen hebben sijnde *Poeloehee* door haer man, daer sij nu mede getrout
is, gedwongen om sulcx te doen, soo sij seyden."

*(After Pieter Nuyts had been recalled in 1629, an investigation was started
against him. From the interrogation of two soldiers, a corporal, Jan Barent-
sen of Delft, and a lancer, Juriaen Smith of Strasbourg about Nuyts's
behaviour, it becomes clear that Nuyts had managed to find his way to
Sincan while the Reverend Candidius was sheltered in the fort.)*

fol. 13: Third question: Is it true that Mr Nuyts had gone to Sincan with a group of soldiers in order to take into custody *Dika*, an inhabitant of the place had gone to Japan in the capacity of leader of the Sincandians? That this *Dika* had escaped and that his house was then ransacked by order of the said Mr Nuyts, whereby a Japanese weapon and a pike were taken out of it and the rest of the goods smashed to pieces? That afterwards other houses were also trampled under foot and razed to the ground and that other Sincandians were threatened by the said Mr Nuyts?

Answer: The answer is yes.

Fourth question: Is it true that the said Mr Nuyts married in the aforesaid Sincan a woman who was not Christianized, by the name of *Poelohee*, in her house and gave to her as gifts, piece-goods like good woollen baizes, pieces of cloth, dungaree[43], a few pieces of damask and other piece-goods, as well as a silver crown brought from Japan by the Sincandians and also a necklace made of silver coins composed of half and quarter reals and a whole piece of eight as a pendant (...).

Answer: The answer is yes. They had been told by *Poelohee* herself that Mr Nuyts had married her and they saw her wearing all the goods given to her by Mr Nuyts, except for the crown, but on several occasions they had seen the crown lying in a basket in her house.

Fifth question: Did the two persons interviewed see, when they were encamped in Sincan with a few soldiers, that the aforesaid Mr Nuyts often came into the village in question and stayed there for five, eight, ten, to fourteen days, sometimes even as long as three weeks as a guest in her house? And that he usually went to *Poelohee's* house at night and that he came back again to his lodging where the two interviewed were lodged, in the morning when the cock crowed and the Sincandians rise and leave their wives?

Answer: The answer is yes and they add that he usually went to *Poelohee's* house with only the interpreter Jan Houtang accompanying him, not wanting the company of other people.

(To the seventh question, if it were true that Nuyts had some Chinese taken from the villages and had them work the fields in chains in the neighbourhood of Sincan, they also answer affirmatively.)

fol. 14: Eighth question: [Is it true] that the said woman *Poelohee* was pregnant by Mr Nuyts and has caused an abortion and killed the foetus, a son?

Answer: Their answer is yes and they say that they understood from *Poelo-hee*, her mother and her sister and other women who had been present, that *Poelohee* was forced to do this by her husband, to whom she is now married, so they say.

76. Interrogation Merchant Paulus Traudenius. Tayouan, 29 July 1630. VOC 1100. fol. 10-12. Extracts.

fol. 10: "Zegt dat de Zinckanders 't haerder wedercompst uyt Japan van de Heer Nuydts soo quaelijck waren getracteert, de Keyserlijcke ende andere geschencken haar affgenomen."

fol. 11: "De Heer Nuyts de Zinckanders uyt de joncquen heeft doen haelen, op de schepen verdeylen ende aldaer in boijen doen sluijten, hare goederen in 't packhuys doen brengen (...)."

fol. 10: (...) that on their return from Japan the Sincandians were so badly treated by Mr Nuyts, the gifts they got from the Shogun and others taken from them (...)

(He also related that Nuyts did not provide the Japanese in the Bay of Tayouan with water and victuals, so that they were destitute and starving.)

fol. 11: Mr Nuyts had the Sincandians taken from the junks, had them divided up over the ships and clapped them in irons, had their goods taken to the warehouse (...)

77. Missive Governor Hans Putmans to Governor-General Jacques Specx. Tayouan, 5 October 1630.
VOC 1100, fol. 333-345.
ZENDING, Vol. III. p. 53.

(Negotiations were held with the Reverend Candidius on the conditions under which he would enter a new period of service with the Company.)

78. Resolution. Tayouan, 17 December 1630.
VOC 1102, fol. 519v.

fol. 519v.: "Ten tweeden alsoo die van Matthau door haere vermetelheijt ende hoochmoet (als geen straffe over de begaene moort van de onse gevoelt heb-bende) noch dagelijcx met eenige wapenen, cleederen alsmeede 't hooft van

Jacob Hooman zaliger (alhoewel voorheene 't selve hier gebracht is) in haer dorp vertooningh doen; veel smadige ende schandelijcke woorden over voorn. faeijt, t'onser gantscher natie groote cleijnachtinge, vilipendre ende disreputatie onder de andere doorpen streckende uijtspreckende ende eenige poincten des accoorts met hun ende die van Bacalau aengegaen, mede niet naercomen te achtervolgen, waerover 2 à 3 reijsen beneeden te comen ontboden sijnde, naerlatich gebleven ende niet verscheenen sijn. Ende de Hr. Generael in sijne missiven jongst ontfangen ons recommendeerende haerluijden voorn. accoort punctelijc te doen volvoeren, ofte soo niet, die van Mathau naer behooren te straffen.

Alsmede die van Sincan selffe ende Domine Candidius voor haer aen ons diverse reijsen versocht hebbende eenige hulpe oms tegens die van Tampsui te vechten, voorgevende deselve eenige hooffden van de haere becomen hebbende. Voorn. Candidius ende Domine Junius sestineerden deselve assistentie ende victorije tegens die van Tampsui den chrachtichsten middel is om de Christelijcke reliegie niet alleene onder die van Sincan maer oock andere dorpen voortganck te doen nemen.

Of 't dienvolgende niet noodich is, soowel om de achtbaerheijt onser natie in sijn geheel te behouden de schandelijcke moort volcomen te wrecken, die van Mathau tot onse devotie te brengen ende de andere dorpen in toom te houden, alsmeede het heijlige begonnen werck des te meer onder dese heijdenen te doen toenemen, den oorloogh tegens een van beijden oftewel alle beijden vervolgens op 't rigoreuste te beginnen ende bij der hant te vatten. Ende off men voor den aenvanck 't jacht *Bommel* ofte een jonque met de advijsen uijt Japan naer Batavia sal largeeren ofte tot d'uijtcompste des selffs alsnoch ophouden."

(Decision on a punitive expedition against Mattau.)

fol. 519v.: In the second place because the people of Mattau full of boldness and arrogance (because they have not undergone any punishment from us for the murders committed) still make a daily show in their village with a few weapons, clothes and the head of the late Jacob Hooman (although this had been brought here before).

They utter many insulting and infamous words over this fact, expressing great contempt and disdain towards our entire nation as well as the bad name that we are supposed to enjoy in the other villages. To make matters worse, they have not observed several points of the agreement made with them and the people of Baccaluan, about which they have been summoned for two or three times, but they have defaulted and failed to appear. And the

Lord General advised us in his letter which we recently received to see to it that they observe the abovementioned agreement strictly and if they do not do this, to punish the people of Mattau accordingly.

Moreover, the people of Sincan themselves and the Reverend Candidius on their behalf have asked for our assistance several times to fight the people of Tampzui, claiming these had seized a few heads of their people. The aforementioned Candidius and the Reverend Junius believe that this assistance as well as the victory over the people of Tampzui would be the most powerful method of making progress with the Christian Faith, not only among the people of Sincan but also in other villages.

The question is, should it be necessary to declare and wage war on one or on both of them, on the one hand in order to maintain the authority of our nation as a whole, to avenge the infamous murders completely, to win the people of Mattau to our belief and to keep the other villages under control, on the other hand to make progress with the religious work now initiated among these pagans. And we wonder whether we shall dispatch the yacht *Bommel* or a junk to Batavia with the demands from Japan before the events begin or whether we shall delay this dispatch until the outcome is clear.

79. Resolution. Tayouan, 19 December 1630.
VOC 1102, fol. 520v.

fol. 520v.: "Den Raet, op alles naer rijpe deliberatie wel geleth, 't gevolch geconsidereert ende overwogen hebbende, hebben met sijne Edele eenstemmich goet gevonden, omme onse macht niet vruchteloos te houden, maer deselve (terwijl bij den anderen is daer 't vereijscht wert te gebruijcken), bij voornoemde resolutie alsnoch te persisteeren.

Mede de gelegentheijt ende moverende redenen om voorn. dorpen te ruïneeren tegens den anderen gebalanceert.

Seeckere missive door den predicant Candidius aen zijne Edele over 't stuck van Tampsui tot assistentie der Sincanders geschreven, naer gedaene lecture wel gediscureert hebbende.

(Ten aensien die van Mathau alreets, over 't niet voldoen des contracts op houden van de wapenen ende gebeenten ende 't naerlaten van beneden te comen, breder in de voorige resolutie aengeroert. Boven dat noch geen straffe over de begaene moort geleeden hebben. Genochsaem, alhoewel eijgentlijc geen feijtelijcke hostiliteijt bethoont hebben, met ons in vijantschap vervallen sijn).

Ende over sulcx een rechtvaerdige streecke tot verneederinge haeres hooch-
moets ende vreese der andere dorpen over haer vereijscht wert. 't Selve een
machtich ende volckrijck dorpjen, (fol. 521) soodat, als men yets daerop soude
attenteeren, sulcx, éér onse macht gescheijden ende verdeijlt is, moet gedaen
werden.

Hebben wijders geresolveert die van Mathau, soo haest (wij) gereet cunnen
vallen, den oorloch op 't rigoreuste aen te doen ende 't selve op naervolgen-
de wijse in 't werck stellen:

Twee joncquen sullen met alle gereetschappen, victualiën ende anders, aff-
geladen ende secretelijc naar Wanckan gesonden werden, vanwaer haere
compste met een champan hier sullen adverteeren.

Als wanneer de Hr. Gouverneur selffs in persoone (omdat alles met goede
voorsichticheijt ende soo weijnich perickel als doenelijc is, soude mogen
verricht werden) met het geordonneerde volcq in chiampans sal imbarcquee-
ren, met deselve de rieviere van Soulangh soo hooch als geraden vinden
opvaeren ende dan voorts te voet naer Mathau marcheeren. De joncquen
ordre crijgende sullen uijt Wanckan de rieviere van Mathau tot ontrent ¼
mijl aen 't dorp sijlen ende aldaer de goederen gelandet werden."

fol. 520v.: Taking everything into account after careful deliberation and
having considered and weighed up the outcome, the council in concert with
His Honour consented not to let our power lie useless but on the contrary to
use it and carry out the abovementioned resolution.

Serious consideration has also been given to the circumstances and motives
for destroying the villages in question, weighing these up against counter-
arguments.

A special letter sent by the Reverend Candidius to His Honour referring to
the matter of Tampzui and rendering assistance to the Sincandians was, after
reading, well discussed.

As far as the people of Mattau are concerned, referring to the fact that they
do not honour the agreement in respect to the possession of weaponry and
bones and the refusal to come to us, this has been dealt with in more detail
in the previous resolution. Besides, they have still not been punished for the
murders they have committed. Although they do not really show actual
hostility, they have lapsed sufficiently into animosity towards us.

And for this reason a justifiable action is required to bring down their pride
and remove the fear other villages have for them. It is indeed a powerful
and populous village itself, (fol. 521) so that, if we should attack it, the action

must be taken before our armed forces are broken up and divided [for other purposes].

In addition, we have decided to make all-out war on the village of Mattau as soon as we may be ready and we plan this in the following way:

Two junks loaded with all the implements, provisions and other requirements will be sent in secrecy to Wancan. Their passage from there will be announced here by sampan.

When the Lord Governor himself (because all must be done with the greatest caution and as little danger as possible) orders the sampans together with the mobilized forces to set sail, we will go up the river of Soulang with them as far as we judge advisable and then continue to march on foot to Mattau. The junks will be ordered to sail from Wancan and go up the River Mattau up to within about a quarter of a mile from the village and the goods will be unloaded there.

80. Resolution. Tayouan, 27 December 1630.
VOC 1102, fol. 522.

> fol. 522: "Op dato bij de Edele Heer Gouverneur Putmans den Raet beroepen sijnde, wert bij sijn Edele denselven voorgedragen hoe dat de predicanten Candidius en Junius bij sijn Edele waeren geweest ende gerapporteert hadden, dat de Zincanders (volgens de beloften haer bij Candidio gedaen) hunlieden soo importuijn ende lastich vielen om de hulp van d'onse tegens die van Tampsui te genieten, dat sijluijden geen excusen ofte uijtvluchten meer hadden om haer te contenteeren. Jae, bonden de saecke soo hart aen, dat Candidio suistineerde, ingevalle sulcx niet in corte geschiede, dat het begonnen werck ende voortplantinge der reliegie daerdoor niet alleene gesurcheert, maer oock die alreets tot sulcx haer beginne hadden (fol. 522v.) weder terugge soude treden ende meer andere onheijlen daeruijt ontstaen.
>
> Ende het weder, omme ons voornemen op die van Mathau in 't werck te stellen, sich tot noch soodanich verthoont hebben, dat niet mogelijc is in Wancken te comen.
>
> Off men dienvolgende, omme alle onlusten ende swaericheden te vermijden ende door 't niet voldoen onser beloften in geen disreputatie bij dese inlantschge natie te comen, niet en behoorden 't exploict op Mathau soo langh uijt te stellen ende dat op Tampsui ter begeerte van de Zincanders bij der hant nemen cunnen ende 't selve in 3 à 4 dagen verricht werden."

(Eventually the Council gave priority to lending assistance to the village of Sincan in its fight against Tampzui, over a punitive expedition against Mattau.)

fol. 522: The Council, called together by the Honourable Lord Governor Putmans d.d. 27 December 1630, was informed by His Honour himself of the visit of the two ministers, Candidius and Junius, to His Honour during which they reported that the Sincandians (because Candidius had made some promises) were bothering them and pressing them very hard to win our assistance against the people of Tampzui that they could not possibly put them off any longer or find an excuse to appease them. They even went so far in advocating their case that Candidius made a point that, if this did not happen within a short time, the work and spreading of the gospel already under way (fol. 522v.) would not only be delayed by it, but also the people who had already made a start would abjure and from this, more misfortune would be spawned. But the weather turned out to be so bad that it was impossible to carry out our plan and reach Wancan.

The question is therefore whether we should not delay the expedition to Mattau for the time being and undertake the one to Tampzui to please the Sincandians (in order to avoid all the trouble and difficulties and a bad reputation with these natives for not keeping our promises) and we can accomplish that one within three or four days.

1631

81. Missive Pieter Nuyts to Governor-General Jacques Specx. Batavia, 13 January 1631.
VOC 1100, fol. 1-2.

(At the beginning of 1631, the VOC had its hands full with the activities of the powerful Chinese 'pirate' Cheng Chih-lung alias Iquan in the waters between the mainland of Fukien and the west coast of Formosa. In Sincan workmen had begun to build a house for the Rev. Candidius.)

82. Missive Hans Putmans to Governor-General Jacques Specx. In the River Chincheo, 22 February 1631.
VOC, 1102. fol. 446-455. Extract.
ZENDING, Vol. III, pp. 55-56.

fol. 446: "(…) om met joncken buyten om naar Wancan ende vandaer de rivier van Mattau naar ditto dorp op te zeylen. Zijn wij eyndelingh den 29 december passado met de joncken, gereetschap ende volck naar buyten geloopen, maar in zee comende vonden sulcken hollen water, dat niet mogelijck zoude geweest hebben de reijse naar Wancan te gewinnen.

Den predicant Candidius over langen tijt voor die van Zincan bij ons geheel instantelyck geïntercedeert hebbende om eenige assistentie tegens die van Tampzui, haere dootvijanden, te mogen genieten, hadden hem stucxgewijse toesegginge daervan gedaen, dat hij soodanich in conseque[ntie] trock, dat in haere vergaderingen zich met beloften dat zulcx zoude geschieden aan haar verplichte. Twelck ons diverse reijsen verthoont hebbende ende zulcx selffs aen ons door de Zincanders versocht zijnde, sustineren de predicanten Candidius ende Junio dat dit den besten ende crachtichsten middel was niet alleen om onse religie onder die van Zincan, maar oock de andere dorpen te verbreijden.

Wij oock onder pretecxt van naar Tampsui te gaan, goet getal Zincanders mede gevoordert ende gescheept hebbende om ons de wegen ende toegangen naar Mattau aen te wijsen. Zoo is bij ons goet gevonden, siende dat (die) van Mattau geen voortganck nemen soude, (fol. 446v.) omme de Zincanders buyten suspitie ende den Mathause tocht soo veel mogelyck was zecreet te houden ende, dat alle onse preparatie niet vruchteloos wesen zoude, met de joncken, sonder weder binnen te comen, naar Tampsui te loopen, omme alsoo ge-

melde Candidius van zijne beloften te ontslaan ende de toegeseyde hulpe aen de Zincanders te presteren. Connende 't zelve in 2 à 3 dagen ten alderlangsten volbracht werden ende zijn de joncquen ende volck dienvolgende onder het beleijt van den oppercoopman Couckebacker derwaerts geseijlt.

Alwaar comende ende gelant wesende, zijn haar die van 't dorp op 't strant tot binnen scheuts van een musquet gerescontreert tusschen de 2 à 300 sterck; doch op haer gechargeert werdende, retireerden de Zincanders. Haer vervolgende zijn handt tegen handt met assegaeijen aen malcanderen gecomen, alwaer de Zincanders een hooft cregen van de principaelste voorvechters der Tampsuiers. Ende vermidts haar dorp meer als een mijl te landtwaers leijt, de Zincanders zelffs de wegen niet wisten ende niets vooruijt sagen als langh riet ende moerasch, daaruijt voor d'onse niet als perijckel soude ontstaan, zijn weder geïnbarcqueert ende vertrocken.

Den 2 januarij voor Tayouan comende, zijn geheel lieffelijck weder ende slecht water. Hebbe terstont een chiampan aen boort gesonden, dat buijten ten ancker soude blijven ende niemant aen lant zouden laten comen, maar notitie zeijnden van 't geene tot den anderen tocht noodich hadden (…).

fol. 447: Alhoewel den aanslach op die van Tampsui tot hulpe ende con[ten]tement der Zincanders door haare ignorantie van de toegangen tot het dorp bijnaa vruchteloos uytgevallen is, zij maar een hooft gecregen hebben ende noch 3 à 4 andere Tampsuiers onder de voet geschooten zijn (die terstont in 't lang gras ende riet sleijpten soodat de hoofden niet crijgen souden), is nochtans door 't zelve sulcx (fol. 447v.) tewege gebracht ende de gemoederen der Zincanders soodanich t'onswaerts getrocken, dat tegenwoordich 't geheele dorp zich begint te neijgen om onse religie aan te nemen. Alreede eenige van de principaelste, daar de meeste andere tot noch opgesien hebben, haare affgoderijen verworpen ende dagelijcx van Candidius onderwesen werdende, soodat de apparentie tot voortganck van 't selve heel groot ende meer als oyt voordesen haar verthoonen. De Heere verleene daertoe meer ende meer sijnnen Goddelijcke zegen.

't Gevoelen van Candidius omme de Zincanders onder politicque wetten te brengen, door hem aen zijn Ed.t geadviseert, can bij ons oock vooralsnoch niet geapprobeert werden. Ende hebben voorn. Candidius, die aen ons versocht om een politicq persoon tot rechter in Zincan te hebben, daarover sulcken contentement gegeven, dat alsnu niet sustineert, veel gevoechlijcker te zijn voort eerste alles noch bij den *Tackasach* van 't dorp met zijn advies affgedaan wert, totdat zijluijden wat meerder geciviliseert ende onse manieren gewoon zijn.

Tot voltreckinge van 't g'ordonneerde huijs in Zincan sijn meest allen de materialen derwaerts gebracht, soodat verhoopen 't selve in corten tijt

behoorlijc volmaackt ende tot de wooninge voor gemelde Candidius ende
bijhebbende persoonen in [progr]essie sal gebracht sijn, wanneer [hij]
vrijelijck ende sonder eenige der Mathauers als andere te vreesen het goede
begonnen werck sal mogen vervoorderen.

Niettegenstaande de gedreijchde ruïne der Mathauers om voorverhaalde
redenen gesurcheert is, zijn wij echter van meeninge soo bastante macht van
costij becomen, 't selve in 't aanstaande noordermousson te effectueeren:
want soo ons genomen concept (fol. 448) onder haer vruchtbaer werdt ende
geen feijtelijcke hostiliteyt daerop volchde, souden daardoor al te superbe
ende hoochmoedich werden, dat apparent groote verhinderingen in 't Zin-
canse werck causeren soude."

(The following is said about the punitive expedition to Mattau:)

fol. 446: [We decided] to take the searoute to Wancan with junks and from
there ascend the River Mattau to the village of that name. When we finally
put to sea with the junks, equipment and crew on 29 December last, we
came upon such wild waters it would not have been possible to make the
journey to Wancan.

For quite some time the Reverend Candidius has very emphatically been
putting in a word with us for the people of Sincan in order that they might
have some assistance against the people of Tampzui, their deadly enemies.
Bit by bit we have been making promises from which he drew such con-
clusions that he committed himself to them in their assemblies making
promises that this would indeed happen. After this had been made clear to
us a couple of times and had even been requested by the Sincandians
themselves, the ministers Candidius and Junius emphasized the point that
this would be the best and most powerful means by which to spread our
religion, not only among the people of Sincan but also in other villages.

Under the pretext of going to Tampzui, we also summoned and embarked
a fair number of Sincandians to show us the way and the entry to Mattau.
When we saw that the people of Mattau were not going to take any steps,
(fol. 446v.) we decided not to disabuse the Sincandians and to keep the expe-
dition against Mattau as secret as possible and, to ensure that all our prep-
arations were not in vain, to proceed to Tampzui with the junks without
coming ashore first, in order to release Candidius of his promises and to
comply with the obligation to help the Sincandians.

This could be done within two or three days at most and thereupon the junks with their crew sailed to Tampzui under the leadership of Senior Merchant Couckebacker.

Upon arrival there, having come ashore, the Sincandians encountered the people of the village of Tampzui, somewhere between 200 to 300 in number, on the beach within range of a musket-shot, but when they were charged the Sincandians withdrew. The pursuit of the Sincandians ended up in a man to man fight with assegais, in which the Sincandians won the head of one of the principal warriors of Tampzui.

And because their village (Tampzui) is situated more than a mile inland and the Sincandians did not know how to get there, nor were able to see anything ahead but tall reeds and marshland, this could only result into a dangerous situation for us, so our men re-embarked and left.

Upon arrival at Tayouan on 2 January, the weather was very good but the water again was nasty. At once I sent a sampan to the ships to tell them to ride at anchor and to let no one come ashore, but to let us know what was needed for the next expedition. (…)

fol. 447: Although the attack on the Tampzui people, to help and to please the Sincandians, has been virtually without success because of their ignorance of the entries to the village, and they won only one head and three to four other Tampzui men were shot down (who immediately were pulled into the long grass and reeds to avoid losing their heads), it nevertheless has had such (fol. 447v.) an effect that the hearts of the Sincandians have turned so much towards us, that nowadays the entire village is beginning to be reconciled with the idea of converting to our religion. Already some of the principal men, even though most others were reluctant, have repudiated their idolatries and are being taught by Candidius every day, so that obviously progress is great and they give this impression more than ever before. May The Lord's rain his divine blessing upon it more and more.

Candidius's idea of bringing the Sincandians under political laws, which he suggested to His Honour, cannot receive our approval as yet. And to the abovementioned Candidius, who asked us for a person from the civil administration to be appointed as judge in Sincan, we gave such a satisfactory answer that he does not insist; for the time being it would be much more convenient if everything were settled by the *Tackasach* of the village after consultation (with Candidius), until these people are more civilized and accustomed to our ways.

(About the house that is being constructed in Sincan.)

Most of the materials for the construction of the house that have been ordered in Sincan has been taken to the place, so we hope it will be pretty much finished within a short period of time and will be established as a residence for the abovementioned Candidius and his fellows-workers, after which he may proceed with the good work he started freely and without fear of any inhabitant of Mattau or others.

Although the imminent destruction of the village of Mattau has been postponed for the reasons we alluded to above, we nevertheless intend to make this effective during the imminent north monsoon, if we can get reinforcements from there who are ready-to-fight: because if the decision (fol. 448) that we took bears fruit there and is followed by no actual hostilities on our side, they may become too proud and arrogant, which would clearly cause large impediments in the Sincandian project.

83. Missive Governor Hans Putmans to Governor-General Jacques Specx. River Chincheo, 6 March 1631.
VOC 1102, fol. 456-459. Extract.

> fol. 458: "(...) bevinden in Tayouhan zoo te water als te landt noch te resteren 400 blancke coppen, te weten: 210 soldaeten, daermede 't fort Zeelandia, de ronduijt Zeeburch, 't huys op Saccam ende dat in Sincan beset is; 94 soo coopluijden, assistenten, ambachtslieden als matroosen op 4 joncken vaerende; 6 Wiltschutten; 90 Matroosen op de jachten *Wieringen* ende *Assendelft*."

fol. 458: (...) still residing in Tayouan both at sea and ashore are 400 whites, namely: 210 soldiers, including the fort of Zeelandia, the redoubt of Zeeburch, the house at Saccam, and the one in our possession in Sincan. Ninety-four merchants and assistants, artisans as well as sailors sailing aboard four junks. Six huntsmen, ninety seamen on board the yachts the *Wieringen* and the *Assendelft*.

84. General Missive.
VOC 1099, fol. 45.
FORMOSA, p. 94. Extract 7 March 1631.

> "(...) 't vermoorden van volck op Tayouhan, die tot omtrent de 66 aldaer van de Mattauwers verraedelijck omgebracht zijn, wert Zijn Ed. oock seer

te laste geleght, uuyt oorsaecken als Uw Ed. bij de neffensgaende pampieren in handen van de heer Van Diemen sullen believen te sien."

(...) The former Governor of Tayouan the Honourable Mr Nuyts is also heavily charged with the death of about 66 men who were murdered so treacherously by people of Mattau. The reasons for that can be learned from the appended papers in the possession of Mr Van Diemen.

85. Missive Governor Hans Putmans to Governor-General Jacques Specx. Tayouan, 17 March 1631.
VOC 1102, fol. 460-461. Extract.
ZENDING, Vol. III, p. 57.

fol. 461: "'t Huijs in Zincan sal in corten tijt voltrocken wesen. Het goede begonnen werck staet daer geheel heerlijc en sullen in 10 à 12 dagen bij Candidius 50 persoonen die hij daertoe bequaem oordeelt, gedoopt werden. Wij verhoopen dat Godt dagelijcx tot volvoeringe van 't selve meer ende meer Sijnen segen sal verleenen."

fol. 461: The house in Sincan will be completed very soon. The Good Work which was initiated fares very prosperously and within ten to fifteen days 50 people, whom Candidius believes are ready for it, will be baptized. We hope that every day God will grant His Blessing in ever increasing quantities for the fulfilment of this work.

86. Dagregister Zeelandia.
VOC 1102, fol. 583. Extracts 20-24 March 1631.
DRZ, Vol. I, p. 44.

"20, 21, 22, 23, 24 ditto. Is bij d'heer gouverneur Putmans in Zincan geweest omme de provisionneele kerck ende 't geordonneerde huys behoorlijck te doen voltrecken. De voortplantinge der religie aldaer verthoont sich heerlijck, d'Heere geve sulcx meer ende meer mach toenemen, opdat dese arme menschen tot behoudenisse haerer siellen eens tot het waere licht mogen gebracht werden."

March 20-24: The Lord Governor Putmans has been in Sincan to ensure the proper completion of the provisional church and the house which had been

ordered. The propagation of the religion there proceeds apace, may the Lord grant that this waxes more and more, so that these poor people for the preservation of their souls may be brought to the true light.

87. Dagregister Zeelandia.
VOC 1102, fol. 587. Extract 30 April 1631.
DRZ, Vol. I, p. 48.

> "30 ditto. Is bij d'heer gouverneur Putmans ende raet geresolveert, de rivierre ende toegang tot 't dorp Mattauw mitsgaders plaetse om te landen ende andere gelegentheden (om in tijde van vijantlijcke attentaten ons met de kennisse derselver te behelpen) te doen besichtigen; bij ider geordeelt werdende, dat de gedreychde straff op voornoemde dorp om verscheyde redenen, soohaest mogelijck sij, dient volbracht te werden."

April 30: Governor Putmans and Council passed a resolution[44] to have a look at the rivers and the entries to the village of Mattau as well as places suitable for landing and other locations (with the intention of making use of this knowledge in times of attacks by the enemy). All were of the opinion that the impending punishment for the village in question has to be put into effect as soon as possible for several reasons.

88. Dagregister Zeelandia.
VOC 1102, fol. 587. Extract 13 May 1631.
DRZ, Vol. I, p. 49.

> "13 ditto. Compt over Wanckan uyt Matthau weder terugge den opper-coopman Koeckebacker ende bijgevoechde persoonen, hebben alles naer behooren ende tijds des gelegentheyt besichticht, sooveel sonder achterdocht conde geschieden. In Mathau waerren wel onthaelt ende op haerre wijse getracteert, sonder dat conden vermercken, de inwoonders iets van ons concept wisten."

May 13: Senior Merchant Couckebacker and those who accompanied him returned from Mattau by way of Wancan. Within the limits of the time they duly inspected everything, as much as possible without arousing suspicion. In Mattau they were well received and treated according to local customs

and they could not discover anything that indicated that the inhabitants were aware of our plan.

89. Information gathered from Alonce de Taulacke and Domingo de Cavadta as well as from four other persons, all natives of the country lying in the vicinity of Manila, who arrived here from Tamsuy on 30 June 1631 on a small Castilian vessel.
VOC 1102, fol. 552-554. Extract.
Duplicate: VOC 1103, fol. 344v.

> fol. 553v.: "Met de inwoonders van Formosa ofte haere naestgelegene dorpen waeren (wij) d'één tijdt in vijantschap ende d'andere tijdt in vreede sonder nochtans malcanderen hostiliteijt met landttochten ofte andersints te bethoonen, want geen Spangiaerden landewaerts gaen wanneer in vreede sijn. Becomen van deselve niet anders als rijs, pijssang ende petattesen, daerom hier niet anders groeyende. In Caubella, 30 mijlen van Quelangh, valt goudt, maar compt weynich ofte niet aff. Ontrent Quelangh op 't vastelant valt veel houtwerck door de menichte der groote ende dicke boomen die daar groeijen. De steen waermede 't fordt gebout is, hebben uijt de bergen rontsomme de baij ofte inham gelegen, gehouwen ende gebracht. Tampsui ligt ontrent 30 mijlen te lande ende ... mijlen te water van Quelang mede in een inham, doch zoo ondiep ende vol droochte, dat met geen jacht sonder te bevallen binnen te comen is. Heeft rontsomme mede een gladde santstrand ende is overal bequaam om te landen."
> (VOC 1103, fol. 345: "(...) want de twee verscheyden wegen tusschen Quelangh ende Tamsui (waervan d'één altijdt in zee can gesien werden ende de ander te landewaert leijt) sijn gladt, effen ende bequaem om te marcheren."
> (VOC 1102), fol. 554; idem: (VOC 1103), fol. 345: "In Tampzui zijn veel soo boomals aardvruchten, te weten: orangappelen, limoenen, piecang, pattettesen ende meer andere, alsmede veel wiltwerck, soo van herten, reen, etc. Hopende dat zij zulcks vangen ende oock van de inwoonders ruijlen. Zulpher is daar in abondantie, maar wert bij de Spangiaarden niet gehandelt."

(According to their own story, Alonce and Domingo were enlisted by the Spaniards in Manila about seven years ago to escort an expedition to Quelang. In June 1631, they had received no wages for their services for two years. Among the other four persons, there were some who had arrived in Quelang only two years ago. As a group they had fled to Tayouan on a small Spanish ship.)

fol. 553v.: With the inhabitants of Formosa or their neighbouring villages they are sometimes in enmity and sometimes at peace, but without showing hostility to one another by mounting expeditions or in any other way, because Spaniards do not go inland when they are at peace. From these natives we receive nothing but rice, pisang, and potatoes, because nothing else grows here [in Quelang]. In Caubella, 30 miles from Quelang, there is gold, but little or none is brought down. In the neighbourhood of Quelang on the mainland a great deal of timber is available because of the many tall, mighty trees growing there. The stones used for the construction of the fort we quarried and carried out of the mountains situated around the bay or inlet. Tamsuy is situated at a distance of approximately 30 miles[45] overland from Quelang and 15 miles[46] by sea also on an inlet, however so shallow and full of dry patches that you cannot possibly come in with a yacht without running aground.

[The northern point] has flat sandy beaches on every side and is everywhere suitable for landing.

fol. 345: *(VOC 1103)* (...) the two different roads between Quelang and Tamsuy (one of these can always be seen from the sea and the other one goes inland) are flat, smooth and suitable for marching.

In Tampsuy there are many fruit trees as well as tubers, namely oranges, limes, pisang, potatoes and more other sorts, and also a wealth of game, like deer, roes, etc. They hope to catch those animals and also to receive some through barter with the natives. Sulphur is available in abundance but is not traded by the Spaniards.

(Another, almost identical, description of the north coast of Formosa can be found in the Dagregister in the entry of 30 June.)

90. Dagregister Zeelandia.
VOC 1102, fol. 590. Extract 30 June 1631.
DRZ, Vol. I, pp. 51-52.

" 't Fort in Quelangh leyt in vier punten, rontsom van grauwen steen met muyrren van ontrent 3½ vaem hooch opgehaelt, is beplandt met 14 stucken, te weeten op de principaelste zeepunt vijff, op de grootste landpunt vier, de derde drie ende de vierde twee. 't Presente guarnisoen bestaet in hondert Castillianenen ende 25 à 30 Pampangers (dat oock arbeytluyden sijn). Naar de Zeecandt ontrent een musquetscheut daer continuelijck ses soldaten ende een officier de wacht houden en van voornoemde bergh can men in 't fort

sien. De plaets daer 't fort leyt is een eylandt, can met chaloupen ende ander licht vaertuych rontsomme bevaerren worden, sijnde op 't nauwste achter 't fort, daer in zee valt, maer 8 vadem breet, twee vadem diep ende geheel clipachtich. Den inham streckt ontrent een halff uyr binnewaerts, verbij 't fort is meest 30 vaedem diep. Het Spaensche vaertuych, om voor de noorde-windt (die aldaer een lager wal maeckt) beschut te leggen, loopt gemeenlijck ter sijden 't fort op negen vadem waters ter rheede. 't Eylandt alsmede de gantsche bay, heeft rontsomme een santstrandt ende is overal bequaem om te landen, 't Verleeden jaer is uyt Manilha aldaer een schip ende patasgen met 1000 realen contant nevens de ordinairie provisie voor 't guarnisoen gearriveert ende ontrent drie maenden geleeden weder vertrocken, met cangans, meel, tarwe ende andere grove waeren meest volladen, doch is gemeenlijkc alle jaeren maer één jacht aldaer gecomen met weynich contan-ten, provisie ende noodelijkcheeden ende met bovengemelde goederen telcken weder geretourneert. De negotie op beyde de plaetsen met de Chine-sen gedreven werdende, bestaet oock meest in voornoemde waeren. Tus-schen 't fort ende den berch daer de capelle op staet, staen ontrent dertich hautte huysen, daer de gouverneur met thien getroude, de meeste officieren van 't guarnisoen, coopluyden ende andere persoonen meer, woonnen. Daer staen niet meer als thien Chineese huysen, dat al arbeytsluyden sijn. Met d'inwoonders sijn d'een tijt in vriendschap, d'andere tijt in vijandtschap, doch geen feytelijcke hostiliteyt, 'tsij met tochten ofte andersints, bethoonen malcanderen. De Spaingaerde gaen niet in 't landt ofte eenige dorpen, crijgen in Quelangh oock geen vruchten anders als pattattesen ende piesangh. In Tampsuy hebben een aerden rondeel, met 5 à 6 huysen daerbinnen, opgeworpen; is met een pagger van dun hout, met rottangh gebonden sijnde, omvangen ende met 5 stucken geschut beset. Doen sij vluchten lach aldaer een cappiteyn met vijftich Castillianen in guarnisoen. Voornoemde fortificatie hebben aldaer gemaeckt, naedat de jachten *Diemen, Slooten* ende *Domburch* tot visite costi geweest sijn, omdat de Hollanders voornoemde plaetse niet soude incorporeeren ende van daer yets vorders op Quelang attenteeren, want tusschen beyde de plaetsen te lande maer dertich mijllen distantie is met twee gladde effen wegen, bequam om te gebruycken. Ontrent een musquet-schoot van 't rondeel leyt een hoochte, vanwaer 'tselve genoechlijck can beschooten werden. De bay heeft rontsomme een sandtstrandt ende can van wedersijde van 't rondeel gelandet werden sonder iemandt te sien. De bay is met laach water heel drooch, soodat niet als joncquen daer binnen connen comen. In Tampsuy is veel wilt werck van hartten, rheën ende anders, alsmede veel soo boomen als aertvruchten, die van de inwoonders ruyllen ende haer toegebracht werden."

June 30: The fort on Quelang has four points, constructed of grey stone with walls of about 3½ fathom high, around its inner structure. It has 14 guns, that is to say five on the principal point directed towards the sea, four on the largest point on the landside, three on the third and two on the fourth point. At present the garrison consists of a hundred Castilians and 25 to 30 'Pampangers' (who are workers as well). From a place near the shore, at about the distance of one musket-shot, continuously guarded by six soldiers and an officer, and likewise from the mountain, one can look into the fort. The place where the fort is situated is an island, which can be reached by small boats and other light vessels. The passage is very narrow, about eight fathoms wide, two fathoms deep, strewn with many rocks, just behind the fort from where it stretches further on to the open sea. The island of Quelang is situated in an inlet which penetrates about half an hour's walk inland, past the fort it is mostly 30 fathoms deep. To anchor safely, that is to be protected a bit from the northern winds (which turn the shore over there into a lee shore) a Spanish ship normally anchors at the roadstead besides the fort in about nine fathoms of water. A sandy beach, which extends all along the island as well as along the whole bay, makes it a safe place everywhere for landing. Last year a ship accompanied by a yacht arrived in Quelang from Manila with 1000 reals cash, besides the ordinary provisions for the garrison. About two months ago they left again for Manila loaded with cangans, flour, wheat, and other coarse merchandise. Usually only one yacht comes there anually which besides the necessities and provisions carries only a little cash and always leaves Quelang with the same commodities as mentioned above. Their trade with the Chinese in both places also consists of these goods. In between the fort and the hill, on which a chapel has been built, stand about thirty wooden houses inhabited by the governor and about ten married men, mostly the officers of the garrison, merchants, and some other persons. No more than ten Chinese houses are located there, all belonging to Chinese workers. With the natives they live sometimes in friendship and other times in enmity, but they do not mount actual hostilities in the shape of expeditions or the like towards eachother. The Spaniards do not visit any of their villages nor do they venture into the hinterland. In Quelang they only get some tubers and bananas. In Tamsuy, they have a roundel constructed of earth in which five or six houses are built, surrounded by a fence of flimsy wood, bound together with bamboo and armed with five guns. When these men fled to

Tayouan, Tamsuy was occupied by a captain and garrison of fifty Castilians. The said fortification was constructed after the Company yachts the *Diemen*, the *Slooten*, and the *Domburch* visited that place, so as to prevent the Dutch from incorporating Tamsuy, from which they could easily undertake a venture against Quelang, as the distance is only thirty miles and both places are connected by excellent, level, smooth roads. Away from the roundel, about as far as the range of a musket-shot, lies an elevation from which the fortification can be easily fired upon. The bay has a sandy beach all around it, so one can easily land at either side of the roundel without being seen. At low tide, the bay is completely uncovered, so that it can only be entered by junks. Game, like deer, roe, and other abound in Tamsuy as well as many trees and tubers, which are brought by the natives to exchange.

91. Missive Governor-General Jacques Specx to Governor Hans Putmans. Batavia, 31 July 1631.
VOC 1102, fol. 149-167. Extract.

fol. 154v.: "De gelegentheden van 't fort Zeelandia, de reduijt Zeeburch als 't huijs in Sinckan, hebben in 't breede verstaen ende houden de wercken, die U Ed. soo tot tegenstant der zee als versterkinge van 't fort ende voortplantinghe der Christelycke religie onder de (fol. 155) Sincanders gemaeckt heeft, wel goet, maer soolangh U.Ed. van gheen goede uitcompste der Compagnies affaire in Jappan, midtsgaders van verbeteringhe in den handel met China verseeckert sijt, connen niet imagineeren op wat insichten U.Ed. zulcken lasten ende extentiën fundeert.

fol. 156: Den aanwas ende voortplantinge van de Christelycke religie onder de Sinckanders hebben gaerne verstaen ende den goeden iver van Dominee Candidius, als andere, daertoe bethoont, is gants prijselijck, maer gelyck in alle zaecken zeeckere maete ende proportie vereyscht wert, moeten U Ed. dit werck oock zoo mesnageren ende door zulcken middelen bevoorderen, daerbij de Compagnie niet en werde beswaert. Aelmoessen behoorden mettertijdt uyt de Sinckanders tot soulagement van de Nederlandtse gemeijnte ende geenszins yets uyt de beswaerde Nederlandtsche gemeijnte tot onderhoudt van de Sincanders getrocken te werden (...).

Is vooreerst genoech, dat de Compagnie ten welstandt van de Sinckanders (...) jaerlijcx met omtrendt 4000 guldens aen tractementen ende onderhoudt van eclesiasticq persoonen in Tayouan werden beswaert."

(In that letter from Batavia, high costs had been brought up which had been made by the VOC on Tayouan:)

fol. 154v.: We were informed in general about the events at the fort Zeelandia, the redoubt Zeeburch and the house in Sincan and we accord our conditional approval to the works Your Honour has carried out with respect to curbing the sea and the extra strengthening of the fort and the propagation of the Christian Faith amongst the Sincandians, but as long as Your Honour is not ensured of a good result in the Company's business in Japan and also of improved trade relations with China, we do not have a clue about on what ideas Your Honour is basing such costs and extensions.

(The High Government also judged that costs incurred on behalf of the Sincandians were too high. The authorities in Batavia thought the missionary work of Candidius should not cost a penny.)
(See also: VOC 1103, fol. 6v.; *and:* Grothe, *Archief Zending*, p. 58).

fol. 156: We are pleased to hear of the growth and spreading of Christianity among the Sincandians. The good and diligent work done for it by the Reverend Candidius and others, is very praiseworthy, but a certain constraint and moderation is required as in all things, which means that Your Honour also has to organize and stimulate this work by such means that the Company will not have to carry the burden. In due time alms ought to be imposed on the Sincandians for the relief of the Dutch community and by no means should they be imposed on the Dutch community for support of the Sincandians. (...)
For the time being it is enough that the Company is charged for the well-being of the Sincandians for the annual fine of 4000 guilders for the salaries and upkeep of people of the church in Tayouan.

92. Missive Senior Merchant Jan Carstens to Governor-General Jacques Specx. Tayouan, October 1631.
VOC 1102, fol. 557-563. Extract.

> fol. 561v.: "(...) dat onsen algemeijnen vijandt op Quelangh geleegen op 't noorteynde van Fermosa sterck met het fortificeeren doende zijn (...)."

(Senior Merchant Jan Carstens in Tayouan to Governor General Specx about the fortification of the Spaniards in Quelang:)

fol. 561v.: (...) that our main enemy lying at Quelang at the northern tip of the island of Formosa is working very hard on fortifications.

(10 October 1631: Candidius wants too much money, that is why he is dismissed, the more so because Junius, who had taken over his missionary work, is speaking the local language very well. See: Grothe, Archief Zending, *III, pp. 60-61.)*

1632

93. Dagregister Zeelandia.
VOC 1105, fol. 230-238. Extract 26 February 1632.
DRZ, Vol. I, p. 72.

"[26 February 1632]: Op dato advijseert den predicant Robertus Junius uuyt Zincan, dat eenige van de inwoonders aldaer onder den anderen geresolveert hadden, om seecker oude ende weynich importeerende questie die van Baccaluan den oorlooge aen te doen, waeruuyt groote onheylen ende ver[h]inderingen in 't goede begonnen werck tot disreputatie van de Compagnie ende onse natie souden connen ontstaen. Derhalven, om sulcx voor te coomen ende behoorlijkce ordre in dese saecke te stellen, versouckende iemandt uuyt den raadt mocht gecommitteert werden; welcken volgenden den oppercoopman Gedion Bouwers ende schipper Thijs Hendricksz Quast door ordre van de E. heer gouverneur den 27 ditto derrewaerts sijn gegaen. Hebben den raadt van voornoemde dorp bij den anderen doen roepen ende haere bequame faulte hun voorgehouden, waerom sulcx zonder voortweeten van Zijne gemelte E. beslooten hadden, wel wetende sonder onse hulpe niet machtich waeren 'tselve te volvoeren ende, soo wij de handt van haer trocken, wat dan te verwachten hadden als hare totaele ruine. Waerop ten antwoorde gaeven, d'heer gouverneur gelieffde dese saecke te vergeten, zij waeren alle niet schuldich daeraen ende zouden maecken zulcx niet meer geschiede; bekenden oock de Compagnie als haere vaeder was ende wanneer uuyt haer dorp vertrocken, tegens haere vijanden niet zoude connen ofte moogen basteren."

February 26: Today the Reverend Robertus Junius reports from Sincan that several of its inhabitants had come together and decided to make war on the people of Baccaluan because of some old and not very important matter, all of which may result in great disaster and a drawback to the work well started, leading to a bad reputation for the Company and our nation.
Therefore, in order to prevent this and to straighten things out in this matter, it was requested that one of the councillors should be put in charge. As a result of which Senior Merchant Gideon Bouwens and the skipper, Thijs Hendricksz. Quast, went to that place on the 27th of this month by order of the Honourable Governor. They summoned the council of the abovementioned village and confronted the members with their obvious mistake, that is to have made a decision on this matter without consulting

with the Honourable Governor, cognisant that they would not be able to accomplish this without our help and that should wash our hands of them, they could expect nothing but their complete destruction.

To this they replied that it would be better if the Lord Governor were to forget the whole business. It was not their fault and they would see to it that this did not happen again. They also acknowledged that the Company was like a father to them and were it to withdraw from their village, they would not be able to be able to oppose their enemies.

94. Original missive Governor Hans Putmans to the Amsterdam Chamber. In the River Chincheo, 14 October 1632.
VOC 1105, fol. 197-200. Extract.

> fol. 200v.: "De voortplantinge der Christelijcke religie in Zincan staet heerlijck ende in gewenschte termen. Den Raadt van voorn. dorp is met Domino Juny verdragen geen heydenen meer in den selven onder haer te lijden. Haere leeraressen ofte oude wijven, die hunne heydensche superstitiën bedienen ende uytvoeren, hebben oock belooft afstandt van 't selve te doen, soodat alles (Godt loff) goeden voortganck heeft. D'Heere zegene 't selve meer ende meer."

fol. 200v.: The propagation of the Christian Faith in Sincan goes well and in a desirable manner. The council of this village has agreed with the Reverend Junius that village people who are not yet converted will no longer be tolerated among them. Their priestesses or old women who perform and execute their heathen superstitions have also promised to desist from these, so that everything proceeds well (praise the Lord). May the Lord give His unstinting blessing to this.

95. General Missive.
VOC 1099, fol. 55. Extract 1 December 1632.
FORMOSA, p. 105.

> "De Christlijcke religie is in Sincan noch dagelijcx meer ende meer toe-nemende, soo dat den *Tackakusach* ofte raad des dorp met domine Junius geresolveert waeren geen heydenen in deselven meer te admitteren, item dat hunne leressen ende oude wijven, die haer heydense superstitie bedienen, oock affstandt van deselve bedieninge hadden belooft te doen, door welcke

twee poincten alles seer heerlijck ende meer als oyt te vooren sijnen goeden voortganck sal connen nemen, daertoe den Almogenden sijnen zegen gelieve te verlenen."

The Christian Faith in Sincan waxes by the day, so that the Tackakusach or council of the village has agreed with the Reverend Junius no longer to admit any more heathens to it. And besides, their priestesses and old women, who perform their idolatrous superstitions, have promised to refrain from the performance of this service. Because of these two points everything will be able to make better than it has ever done before, may the Allmighty grant this His blessing.

(On December 6, 1632, Governor Putmans, Gideon Bouwers and the as yet unordained Bonnius go to Sincan.)

96. Dagregister Zeelandia.
VOC 1109, fol. 208-212. Extract 2 December 1632.
DRZ, Vol. I, p. 81.

"9 dito. (...) Des achtermiddachs compt de heer gouverneur Putmans weder uyt Sincan ende hadden die van het dorp Teopan aen Sijne E. ende den raet in Sincan belooft wederom in haer dorp te comen woonen, 'twelck sij 'tsedert den jongsten brant daer geschiet, hadden verlaeten. Die van het cleyne (fol. 210) dorp Nieuw Baccaluan, sijnde altsamen voor desen gevluchte Sincanders, beloofden wederom in haer voorige dorp Sincan te comen woonen, maer de reste in Out Baccaluan woonachtich conder daertoe noch niet verstaen, maer souden het naeder in bedencken nemen."

December 9: Governor Putmans has returned again from Sincan late afternoon. The villagers of Teopan promised the Honourable Governor and the council in Sincan to return and live in their village again, which they had abandoned since the recent fire there. The people of the small village (fol. 210) of New Baccaluan, who all are Sincandians having fled some time ago, promised to return and live in their former village of Sincan again, but the others who were living in Old Baccaluan are not yet able to consent to it, but would take it into consideration.

1633

97. Missive Governor Hans Putmans to Governor-General Hendrick Brouwer. Tayouan, 18 January 1633.
VOC 1109, fol. 217-219. Extract.
ZENDING, Vol. III, p. 62.

fol. 219: "De voortplantinge van de Christelijcke religie in Sincan heeft (Godt loff) soodaenich toegenomen dat alle die daer woonen hunne affgoderijen wech geworpen ende nu altsamen den eenigen Almogenden Waren Godt willen aenroepen ende dienen. De andere dorpen als Mattauw ende Zoulangh houden hun still, alleene dat die van Mattauw somtijts noch achter onsen rugge hun beroemen van 't leelijcke moordadige faict aen d'onse begaen. Doch wij hopen, gelijck het oock nodich zij, dat nu Jappon weder open is, dese eyndelinge noch eens loon naer verdienste sullen ontfangen. Waeren der meer werckers in den wijngaert des Heeren, daer wierden meer sielen gewonnen ende Gode toegebracht. Soo veel hier aengaet is geen stoffe om Domine Junij te assisteeren, soo dat U Ed. in toecomende daeraen sal gelieven te gedencen."

fol. 219: The propagation of the Christian Faith in Sincan has made such progress (praise the Lord) that all people living there have cast off their idolatries and do now want to worship and serve the One and Only True Almighty God. The other villages like Mattau and Soulang keep quiet, except for the fact that behind our backs the people of Mattau sometimes take pride in the evil and criminal act committed against our men[47]. But we hope, and it is indeed necessary, that now Japan is open again[48], they end up getting their just deserts. Were there more labourers in the Lord's Vineyard, more souls would be saved and brought to the Lord.
As far as the situation here is concerned, there is nobody available to assist the Reverend Junius, so that Your Honour must be so gracious as to think about that in the future.

98. Missive Ordinand Pieter Bonnius to Governor-General Hendrick Brouwer. Tayouan, 18 January 1633.
VOC 1109, fol. 215.

(Ordinand Pieter Bonnius has arrived in Tayouan to help out in church matters.)

99. Resolutions taken by Nicolaes Couckebacker c.s. Tayouan, 10 March-23 July 1633.
VOC 1113, fol. 760-766. Extracts.

fol. 761v.: "[15 March] Ten laetsten dat de sieckeraer Pieter Heere, om verscheyden insichten ende zijnes selffs instandelijck versouck, tot bevoorderinge van de Christelijcke Religie in Sinckan bij provisie ende om een preuve te nemen tot de comste van scheepen van Batavia zal gebruijckt werden ende met zijn familie woonen gaen (...)."

fol. 763: "[19 May] (...) Ten derden ofte men Taccaran, overste in Mattauw, van denwelcken den predicant Robbert Junyus in Sincan per zijnne missive in dato 14 deser adviseert soo zeeckerlijck verstaen hadde, dat gemelte Taccaran (zoo hij aen een yder zelver gaff te kennen) voorgenoomen ende vastelyck beslooten hadde neffens noch eenige van 't voorschreven dorp (als voordesen *Dijck* in Sinckan hadde gedaen) met een van de Japansche Chineese joncque naer Japan te vertrecken ende alle preparade tot den reijse noodich was bijeen versamelende ende toemaeckende; van gelijcken niet naerliet door zijn opgeblasentheyt ende groots gemoet die Chineesen die in Wancan om te visschen ende haeren handeldrijven leggen als andere daer te lande frequenteerende (niettegenstaende Compagnies pas hebben) om zijnnen licentie ofte stock te becoomen eenich gelt als andere goederen aff te persen ende dengeenen die bevonden werden 't selve niet te hebben alles te ontweldigen ende aff te nemen, en behoorde in zijn voornemen ende actien bij d'één ofte d'ander middel te stutten ende daerinne te versien oftewel in de oogluyckinge ende patientie tot de compste van de scheepen van Batavia als tot noch toe geschiet is te laten passeren ende ongemerckt doorgaen (...)."

fol.761v.: [15 March] Finally for different reasons and on his own urgent request Pieter Heere, visitor to the sick, will fulfil the task of promoting the Christian Faith in Sincan and proceed to live there with his family, in order

to fill the gap and as a trial period, until the arrival of the fleet from Batavia. (...)

fol. 763: [19 May] In the third place [we discussed whether] we should not in some way put a spoke in the wheel of Taccaran, headman in Mattau, obstructing his intentions and actions and provide the means to do this, we should let him go on and proceed unremarked, turning a blind eye to him and exercising patience which is what is happening just now, until the arrival of the fleet from Batavia. Reverend Robert Junius in Sincan reports in his letter of the 14th of this month that he had explicitly heard that this Taccaran (as he himself is telling to everybody) intends and is determined to leave for Japan in company of a few other men of the village in question on one of the Japanese Chinese junks (as Dika in Sincan had done before)[49] and is gathering and preparing all the things necessary for the journey. At the same time he does not fail, proud and haughty as he is, in order to get his licence or merchandize, to extort some money and other goods from the Chinese residing in Wancan for fishing and trading and also from others who frequently come ashore (although they have the Company's permission), and to terrorize and beat those who appear not to have it.

100. Missive Governor-General Hendrick Brouwer to Senior Merchant Nicolaes Couckebacker. Batavia, 12 May 1633. VOC 1107, fol. 247.

fol. 247: "(...) Gemelde Sr. Putmans sal cort naerdesen van hier vertrecken om bij UE. te comen met een aensienelijcke macht van 7 ofte 8 jachten, om het gouvernement ende de directie van deses Compagnie saecken aldaer noch te continueren.

Nevens sijne Ed. sullen (wij) op alle nodige saecken behoorlijck ordre geven, doch tot pré-advijs hebben goet gevonden dit jacht UE toe te seijnden ende daerbij te ordineren om, sonder langer uijtstel, te revengjeren de schadelijcke moort begaen aen den coopman Mathijs Jacobsz. ende eenige onser maetrosen bij d'inwoonderen van 't eijlandt 'den Gouden Leeuw' genaemt, dat tot noch toe is uijtgestelt bij faulte van goede gelegentheyt ende nochtans de verseeckeringe van Compagnie's staet, de achtbaerheyt onser natie ende de bevorderinge van de Christelijcke religie sulcx ten hoochsten is vereyschende.

Soo is 't dat wij, naer verscheyden communicatien met den Gouverneur Put-
mans als andere overgecomen vrunden daerover gehouden, goet gevonden
hebben gemeld eylant gansch ende gaer tot exempel van andere te laeten
ruïneren ende depeupleren; ende om 't selve des te seeckerder ende met 't
minste verlies van d'onse in 't werck te stellen, dat men alle 't Chineese
vaertuych dat op 't arrive van dit jacht *Boecaspel* costij gevonden wert sal
aenslaen op 't alderspoedichste voorsien ende zeijlraet maecken, om voor-
eerst met hulpe van de Matauwers, Zoulangers ende Sincanders, die UE sal
laeten aenspreecken omdat hun daertoe prepareeren gemelte Goude Leeuws
Eijlant aen te tasten ende alle d'inwoonders daervan te lichten om onder die
van Sincan ende andere te verdeijlen."

fol. 247: (...) The abovementioned Putmans will leave from here shortly to go
to Your Honour with a reasonably powerful fleet of 7 or 8 yachts, in order
to see to the continuation of the business there on behalf of the government
(in Batavia) and the Board (in Amsterdam).

With His Honour we will pay attention to all essential matters, but before-
hand we have decided to send to Your Honour this yacht and also to give
orders to avenge the foul murder committed on the merchant Mathijs
Jacobsz. and a few of our sailors by the inhabitants of Golden Lion Isle
without any further delay, which until now had been postponed for lack of
a good opportunity, but which nevertheless is very urgent in view of secur-
ing the position of the Company, the respectability of our nation, and the
promotion of the Christian Faith.

Therefore we have decided, after some discussions concerning the matter
with Governor Putmans and other friends residing here, to have this island
devastated and depopulated entirely as an example to others. And to execute
this with the greatest possible expediency and with as few casualties on our
side as possible, warning will be given to all Chinese ships present there as
soon as this yacht by the name of the *Boecaspel* arrives, to be ready to sail
as quickly as possible, in order to prepare the attack against Golden Lion
Island, with the assistance of the people of Mattau, Soulang and Sincan,
who must be addressed by Your Honour, and to deport all its inhabitants
and distribute them among the people of Sincan and other villages.

101. Instruction for Governor Hans Putmans and the Council in Tayouan as well as for the fleet destined for the China Coast. Batavia, 31 May 1633.
VOC 1107, fol. 253-264. Extract.

fol. 257: "(…) soo sult ghij ontrent de maent February met een gedeelte van onse macht oftewel altsamen naer dat ghij siet waer meest te vorderen sij, naer Tayouan oversteecken om die van 't Goude Leeuws eylandt ende Mattau aen te tasten, haere dorpen in brandt te steecken ende gansch en gaer te vernietigen, de gevangenen onder die van Sincan verdeijlen ende alsoo gemelte dorp vergrooten, sonder toe te staen datter eenige inwoonders op gemelte twee plaetsen naer de gedaene vernielinge sullen gedoocht werden te wonen.

Laet dit met soodanige macht ende reputatie geschieden, dat dese brutale natie mach gewaer worden, dat sij ten rechten over soo leelijcken feijt, voordesen aen d'onse begaen, rechtvaerdich gestraft werden ende 't selve alle andere bijgelegene dorpen tot een levendich exempel mach dienen.

Om dit met des te meerder verseeckeringe t'effectueren sal 't nodich wesen dat ghij die van Mattauw, Zoulang ende Sincan tot assistentie ontbiet omme die van 't Goude Leeuws eijlant waertoe sij alle (naer verstaen) seer graech sijn, eerst aen te tasten ende in 't wederom keeren (dit volvoert sijnde) die van Mattau altsaemen aen te vatten ende in 't fort vast te setten ende alsoo 't dorp Mattauw dan datelijck met des te meerder avantagie en voordeel aen te grijpen ende de moort aen d'onse gepleegt te beter te straffen.

Doch sal dese tocht op Mattauw ende 't Goude Leeuws eijlandt niet bij der hant genomen worden voor ende aleer de saecken van China in behoorlijke termen gebracht ende alles aldermael vereffent sij (…).

fol. 260: Den proponent Bonnius ten aensien van de goede rapporten die van hem vernemen ende vermits hij den dienst op Tayouan als predicant is waernemende ende sich met sonderlingen ijver is oeffenende in de Zincanse tale op hoope dat hij de kercke Godts aldaer mettertijdt soude mogen comen te doen sonderlingen dienst tot verlichtinge van die blinde heydenen ende verbreydinge van 't Heylige Evangelium, sullen U Ed. met advijs van predicanten Candidius ende Junius op nieuws mogen aennemen onder verbintenisse van drie ofte meer jaeren."

fol. 257: (…) some time around February you will cross over to Tayouan with part of our naval power or all of it, wherever you can possibly summon them, in order to attack the inhabitants of Golden Lion Island and Mattau, to set fire to their villages and destroy these entirely, to distribute

the prisoners amongst the people of Sincan, enlarging this village in this manner, and not allowing any inhabitants to live in these two places again after the destruction has been carried out.

(They should be punished for the crime done to us, in such a way as to set an example to all the other villages.)

To make this all the more effective it will be necessary that you demand the assistance of the people of Mattau, Soulang, and Sincan in order to attack the people of the Golden Lion Isle first, which, as we have heard, they are eager to do, and, on the way back, (after this has been carried out) to attack the people of Mattau, every single one of them and detain them in the fort, then raid the village of Mattau straightaway with even more success and profit, punishing them harder for the killing of our men.

But this expedition to Mattau and Golden Lion Island will not be undertaken before the business with China is put in order and everything has been straightened out.

(Candidius and his wife, Sara, live in Sincan. Next to his new stone house, a redoubt will be built, just like the one next to the house of the Rev. Junius. The plan was to connect these two redouts together when the time was ripe. Favourable reports about the young Ordinand Bonnius praising the way he serves as auxiliary minister at Tayouan and his willingness to learn the Sincandian language. This leads to the proposal for the renewal of his contract for three or more years.)

102. Missive Governor Hans Putmans to the Commander or Officers of the ships reaching Tayouan from Batavia. Tayouan, 31 May 1633.
VOC 1113, fol. 528-530.
ZENDING, Vol. III, p. 63.

(Putmans writing to the commander of the fleet coming from Batavia: church matters in Sincan are making good progress, but Taccaran, chief of Mattau, has caused the Company a great deal of trouble in the vicinity of his village and in Wancan.)

103. Dagregister Zeelandia.
VOC 1114, fol. 15-72. Extract 7 July.
DRZ, Vol. I, p. 107.

"[7 July] (…) Insgelijcx, bij alle mogelijcke middelen trachten Taccaran, overste van het dorp Mattauw, van sijn vertreck naar Japan te doen desisteeren, alsoo sijne verschijninge aldaar naar alle apparentie aldaar groot quaat voor de generaale Compagnie soude connen causeeren. Weshalven verstaan wert, dat men den predicant Candidius, die met gemelte Taccaran voor deesen een seer goet vrundt geweest is, daartoe sall committeeren omme ditto Taccaran met soete middelen ende, in vougen als per resolutie daarvan te sien is, tot het verblijven te beweegen (…)."

July 7: (…) Likewise to dissuade Taccaran, head of the village of Mattau, from making his departure to Japan, because it is clear that his presence there may cause great misfortune to the Company in general. Therefore the decision has been taken that the Reverend Candidius, who used to be a very good friend of this Taccaran, will be charged with persuading this Taccaran to stay by gentle persuasion and according to the resolution.

104. Resolutions taken by Hans Putmans c.s. on board the *Middelburg* off the China Coast, 18 June-28 September 1633.
VOC 1113, fol. 578-591.

fol. 581v.: "[7 July] Ten jonghsten wert voor het bequaemste geoordeelt dat men Taccaran, overste van het dorp Mattouw, door den predikandt Candidius, waermede voordeesen seer groote vrintschap heeft gehouden, op sijn aencompste vrindelijck sal laeten onthaelen ende met een aengename schenckagie te vereeren, gevende hem ondertusschen te verstaen, dat wij met 12 à 15 scheepen hier sijn verscheenen ende noch 5 à 6 dito eerstdaechs te verwachten staen, met apparentie om binnen 3 à 4 maenden daer te verschijnen omme die van Goude Leeuws eijlandt aen te tasten; tot welcken tocht hij door voorspraecke van gemelte Candidius als hooft soude connen gebruijct werden. Ende ingevalle hiernaer niet wilde luysteren, staet vastelyck te duchten dat gemelte Taccaran van de Chineesen ofte Japanders gestijft wert ende sal alsdan nodich wesen, al soude men veel schencken, dat men hem met schenckagie ende soete redenen sien te bewegen.
Doch soo dit oock niet wilde lucken, (fol. 582) dient hem aengeseght, dat soo wanneer wij daer comen ende hij Taccaram naer Japan waren gegaen, 't

selve soo qualijck soude nemen, dat wel lichtelijck sijn dorp derhalven souden aentasten. Ende 't geene sich seedert in Taywan (dit poinct raeckende) naerder mochten geopenbaert hebben, sal den president Couckebacker hierbij ofte aff meugen doen. Doch in alle maniere verstaedt den Raet dat gemelte persoon in geenen deele dient te vertrecken, alsoo het de Compagnie op het hoochste schadelijck soude weesen."

fol. 581v.: (July 7) In the last place it was considered most sensible that the Reverend Candidius should receive amicably Taccaran, head of the village of Mattau who used to be his good friend, upon arrival, and to honour him by giving him a pleasant gift, but to let him know at the same time that we have shown up here with 12 to 15 ships and expect another 5 or 6 to appear at any time, in order to attack within 3 to 4 months Golden Lion Island. He could be of service to this expedition as a leader, on the intercession of the aforesaid Candidius. And if he is not amenable to this proposition, we must fear that this Taccaran will receive the support of the Chinese or the Japanese and it will then be necessary to prod him by giving presents and by gentle words, even if we have to give a great many.

But if this does not work either, (fol. 582) we must warn him that should we arrive in Formosa and he, Taccaran, has gone to Japan, we would resent this so much that we could easily destroy his village for that very reason. And President Couckebacker will take into account everything that will occur in Tayouan in this respect. But, in any case, it is clear to the Council that this person should at all costs be prevented from leaving, as it would be very harmful for the Company.

105. Missive Governor Hans Putmans to Senior Merchant Nicolaes Couckebacker. On the *Middelburg* off Lamoa, 9 July 1633.
VOC 1113, fol. 554-558. Extract.
ZENDING, Vol. III, pp. 64-65.

fol 557v.: "UE. weten wat onlusten de Sincanders met hun vertreck naer Japon ons aldaer hebben veroorsaeckt, ende zoude desen Taccaran naer alle apparentie, nu de geslagen wonde noch niet geheel geneesen is, wederom nieuwe ulseratie causeeren, ende de wonde slimmer als oyt te voren geweest is, stinckende maecken."

(Two points already mentioned above: the lodging of Candidius and his wife and the problem of preventing Taccaran from going to Japan. See entry 7 July 1633.)

fol 557v.: (...) Your Honour is aware of the trouble that was caused by the Sincandians when they went to Japan. And this Taccaran would clearly cause new problems once more, as the wound inflicted has not yet cured completely now, and he would cause the wound to putrefy more, worse than ever before. (...)

106. Missive Governor Hans Putmans to Governor-General Hendrick Brouwer. In the yacht *Catwijck* in the River Chincheo, 30 September 1633.
VOC 1113, fol. 653-668. Extract.
Duplicate: VOC 1113, fol. 776-787.

> fol. 665v.: "Dit brengt ons dickwils in groot naerbedencken oft wij alvast op onsen ingestelden wijscheijt sullen mogen ofte dienen te staen, gemerckt wij daer onse cleijne macht van goede, wel geoeffende soldaten niets sonders ofte groots ofte remarcquabels op Maccao ofte Quelangh, maar wel op Mattauw sullen connen tewege brengen."

fol. 665v.: This often brings us to deeper reflection if we already may or should be proud of our political choices, in view of the fact that with our small army of good well-trained soldiers we will not be able to bring about anything special, big or remarkable at Macao or Quelang, but indeed only at Mattau.

107. Resolutions taken by Senior Merchant Paulus Traudenius c.s. Tayouan, 3 September-20 October 1633.
VOC 1113, fol. 707-714. Extract.

> fol. 713: "[20 October] (...) een missive van dominee Robertus Junius, dienaer des Godlycken Woorts in Sinckan, hebben becomen. Daerinne adviseert dat van verscheyden personen vastelycken gewaerschouwt is, dat op hem, dominee Candidius ende Jan Gerryts van Noorden, voorleser, seer bij de Mattauwers werdt geloerdt ende dat groot pericul, buytenshuys ende in 't dorp haer begevende, van haer leven lopen alsoo dito Mattauwers 's nachts

onder de pagger van de reduyt hadden sien loeren ende cruypen, waerover sijluyden oordelen men gemelte Mattauwers 't dorp Sincan behoorde te verbieden te frequenteren ende, soo wanneer aldaer verschenen alvore gewaerschouwt sijnde, voor vijanden te houden ende aen te tasten.

't Welck den Raed in consideratie gegeven sijnde hoe ende in wat manieren daerin diende te versien alsoo weten alrede onse geveynsde vrienden ende eenighe avan(tagie) siende vijanden sijn, derhalven deselve Sincan verbieden genouchsaemm voor vijanden verclaeren, daer nochtans om pregnante redenen tot beter gelegentheyt te moeten veynsen altijdt is geoordeelt."

fol. 713: October 20: (…) We received a letter from the Reverend Robertus Junius, servant of the Word of God in Sincan. In it he reports that a serious warning has been given by several people about considerable prying perpetrated on him, the Reverend Candidius, and the reader in the church, Jan Gerryts van Noorden, by the people of Mattau and that their lives were in great danger as soon as they ventured outside, into the village, because they had seen that these inhabitants of Mattau were peeping in and creeping under the fence of the redoubt at night, and therefore they thought it would be better were these men from Mattau prohibited from coming and going to the village of Sincan and that were they to show up again after this warning, they would be considered enemies and be attacked.

This has been presented to the council for consideration about how and in what way this should be met, but since we already know who pretend to be our friends and who are enemies looking for some profit, we forbid this village of Sincan simply to proclaim themselves as enemies, because pretending has always been our politics (for good reasons), until there is a better opportunity.

(Regarding the letter from the Reverend Robertus Junius about the intentions of the people of Mattau, the council is inclined to notify him to solve the problem himself, in conjunction with his Dutch companions in the village.)

108. Missive Gideon Bouwers to Antonio van Diemen. Batavia, 21 October 1633. VOC 1113, fol. 683. Extract.
ZENDING, Vol. III, p. 66.

"In Sinckan staen de saecken noch redelijc ende heeft de christelycke voortplantinge tamelijc progres, sulcx, dat men eenen heerlycken oogst te gemoet

soude mogen sien, ten waere de Mattauwsche kevers de vruchten in veelen deelen niet bedorven. 't Is seecker dat de Mattauwers dit heerlyck werck ende desselfs voortganck seer verachteren door haere groote ende stoute opgeblasentheyt, die noch dagelyckx aenwast, ende soo niet vernedert werden, is te duchten, dat wel haest tot een groot quaet mochten uytbersten, doch wy verhoopen, hoe de hant hooger verheven is, ende dienvolgende te langer vertoeft, den slach oock dies te harder neder comen zal."

In Sincan the situation is reasonably good and the propagating of Christianity is making steady progress, going in such a direction that an abundant harvest may be hoped for, if only the Mattau beetles do not ruin the fruit in many ways. It is certain that the people of Mattau impede this divine labour and hinder its progress very much by their overweening and reckless conceit, which waxes by the day, and were they not to be disgraced we are afraid it may explode into an enormous disaster, but we expect that the higher the hand is lifted and therefore the longer it remains in the air, the harder the blow will fall. (...)

109. Missive Senior Merchant Paulus Traudenius to Governor-General Hendrick Brouwer. Tayouan, 24 October 1633.
VOC 1113. fol. 692v.

(Although Christianity gains a steady stream of adherents in Sincan all the time, some are incited against it by the troublemakers from Mattau.)

110. Missive Governor Hans Putmans to the Directors of the Amsterdam Chamber. Tayouan, 28 October 1633.
VOC 1114, fol. 1-14. Extract.
ZENDING, Vol. III, p. 68.

"Het goddelycke en heerlycke werck in Sincan onder de heydenen neempt, Godt lof, redelycken voortganck, maer onwillighe, die door de Mattauwers ende andere haer laten opruyen, sijn der noch veele, soo dat ten uytersten nodich sij gemelte Mattauwers eenmael werden gecastigeert, ende soo 'tselve van dit jaer niet en can geschieden, gelijck verhopen wanneer d'E. Hr. Gouverneur Hans Putmans alhier zal comen te arriveren, soo staet te beduchten wel yets by haer tot onser natien nadeel, dat Godt verhoede geresolveerd ende geattenteert mochte worden, ende dat door dien gemelte Mattauwers haer zeer vreemd ende absurd by wijlen aen stellen. Wat deze saecke verder

concerneert sullen ons aen de praedicanten Candidius ende Junius, die niet
en twijfele U Ed. in't largo daer over sijn adviserende, referen. Tot dit voors
werck sullen haer E. soo veel de helpende handt aenbieden als eenichsins
Comp. consitutie sal willen toelaeten (...)."
"De Christelycke religie neempt in Sincan onder de inwoonders, Godt loff,
heerlyck toe, ende meyne, soo haest die van het dorp Matthau over het
enorm fayct aen d'onse ten tijde van d'Hr Nuyts begaen, naer behooren
gestraft werden."

The Christian Faith is proceeding wonderfully in Sincan among the inhabi-
tants, praise the Lord, and I have the idea that it will have more progress
daily, (...) as soon as the people of the village of Mattau are properly
punished for the great crime committed on our men during the days of Mr
Nuyts.

111. Missive Reverend Robertus Junius to Governor Hans Putmans. Sincan, 7 November 1633. TEDING 15, fol. 1.

"Den brenger deses Isbrant heeft Candidius eenige dagen geleden naer de
noort gesonden om uit haer te vernemen ofte om mede te gaen naer het
Goude Leeuws Eylant gezint waeren, hij rapporteert dat Baculuan daer toe
gesint is, Soulang desgelijcken. Jaa soo gisteravont vande Soulangers dien in
't dorp alhier gecomen waren verstonden soudender wel 200 mede willen
gaen. Mattau heeft tot dien oorlog geen herte, nochtans meent Isbrant datter
weijnige noch gevonden sullen werden, wat hier ontbreeckt kan Isbrant
mondeling beter vertalen als ick met schrijven soude connen stellen.
Het dorp Sincan heeft een swaar hooft, veele van haer meijnen dat nict mcdc
zullen gaen alsoo vreesen voor den noordenwint etc. Verhoope evenwel noch
een goet deel gevonden sullen werden.
Dominee Candidius inclineert daertoe dat eene van ons beyde behoort mede
te gaen maer EHr. gelieft te commanderen ende zijn E. gevoelen hiervan ons
te laeten weten, sal één van beyde hem claer connen maecken, dit metter
haest, sullende een cleyn briefken van zijn E. verwachten opdat wanneer
vertrecken sullen bekent mach zijn."

Several days ago, Isbrant, the bearer of this letter, was sent to the north by
Candidius to learn from those there if they would be inclined to accompany
the Company's troops to Golden Lion Island. He reports that Baccaluan is

well disposed towards this, Soulang likewise. Yea, as many as two hundred would like to go along, as we were apprised yesterday evening from the Soulangians who came to this village. According to Isbrant, Mattau does not have a heart for this war, nevertheless he thinks that some will be found there. The dearth in the details can be better conveyed orally by Isbrant than I could do in writing.

The village of Sincan has grave doubts about this venture. Many of them seem to think they should not go along because they fear the northern wind etc. Yet we do hope to find a good many people to participate. The Reverend Candidius is inclined to think that one of us two should be required to go along on this expedition, but it would be best if Your Honour would graciously issue a command and let us know whom of us should make the proper arrangments to depart on this expedition. We will expect very shortly a brief note written by His Honour when the time for departure has been chosen.

112. Missive Governor Hans Putmans to the Reverend Robertus Junius. Tayouan, 7 November 1633. TEDING 14, fol. 1.

"Op stante pee gewert ons UE. missive per Isbrant, waer uit met verwonderinge verstaen die van Sincan hebbende weijnig moet om neffens ons 't Goude Leeuws Eylant aen te tasten, de Soulangers ende Baculuanders verstaen, daertoe heel gesint te zijn ende tot Soelang wel 200 man hebben te verwachten, laet op overmorgen soo het goet weer blijft alswanneer een seyn met groff canon sullen doen, ons gemelte persoonen toecomen want wij geresolveert sijn met den eersten 't selver bijder hant te nemen.

UE. schrijft het noodich waere eene uwer beyden mede ginge 't welcq wij met Ue. alsoo nodich achten om hun best te verstaen ende wat goets voor te houden. Candidius, alsoo Junius zijne huysvrouwe swanger is, sal daer toe best connen [gebruiken] die wij soo wanneer de 3 scheuten gegeven zijn, neffens de bovengemelte inwoonders sullen verwachten."

This instant we have received Your Honour's letter via Isbrant, from which we are amazed to understand that those of Sincan seem to have little heart to go with us to attack Golden Lion Island. The Soulangians and Baccaluangians seem to be most eager for that purpose so we learn and we can expect as many as 200 men from Soulang. If the weather stays fine, do be

alert, on the day after tomorrow when we have given a signal with the heavy cannon, that the persons mentioned come over to us because we are resolved to begin with the undertaking on the first possible occasion.

Your Honour writes that it will be necessary that one of you two should accompany them on that expedition, which we think to be appropriate in order to understand them well and to encourage them. As Junius' wife is pregnant, Candidius would be the most suitable to accompany us. As soon as the three shots have been fired, we will expect him together with the abovementioned inhabitants.

113. Missive Reverend Robertus Junius to Governor Hans Putmans. [Sincan], 8 November 1633. TEDING 15, fol. 1-2.

"UE. missive van gisteren gewert ons heden ontrent 5 glasen, daer naer wij ende meer met ons verlangden, wij hadden wel gewenst dat Isacq zijn reyse wat vaerdiger hadde volbracht, sijnde hier 's morgens een peert hebbende affgevaerdigt, doch segt tot excuse dat op Saccan comende dat hem oocq heeft doen tardeeren, dat eenige Sinckanders (niet tegenstaende een groot getal hem claer hout om mede te gaen) om naer Lamey te vaeren een swaer hooft hebben, sal UE. uit dominee Candidius die UE. op morgen te ver-wachten heeft connen verstaen aen wien ick mij gedrage.

Wij hebben datelijck, UE. missive doorlesen zijnde, een man naer de Noortse dorpen gesonden ende UE. last laeten bekent maecken, wij verhoo-pen dat alle degenen die mede willen gaen op morgen avont op Saccan gereet sullen gevonden werden want achten op Saccan (soo maer tegen de avont claer zijn) beter sullen connen vernachten als op Tilosan, UE. can dan soo vroug als goet dunctt deselvige op Tayouan door vaertuyg laeten haelen opdat alsoo, inden name onses Godts, dit wercq begonnen mach werden dat niet en twijffelen ofte uitvallen sal ter eeren onses Godts ende tot der luyden die levendig blijven haer salicheyt, datt dan oocq soodanigen vreese inden omleggende storten zal dat in toecomen haeren handen soo licht niet meer sullen leggen aen onse natie, noch het christenbloet soo lichtelijck niet meer vergieten (…)."

Today, around 5 *glasen*[50] we received Your Honour's letter of yesterday, for which we and many others were really on the lookout. We had wished that Isacq[51], to whom we had sent a horse in the morning, had carried out his journey more quickly, but he said, by way of an excuse, that upon his

arrival in Saccam he had been delayed. The reason was that some Sincandians (despite the great number of them who were ready to depart) were not inclined to set sail to Lamey. The Reverend Candidius, whom Your Honour can expect tomorrow, will provide Your Honour with further information, in whose hands I place myself.

Immediately after we had read Your Honour's letter, we sent a man to the northern villages and made Your Honour's assignment known. We hope that all those who are willing to accompany us will be found to be ready tomorrow evening in Saccam because we consider it better to spend the night in Saccam (if we are ready by the evening) than in Tilosan. Then Your Honour can have them picked up by vessels from Tayouan as early as you consider best, so that in the name of our God we can start with this work, about which we have no doubts at all that it will turn out to be in honour of our God and the salvation of those who will survive this event. At the same time, it will frighten those in the vicinity so that in the future they will not lay their hands so easily again upon those of our nation nor shall they lightly shed any more Christian blood (...).

114. Dagregister Zeelandia.
VOC 1114, fol. 15-72. Extracts 18, 19, 25 November 1633.
DRZ, Vol. 1, pp. 141 en 143.

fol. 38v.: "18 ditto. Arriveert alhier een der 4 joncken, dewelck op 12en stantij naar 't Goude Leeuwseylandt, om 'tselve te verdistrueeren, waren vertrocken, ons rapporteerende, een Duytsman ende Sinckander in 't opmarscheeren van seeckere naeuwe passagie waaren doot gebleeven, waardoor de Sinckanders, Soelangers ende Chineesen altsaamen waaren op de loop geraact, maer d'onse, aantreckende, brachten die van 't eylandt daatelijck op de (fol. 39) vlucht, die hun in eenige speloncken, die de nature zoo 't schijnt daar onder d'aarde geschaapen heeft, zijnde well ½ mijlle lanck, zonder weeder tevoorschijn te coomen, hadden verborgen. Alle de huysen bestaande in enn groot dorp waaren verbrant ende menichte van varckens dootgeslaagen, sonder dat d'onse iets voirders op die van 't eylandt hadden connen verrichten. Gemelte eylandt was uyttermaaten schoon met meenichte van clappusboomen, pattattesen, milie ende andre aartvruchten well versien, rontsom meest clippich met een cleyne sandtstrant aen de noordzijde ende aen de zuydsijde, daar d'onse gelandt waaren, wat craelachtich; meest rontom met een cleyn bosschasieken van ontrent 100 à 150 treeden breedt,

'twelck gepasseert sijnde, soo schoon ende ordentlijck beplant was dat d'onse altsaamen verclaarden nooyt meer diergelijcke gesien te hebben.

fol. 39v.: (...) 25 ditto heeft de Hr. Gouverneur Putmans den Raadt beroupen ende denselven in serieuse bedenckingen gegeven ofte men volgens d'ordre van de Ed. Hr. Gouverneur Generael ende Raaden van India om 't enorm faict bij die van Mattauw aen d'onse begaan naar merite te wreecken, alsnu sall bij der handt vatten, oftewel ten aansien van onse cleijne macht, het gras noch lanck en het weynich voordeel dat op 't ende onder Leeuwe Eylandt jongst becomen is, 't selve tot naerder ontseth van Batavia sall naerlaeten."

fol. 38v.: November 18: One of the four junks which had left for Golden Lion Island on the 12th of this month to explore it, has returned home and reported to us that a Dutchman and a Sincandian had died in a particularly narrow pass during the march, as a result of which all Sincandians, Soulangians, and Chinese had run away. But our men regrouped and chased the people of the island immediately, until these went hiding in a few caves half a mile in length (apparently created there by nature beneath the surface of the earth) without ever appearing again.

All the existing houses in a big village were burnt down and a herd of pigs was killed, but no further action by our men against the inhabitants of the island was possible.

The isle in question is extremely pleasant and well-provided with many coconut palms, potatoes, millet, and other fruits of the earth. It is largely surrounded by cliffs but there was a small sandy cove on the northern side and on the southern side, where our men had landed, the beach was somewhat pebbly. All around for the most part there was a small forest of a width of approximately 100 to 150 paces, which, when crossing it, appeared to be planted so prettily and neatly that our men agreed they had never seen anything like this before.

fol 39: November 19: (...) In the afternoon the Honourable Commander Bruyn returned from Golden Lion Island with the yacht the *Wieringen* and the other junks and he confirms the description given above.

fol. 39v.: November 25: (...) The Lord Governor Putmans summoned the council and asked it to seriously consider whether, in accordance with the order of the Honourable Lord Governor-General and the Council of the Indies, we should make a start with the justified revenge for the serious crime committed by the people of Mattau against our men now, or later after further approval from Batavia, taking into account the paucity of our

military force, the fact that the grass is still long, and the very little profit that was gained at Golden Lion Island recently.

115. Missive Reverend Robertus Junius to Governor Hans Putmans. [Sincan], 25 November 1633.
TEDING 15, fol. 2-3.

"De missive van Sr. Gedion ter ordinantie van UE. geschreven is op den middag ter hant gecomen, gelesen zijnde hebbe wij tot wederschrijven terstont vaerdig getoont ende dese naervolgende invallen willen communiceren (voorbijgaende den schandelijcke moort voordesen aen de onse zoo bedriegelijck ende sinisterlijcq geperpetreert), daer nu en dan occasie ende gelegentheyt zijnde soo wijtmondig van derven discoureeren, niet alleene tot spott en schande van onse natie maer oock van onsen Godt ende zijnen dienst, als oocq de groote molestie die onse overicheyt nu en dan 't sedert heeft moeten lijden, gelijck onder andren wij gedenckt dat niet ontsien hebben eenigen tijt geleden als des Compagnies pas, eenige Chineesen om in Wanckan te visschen medegegeven, te scheuren, de Chineesen te slaen ende het haere te ontnemen, maer oocq daerenboven eenen der Chineesen het hair tot een victorie aff te snijden seggende wat hebben wij met het *Soulatt van den Tion* te doen, niettegenstaende dit alles soo can ick oock niet sien ofte dese moordenaers aldus in haer ruste gelaeten, sullen het eene quaat op het ander leggen ende alsoo het quade vermeeren wanneer wij op het swacxte zijn yetwat tot onsen nadeel soucken te attenteeren, gelijck al voor desen te kennen gaven verstaende den E. Heer verdreven was. Laet hier bijcomen dat dit differeeren het werck des Heeren in Sincan oocq seer schadelijck is, ick can niet sien off bouwen sonder fondament soo dese schelmen niet gestraft ende haere zeylen ingenomen werden, is dit niet het eerste ende eenige dat van dese Sincanders moeten hooren soo wanneer met haer van onsen godsdienst spreecken, toucheeren het naerlaeten eenige haerder manieren, wat hebben wij met en te doen wij willen nae Mattau vertrecken, was dat niet het seggen van Tioulatt, saterdach lestleden, tegens Jan, seggende: '*soo gij niet wilt toestaen het dansen op den troch, zoo sullen wij na Mattau vertrecken*'. Baert dit verschoonen niet een groote stoutheyt in dese natie, ons aensiende als vervaerden luyden die niet derven revengeeren het gene aen onse lansluyden is geschiet, daer zij contrarie niet ongewroocken sullen laeten sijnde haer een varcken doot geslagen ofte het alderminste affgehaelt al waer het oock veel jaeren geleden. Dit mijn schrijven confirmeeren de Soulangers noch vers, zijnde onlancx gebeurt. Dit uitstellen baert dit oocq niet een grootsheyt in dese Sincanderen soo dat haer niet ontsien alles dat haer inde mont comt

uit te spouwen gelijck noch heden mij is wedervaeren wanneer den Sincan-
der, die den winthont heeft, aenseyde dat sijnen hont weder over moste
geven dat hem het uitgegevene weder soude gerestitueert werden, hebbende
oocq alle mijne honden die nu zoo lange hadden gevoet selver moeten over-
geven, seggende: (fol. 3) '*soo mij den winthont wert affgenomen zoo wil ick
weder heydens worden ende den Godt des Hemels verlaeten ende sal mij heel
anders aenstellen als tot noch toe niet hebbe gedaen*'. Dit passeerde in
presentie van een Mattouwer dat mij oock niet weijnigh bedroeffde, het
verlaten van deze Sincandren op Mattauw verswactt niet alleen het werck van
Sincan maer stelt hetselve in prijckel van gebroocken te werden, om dit te
bewijsen heb ick veele exempelen, is het niet openbaer in eenen Takareij die
sijne vrouwe hadde verlaeten, seggende: '*soo de Hollanders mij weder bij
mijn vrouwe willen brengen soo sal icker één onder de voet werpen en
wegloopen*'. Hierbij comt noch een anderen die sijn vrou verliet met 3
kinderen. Bracht het met bidden en smeecken soo verre dat wederkeerde
ende de nieuwe die metter haest getrout hadde weder verliet soo dat nu
meynde de questiën waeren gedecideert. Niet lange daer naer verstaen wij
datse weder hadde verlaeten ende die geen kindren hadde getroutt, strijdende
recht tegen onse manieren. Dit zijn immers dingen van quade consequentie
welcke zonder twijffel zouden ophouden soo Mattau maer wierde gestraft,
och gelieffden 't onsen Godt dat victorie van dese luyden mochten behaelen,
veel goedts soude dit medebrengen, niet alleen een vast fondament aen dit
gebouw maer oock een bequam middel tot salichheyt van dese omleggende
dorpen voor welcke wij in cleenachtinge gecomen zijn ende zoo zoude een
vasten pays tusschen ons ende dese Mattauwers connen geraemt worden, die
sij alsnog vast te zijn haer niet connen imagineeren, dat Soulang tot assisten-
tie haer zullen laeten gebruycken. Vertoonen verscheyde dingen insonderheyt
dat nu gedreycht werden van die van Mattau omdat sij een Tirosener hebben
dootgeslagen. De Sinckanders soo ick verstaen kan ende noch heden van
Ticuta heb gehoort, soude gewillich sijn ende gaerne medegaen, ja, zijde hij,
de Sincanders zoude men vooruit connen zenden om het gras aff te branden,
toont ons oock met het Woort des Heeren dit een billicke saecke te zijn,
streckende tot Godes Eere ende Salicheyt van dese luyden hebben wij
derhalven hierover niet sijnen segen te verwachten, die toch den eenigen
chrijgsman is die onse handen can leeren strijden. Dit is het Edele Heere dat
op het spoedigste hebbe bij malcanderen vergadert, verclarende mijn opinie
nopende den oorlooch aen te nemen tegen Mattau (...)."

The letter written by Sr. Gedion[52] upon Your Honour's orders was handed
over to us this afternoon. Having perused it directly we have applied our-

selves to replying. We would like to communicate to you the following
events; (passing over the shameful murder committed before on our people
in such a deceitful and sinister way), occasionally we find an opportunity on
which we dare to speak about it with them at greater length. This seems not
only to have the effect that it continuously provokes mocking and shame not
only on our nation, but the more so also of our God and His divine wor-
ship, as well as to our authority which was so seriously injured and since
then has to suffer every now and then, as among other things we think that
lately they have not hesitated to tear up the permits distributed by the
Company to several Chinese to fish near Wancan, to molest the Chinese and
to take away what was theirs, and, what is more, they even dared to cut of
the hair of one of those Chinese fishermen as a token of a victory, saying:
'what have we got to do with the Soulatt of the Tion?'[53] Notwithstanding
all this, I also cannot see whether these murderers, while being left alone
like this, will continue to pile one evil practice upon the other and will thus
multiply their infamous behaviour especially by trying to harm us and seek
after our blood when we are in the weakest position, just as we indicated
before when we learned that the honourable gentleman had been driven
away. In addition to all this, this postponement is very harmful to the works
of the Lord in Sincan. I cannot see that we can continue to build without
foundations when these villains go unpunished and as we do not take the
winds out of their sails. This is not the first and only matter about which we
have to listen to these Sincandians when we are speaking with them about
our religion, touching upon the relinquishing of some of their habits, by
saying: *'What business is it of ours? We want to depart to Mattau.'* Was that
not the meaning of the words spoken by Tioulatt[54] to Jan[55] last Saturday,
saying: *'When thou wilst not permit the dancing on the trough, so we will
leave for Mattau.'*[56] Does this condoning of their conduct not even engen-
der a greater delinquency in this nation, who see us as frightened people
who do not dare to avenge that what was done to our fellow countrymen.
While they themselves, in contrast, do not even fail to avenge the beating to
death of one of their pigs or any trifle which is taken away from them, even
should this have happened several years ago. What I have written happened
very recently, so it is confirmed by the Soulangians. This postponement also
encourages such arrogance in these Sincandians that they do not fail to utter
everything that happens to come into their heads, what is just what hap-
pened to me today when I told the Sincandian who owns a greyhound that

he was obliged to hand over his dog and that he could claim restitution for his expenses. After all, all my dogs, which had been kept for so long, had to be handed over as well. He answered by saying: (fol. 3) *'should the greyhound be taken away from me, then I will again become a pagan and abandon the God of Heaven and I will conduct myself very differently from the way I have done so far.'* This took place in the presence of the Mattauwer, which did grieve me very much. The fact that these Sincandians are relying upon Mattau and are willing to leave their own village not only weakens the work in Sincan but also puts it in danger of destroying it, which I can prove by many examples. Is it not obvious in the case of one named Takareij, who had left his wife saying: *'If the Dutch want to bring me back to my wife, so will I trample one of them and run away?'* Added to this is another, who left his wife with three children. By pleading with him, we got him to leave his new wife, whom he had married in a hurry, and return, so that we thought the issue had been solved. But not long after we were told that he had left his first wife and children again for his other wife without children, acting in stark contrast to our customs. Indeed matters like these spawn bad consequences which indubitably would stop if only Mattau could be punished. Oh, if only it should please God that we would gain victory over these people, that would bring so many good results with it, not only a solid foundation for this building but also an excellent instrument to the salvation of these surrounding villages among whom we have come to be held in low esteem. Or, if a steady peace could be designed between us and these people from Mattau, which they for the time being could not imagine to be permanent. We are not quite sure that those of Soulang should allow themselves to be used to come to our assistance. This has been shown by several things, including that at the moment they are threatened by Mattau because they have beaten a man from Tirosen to death. The Sincandians, so I have heard today from Ticuta[57], seem to be willingly to go along with us on the expedition, yea, he said that we could send the Sincandians in advance to burn off the grass. This also shows us by the Word of the Lord that this is a fair matter indeed, that will be accomplished in the honour of the Lord and for the salvation of these people, so we can therefore not expect to receive the blessing of Him Who is the only Warrior who can teach our hands to fight. These are the facts that we have gathered here as quickly as possible, which illuminates my opinion about starting a war against Mattau (...)

116. Missive Reverend Georgius Candidius to Governor Hans Putmans.
Sincan, 25 November 1633.
TEDING 15, fol. 3-4.

"De missive van Sr. Gedion door last van sijn E. geschreven is ons op dato deser wel geworden, waeruit verstaen dat den raet geciteert is om op morgen te delibereeren wat best in de saeck van Mattau diene bij der hant genomen te werden ende waerin aen ons versocht wert reden ende motijven voort te brengen waerom wij souden sustineeren ende gevoelen dat sulcx voortgancq behoorde te hebben. 't Welq wij niet en hebben connen off derven noch willen weygeren, maer hertelijck gaerne deselve onse reedenen ende motijven verclaeren, ende zijn dese:

Eerstelijck dat ick onaengeroert voorbij gae den schandelijcke verraedelijcke ende onder schijn ende gelaet van vruntschap geschieden moort aen ons onnoosel ende onschuldig volcq in de reviere van Mattau ontrent 70 stercq, welckers bloet wraeck eyst, (fol.4) welckers hooffden noch in Mattau tot beschimpinge en bespottinge op 't toneel in haere feesten te proncq gestelt werden. Soo achte ende gevoele ick ganschelijck uit 't geene mij dese 4 maenden over, dat alhier mijn dienst weder hebbe waergenomen, bejegent, dat ick gesien ende gehoort, dat niet alleen de voortplantinge der religie alhier onder deze heydenen om welckers wille zoo veel moeyte, arbeyt ende oncosten alreede gedaen is, onder de welcke oock alreede soo veel verweckt is dat over de 200 persoonen gedoopt zijn een groote menigte tamelijck onderwesen, die metten eersten noch zouden conne gedoopt werden. Ja 't gansche dorp zijne affgodrije verworpen ende met den mont onses Godts belijt niet alleen geenen vordren voortganck meer zouden hebben maer oock 't geene alreede gedaen is te niet gemaeckt sal werden, indien dit dorp niet gestraft en wierde.

Ten andren soo achte ende gevoele ick ganselijck dat indien wij niet bij tijt dit dorp Mattauw den oorloog aendoen ende alsoo daer mede hen ende den omleggende dorpen eene vreese en beven injagen dat ons Sincan uit vreese van die van Mattau, met de Mattauwers sal confereeren ende aenspannen ons in Sincan sal dootslaen, den oorloog continueeren ende voortaen met gemeene cracht ende macht verhoeden dat geene Hollanders meer in haere dorpen in nestelen.

Ten 3en soo schijnt zulcx te vereysschen de reputatie van onse natie die door de gansche werelt groot ende in extime gehouden zijnde alhier onder de voeten getrapt wert, met welckers hooffden den welcken wij tot een belachinge ende verspottinge voorgestelt werden, met welckers hoofden zij op haere feesten tot onse beschimpinge seltsaem verciert over ons triompheeren,

met welcker vermoorder geschrey in de revier, zij haer in haere maeltijden
vermaecken hetselve geschrey ende gekerm nabotsende, den welcken wij een
spreeckwoort zijn, een materie ende stoff van gecken en boerterijen.

Dit zijn mijne principaelste redenen waerom ick zoude gevoelen dat, soo 't
mogelijck waere, dit dorp Mattauw nu mochte gestraft werden, om alles
wijttloopender te bewijsen waerom ick dit gevoele, en can den jegenwoordi-
gen tijt niet lijden ick 't schrijve want den brenger deses seer aendrijvett om
te vertrecken segge dat hij vandaeg noch antwoort op Tayouan moste bren-
gen ende zulcx met weijnigh niet can voldaen werden, dieshalven geresol-
veert op Tayouan op morgen selfs te verschijnen ende 't gene vorder van mij
verzocht wert mondeling te rapporteren ende t'antwoorden."

From the letter, written by Sir Gedion on the orders of His Honour, that has
reached us in safety on this date, we understand that the council is convened
to discuss what would be the best thing to do should arms be taken up
against Mattau tomorrow, and in which we are requested to give our argu-
ments and opinions of why we support the progress of this matter which we
did not dare nor wished to refuse, yet we are willing to explain our motives
and reasons, which are the following:

Firstly, I simply cannot ignore without any show of emotion the shameful,
treacherous murder that was committed on our innocent and unwitting
people, of whom about seventy were killed in the Mattau River under
pretext of friendship. The blood they shed, cries out for revenge. (fol. 4)
During feasts in Mattau their heads are still put on display and as such are
exposed to abuse and mockery. So from everything I saw, heard, and
experienced during these four months after I had again acquiesced in my
duty to serve here, I feel with my whole heart that not only for the propaga-
tion of the religion among these pagans for whom we already have expended
so much effort, labour and expense and among whom already so much has
been accomplished that over two hundred people have been baptized and a
large number of them is reasonably well taught so they will be baptized
soon, yea the entire village has rejected its idolatry and worships our God
in name only, but this only means that, if the village of Mattau is not
punished, everything that has been accomplished thus far will not only enjoy
no progress but will also be undone.

Secondly, I am utterly convinced that if we do not wage a timely war
against Mattau and by that act at the same time terrify the surrounding
villages, that our friends in Sincan will, out of fear of those from Mattau,

submit themselves to that village and will conspire together to beat us to death in Sincan and continue hostilities towards us, so that they will prevent any Dutchmen from possibly settling themselves in their villages ever again. Thirdly, it seems necessary to protect the reputation of our nation, which is held in great esteem all over the world, but that is trampled here to such extent that we are being made a fool of and are exposed to mockery. At their feasts they amuse themselves by putting the heads of their Dutch victims on display, all curiously adorned, while they relive their triumph, mimicking the cries of the people being murdered in the river, with which they, taunting us, amuse themselves during their meals mimicking the cries and moans, so that we have become proverbial and material for the buffoonery of fools.

These are the principal reasons for my feeling that, if possible, Mattau should be punished now. Time is running out, so I am not able to argue my opinion elaborately because the one who brings you this message has urged me that he was ordered to deliver my answer at Tayouan today, because I do not consider it possible to leave this matter in this way, I will appear tomorrow at the meeting of the council in person to report and answer your question orally.

117. Missive Reverend Robertus Junius to Governor Hans Putmans. Sincan, 9 December 1633.
TEDING 15, fol. 5.

"Heden tegens den avont comt bij mij één van die Chineesen die aengenomen hebben suycker van het gewas ontrent Sincan staende te leveren, secht dit jaer het suyckerriett eenen goeden scheut genomen te hebben. (...)
(...) het wercq van Sincan verthoont hem jegenwoordig beter als te voren, veele gewillige luyden bevinden wij die haer gaarne willen laeten onderwijsen als te voren, veele staat dit Mouson noch te doen soo maer door de Mattauwers niet verhindert werden. Ben noch wel gesint eenigen tijt mijns levens tot haerder salicheijt ende Godes eere te versleyten, verhoope UE. mij daerin oock couragieren zult (...)."

Today at eventide, one of the Chinese, whom we had engaged to deliver the sugar from the crop planted at Sincan, came to see me. He told me that the sugarcane has grown well this year.

(…) at present matters in Sincan are at a better pass than they were before. Many obedient people are still to be found, whom we, just as before, would gladly teach. This monsoon so many things are to be accomplished if only matters are not obstructed by Mattau. I am inclined to pass somewhat more time of my life here in the service of the people's salvation, and in the honour of God, hopefully Your Honour will encourage me in this purpose (…).

1634

118. General Missive.
VOC 1111, fol. 260. Extract 20 February 1634.
FORMOSA, p. 126.

"Dat gemelte gouverneur Putmans met sijne overgeblevene macht, ende een opgeraepten hoop Sincanders ende andere inwoonders van Formosa een tocht op het Gouden Leeuws eylant gedaen hadde, tot straffe ende weerwrack van de hostile proceduyren, die de inwoonders van ditto eylant voor desen tegen d'onse gepleecht ende begaen hebben. Dan dat met de voorsz. tocht niet anders en was uytgerecht, als dat hij de huttiens, tuynen ende weynig provisiën, van ditto eylants ingesetenen verbrant ende geruyneert hadde, sonder dat men heeft connen bevinden datter eenige van de voorgenoemde eylanders gebleven was, alsoo haer op d'aencompste van onse macht, datelijck nae het geberchte ende hunne verhoolen speloncken begaven ende onthielden."

(...) that aforesaid Governor Putmans with the rest of his army, collaborating with some scratch Sincanese troops and other inhabitants of Formosa, have carried out an expedition to Golden Lion Isle, serving as a punishment and revenge for the aggressive attacks made on our men some time ago by the inhabitants of this island.
(...) that the only thing accomplished by this expedition was the burning down and destruction of the huts and gardens and of some of the stored food of the inhabitants, without having been able to find out if any of these islanders had stayed behind, because they had run away into the mountains and their hidden caves the very minute that our soldiers had arrived.

119. Dagregister Zeelandia.
VOC 1114, fol. 15-72. Extracts 20, 21 January 1634.
DRZ, Vol. I. pp. 106-198.

"[20, 21 January] (...) verstonden uit ditto Junij dat die van Mattauw, bij die van Soulangh ende Sinckan gedreycht zijnde hun d'oorlooge aen te doen, zeer bevreest waeren dat wij de parthije van Sinckan zouden toevallen ende om vreede versochten dat apparent stondt te volgen, houdende alsoo t'eene meth t'ander in de scheede, doch vermercten uit alle omstandicheden dat die van Soulangh ende Sinckan, zoo wij hun maar eenige toesegginge van hulpe

hadden willen doen den oorlooge met ons tegens Mattauw aen te vatten, gantsch geresolveert souden bij der handt genoomen hebben."

fol. 43v.: January 20, 21 (...) by the same Junius we were informed that because the people of Mattau had been threatened with war by those of Soulang and Sincan, they were very much afraid that we would take sides with Sincan and were suing for peace, which clearly was at hand. We are keeping all avenues open but perceived from everything that was going on that the people of Soulang and Sincan were planning to make war against Mattau together with us as soon as we promised to help them in any way.

120. Missive Reverend Robertus Junius to Governor Hans Putmans. [Sincan], 23 February 1634.
TEDING 15, fol. 5-6.

"Ick hebbe naer UE. ordre Lampsack aengeseyt dat allen vlijt soude aenwenden dat binnen weijnig dagen 2 à 3 canasters suycker souden claer maecken opdat noch met dit schip Bredam vervoert ende om den Heer Generael te laten sien, wechgesonden mochte werden. Gaff tot antwoort dat noch hoopten geschieden zoude bij aldien morgen 2 stercke buffels (want koebeesten niet sterck genouch zijn) dat swaere hout om te drajen daer onder het suyckerriet geparst sal werden. Soohaest dit suyckerriet tot suycker gemaeckt sal sijn sullen dan de 2 buffels weder op Sackan bestellen. Hebben derhalven desen tot dien eynde ingestelt opdat UE. belastende dese 2 buffels te laeten volgen, zij overmorgen aen dit suyckermaecken beginnen mochten. Om dese buffels te haelen gaen Chineesen die het suycker te leveren hebben aengenomen wachten op Saccam (...)."

On Your Honour's orders I have said to Lampsack that he should be as diligent as possible so that we would be able to prepare 2 or 3 canasters of sugar for shipment on board the *Bredam* so we can show the Lord Governor-General. He replied that he hoped that would be possible if only tomorrow he could use two strong buffalo (because cattle are not strong enough) to turn the heavy yardarm under which the cane has to be crushed. Immediately after the sugarcane has been turned into sugar we will make sure that the two buffalo are brought back to Saccam. Therefore this is set up for that purpose, so that we trust Your Honour will give orders to send these two buffalo over so they will start sugar-making the day after tomor-

row. The two Chinese we hired to deliver the sugar will wait for the buffalo
to arrive at Saccam. (...)

121. Missive Reverend Robertus Junius to Governor Hans Putmans. [Sincan], 4 April 1634.
TEDING 15, fol. 6.

"Heden weder thuyscomende wierter verscheyde gediscoureert onder anderen
oocq hoorden wij dat de Mattauw soude mede gestemt hebben met den
roover. Dat Doswan verclaerde, hier zijnde gecommen, een grooten leugen
was, dat met ons gesint waeren den roover te ressisteeren. Daer van soo 't
soo is haest een preuve hebben zullen.
Het zijn meest onse Sincanders die Saccam geplundert hebben. Paulus Struys
huys opgebroocken ende alles uitgehaelt, daer van t'sijner tijt beter gelegen-
theyt zijnde spreecken connen. Kado, dien ick op mijn vertrecq naer Tayou-
an naer Soulang ende Mattauw gesonden hadde, quam mede hier als ick
quam, rapporteerde dat Soulang tot onsen dienst bereyt was ende naer den
roover toe wilden om die te bestormen.
Doswan uit Mattau sprack soo verre (te meer omdat men hem opleyde dat
mett den roover zoude samenspannen oock opdat haer behulpich mochten
zijn in toecomende om Zoulang te verneederen) dat belooffden op over-
morgen ochtent dat soude donderdach 's morgens zijn, alhier hem soude
laeten vinden met een groot getal uit Mattau vergeselschapt met Bacluan. Dat
dan t'samen, ick weder ofte Candidius mede gaen, andermael sullen besou-
cken off dese inwoonders den roover op 't lijff met brengen connen. Welcke
soo geschiede vertrouwe veel goets baeren zal in onse zaecke, dese natie
viant vanden roover ende om ons te helpen vaerdich, daer de Heeren sijn
genade toegeve, soo dan donderdach commen sal UE. van Saccam laeten
weten soo maer daer een uyr op den dach een champan mochten vinden dat
vertrouwen (...)."

Today when we returned home again we were told, among other things, that
the Mattau had been conspiring with the pirate, which Doswan[58], who had
come here, declared to be just a lie, that on the contrary they were quite
willing to join us in resisting the pirate. If that is true it will soon be proven
to us.
Those who plundered Saccam actually turned out for the greater part to be
our Sincandian friends. The house of Paulus Struys[59] was devastated and
everything was taken away. Sooner or later we will find a better occasion to

inform you about it. Kado whom I, upon my departure for Tayouan, had sent to Soulang and Mattau came back here the same moment as I arrived, reporting that Soulang was at our service and ready to go and attack the pirate.

Doswan from Mattau went as far as to make a promise (all the more so because we suspected him of conspiring with the pirate under the pretext of lending a helping hand in the future humiliation of Soulang) that on the morning of the day after tomorrow, in effect Thursday morning, he would show up here with a great many men from Mattau in the company of Baccaluan, and then that they, either accompanied by Candidius or by me, should again try to pay a visit to the pirate to see if these inhabitants will be able to bring him along alive and well, which I trust would be very beneficial to our cause, this nation, being the pirate's enemy and willing to help us. If the Lord only would grant us His mercy, so that they will show up on Thursday, then from Saccam we will let Your Honour know if we will be able to find a sampan that day with a crew whom we can trust. (...)

122. Dagregister Zeelandia.
VOC 1114, fol. 52. Extract 9 April 1634.
DRZ Vol. I, pp. 162-163.

> "Ontrent den middach zijn hier verscheyden Sinckanders met Domino Junij (de geruchten uit Dominee Candidy verstaan hebbende) ende het hooft van den stalmeester die eene van de achtergebleevene vuijtgestelde wacht geweest was, verscheenen. Verstonden meede dat Hendrick Tijt die het commandement over de uitgestelde wacht gehadt hadde (seer deerlyck gemarteliseert) een stuck weechs hiervandaen hadden sien liggen."

fol. 52: April 9: In the afternoon several Sincandians have appeared here accompanied by the Reverend Junius (who had heard the rumours from the Reverend Candidius) carrying the head of the groom who had been a member of the reconnaissance patrol. We also heard that they had seen [the corpse of] Hendrick Tijt (who was the commander of the patrol) lying severely tortured at some distance from here.

123. Missive Reverend Georgius Candidius to Governor Hans Putmans. Sincan, 11 April 1634. TEDING 15, fol 6-7. Extract.

"(...) verstaen dat de Mattauwers sich souden laeten verluyden datse pays met den roover hadden ende soo haest de roovers het fort zouden ingenomen hebben datse dan souden hiercomen, de Hollanders met de Sincanders mede verjagen (...)."

(...) We overheard that the inhabitants of Mattau had let it be known that they had concluded the peace with the pirate and that they made terms that as soon as the pirates had taken the fortress [Zeelandia], that they would come over here in order to drive the Dutch away together with the Sincandians. (...)

124. Dagregister Zeelandia. VOC 1114, fol. 52a. Extract 11 April 1634. DRZ, Vol. I, p. 163.

"Naer de middach verstonden, dat de roover zijn volck met twee champans in de rivier van Jockan aen landt setten, alsmeede dat de Matouwers haer lieten verluyden dat met den roover gesint waeren aen te spannen, om soo haaste den roover 't fort in [handen] hadde, de Sinckanders ende de aldaer residerende Hollanders datelijck te verjagen."

fol. 52v.: April 11: (...) Later today we heard that the pirate had had his people disembark on two sampans in the river near Jockan, and also that the inhabitants of Mattau had let them know that they wanted to join forces with the pirate, in order to drive out the Sincandians and the Dutch as soon as the pirate had conquered the fort.

125. Missive Reverend Robertus Junius to Governor Hans Putmans. [Sincan], 12 April 1634. TEDING 15, fol. 7.

"De variabiliteyt deser natie maeckt mijn schrijven variabel. Gistren was het gesecht, besloten ende uitgesproocken dat op morgen, zijnde den 12en, Mattauw en Bacluan hier verschijnen zoude met haer geweer, daerbij wij dan

hoopten dit dorp ende de cleene bij te vougen op hoope den roover Janglau noch eenige affbreuck zouden doen dat wij meenden daer mede geschieden zoude alwaer 't maer haer eens vertoonden, doch verstaen daer niet van vallen sal. 't Sijn maer praetjens, wij connen niet sien dat met dit volcq iet wat uitrechten sullen tot onsen voordeel. Wij hebben haer eer te verwachten tot onse vianden, gelijck wi daervan al verscheyde slordige dizcoursen van dese en gene verstaen hebben. Godt de Heer is de gene die ons helpen sal, wij hadden gaarne gesien dat dit dorp daer wij doch soo veel voor gedaen hebben ergens in gethoont hadden haere lieffde t'onswaerts doch sien daernaer te vergeeffs. Dit dorp heeft sich al claer gemaectt om te vluchten, een deel sijnder al gevlucht, soo dat eer schade dan voordeel van haer te verwachten hebben gelijck alreede gebleecken is, hebbende Saccan gespolieert, Pauls huys opgebroocken ende alles daeruit gehaelt. De swarten daertegen seggen affgesmeert, zij houden dit rooven voor een goeden ougst, majende daer niet gesayt hebben haer dunckt dit veel gemackelijcker zijn als jaer uit jaer in haere velden te gaen, ende dit rooven hout nog niet op. 't Is op 't hoogste noodich dat UE. dit voorcome, condet wesen dat eenige Sinckanders vande Chineesen affgesmeert wierden soude niet schaden. 't Can niet schaden dat UE. haer dreycht te deurschieten soo daer op bevinden ende alle de champans vande wal affhout off sij sullen 't noch meer pleegen, haer dit eens op het rigureuste verboden zijnde zullen ophouden want dit volcq met een harden toom bereden moet zijn off daer is niet van te crijgen (...)."

The fickleness of this nation pervades my writing with unpredictability, as was said yesterday, the decision was taken that the next day, being the 12th, Mattau and Baccaluan should appear here in Sincan each with their muskets, with whom we then hoped to band the warriors of this village and those of the small villages so they could inflict even greater injury on Janglau the pirate, being quite convinced that this would actually happen. We were soon disappointed as we learned that the positive news seemed to be based on nothing more than rumours. Therefore, at the moment, we do not see that we can accomplish anything to our advantage with these people, instead we can expect them to act as our enemies, of which we have seen so many different proofs. God the Lord is the One Who shall help us. We should have been so pleased to have seen this village, for which we have done so much already, give a sign of their love for us, yet we wait for that sign in vain. The inhabitants of this village have already made it clear that they wish to run away, some of them have already escaped, so that we can expect harm rather than any advantage from them, as it has already become

evident. They have plundered Saccam, demolished Paul's house and taken everything out. The *blacks* impudently say about it that they had taken this stealing for a good harvest, reaping where nothing had been sown. They claim this is a much easier way than working their fields year in year out. Nor has this stealing yet reached its limit. It is therefore of the utmost priority that Your Honour should prevent that. It would not cause great harm if only a few Sincandians were to be deceived by the Chinese, yet it would not cause any harm were Your Honour to threaten them with shots being fired at everybody being seen aboard a sampan, which will cause all sampans to keep away from the shore, otherwise they will surely commit more offences. Should this not be forbidden to them in the most rigorous way, which is the only way to make them stop and the only way these people can be reined in sharply, they are of no use. (...)

126. Dagregister Zeelandia.
VOC 1114, fol. 52v. Extract 12 April 1634.
DRZ, Vol. I, p. 164.

"Verstaen mede door de Chineesen, dat de roover sich naar Tamsuy heeft getransporteert, alsmeede dat seer verleegen is om rijs, dat dienvolgende wel iets op de dorpen (Sinckan, Soulang, Mattauw ende d'andre daeromtrent liggende) mocht attenteeren.
Aengaende die van Mattauw dat geneegen sijn met den roover aen te spannen, hebben op heeden door een missive van Dominee Junijus verstaen sulcx niet waar te weesen, maar dat ter contrarie souden sustineeren om neffens die van Soelang ende Sinckan den roover te helpen resisteeren, waartoe voorn. Junius ende Domine Candidius gerecommendeert sijn haer uiterste devoir te willen doen en geen diligentie te spaaren dat sulcx mocht in 't werck gestelt werden."

fol. 52v.: April 12: From the Chinese we also learned that the pirate had moved to Tamsuy and that he is in great need of rice, so that he might turn to the villages (Sincan, Soulang, Mattau and the other surrounding ones). Regarding the problem of the people of Mattau being inclined to conspire with the pirate, today we learned through a letter from the Reverend Junius that this is not true, but on the contrary that they would claim to make an effort to defy the pirate together with the villagers of Soulang and Sincan,

for which the said Junius and the Reverend Candidius have been urged to do their utmost and to strain every sinew to bring this about. (…)

fol. 53: April 13: *(Chinese pirates scour the coasts of Formosa and Japan. The 'pirate' Iquan conceived the plan of capturing Quelang during an eclipse of the moon. As a result of the hostilities 16 people were killed and about a hundred wounded.)*

127. Missive Reverend Robertus Junius to Governor Hans Putmans. Sincan, 14 April 1634.
TEDING 15, fol. 8.

"Wij laeten niet naer daeglijcx Sincandren uit te senden verre om de zuyt om te vernemen waer dat den roover zoude moogen zijn. Niemant brengt ons tidinge van hem. Seggen hem niet te connen sien, soo hij niet is bij Tampsuy geloove niet datter is. Heden is den jongen mannen opgeleyt weder heen te loopen zoo verre als connen comen, om te vernemen waer hij mochte sijn. Het wort hier gesecht van de Chineesen dat niet weijnig zijn deel gecregen heeft, doen hij onlancx doende was aen 't fort, daer souden der meer als 100 gequest sijn ende 40 dooden soo dat wij gelooven dat niet weynig bange is. Wij houden 't daer voor (soo de Heere onse Godt gelieve dat hem noch eens tegenstaen dat vast vertrouwen) dat in toecomende niet meer dencken sal soo een fort aen te doen maer datelijck hem op de vlucht sal begeven. Sijn E. vertrouwe vastelijck alle vlijt ende naersticheyt doen sullen om dese inwoonders tegens den roover te instigeeren. Mattauw sullen wij daertoe niet connen crijgen alzoo eens met de roover gesint, is soo der gesecht wert. Tot Soelang is goede hoope, die wij op gisteren aanseyde dat Antul eersdaegs comen zoude om met mij daervan te spreecken.

Bacluan een groot deel van haer was hier gisteren met pijl en boge sijnde gezint om te vechten doch door dien onse Sincanders niet bijder hant waeren ende onseker was waer de roover mochte sijn, sijnse wedergekeert, souden wederkeeren is het roupen (…)."

Every day without fail we send out Sincandians far to the south to see if they can find out were the pirate may be skulking. Yet nobody brings us any news about him. They say that they cannot see him. If he is not in the neighbourhood of Tampsuy they do not believe that he is still prowling around here. Today the young men were sent out again with the commission to walk to the south as far as they can go to learn were he might be. Over here it is said by the Chinese that he got more than he had bargained for

when he tried to attack the fortress, which resulted in over a hundred wounded and forty dead, so that we believe that he has got the wind up. We hope that it is true (so it would please the Lord our God that we will once more oppose him, in which we steadfastly trust) that in the future he will never again conceive the idea of launching an attack on a fort such as this, but that he will take instant flight. His Honour must steadfastly trust that we will show every diligence and assiduity in inciting these inhabitants against the pirate. It seems that we will not persuade Mattau to this because of their sympathy with the pirate, which the people talk about. We do however have good hope of Soulang. Yesterday we told them that Antul[60] should arrive before long in order to discuss the matter with me. The majority of the inhabitants of Baccaluan who are very much inclined to fight, came here yesterday carrying their bows and arrows. However, because our Sincanders were not at hand at that moment and because of the uncertainty of the whereabouts of the pirate, they have returned to their village saying that they would come back (...).

128. Missive Governor Hans Putmans to the Reverends Georgius Candidius and Robertus Junius. Tayouan, 18 April 1634. TEDING 14, fol. 2-3. Extract.

> "De missive van dominee Junius den Maleyer medegegeven is door versuym ons naer de middach eerst ter hant gestelt ende oversulcx op huyden morgen niet beantwoort. Aengaende de Sincanders dat dagelijcx uitgaen om te verneemen waer den roover sich onthout is ons lieff te verstaen, doch presumeeren dat weynich naerscheyt daertoe doen, maer dat het haer eer om d'onse te berooven te doen is, want noch eergisteren uit seeckeren Chinees verstaen hebben dat in Tancoja met een cloucqe macht van joncqen is onthoudende. Dienvolgens connen wel bevroeden, bij aldien de Sinckanders naersticher deden ende wat meer uitgingen wel vernemen souden waer dat hij was (...)."

The letter written by Reverend Junius and handed out to the *Maleyer*[61] was owing to negligence only handed over to us past noon which is the reason why it was not answered directly this morning. Concerning the people of Sincan who are sent out everyday to investigate the whereabouts of the pirate we are most pleased, yet we presume that they will show little diligence in this, because their prime purpose is to rob us, as the day before

yesterday we were informed by a certain Chinese that a fairly substantial number of junks was at anchor in Tancoja. This leads us to suspect that if the men from Sincan had displayed some more diligence and had ventured a little further, they certainly would have traced were he could be found. (...)

129. Missive Reverend Robertus Junius to Governor Hans Putmans. Sincan, 18 April 1634.
TEDING 15, fol. 9. Extract.

"De occasie mij gegeven zijnde aen UE. te schrijven hebbe deselve niet willen voorbij laeten gaen. Hoe de saecken staen tusschen Soulang en Mattauw heeft zijn E. uit de missive van dominee Candidius connen verstaen, wij sullen daertoe arbeyden zoo veel mogelijck is dat Sincan nau verbonde worde met Soulang, ende nu in dese gelegentheyt van Mattau gedreijcht zijnde dat tot assistentie van Soulang haer vaerdig te toonen (...)."

We did not want to relinquish the proper occasion offered to us to write to Your Honour. Your Honour can understand from the letter of Reverend Candidius how matters are between Soulang and Mattau at the moment. Therefore we endeavour to the best of our abilities that Sincan will be allied closely to Soulang and that now, while Soulang is being threatened by Mattau, Sincan will show they are ready and willing to assist Soulang against their enemy. (...)

130. Dagregister Zeelandia.
VOC 1114, fol. 54-55v. Extracts 18, 19, 20 April 1634.
DRZ, Vol. I, pp. 167-168.

fol. 54: [18 April] "Op heeden becomen een missive van Dominee Candidius ende Junius uijt Sinckan, waeruijt verstaan dat de Sinckanders daagelijcks uytgaan om te verspieden waar sich den roover mochte onthouden, doch dat van deselver niet connen verneemen. Alsmeede datter een Chinees van den roover in de Japansche joncque onder Injeey Wattingh sich soude verschuijlen, die voordeesen in Sinckan om waapenen te coopen eenigen tijt hem soude onthouden gehadt hebben, dat oock bij Dominee Junius ende den sieckentrooster Jan den Tijt soude gesien sijn.

fol. 54v.: Waarover bij den Ed. Hr. Gouverneur Putmans ende den Raet geresolveert wiert dat men Dominee Junius ende voornoemde sieckentrooster sall

ontbieden ende de Japansche joncque visiteeren om te sien off voornoemde Chinees noch bij haer (...) soude gekent connen werden.

[19 April] Op heeden verstaan uyt een missive van Dominee Junius uyt Sinckan hoe dat bij die van Soulangh alle preparade tot den oorlooge tegen die van Mattau gemaect wert ende dat bij Dominee Junius als Candidius alle diligentie aengewent wert om die van Sinckan met die van Soulangh meer en meer te verbinden, doch dat tot noch toe in 't selve weynich connen optineeren. (...)

fol. 55: [20 April] De Sinckanders die voordeesen verscheyden maalen derwaarts uytgesonden sijn, hebben mede geenige joncquen connen verneemen, sulcx dat vastelyck vertrouwen dat sijn boos voornemen ende geprojecteerde aanslach sall gestaect hebben."

fol. 54: April 18: Today we received a message from Sincan from the clergymen Junius and Candidius. It informs us that the Sincandians are leaving their village every day to find out where the pirate is skulking, but that they have not been able to discover him. Also that in the company of the pirate and presumably hiding in the Japanese junk under command of Injeey Wattingh, there is a certain Chinese, who once resided in Sincan for some time to purchase some weapons and who, so they say, has been seen in the company of the Reverend Junius and Jan den Tijt (who cares for the sick). On this matter the Honourable Governor Putmans and the council decided to summon the Reverend Junius and the assistant in question and to search the Japanese junk to see if they still know the whereabouts of this Chinese. (...)

fol. 54v.: April 19: Today we gathered from a letter from the Reverend Junius that all preparations needed for war against the village of Mattau have been made by the people of Soulang and that the clergymen Junius and Candidius are doing their utmost to unite those of Sincan with those of Soulang, but that they have not been able to achieve much in this respect so far.

fol. 55.: 20 April: The Sincandians who have been sent over there a couple of times could not discover any junks, so that we trust that he has called a halt to his vile intentions and planned attack.

131. Dagregister Zeelandia.
VOC 1114, fol. 55. Extract 24 April 1634.
DRZ, Vol. I, p. 168.

fol. 55: "Tegens den middach compt alhier van Sinckan Dominee Junius, rapporteerende, dat over 't geene op gisteren bij de Ed. Hr. Gouverneur ende Raedt geresolveert is wijtloopich met Dominee Candidius heeft gediscoureert, zijnde haar advijs van de cleijnste dorpen aff te beginnen, dewijle die van Sinckan om deselve te helpen straffen haaren dienst presenteeren. Ende dat een van haar beyden met eenige der principaelste Sinckanders vooruijt naar voornoemde dorpen souden gaan (fol. 55v.) om haer aan te dienen, dat alle 't geene bij haar soo van de Nederlanders als Chineesen gerooft is gehouden sullen sijn te restitueeren, neffens een straffe die voornoemde Junij ofte Candidius met de Sinckanders rechtmaatich sullen bevinden te behooren."

fol. 55: April 24: Around noon the Reverend Junius arrived here coming from Sincan, saying that he has discussed at length with Reverend Candidius all that has been decided upon yesterday by the Lord Governor and the council and that it is their advice to start with the smallest villages and that the people of Sincan offer their assistance to punish these. And that one of them would go ahead to these villages in question with a few of the most important Sincandians in order to announce that they would be obliged to restitute everything that had been stolen by them either from the Dutch or from the Chinese, apart from the punishment which the said Junius or Candidius together with the Sincandians would think appropriate.
(To enforce this, soldiers and a representative of the Governor will be sent as well.)

fol. 56: "25 Ditto een uyr voor daage is den ondercoopman Pieter Smith, den Sargiandt Teeck, neffens 20 soldaten volgens op gisteren gearresteerde resolutie naer de cleijne dorpen toe gesonden, die 'savonts wederom quaamen, rapporterende dat alles ten dienste van de Compagnie well gesuccedeert was ende dat ijder dorp tot een straffe vier varckens hadden opgebracht, neffens parthije andre goederen van weijnich importantie, met beloften haar in toecomende voor sulcx als ander quaat te wachten."

fol. 56.: On the 25th of this month one hour before daybreak, Junior Merchant Pieter Smith and Sergeant Teeck together with 20 soldiers were sent to the small villages in accordance with the resolution which was decided upon yesterday, returning at night reporting that everything has been arranged satisfactorily to suit the Company and that each village had produced four pigs as a fine as well as a clutter of other goods of trifling importance and had promised to take care not to misbehave again in this or any other way.

132. Missive Governor Hans Putmans to the Reverends Georgius Candidius and Robertus Junius. Tayouan, 27 April 1634.
TEDING 14, fol. 1-2.

"Op gisteren tegens den avont gewert ons UE⁵. missive, waeruit verstaen noch al veele goederen onder die vande cleene dorpen ende principael die van Sincan soude schuylen, dewelcke UE⁵. hadden voorgestelt dat alles souden opbringen, doch vreesden daer weynig op zoude volgen ten waere men door hardichen (die UE⁵. meijnden daer toe noodich van doen te zijn) 't selffden voorderde, dat onsen persoon off den luytenant met den goede troupe soldaten daertoe noodich vereyscht wiert. Wij connen mede wel begrijpen dat dit faict bij hun begaen wel op het alderrigureuste behoorde gestraft te werden, maer onses oordeels isset voor alsnoch beter een weijnig door de vingren gesien als de saecke hooger te heffen als met authoriteyt connen uitvoeren ofte het uyterste, dat is den oorlooge, te verwachten alsoo des Compagnies constitutie jegenwoordich 't selve niet wel zoude willen lijden. Echter is bij den Raet volgens vorige resolutie over die vande cleene dorpen getrocken, goetgevonden UE⁵. den luytenant met den sarjant Teecq, den stalmeester ende een troupe van 32 soldaten met beyde de boots, soo haest hier gearriveert zijn, toe te laeten comen, omme op vorige wijse tegens die van Sincan te procideeren ende hun alles soo veel mogelijck te doen opbringen, daerenboven ider kercke een straffe, soo 't wesen can, te doen geven: ten minsten van 2 varckens ider met de moort der Chineesen, als de gene die des Compagnies 2 paerden (fol. 2) ende 2 bocxkens gedoot hebben. Dientmen noch wat te simuleeren om ondertusschen pertinent te vernemen wie de uitvoerders van soodanigen wercq geweest zijn ende deselve opzijn onversienste in toecomen met authoriteyt te straffen ende lichten (ondertusschen dient vande cleene dorpen alles noch dagelijcx, datmen verstaet dat zij hebben te vorderen al soude men in toecomen soo 't geraden is, in diergelijcke forma daer noch eens verschijnen)."

Gelieft mede te versorgen dat soo veel vande grootste bambousen als eenigh-
sints mogelijck is herwaert aen gesonden werden, alsoudemen deselve in de
rivier van Soulang doen hacken. 100 à 200 geheel oude ditos, dienen ons tot
het maecken van atap met den eersten in een cleen vlotjen toegesonden te
werden, soo veel stroos als beyde boots dagelijcx connen haelen sullen
verwachten.

Op eergisteren is bij ons andermael een champan affgevaerdicht naer Tan-
coya ende Tampzuy om te vernemen de sekerheyt off den roover vertrocken
is off niet. Die op heden geretourneert is, brengt tidinge dat gantsch niet
vernomen heeft, waerover vast gelooven dat sich na de custe van China ofte
Pedro Branco sal getransporteerd hebben.

Ingevalle de boots die wij in Sincan om stroo hebben gesonden morgen hier
verschijnen sullen den luytenant met de geseyde soldaten derwaerts depe-
cheeren om met sijn volcq tegens overmorgen ochtent vrough aende groote
brugge met gemelte boots te comen. Soo UE. oordelen de Sincanders vande
compste der soldaten dienen kennisse te hebben, connen UE. op overmorgen
met het lemiere vanden dach den luytenant aende groote brugge kennis
daervan doen om sich daer naer te richten. Anders sulcx niet noodich zijnde
hebben UEˢ. sijnen persoon met de soldaten op geseyde tijt te verwachten,
tot een teecken wanneer den luytenant hier vertreckt sullen een groff canon
lossen (…)."

Yesterday towards the evening, we received Your Honour's letter, from
which we were informed that a goodly amount of trade goods were being
kept hidden by the inhabitants of the small villages, principally by those of
Sincan who had made promises to Your Honours to hand over everything to
you. However, we feared that little of what they had said would actually be
carried out unless they are dealt with more harshly, which Your Honours
believe is quite neccessary. In order to make any progress in this matter,
our person or that of the lieutenant, together with the good group of soldiers
will be required. We are also well aware that this evil deed they committed
needs to be punished in the most rigorous fashion, yet in our judgement it
would be better to make some allowances so as to raise the whole matter to
a somewhat higher level, to that on which we can exercise with real author-
ity. Otherwise the extremity, which means to start a war on them, is to be
expected with which the strength of the Company today could not cope very
well. Nonetheless it was the council, in accordance with a preceding resol-
ution taken about the little villages, which agreed to send Your Honours the
lieutenant with Sergeant Teeck[62] and the groom, accompanied by a party

of thirty-two soldiers with both vessels as soon as they have arrived here, in order to march just like as was done before against those of Sincan and order them to comply with everything as strictly as possible. In addition to this, every 'church' should, if this be possible, be given its own punishment, which would consist of at least two pigs for every person counted guilty of murdering a Chinese, as well as those who killed two of the Company's horses and the two goats. One should simulate a little in the meantime in order to be sure about the actual perpetrators of such a deed, so that in the future it will be possible to punish them unexpectedly. Meanwhile, the inhabitants of the small villages should be made daily aware of the fact that it is their duty as elders to produce the putative goods, otherwise should it be necessary, we shall certainly appear there once more just like we have done before.

Please also take care to see to it that you can get as many of the largest bamboos as possible to be sent over here. If they are taken out of the river of Soulang make sure that about one or two hundred old ones are cut which will serve us for the construction of an *atap*[63] in addition with those which were sent over on a little raft, and as much small straw as both the boats are able to transport daily.

On the day before yesterday we again sent a sampan to Tancoya and to Tampzui in order to learn with certainty if the pirate has left the island or not. They returned today bringing the message that they have seen nothing of him at all. This leads us to believe firmly that he has left for the China Coast or for Pedro Branco.

Should the boats which we have sent to Sincan to collect straw appear over here, we will send the lieutenant along with those soldiers mentioned to you in order to arrive with his people in these boats early in the morning of the day after tomorrow at the large bridge [near Zeelandia Castle]. If Your Honours consider it better to inform the Sincanders about the arrival of the soldiers, the day after tomorrow at the first daylight, Your Honours should inform the lieutenant on the large bridge about this so he can act accordingly. Otherwise, should this not be necessary Your Honours can expect the soldiers at the appointed time, on the departure of the lieutenant we will give you a sign with a shot fired from the heavy cannon (...).

133. Dagregister Zeelandia.
VOC 1114, fol. 55v-56. Extract 27 April 1634.
DRZ, **Vol. I, p. 169-170.**

"(...) van gelijcken, dat den Leutenant Johan Jeuriaensz. op 't versoeck van
Domine Candidij ende Junij met 32 soldaaten, om de gerooffde goederen, op
gelijcke wijse als in de cleijne dorpen geschiet is, van de Sinckanders te vor-
dren."

fol. 56.: April 27: (...) Likewise that the Lieutenant Johan Jeuriaensz., at the
request of the clergymen Candidius and Junius, (went) with 32 soldiers to
demand the return of the stolen goods from the Sincandians as had happened
in the little villages.

134. Dagregister Zeelandia.
VOC 1114, fol. 56v. Extract 29 April 1634.
DRZ, **Vol. I, p. 171.**

"'s Avonts compt den lieutenandt met de parthij op gisteren naar Sinckan
vertrocken, alhier wederom terugge, rapporteerende, dat eenige goederen
van weijnich importantie hadden gerestitueert, neffens 16 varckens tot een
straffe. Zijnde vorders aldaar weijnich te verrichten."

fol. 57: April 29: In the evening the lieutenant, who had left with his party
yesterday for Sincan, reported that they had restituted some goods of little
importance, apart from paying their fine of 16 pigs. Apart from this there
was little else that could be done over there.

**135. Missive Governor-General Hendrick Brouwer to Governor Hans
Putmans. Batavia, 13 May 1634.**
VOC 1111, fol. 327-336.

fol. 334v.: "(...) Dat U Ed., naer sijn aencompste in Teyouan met de reste-
rende macht ende behulp der ingesetene van Sincan, Soulangh ende Teyouan
een tocht op het Goude Leeuws eylant gedaen ende een welverdiend revengie
genomen hebt over de moordadicheyt voordesen aen ons scheepsvolck
begaen ende geperpetreert, hebben wij gaerne vernomen ende souden van
gelijcken wel genegen sijn omme ernstlijck te straffen het enorme faict ende
massacre van die van Mattauw, te meer deselve, vilipenderende ons respect

ende gesach in Teyouan, haer op onse gedaene insinuatie in de voorn. expeditie op het Gouden Leeuws eijlant met die van Sincan ende Soulangh niet en hebben gepresenteert ofte daertoe eenige hulp ende assistentie gepresteert. Dan vermits wij desen jaere geen conciderable macht ende geen crijgsvolck altoos naer Teyouan sullen connen uijtsetten ende dese saecke, ons geen schaedelijcker consequentie te causeeren, mede met ernst ende reputatie dient uijtgevoert (gelijck wij voor seeker meenden met voorgaende macht soude sijn geschiet), soo hebben goet gedacht de voorgenomen wraeck op Mattau mede tot beter opportuniteijt uijt te stellen, ten waere wij U Ed. door groote vaderlantse secoursen meerder macht toeseijnden mochten, als noch voor alsnoch geschapen is. U Ed. sal derhalven met haer noch dissimuleeren, hoewel de saecke noijt beter in 't werck gestelt ende ten effecte soude connen gebracht werden als in dese conjuncture van tijt, dat de Sincanders ende Soulanghers tesaemen aengespannen sijnde die van Mattau den oorloch aengedaen ende groote vrese aengejaecht hebben."

fol. 334v.: (...) with pleasure we received the news from Your Honour that after your arrival in Tayouan you mounted an expedition to Golden Lion Island with the remainder of the army and with the assistance of the inhabitants of Sincan, Soulang, and Tayouan, and that you exacted well-deserved vengence for the murders once committed against our sailors.

And we would equally be inclined to punish severely the heinous crime and massacre committed by the people of Mattau, the more so because, ridiculing our respect and authority in Tayouan, they neither showed up in the said expedition on Golden Lion Island in the company of the people of Sincan and Soulang in answer to our prompting nor did they contribute any help or assistance to it. But because we will not be able to send a considerable force or any soldiers at all to Tayouan in the near future this year and because this matter, to prevent any more harmful consequences, must be resolved in a properly creditable way once and for all (which we had been definitely convinced could have been done with the previous force), we thought it would be a good idea to delay the planned revenge on Mattau until a more promising occasion than that which is presented now, when we may well be able to send a bigger force to Your Honour, because of the influx of large numbers of auxiliary troops from the fatherland.

Therefore Your Honour must keep on fooling them for a while longer, although the matter could never have been realized and effectuated any

better than at this moment, now that the villagers of Sincan and Soulang have joined together and fight and terrorize the people of Mattau.

136. Missive Reverend Georgius Candidius to Governor Hans Putmans. Sincan, 14 May 1634.
TEDING 15, fol. 10.

"Op dato deser comt Tacarang uit Mattauw, verhaelt hoe datse gisteren weder met Soulang gevochten ende dat op de zijde van Soelang 2 bennen gebleven, ende datse noch veel gewonden ende swaerlijck gequetsten gecregen, op de zijde daerentegen vande Mattauwers niemant gebleven ende datse wel veel maer niet swaerlijck gequetsten hadden. Verhaelt verder datt Tammasserij ende noch eenen Tacalamey, alle beyde Sincanders, gisteren in 't vechten bennen gecomen bij haer met eenige cleetjes seggende datse uit den naem van Candidius gestiert waeren om pays te maecken ende datse dese cleetjes tot een straffe van de Soulangers zouden nemen, waer op Tacarang vergramt zijnde sijn houwer heeft uitgetrocken, willende de selve cleetjes ontstucken cappen doch niet gedaen maer haer van sich wech doen gaen, ende in 't vechten onverhindert voortgevaeren. Nu vandaeg, zoo quam hij vernemen, off sij uit de Hollanders name gestiert waeren met eenen daertoe te arbeyden dat wij Tamassarey ende Takalamey niet en mosten gelooven, zoo sij 't anders verhaelden als hij 't ons in presentie van veel volcq vertrocken hadde, dese beyde persoonen bennen van mij niet gestiert, zij bennen wel bij mij geweest, hadden gaerne gehatt datse uit mijn naem mochten gaen om pays te maecken maer hebbe haer geantwoort, wouden se gaen datse mochten gaen, maer datse haer niets uit den naem vande Hollanders aenseggen zouden; woudense vechten datse mochten vechten ende soo niet, datse mochten pays maken datse doen zouden zoo se goedvonden, doch de Hollanders daerin niet te noemen. De reden waerom ik haer niet en hebben willen 't jawoort geven datse uit den naem vande Hollanders zouden gaen ende pays maecken sijn dese:

1en) Omdat geen last van sijn Ed. daertoe hadde;

2en) Omdat mij dunckt voor de Hollanders veel profijtelijcker te wesen datse malcanderen lustig wat op de mutse gaven ende dat weder om verscheyde reedenen: 1en om datse haer macht aen malcanderen selver soude verslijten, 2en omdat de viantschap van dese beijde dorpen dies te bitterder zoude werden ende dat wij heden off morgen altijt na onsen wille het eene dorp op onse zijde zoude mogen hebben tegen het ander dorp om sich te revengeeren, 3en omdat het vernederde dorp tot de Hollanders ganselijck sijne toe-

vlucht soude nemen 't welcq noch niet geschiet want se alle beyde effen trots zijn.

Ten 3en) Soo hebbe ick niet willen hebben datse zouden gaen uit den naem vande Hollanders om dat ick vreese zij in furie zijnde doch niet na ons geluystert hebben ende ons hierin niet gehoorsaemt, ende naer ons luysteren ons daermede schande ende verachtinge souden aengedaen hebbben;

4en) Omdat mij bekent was dat de Mattauwers soo op Soelang vergramt waren datse gansch tot geen pays verstaen en souden ende de Soulangers oock soo trots ende opgeblasen waren datse noyt bij ons bennen gecomen om te verzoucqen dat wij ons de saecke souden willen aennemen ende den pays maecken. Hierbij comt oock datse den roover voor ons hebben verheelt diese in haer dorp hadden ende deselve niet hebben willen overleveren hoewel sulcx notoir ende kennelijck genoug was. Dit sijn de reden geweest waerom ick niet gewilt hebbe datse uit der Hollanders naem souden gaen ende pays maecken. Overmorgen, den 16en, sullense weder malcanderen slach leveren. Soo zijn Ed. verstonde dat men daertusschen zoude spreecken uit den naem van sijn Ed., meene dat dan een pays soude getroffen connen werden, na mijn oordeel was 't beter datse continueele oorloge tegens malcander voerde ende dat wij niet daer tusschen mosten spreecken ten waere dat Soelang seer vernedert zijnde sulcx ernstelijck van ons verzochte. Maer soo Mattau groote neerlage creege ende de Soelangers langer wilden vechten dat wij haer zoude late betijen, ofte indien wij zagen datse alle beijde tot peys genegen waeren ende doch pays sonder ons souden maecken dat wij ons dan de saeck zouden aennemen ende uit authoriteyt den pays beschicken. Verwachte hierover het gevoele van sijn Ed. ende na 't selve sullen hier in deze saecke te wercq gaen (...)."

On this date Tacarang arrived from Mattau, and told us how they fought with Soulang yesterday and that on the side of Soulang two died in the battle, also that many were wounded, some of them seriously. Yet on the Mattau side nobody was killed; however, they did suffer several casualties but none of them was seriously hurt. Furthermore, he informed us that Tammasserij and also one Tacalamey, both being Sincandians, came to them during the fighting yesterday offering them some cloth in the name of Candidius and that they had been sent especially to make peace and that they would take this cloth back from the Soulangians by way of punishment. At this Tacarang being wrathful unsheathed his chopper, wanting to cut that cloth into pieces, though in the end he did not carry that out but made it clear that he wanted them to leave, and afterwards went on fighting as

though nothing had happened. Today, he came to find out if they had really been sent in the name of the Dutch. At the same time he made it clear to us that we should not believe Tamassarey and Takalamey should they tell us something to the contrary to that what he told us in the presence of other people. Both these persons were not sent by me, yet they have come to see me and would have liked it very much if they could only have gone to make peace in my name, but we answered them that if they wanted to go, we had no objections as long as they would not promise anything in the name of the Dutch, whether they wanted to fight or whether they wanted to go and make peace as long as they only would not mention the Dutch. The reasons why I did not want them to have my consent to go and make peace in the name of the Dutch are these: firstly) because we have not been given any orders from His Honour to that end; secondly) because it seems to me that it will be much more profitable to the Dutch should they, every now and then, beat each other up lustily. And again because of different other reasons: 1) because then they will wear away their vigour on each other; 2) because then the enmity of both these villages would be fed to become more bitter so that we will always be able, be it today or tomorrow, to make use of the fact that one village could fight on our side to take revenge against its enemy; 3) because then the humiliated village would seek refuge with the Dutch which has not happened yet because both of them are equally proud. Thirdly) I did not want them to go in the name of the Dutch because I feared that if they, after having listened to us, were to be beset by a true fury they would no longer obey us, by which they would have disgraced us and made us an object of contempt; fourthly) because it is known to me that the people of Mattau are so full of spleen towards Soulang that they would never advocate peace. Besides the Soulangians are so proud and puffed up so they would never come to us in order to request we take the matter in hand and make peace. Moreover, because they did hide the pirate from us in their village and refused to hand him over to us. These were the reasons why I did not want them to make peace in the name of the Dutch. The day after tomorrow being the 16th, they will again fight each other. Should His Honour suddenly decide we should interfere in his name believing it would be possible to make peace between them, in my opinion it would be better were they to wage their constant war against each other and that we should not interfere unless Soulang should suffer great humiliation demanding aid from us most earnestly. Should Mattau be defeated after which the Sou-

langians would like to continue the fighting, then we would leave them alone or if we saw that both of them were inclined to make peace without our intervention and were they to make peace without us, then we could take up this matter and deal with it authoritatively. About this we expect His Honour's opinion so that we can follow his orders (...).

(The church at Tayouan had grown too small to accommodate all the Christian community.)

137. Missive Governor-General Hendrick Brouwer to the Church Council in Tayouan. Batavia, 27 June 1634.
VOC 1111, fol. 376-378.

fol. 376v.: "Eersame vroome Godtsaligen, (...) Uwe aengenaeme generale en particuliere missive van dato den 24 ende 27 februari 1634, daaruijt (...) vernomen hebben den goede stant ende verbeterde constitutie der religieuse saecken in Sincan alsmede den grooten aenwas ende vermeerderinge van de gemeente, (...) soodanich toegenomen heeft dat oock de kercke die aldaer van ons gestaen heeft ende door den grooten toeloop van bekeerde ende verlichte harten te cleijn geworden is, meer als de helft heeft moeten vergroot ende uijtgeleijt worden.

fol. 377: (...) dan hoopen echter met de volgende vaderlantsche schepen sodanigen bequamen stoffe te becomen, dat Teyouan ende andere plaetsen van Indiën behoorlijck gedient ende naer eysch van leeraers ende predicanten versorcht sullen connen werden. Wij vertrouwen vastelijck dat het wel noodich ende dienstich soude weesen dat men eenige van de aparenste kinderen der voorneemste persoonen in Sincan, Soulangh ende andere werken soo verre poogde te leeren ende te brengen, dat se vooreerst tot schoolmeesteren ende mettertijt tot leeraren van haer compatriotten souden werde gebruyckt, mits genietende eenich maendelijcks tractement van ses, acht, thien ofte meer guldens, waerdoor deselve ende haere ouders mitsgaders haere lantsaeten te meer aen ons verbinden souden. Deese souden haere gemeente gestadich bijblijven, als wesende in haere eijgen vaderlant. Soo hen naer behooren comporteren, connen met een cleentien, alsoo weijnich behoeven, gevoordert werden ende andersints souden oock met cleene schrupulen connen verlaeten werden.

Dat de wederspannige inwoonders ende wilden van Mattauw het werck des Heeren in Sincan seer tegenhouden ende verachteren, connen wij met U Ed. seer wel consideren dan dat hetselve niet anders als met verwoesting, uijt-

roeijinge ende vernieling van het voornoemde dorp soude connen gevoordert werden (...).

fol. 377v.: Evenwel blijven wij genegen ende geresolveert om, volgens U Ed. instantelijck ende hartelijck begeeren, te revengeeren ende, andere ten exempel, rechtveerdelijck te straffen de moordadige actien ende massacren die de inwoonders der dorpen Mattauw ende Tacarciangh op verscheijden tijden ende verstonden soo trouwelooselijck aen de onse begaen en geperpetreert hebben. Temeer deselve vilipenderen ons respect ende gesach in Tayouan, haere neffens die van Sincan ende Soulangh op den tocht ende expeditie van het Goude Leeuws eijlant niet gepresenteert oft daertoe eenige assistentie gepresenteert hebben. Ende hadden daeromme niet liever gesien dan dat den Gouverneur Putmans, volgens den last ende macht die hij in den jaere voorleden daertoe gehad heeft, de occasie waergenomen ende neffens die van het Goude Leeuws eijlant oock die van Mattauw aengetast ende na de merite van haere geperpetreerde misdaet gestraft. Alsoo wij in desen jaere 't selve sullen moeten uijtstellen doordien van volck en schepen niet wel voorsien sijn, om alsoo door eenich ongeval geen schadelijcke consequentien meer te causeeren ende tselve ter gelegenertijt met reputatie te revengeeren.

fol. 378: Den predicant Georgius Candidius (...) geeft ons (...) noch andermael in bedencken ofte men tot invoering ende meerder bevestinge van ons gesach ende authoriteyt op Formosa niet en behoorde eenen expressen dictator ofte rechter in Sincan te houden, omme de Sincanders mitsgaders de inwoonders van Soulangh ende Backeloangh allenskens nae onse wetten ende costuymen te gewennen ende alle cleijne differenten ende voorvallen- de questien *ex authoritate* aff te doen. Wij hebben hetselve andermael in deliberatie geleijt ende hebben tot het instellen van soodanige rechter ofte dictator noch niet connen verstaen, soo om de oncosten te excuseeren als dat wij oordelen de futile questien der voorz. dorpen noch vooreerst bequaemelijcker door U Ed. bij forme van acomodatie als door absolute macht van soodanigen rechter beslist ende gedecideert soude connen werden."

fol. 376v.: Honourable and Godfearing Council, in Your amiable general and private letters of February 24 and 27, 1634, I was informed about the good state and improved position of the religious matters in Sincan and of the great increase and augmentation of the community, (...) which has increased so much that our chapel standing there has also become too small, because of the great influx of converted and enlightened souls, and should be enlarged by more than half.

(After the death of the ordinand (proponent) Bonnius, the High Government in Batavia had most willingly sent a new preacher to Tayouan, were it not

that in Batavia, after the death of the Rev. Sebastiaen Danckaert, there were also just three clergymen present. Under the circumstances, Zeelandia would just have to be patient. As soon as reinforcement arrived from the fatherland, one of them would be sent to Formosa.)

fol. 377: (...) So we hope to receive such competent material with the next fleet from the fatherland, that Tayouan and other places in the Indies will be properly served and taken care of in accordance with their demand for teachers and clergymen. We are firmly convinced that it would be necessary and useful to try to teach and bring some of the most outstanding children of the principal people in Sincan, Soulang, and other settlements so far that they could be used in the first place as schoolteachers and later on as teachers of the Gospel for their compatriots, if only they could enjoy a monthly stipend of six, eight, ten or more guilders, by which we could engage their loyalties more and those of their parents as well as their compatriots.

(This is the way it is done in Ambon, Banda, Ceram and other places.)

The fact that the rebellious and savage inhabitants of Mattau greatly obstruct and are contemptuous of the works of God in Sincan gives us and Your Honour great food for thought whether these works can only be accomplished if the very village of Mattau is destroyed, exterminated and ruined. (...)

fol. 377v.: But, in accordance with the pressure and strong desire of Your Honour, we are still inclined and convinced to seek vengeance and, as an example to others, to punish lawfully the murderous acts and massacres which the inhabitants of the villages of Mattau and Tacarciangh have committed against our men on different occasions, very perfidiously (as we were told).

The more so because they ridicule our power and authority in Tayouan and failed to show up alongside the people of Sincan and Soulang during the march and expedition to Golden Lion Island nor did they render any assistance. That is why we should prefer to have seen Governor Putmans taking advantage of the situation, in accordance with the instructions and the power he possessed during the past year, so that he had attacked not only the inhabitants of Golden Lion Island but also the people of Mattau and had punished them in a manner befitting with the crime they had committed. But this year we will have to postpone this because we are not well enough equipped with men and ships, in order to be sure that no harmful conse-

quences may follow accidentally and that revenge will be taken in due time with success.

(The Reverend Junius has completed a five-year-term and wants to leave. Moreover, during the time he still remains in VOC service on Formosa he wants to earn the same salary as Candidius. His request will not be honoured. The arguments produced by Batavia are that his studies have been financed by the Company and that later on Formosa he has always been able to live in a house at the Company's expense.)

fol. 378: With the purpose of achieving the affirmation and sounder foundation of our rule and authority on the isle of Formosa, the Reverend George Candidius again begs us to consider the possibility of a special dictator or judge in Sincan to acquaint the Sincandians and the inhabitants of Soulang and Baccaluan gradually with our laws and manners and to settle all small disputes and problems which occur *ex autoritate*. We have taken this into consideration again but we have not yet come to a conclusion on the subject of the appointment of such a judge or dictator, on the one hand because we do not want to spend any money and on the other hand because we are of the opinion that the trivial problems of these villages should rather be discussed and resolved by Your Honour to seek a settlement than through the absolute power of such a judge.

138. General Missive.
VOC 1111, fol. 4-143.
FORMOSA, p. 135. Extract 15 August 1634.

"Den godsdienst ende voortsplantinge van de christelijcke religie in Sincan nam dagelijcx sonder eenige verhinderingen soodanige toe dat de kercke tot exercitie van de groote dienst aldaer gemaect, voor den volcke te klein geworden was, ende wel de helft vergroot moste worden.

Het dorp Soulang onlangs geleden met die van Mattauw over eenige gerese onlust in termen van oorloge staende, soo hebben haer die van Sincan aen het dorp Soulang wat verobligeert sijn haer bij d'selve gevoucht omme met gecombineerde macht die van Mattauw te overvallen en den oorloch aen te doen. Waerover de Mattauwers, vreezende dat wij Sincanders bijstaen ende revengie nemen souden over de moordadige actien tegen ons voor desen gepleecht, soo verslagen sijn geworden, dat eenige met haere goederen alreeds gevlucht ende om in vrede te blijven, aen die van Sincan toegestaen

ende geaccordeerd hadden alle den conditien, die d'selve haer voor geworpen hebben. "

The religion and propagation of the Christian Faith in Sincan is growing daily without any obstruction in such a way that the church that was built there for the main service had become too small for the people and had to be expanded by half.

The people of Sincan, who are indubitably under obligation to the village of Soulang, have sided with that village (which recently found itself in a state of war with the people of Mattau because of a few difficulties which had been arisen) in order to attack the people of Mattau and declare war with joint forces. Because the people of Mattau fear that we back the Sincandians and want to avenge the murderous crimes committed against us in the past, they have become so dismayed about this that some of them have already fled away with their goods and, in order to preserve peace, have conceded to the Sincandians and have accorded to all terms these people presented to them.

139. Dagregister Zeelandia.
VOC 1114, fol. 67. Extract 25 August 1634.
DRZ, Vol. I, p. 188.

"Op dato verstaen uit Dominee Junius, dat die van Mattauw een Soulangsche vrouwe (onder 't decxsel dat die van Teosien sulcx souden gedaen hebben) 't hooft hebben affgehackt, soo dat wel lichtelijck den oorlooge bij die van Soulangh weder bij den handt mochte genomen werden."

fol. 67: August 25: Today we heard from the Reverend Junius that the people of Mattau (pretending that the villagers of *Teosien*[64] had done this) cut off the head of a woman from Soulang, so that the people of Soulang can be expected to take up arms soon.

140. Missive Governor Hans Putmans to the Reverends Georgius Candidius and Robertus Junius. Tayouan, 8 September 1634.
TEDING 14, fol. 3.

"Op heden in collegialite vergaderinge vanden raett hebben wij UEs. saecken (wegen 't vervoeren der 5 Sincanse jongens neffen eene der predicants naer

Nederlant) voorgestelt, waerop na lange ende veelvuldige debatten ende overwegingen van saecken bij den raet is gemoveert ende tot UEs. naerder onderrichtinge 't naervolgende gealligeert:

Ten eersten wert bij den raett geoordeelt datmen dito saecke behoorden uit te stellen tot toecomende jaer om onderentusschen dies aengaende advijs vande Ed. Heer generael te versoucken ende dat UEs. neffens ons sulcx aen sijn Ed. eerst behoorden te advijseeren, te meer volgens UEs. voorstel wel 10 jaeren soude aenloopen eer dat se tot perfectie zoude connen gebracht werden. Soodat dienvolgen naer 't oordeel vanden raett in een jaer weynig verachteringe can toegebracht werden, in welck jaer de saecke beter ende rijpelijcker can overleijt, gereconsidereert ende in toecomenden ten meesten dienste vande Compagnie dies aengaende vruchtbaerder resolutie werden getrocken.

Ten anderen dat Godt Almachtig den sieckentrooster Jan Gerritsen uit dese werelt heeft gelieven te haelen ende tot noch toe geen apparentie en zien om eenen diergelijcken te becomen waervan inde Sincanse taele, segge saecken, zoo wel dienste (als bij lange continuatie 't welcq tijt vereijscht) zoude connen trecken, dienvolgens één van UEs. beyden mede naer 't vaderlant vertreckende alles bij één persoon die mede sterffelijck is soude moeten waergenomen werden.

Ten derden wert noodich vereyst dat alle sondaegen alhier een predicatie wert gedaen, ende sulcx soude voor één persoon seer swaer ende niet mogelijk om doen wesen gemelte persoon (dat Godt verhoede) comende te overlijden souder niet gevordert werden ende lichtelijck wederom heel in ruïne ende te niet loopen.

Alle welcke bovenstaende motijven ende redenen den raet heeft goetgevonden (eer dat wij tot finale desisie der saecken comen) UEs. aen te dienen ende daer op naerder UEs. antwoorde op morgen in te wachten (...)."

Today during the collegiate meeting of the council we have put forward Your Honours' affairs (concerning the sending of five Sincandian boys as well as one of the Reverend gentlemen to the Netherlands), which were brought up in the council in many long debates and deliberations, and about which we have drawn up the following for Your Honours' information:

In the first place the council was of the opinion that we should postpone that matter until next year, in order to be able in the meantime to request the Honourable Lord General for advice, and also that, besides us, Your Honours ought to consult His Honour first, the more so because according to Your Honours' proposal it would take about ten years before they could be

brought to fruition. Consequently, the council believes that one year will not cause too great a delay. In this year the matter can be given some further careful thought, it can be reconsidered, and finally a resolution can be passed that will be much more apposite to the benefit of the Company.

Secondly, because it has pleased Almighty God to take the catechist Jan Gerritsen from this world and because we, so far, have not seen any chance to find anyone of that ilk for the service who speaks the Sincandian language so well and has a similar good understanding of matters over there as he did due to the long duration of his service, therefore if one of Your Honours were to depart with them to the mother country, everything would rest in the hands of one mortal being. Thirdly, it is absolutely essential that a sermon be given regularly to all the sinners over here, such that for one person it would be very difficult, indeed impossible, to do so. Were that person (God forbid) to die, any progress would come to a standstill and everything would be undone and easily be reduced again to ruins. Because of all the motives and reasons mentioned above, the council has agreed (rather than to come to a final conclusion) to announce this to Your Honours and to expect Your Honours' replies tomorrow (...).

(The idea proposed by Candidius and Junius to give some boys from Sincan a religious education in the Netherlands is approved by Governor Putmans.)

141. Missive Governor Hans Putmans to Governor-General Hendrick Brouwer. Tayouan, 28 September 1634.
VOC 1116, fol. 333-348.
Duplicate: VOC 1116, fol. 362-363v.
ZENDING, Vol. III, p. 69.

(In this missive a plan forged by the preachers in Sincan whereby intelligent boys from that village will be sent to the Republic to enjoy a Christian education is discussed. The ultimate goal is to be able to send them back to their own country as preachers. Governor Putmans expresses his support for this plan.)

142. Dagregister Zeelandia.
VOC 1114, fol. 71. Extract 7, 8 October 1634.
DRZ, Vol. I, p. 195.

> "(...) verstaen meede uyt Dominee Junyus, dat die van Sinckan ende Sou-
> langh met den anderen om de suydt teegen die van Taccariangh vuyt vechten
> hadden geweest ende dat die van Sinccan vier hooffden, waaronder Tamastu-
> reij, sijnde eene van de principaale bekeerde Christenen, hadden verlooren,
> sulcx dat daarover bij de Sinckanders een groot misbaar ende droeffheijt
> gemaact wert."

fol. 71: October 7, 8: (...) we also heard from the Reverend Junius that the
people of Sincan and of Soulang joining with the others had been fighting
the people of Taccareyan down to the south and that the Sincandians had
lost four heads, among them that of *Tamasturey*[65] who is one of the princi-
pal new Christians. On account of this the Sincandians are raising an outcry
and great sorrow.

143. Original Missive Governor Hans Putmans to the Amsterdam Chamber.
VOC 1114, fol. 1-14. Extract.
ZENDING, Vol. III, pp. 71-72.

fol. 3: "Ondertusschen deden een tocht op 't Gouden Leeuwe ofte Matthijssen
Eijlandt, 9 à 8 mijlen om de Zuydt van hier gelegen, met hope om eenige
Mattauwers in handen te becomen ende alsdan het inorm faict, aan d'onse bij
tijden van de Hr. Nuydts begaan, naar merite te straffen. Doch den tijt ver-
scheene zijnde om gemelte tocht bij der handt te vangen, quamen wel de
Soulangers ende Zinckanders ende bijgelegene dorpen, maer geene Mattau-
wers ten voorschijn.
Zetten vorengemelte gemelte tocht voort ende cregen d'onse met verlies van
een Hollander ende een dito Zinckander het gantsche eijlandt in. De inwoon-
ders, hunne negrijs ende huijsen verlatende, vluchten in soodanige speloncen
(die den natuere zoo't schijnt tot haarder behoudt daar geschapen heeft) dat
d'onse, naardat twee mael daerop waren geweest ende alles wel besocht
hadden, niet één mensche conden vinden.
Dito eijlandt is soo schoon ende ordentelijck met clappersboomen beplant
ende alderhande aerdtvruchten besaijt, dat een ider die der op geweest heeft
verclaart zijn leven diergelijcke niet aanschouwt te hebben. Dan heeft

gantsch geen goede wheeder ende is oock weijnich ofte niet als verversinge
daer op te halen (...).

fol. 9v.: Dit winnen der zielen onder dese heijdense natie in Sincan neempt
noch dagelijcx meer en meer door de genadige bestieringe Godes toe, soo
dat, naer de predicanten Candidius ende Junius verclaren, dit gantsche dorp
in corten tijtt de Christelijcke religie niet alleene aengenomen, maar oock
alle sielen, uittgesondert weijnige, (fol. 10) daerin woonachtich, zullen gedoopt
ende die tot hare jaren gecommen, onderwesen zijn.

Ware te wenschen die van 't dorp Mattauw eens ten rechte over het inorm
faict bij tijden van de Hr. Nuijdts aan d'onse begaen, mochte gestraft werden
(...).

Godt zij loff dat den handel goeden voortganck heeft genomen.

De predicanten voornoempt versoucken seer instantelijck aen d'Ed. Hr. Gou-
verneur Generael om eenige deser jeucht van het dorp Zincan tot vier à vijff
in 't getall naar 't vaderlandt te mogen vervoeren, omme d'zelve aldaar
onder 't opsicht van één van hun beijden in onse schoolen te laten onderwij-
sen ende soovoorts tot de studie ende van de studie tot bequame predicanten
op te queecken, 't welck (ingevalle het Godt Almachtich geliefde te segenen,
gelijck wij hope: jae) wij met hun oordeelen een seer treffelijcke saecke tot
bevoirderinge van dit heerlijcke ende heijlige werck zouden wesen (...)."

fol. 3: In the meantime we mounted an expedition to Golden Lion or Mat-
thijssen Island[66], which is situated 8 or 9 miles to the south of here, hoping
to lay hands on a few men from Mattau and then to punish them for the
enormous crime committed against our soldiers in the days of Governor
Nuyts. But when the time came to begin this expedition, the men from
Soulang and Sincan and neighbouring villages were present, but those from
Mattau were not. We carried on with this expedition and succeeded in
having our men search the entire island, losing only one Dutchman and one
Sincandian. The inhabitants of the island left their hamlets and houses and
escaped into caves (which nature seems to have created there for their
salvation). These caves were such that after two visits and thorough searches
our men were not able to find a single person.

This island is planted with coconut palms and is sown with all sorts of
tubers so beautifully and properly done that everybody who has visited there
testifies that never in his whole life has he seen anything like this before.
But the weather is always bad and little or no fresh water can be found
there.[67]

fol. 9v.: This salvation of souls among these heathen nation in Sincan steadily waxes every day through God's merciful guidance so that within a short time, as Reverend Candidius and Reverend Junius declare, this entire village will not only have accepted the Gospel but all souls living there will have been baptized, with the exception of only a few, (fol. 10) and the people who are of a proper age for it will also have learned the Gospel.

It is our wish that the people of Mattau may once and for all be justly punished for the enormous crime they committed against our people in the days of Mr Nuyts. (...)

Praise the Lord that trade is developing well.

The ministers mentioned above ask the Lord Governor-General very emphatically to be given permission to transport a few of the young people of Sincan, 4 or 5 in number, to the motherland, in order to have them educated in our schools under the supervision of either of them and to educate them for the study of theology and make them after their study into good ministers, which (if it pleases the Lord Almighty to bless this, which we hope: Yea) we agree would be an excellent idea for the propagation of this good and holy work (...)

(Governor Putmans would like to settle two or three thousand poor refugee farmers from war-torn Germany (The Thirty Years' War 1618-1648) in Formosa to work in the fields.)

144. Dagregister Zeelandia.
VOC 1116, fol. 232. Extracts 29, 30, 31 October 1634.
DRZ, Vol. I. pp. 199.

"29, 30 ende 31 en ditto. (...) Op dato is mede bij d'E. heer gouverneur Putmans ende raedt, ten versoecke van de Sinckanders, goetgevonden, dat men gemelte Sinckanders met 60 à 70 Nederlantse soldaten, om tegen die van Taccreyangh te oorlogen, zal assisteeren, alsoo den raet verhoopt, gelijck domine Junii verclaert, 'tselve in 't werck des Heeren seer voorderlijck zal zijn ende ditto Sinckanders temeer aen ons verbinden."

fol. 232: October 29, 30, 31: (...) Today the Honourable Governor Putmans and the council have given their assistance to the Sincandians, at their own request, in their war against the people of Taccareyan by sending 60 to 70 Dutch soldiers, because the council expects this will aid the Holy Labour

and will commit these Sincandians to us more, just as the Reverend Junius professes.

145. Dagregister Zeelandia.
VOC 1116, fol. 232v. Extract 6 November 1634.
DRZ, Vol. I, pp. 199-200.

"6ᵉⁿ ditto. Compt alhier wederom met gewenschte victorie den luytenant met de partie, raporteerende dat op gisteren tegen den middach ontrent de Taeffel om de zuyt de wilden van Taccareyan, die ontrent naer gissinge 150 à 200 in 't getal zeer cloecke rustige mannen sterck waren, hadden gerescontreert ende 5 derselver door onse soldaten (die met hare musquetten in seecker cleyn bosschagieken verborgen lagen) waeren dootgeschooten, tot geen cleyn genoegen ende contentement der Sinckanders ende Soulangers, die datelijck volgens haere gewoonelijcke maniere de hooffden daervan namen om, thuys comende, daerover de behoorlijcke feeste te houden. Bij d'onse wert mede vermeynd, datter noch wel ontrent de 20 à 30 gequetste onder de Taccarey-anders zouden zijn, doch de zeeckerheyt connen niet weeten, alsoo datelijck altsamen de vlucht namen."

fol. 232: November 6: The lieutenant has come here with his soldiers to report again on a welcome victory: early yesterday afternoon near the Table to the south they had encountered the savages from Taccareyan, who were an estimated 150 to 200 very brave and disciplined men strong. And that five of these had been killed by our soldiers (who had been hiding in some small grove), to the great joy and pleasure of the inhabitants of Sincan and Soulang, who, according to their custom, immediately started to take the heads with the purpose of celebrating a proper feast on their return home because of these. We presumed that there would be about 20 to 30 wounded among the people of Taccareyan, but we did not know for sure as they had all escaped immediately.

146. Dagregister Zeelandia.
VOC 1116, fol. 232v-233. Extract 9 November 1634.
DRZ, Vol. I, p. 200.

"9ᵉⁿ ditto. Op dato wert bij d'heer gouverneur Putmans ende raet geresol-veert, dat men met de politijcque bedieninge in Sinckan sal continueeren

ende dat de executie, om de predicanten van den hatelijcken naem t'ont-
lasten, door den sargiant Jan Barentsen sal in 't werck gestelt werden;
alsmede dat eene (fol. 233) van de predicanten tot de weeckelijcxse ofte son-
daechse predicatie voor de Duytse gemeynte sich sal laeten gebruycken;
item, alsoo de Chineesen, die in Wanckan calck branden ende visschen als
aen Sacam in haere thuynen, van die van Mattau ende Soulangh grooten
overlast lijden, dat men d'selve met passen sal accommodeeren om haere
neringe onverhindert te mogen volvoeren, mits zeeckere clausule in 't
Chinees daerbij vougende, dat zoo die van Mattauw ende Soulang de Chinee-
sen meer molesteeren, dat hun voor den naersmaeck in toecomende hebben
te wachten."

fol. 232v.: November 9: Today the Lord Governor Putmans and the council
decided to perpetuate political power over Sincan and also that this will be
carried out by Sergeant Jan Barentsen in order to relieve the ministers from
having to take unpopular actions. (...)
fol. 233: And also to have the Chinese, who are severely disturbed by the
people of Mattau and Soulang when they are fishing and burning lime in
Wancan or working their gardens near Saccam, accommodated with passes
to guarantee the unimpeded execution of their business, adding a certain
clause in Chinese that should the people of Mattau and Soulang hinder the
Chinese again, they should expect the consequences [of their behaviour].

147. Missive Reverend Robertus Junius to Governor Hans Putmans. Sincan, 11 November 1634.
TEDING 15, fol. 11.

"De laetste woorden die Autul uit Soelang met ons hadde bestonden in een
noodinge van mij en den luytenant, daer doen maer overloops op antwoorde
alsoo hij gelijck oock wij op ons vertrecq stonden. Heden heeft hij weder
eenen expressen mij toegesonden daermede versouckt op maendach toe-
comende mij wilde laeten vinden in Soelang van meeninge zijnde ons te
onthaelen ende de vruntschap die onder ons is te vermeerderen. Hebbe den
Soulanger geantwoort dat in bedenckinge zoude nemen dat op maendach off
sondach t'savonts, dat overmorgen is, weder soude comen dat hem dan
soude antwoorden. Onzes oordeels soude ons ginder gaen, al wasser de
luytenant bij, die van Autul genoodicht is, noch op 't velt zijnde, veel goets
soude baren en ons nauwer aen malcanderen verbinden ende Mattau suspect
wesen, want daeruit soude besluyten dat weeder malcanderen sochten tot

haren nadeel dat dan immers tot haare vernederinge soude strecken. Geliefde zijn E. oocq iets wat haer aen sullen seggen. Soude dan geleden ende onthaelt zijnde dat Autul met ons nemen ende nae Tayouan brachten om weder te onthaelen waere al des te beter dit is ons gevoelen. Sijn E. kan hierin ordineeren na gelieven ende als dienstigst in dese conjuncture, sal hier niet in doen tot naerder bescheyt van zijn E. ontvangen hebbe dat op morgen met den brenger deses verwachten sal, zoo zulcx van zijn E. goet gevonden wort zoude wel één à twee paerden van doen hebben ofte mosten in een champan gaen alsoo de wech wat verre is. Uit Soelang comende soude noch nader verstaen wat vruchten desen oorloog voort gebracht hebben dat dan alles zijn Ed. mondeling conde verhalen alsoo van meeninge ben uit Soelang (zoo zijn E. dit toestaett) over te steecken na Tajouan ende dan verders met sijn E. spreecken van een brieff te senden na Tackaryan, dat het versouck is van Sincan."

The last words that Autul from Soulang spoke to us consisted of an invitation to me and the lieutenant, to which we then casually answered that we were about to leave as well. Today he has sent me another express letter in which he requests us to go to Soulang next Monday because they want to entertain us and to strengthen our common bonds of friendship. We have answered the Soulangian that we will give the invitation our due consideration and that when he returns on Monday or Sunday evening, which is the day after tomorrow, that we then will answer him. We have the feeling that by going there, if the lieutenant who is out in the fields at the moment but who was also invited by Autul were to accompany us as well, will be a very good thing for us to do and will bring us closer together and simultaneously will make us highly suspect to Mattau, because they will conclude that we are again seeking a rapprochement with each other which would be very much to their disadvantage for it would only serve to add to their humiliation. We would be very much obliged if it would please His Honour to advise us what we should say to them. However, we have the feeling that it would be preferable that having been entertained by them, afterwards we should take Autul with us to Tayouan to entertain him in his turn. His Honour can pass judgement on this matter just as he pleases and as to what would be best in this case. Therefore, I will not do anything before we have received His Honour's answer that as we expect will reach us tomorrow by the same carrier who delivers this letter. Should His Honour agree to it, we would either like to have two or three horses, or we would have to travel by

sampan the road being overly long. Upon our return from Soulang we will try to find out what spoils this war has brought us, then we will be able to report everything to His Honour in person because I would like, should His Honour permit it, to go across directly to Tayouan from Soulang to discuss with His Honour, on the request of Sincan, the sending of a letter to Tackaryan.

148. General Missive.
VOC 1111, fol. 81-134. Extract 27 December 1634.
FORMOSA, pp. 136-145.

> fol. 104: "De saken van Sincan bleven God loff noch in goeden stant. Ende wat aengaet haer Ed⁵ ordre van eenige jongelingen in des Heeres heilige woort op te trecken ende die so verre daer in te oeffenen dat metter tijt bequaem mochten werden om in hunne moeder taele andere te connen onderwijsen, dan alsoo de selve jongelingen daer teveel liberteijte sijn hebbende, waerdoor apparent tot sulcx niet wel en souden connen werden gebracht, so stellen de predicanten aldaer leggende dominee Candidius ende Junius voor, off het niet dienstiger soude wesen dat men 4 à 5 van soodanige jonge inboorlingen van Sincan onder het opsicht van een der voorseijde twee predicanten (dat dominee Robertus Junius soude wesen) naer het vaderlant sonde om deselve aldaer wel te laten studeeren sonder eenige liberteijte te geven ende gestadich onder sijn opsicht bij de studie te houden. Waerop den gemelte Putmans aengenomen hadde 't selve aende heer Generaal te adviseeren."

fol. 104: Matters in Sincan are (thank God) proceeding well. And regarding the order of the authorities in Tayouan to educate some boys in the Holy Scriptures and to train them to such an extent that they would be competent to teach others in their native language in due time, for the reason that these boys have too much freedom there so that they apparently are not able to achieve this, the clergymen residing there (Candidius and Junius) make the following suggestion: would it not be more efficacious to send 4 or 5 of such young natives of Sincan to the motherland under the supervision of one of these two ministers (who would be Robertus Junius), to have these boys study hard without granting them any freedom and to confine them to their studies constantly under his supervision.

Upon which the said Putmans undertook to recommend this to the Lord General.

1635

149. Dagregister Zeelandia
VOC 1116, fol. 237v. Extract 2, 3 February 1635.
DRZ, Vol. I, pp. 208.

"Adij primo, 2 ende 3en februarie. Hadden harde noordelijcke winden. Op dato wert bij d'heer gouverneur Putmans ende raet (alsoo verstaen hebben uut de predicanten, dat onder die van Sinckan verscheyden windthonden werden gevoet ende aengequeeckt) geresolveert, dat men, om alle onheylen, die daeruut zouden connen ontstaen, haer d'selve sal sien met de gevouchlijckste middelen af te coopen ofte andersints affhandich te maecken ende, zoo zij daertoe niet en willen verstaen, dat men ditto honden, als zijnde des Compagnies eygen, uut haere huysen sal laeten haelen, dootschieten ende haerluyden echter tevreedenstellen, waerin, naer 't seggen der predicanten, geen swaricheyt is geleegen."

fol. 237: February 2, 3: Today it was decided by the Lord Governor Putmans and the council (because we learned from the ministers that among the people of Sincan several deerhounds are being bred and reared), that because of all troubles that might emerge from this, efforts will be made to buy them from the people with all suitable means or to relieve them of them in some other way and, if the Sincandians do not want to co-operate, that these dogs, being the property of the Company, will be taken out of the people's houses and will be killed, but that the people will receive compensation, in which lies no harm, according to the ministers.

150. Missive Governor Hans Putmans to Governor-General Hendrick Brouwer. Tayouan, 20 February 1635.
VOC 1116, fol. 311-323.

fol. 319v.: "Aengesien wij eenige jaeren herwaerts maer voor momentelijc den mousson ondervonden hebben, ons zoodanigen quantiteijt suijckeren, als well voor patria, Persia als well Japan geeijscht, ons uit China (...) niet sonder merckelijcke verho* inge van prijs jaerlijcx soude connen toegebracht werden, zoo hebben wij (...) verscheydene hier gesetene Chineesen geëxamineert om partije suijckerriet tot een preuve op't vastelant van Formosa te planten, haer daertoe des Compagnies coebeesten om 't lant te beploegen

ende cleijne som van penningen haer presenterende (...). Dat zij eijndelinge
over twee jaer partije zuijckerriet uit China gebracht, hetselve hier geplant
ende nu twee jaer achter den anderen geheel goet bevonden is, sulcx dat zij
gissinge maken van ontrent Maij 3 à 400 picoll van 't geene hier is gewassen
sullen connen leveren, die zij meijnen immers soo witt als die van China sall
vallen. Dit wellslagen van desen suijcker is soo aenlockende dat zij van
meijninge zijn dit mousson met ontrent 300 man 'tselve bij der hant te nemen
ende verhoopen, ingevalle het weder well slaecht ende (niet) door die van
Soulangh ende Mattauw den brant 'tzij bij oorloge ofte (fol. 320) moedwill
daerin gesteecken wert, in de tijt van ontrent 15 à 16 maenden 3 à 4000
picoll dito te leveren ende het naestte jaer daeraen, zoo maer vastelijc mogen
vertrouwen dat die van Mattouw haer geen overlast sullen aendoen, zoo veel
als de Compagnie tegenwoordich is eijsschende. 't Welck voorwaer voor de
Compagnie een overtreffelijcke ende niet min profijtelijcke saecke soude
wesen, ingevalle niet d'één ofte d'ander tijtt (...) dese Mattaouwers, daervan
jelours wesende, den brant daer connen insteecken, 't welck eens geschieden-
de dese armeluijden ten groote schade zoude toebrengen ende zoodanich
bevreest maken, dat niet weder op nova souden derven bij der hant nemen
iets aen te planten.

Derhalven oock met den aldereersten zonder eenich uitstel, zoo men den
goede saken ende het voortplanten van de Christelijcke religie mitsgaders des
Compagnies authoriteijt, gesach ende proffijt wil mainteneeren, hooch-
noodich zall zijn, dat het enorm faict bij die van Mattouw begaen eijndelinge
eens gestrafft ende het dorp van Mattouw gantselijck tot exempell van
anderen geruïneert wert, waermede die van Mattouw niet alleene onder
behoorlijcke subjectie, maer oock alle andere dorpen (...) ons oock in alles
zouden obediëren.

Verscheyden affronten bij die van Mattouw ons aengedaen, hebben met
oochluijckinge moeten door de vingers zien ende als ongemerckt laten
voorbijgaen. Gelijc het onder andere is gebeurt dat wij seeckere Chineesen
met onse passen om calck voor de Compagnie in Wanckan te branden
versien hadden, welcke voorsz. Mattouwers den Chineesen alle het haer
affgenomen, het pas in stucken gescheurt ende verachtelijc wech gesmeeten
hebben. Hierdoor wert ons gesach ende authoriteijt gants onder de voet
getreden, sulcx dat wij vreesen, soo hierin niet tijdelijc wert versien, hetselve
eijndelinge hooger (tot groote schade van de Generale Compagnie, 't zij met
het suijckerriet in brant te steecken, de Chineesen te verjagen ofte des
Compagnies wet altsamen aen te tasten) zall uitbersten, waerdoor hetgeene
in de Christelijcke religie gevoordert is mede gants ende gaer soude vernie-
ticht werden.

Met ontrent 400 cloecke soldaten die men ons van Batavia in't jongste van
het Zuijdermousson zoude dienen toe te senden, zouden niet alleen Mattouw,
maer oock die van het dorp, ofte de dorpen, van Taccareijangh t'onser
devotie (gebracht) ofte ten minsten verjaecht ende een treffelijcke tocht in't
geberchte (om door eenige kenders van mineraelen t'ondersoecken wat daer
soude mogen vallen) (fol. 320v.) connen gedaen werden. (...)
fol. 321v.: (...) wat voor mineralen op den zeer hooge geberchte ende op een
seer treffelijc climaet (niet seer ver van gout-, silver-, tin-, cooper-, iser- en
de loot-mijnen van China ende Japan gelegen) men noch soude connen
comen onderentusschen te vinden, is ons onbewust, doordien tot noch toe bij
sommige natie nimmer, voor soo veele ons bekent zij, eenich ondersoeck
daervan is gedaen. De Chinees heeft zijn Rijck noijt soecken te vergrooten,
de inwoonders zijn seer brutaell ende weijnich ofte geeniche mineralen, also
alleene iser, is bij haer bekent. De Spangiaert, gelijc wij, heeft hier noch
weijnich jaren geseeten, soo dat buijten twijffell tot noch toe daer geen
kennisse van zij wat mineralen in het geberchte hier souden mogen vallen."

fol. 319v.: As we have experienced the monsoon for several years now for
only a short time, and such an amount of sugar, requested on behalf of the
motherland, Persia as well as Japan, may not be brought to us from China
every year without a considerable increase in the price, we have tested
several resident Chinese to be planters of a trial run of sugarcane on the
mainland of Formosa by way of experiment, providing them with some of
the Company's cattle to plough the land and with a small amount of money.
Finally the party of sugarcane which they fetched from China two years
ago, has, after the planting over here, already proved to be very good over
the past two years, so that they estimate being able to deliver by May 300
to 400 picol of what has been grown here, which they think will be as white
as Chinese sugar. A successful production of this sugar is so tempting that
they envisage initiating it this monsoon with approximately 300 men. They
expect, should the weather remain fair and if the crop is not set on fire by
the inhabitants of Soulang and Mattau, either because of war or (fol. 320) on
purpose, to produce 3000 to 4000 picol within a span of time of about 15 to
16 months and the year after, as long as it can be counted upon on the
people of Mattau not molesting them, as much as the Company is demand-
ing at this time. This certainly would be an excellent and no less profitable
business for the Company, if only these villagers of Mattau, in a jealous
mood, were not to set fire to it some time or another, which, should this

occur, would cause these poor people great damage and scare them so much that they would not dare to start planting anything again.

That is why it will also be necessary, if we want to keep up the good work and the propagating of the Christian Faith as well as the authority, power, and profit of the Company, to punish immediately and without any further delay the crime committed by the people of Mattau and ruin the village of Mattau completely as an example to others, by which not only these people will be subjugated but also all other villages will obey us in everything.

We have slyly turned a blind eye to several affronts committed by the people of Mattau and pretended not to notice. For example, when we provided some particular Chinese with our permits to burn lime for the Company in Wancan, these men from Mattau robbed the Chinese of their passes, tore them to shreds and threw them away, with the greatest contempt. Our authority and power are trampled upon by such behaviour, so that we fear, if this is not countered, it will go from bad to worse (to the great detriment of the General Company) either by setting fire to the sugar-cane, the expulsion of the Chinese, or the general contempt for the law of the Company, by which everything that has been accomplished concerning Christianization would be completely destroyed.

With a group of 400 stalwart soldiers who should be sent to us from Batavia with this impending south-west monsoon, not only Mattau, but also the inhabitants of the village or villages of Taccareyan could be brought within our sphere of influence or at least be driven away. And an excellent expedition to the mountains could be mounted, in order to have the minerals available there examined by a few experts.

(The VOC is still insufficiently informed about the mineral resources of the island.)

fol. 321v.: (...) what kind of minerals might be found in the higher parts of the mountains and in excellent conditions (situated not so far from the gold, silver, tin, copper, iron-ore and lead mines of China and Japan), is unknown to us, because no nation has ever investigated it, as far as we know. The Chinese has never tried to enlarge his Empire [here], the inhabitants are very brutish and apart from iron, hardly any or indeed no other minerals at all are known to them. The Spaniard, like us, has been here for only a few years, so that there is no doubt that so far knowledge is lacking of the kinds of minerals which may be hidden in the mountains.

151. Missive Governor Hans Putmans to Governor-General Hendrick Brouwer. Tayouan, 9 March 1635.
VOC 1116, fol. 324-329.
ZENDING, Vol. III, pp. 73-76.

fol. 328v.: "(...) dominee Junius (is) dagelijcx buijtens tijts besich om drij jonge Hollantsche quanten, die still ende modest van leven zijn, inden godsdienst ende principaele de Sinckanse tale te onderwijsen waervan zij moet hebben in toecomende goede diensten te trecken ende predicanten mede te sparen. Noopende den politicquen dienst in Sinckan meijnen wij bij U Ed. sullen versoecken om een bequaam persoon van aensien aldaer te hebben, om 'tselve in hare plaetse waer te nemen ende eenige wetten daerop te raemen, waernaer sich desen persoon soude hebben te reguleeren. (...)

De Sinckanders hier voor den Raet, gelijc in Amboina geschiet, te dagen, zoude vooreerst bij hun niet behoorlijc naergecomen ofte geobedieert ende dienvolgende door groote ende voor hare onge-woonlijcke straffen daertoe moeten gebracht werden, 't welck niet alleen het wechloopen van veele Sinckanders, maer oock wellichtelijc een gantsche dempinge van het goede begonnen werck ende eene geduerige oorloge tusschen hun en ons soude veroorsaecken.

fol. 329: (...) Een derde predicant ofte proponent, om de duytsche ge-meynte te bedienen, is hier noodich (...)

Wij vertrouwen vastelijck dat geene diergelijcke bequame plaetse om heijdenen te bekeeren meer in Indiën te vinden is, want waren der meer leeraers, dan er waren meer bekeerde nieuwe christenen gelijck wy onlangs gesien hebben inde cleyne dry dorpen dichte by Sinckan gelegen, die maer verlangen om iemant te hebben, die haer onderwijst ende alsoo bevryt te werden van Soulangh ende Mattouw, die dese luyden somtijds overlast aendoen."

(The ministers Candidius and Junius had expressed three wishes to Governor Putmans and the members of the council: they asked permission to send 4 or 5 intelligent young Sincandians to the mother country to be trained as protestant ministers. They wanted to be relieved of the administrative responsibilities in Sincan and wished to be discharged of the obligation to preach the Sunday sermon at Tayouan. In his missive of 28 October, governor Putmans lets his feelings be known about the first point.)[68]

fol. 328v.: (...) Reverend Junius occupies himself in his leisure time with the education of three young Dutch boys in the Gospel, especially in the Sincan language, which they expect to be of good service to them in the future and may relieve the ministers [from some of their tasks].

Regarding the administrative service in Sincan, we endorse a request to Your Honour to install a capable man with authority over there to attend to this in their stead and to pass a few laws which this person would have to impose. To summon the Sincandians before the council, as is the case in Amboina, would neither work here now nor would it be obeyed by them unless they are forced to do this by means of severe and to them unknown punishments.

This would not only cause the flight of many Sincandians, but perhaps also a setback in the good work we have started and a long drawnout war between them and us.

fol. 329: A third minister is needed to serve the Dutch community (...). We are certain that nowhere in the Indies there exists a place more suitable to convert heathens, because if there were more teachers, more newly converted Christians would be won, as we have recently seen in the small villages close to Sincan, which are constantly desiring to get someone to teach them and thus hope to be freed from Soulang and Mattou, which harrass them every once in a while.

152. Missive Reverend Robertus Junius to Governor Hans Putmans. [Sincan] 10 May 1635.
TEDING 15, fol 39.

"Uit onsen van gisteren heeft zijn Ed. connen verstaen het miscontentement ende ontsteltenissen der Sincanderen tegens Mattau welck niet affneemt maer aenwast, dagelijckx vergaderen. Hebben op heden besloten den wech der Mattau te stoppen, dat is dan oorloog haer aen te doen, doch is noch uitgestelt tot morgen. Wij achten op het hoogste noodig onse beloften te connen voldoen dat 30 à 40 cloucqe mannen met den aldereersten, jae waer het noch heden, herwaarts gesonden wierden, opdat haer dorp voor een inval bevrijden mochten, te meer alsoo onsen Sinckandren seggen verstaen te hebben dat zij zouden geseyt hebben: '*daer zijn niet veel Hollanders in Sincan, na 10 à 12, laet ons in haer dorp vallen*', altoos is 't seker Mattauw hoorende datter nieu volcq in Sincan comt sal bevreest worden. Weynig Sincanders gelooven dat het daertoe comen zal dat tegenstant zouden bieden, maer veel eer dat

Mattauw eersdaegs eenige varckens zouden opbrengen ende aen Sincan tot straffe geven, dat het witt is daer zij na micken, voor de veelvuldige injuriën aen haer bewesen, het zij hoe het zij zoo noch 30 à 40 man hier hebben zullen haer uit dit dorp connen houden dat Sincan siende ons noch nauwer aen Sincan verbinden zoude. Wij verhoopen, ja twijffelen niet off zijn Ed. de voorgeseyde soldaten noch heden off ten hoogsten morgen vroug ons toezenden sal, ende zoose vandage niet comen verhoopen een brieffken daer uit bescheyt krijgen meugen, opdat onsen daer mede verheugen mochte, wij meenen dese musquettiers voor 't dorp comen, zoo elcq haer geweer eens off 2 mael lossen, des te beter zijn zoude. Wij oordeelen beyde in dese conjuncture zeer proffijtelijck voor onsen staet zoo zijn Ed. selffs met een troup zijnde zoo veel alsser gemist connen werden conde met den aldereersten hier comen, anders niet zijnde als musquettiers op dat dese natie weten mach datter noch volcq is (dat dese natie meent niet) dewelcke wij sijn Ed. souden seggen zijn Ed. te vergeselschappen, diermede men dan na Baccluan om een wandeling ende soo voorts naer het dorpjen daer zijn Ed den Bandanees eens haelden souden connen reysen dat wij meenen een groots schrick in de noortsche dorpen brengen zoude, zijn Ed. weet dat niet verre is, dat oostersonne weder in Sincan connen wesen, souden dan van verscheyde dingen met zijn Ed. nopens Sincan, Soulang, ende Mattauw connen spreecken (Bacluan meer gehoort hebben dat Sincan, Mattau wil beoorloogen. Legt al onder de voet, sijn seer bevreest willen wel een deel verckens geven)."

From yesterday's letter[69] Your Honour will have been able to understand that the discontent and dismay of the people of Sincan against Mattau has not waned, but, on the contrary, is increasing all the time about which we meet daily. Today we have decided to blockade the road to Mattau. In effect this implies declaring war on them, yet this has been put off till tomorrow. We consider it to be absolutely essential to fulfil our promises that thirty or forty stalwart men on the first possible occasion, yea, if only that could be today, could be sent over to here so that we will be able to safeguard their village from a raid, the more so because our Sincandians say that they have understood that those from Mattau are supposed to have said: '*There do not seem to be many Dutch in Sincan, around ten or twelve, let us invade their village.*' For, aye, it is certain that when Mattau discovers that new troops have arrived in Sincan they will grow apprehensive. Not many people in Sincan believe that Mattau will offer resistance, but rather that before long Mattau will come up with some pigs in order to give them in punishment to Sincan. This is their [Sincan's] aim after the many wrongdoings committed

to them. Be that as it may, if only we could have thirty or forty men over here we will be able to keep them all out of this village. Once this is recognized by Sincan it will become more closely attached to us. Yet we do not doubt that His Honour will even send the aforementioned soldiers today or at least not later than tomorrow early in the morning. If they do not arrive today we hope to receive a note from which we will be apprised of your message, so that as far as we are concerned we can look forward to it. We are of the opinion that it would be so much the better if these musketeers, the moment they arrive in the front of this village, should all fire their guns once or twice. Both of us judge it to be very rewarding to our nation should His Honour, with as many men as can be missed over there, immediately come over here, musketeers only, so that Mattau will learn that there are still more soldiers (which that nation does not seem to believe), who as we will make clear came to accompany His Honour and who could walk to Baccaluan and on to the little village, out of which His Honour once picked up the man from Banda, this we believe will cause real fear in the northern villages. His Honour is aware of the fact that it is not far away and, that he could be back in Sincan by the next morning, so we also could use the opportunity to discuss with him several matters about Sincan, Soulang, and Mattau (Baccaluan having heard that Sincan wants to make war on Mattau, already submits itself and is in great fear. They are willing to offer some of their pigs).

153. Dagregister Zeelandia.
VOC 1116, fol. 241-241v. Extracts 9, 10, 11, 12, 13 May 1635.
DRZ, Vol. I, pp. 214-215.

"9en ditto. Des avonts becomt d'heer gouverneur een missive van de predicanten uut Sinckan, uut welckers teneur verstonden, hoe zeeckeren Taccaran uut Mattou, die voor desen bij d'onse als een vrundt om verscheyden insichten een tijt lanck aldaer wel getracteert ende onthaelt was, sich zeer vermeten, stout ende hoochmoedich naest eenige tijt herwaerts heeft aengestelt, verscheyden fulminatiën tegen de Nederlanders, die van Sinckan, als d'omleggende dorpen uutspoouwende, allegeerende, dat d'Hollanders voor hem vreesden omdat zijluyden haer hadden dootgeslagen ende, zoo die van Sinckan bij d'onse wilden gevreest zijn, dat se mede soo moesten doen; sulcx dat die van Sinckan hierover zeer ontstelt waren, gantsch inclineerende om die van Mattau den oorloge aen te doen, temeer, omdat seggen verstaen te

hebben, die van Mattau haer dorp willen in brandt steecken, alsoo daer maer 10 à 12 Hollanders waren. Zij adviseeren mede, hoe gemelte Taccaran sich niet ontsien heeft zeecker instrument, bij haer *pockon* genaempt, in Topangh te brengen, waermede zooveel wil uutdrucken, dat hij haer voortaen wil beschermen. Ende, alsoo dit alles tot disreputatie ende crenckinge van des Compagnies alreets vercregen gesach, ingevalle daerinne niet tijdelijck wierde versien, soo versoecken de predicanten zeer instantelijck den persoon van d'E. heer gouverneur met een partie van ontrent 80 ofte 100 soldaeten, alsoo achten ende voor vast houden, dit de Sincanders sal animeren ende die van Matau haeren hoochmoet doen sincken mitsgaders d'andere dorpen in behoorlijcke obediëntie ende vreese houden; oock, om des te meerder schrick onder dese brutale natie te baeren, zoude d'heer gouverneur naer Baccaluan (onder den naem van uut wandelen te gaen) naer 't oordeel van voors. predicanten een tocht connen doen, sonder nochtans de wapenen te gebruycken.

10[en] ditto. Hadden noordelijcke windt ende wert op huydenmorgen vrouch op 't schrijven der predicanten geresolveert, dat d'E. heer gouverneur sich op stante pee met een partie van 75 à 80 soldaten naer Sinckan sal transporteeren ende is Zijne E., alles claer zijnde, derwaerts vertrocken; een weynich naer den middach, Zijnne gemelte E. in Sinckan gearriveert zijnde, wiert datelijck geresolveert ende goetgevonden, met advijs van de predicanten, den *pockon*, bij Taccaran in Sinckan gebracht om naer Topangh te brengen ende aldaer gelaten, datelijck met hulpe van de Sinckanders op eene van de principaelste kercken te verbranden, 'twelck alsoo met groot genoegen van de Sinckanders oock datelijck geëffectueert wiert.

11[en] ditto. Des morgens treckt het jonge manschap van Sinckan wel gewapent volgens haer gebruyck tot begin ende aensegginge van oorloge tot dichte bij de velden van Mattau, aldaer den wech tusschen Mattau ende Sinckan gelegen sluytende. In 't marcheeren derwaerts ontmoeten eenige Mattauwers, die hun datelijck op de vlucht begaven. Dit alsoo geschiet zijnde, verscheenen eenige van Mattau bij d'outste van Sinckan, die hun in Baccaluan lieten vinden, alwaer hun d'occagie van deesen begonnen oorloge wiert aengecundicht, namentlijck, dat Zijne E. in Sinckan comende, het gepasseerde van Taccaran hadde verstaen ende daerover, nevens die van Sinckan, ten hoochsten ontstelt ende vergramt was, weshalven den *pockon* hadde doen verbranden. Waerop die van Mattau het hooft datelijck in den schoot leyden ende bekenden, dat Taccaran zeer qualijck hadden gedaen, dat denselven met zijne goederen alreets in een ander dorp gevlucht was, dat zij mede bereyt waren een billijcke straffe te geven om also te apayseeren ende de gereesen ver-

schillen neder te leggen. Zij zouden dorp Mattou daervan raport doen ende des anderen daechs 's morgens weder in Bacaluan verschijnen.

12ᵉⁿ ditto. Waeren d'outste van Sinckan ende eenige gecommitteerden ofte principale van Mattou in Baccaluan noch besich om over de geresen verschillen te contracteeren wat straffe die van Mattau aen die van Sinckan zouden geven, ende zijn eyndelinge volgens hare brutale manieren geaccordeert ende overeengecomen dat die van Mattauw aen die van Sinckan zouden ter handt stellen negen levendige verckens ende 6 à 8 van haere grootste hasegayen tot een erkentenisse, dat die van Mattau die van Sinckan hadden verongelijct ende hun, als overwonnen zijnde, gaerne onder d'selve submitteerden ende versochten voortaen in vreede te mogen leven, sulcx dat dit hoochmoedige dorp (Godt zij loff) door dusdanigen cleenen middel voor dees tijt is vernedert. Waeruut oock te consideeren is, dat met een tamelijcke macht van ontrent 400 soldaten dit gantse dorp lichtelijck zoude connen vernieticht werden, tot een rechtveerdige straffe van hun aen d'onse begane inorm faict over 6 jaren geschiet met het massaceren van 61 soo officieren als soldaten.

13ᵉⁿ ditto. Zijn de geaccordeerde hasegayen ende 5 varckens bij de Baccaluanders in Sinckan bij d'heer gouverneur gebracht, de resterende 4 souden mede volgen. Weshalven Zijne gemelte E., naerdat op alles goede ordre gestelt ende die saecke naer wensch uutgevallen ende verricht was, ontrent den middach weder naer Tayouan is vertrocken, alwaer tegen den avondt arriveeren."

fol. 241: May 9: In the evening the Lord Governor received a letter from the ministers in Sincan, from which we comprehended how a certain fellow named Taccaran from Mattau, who for some time used to be taken for a friend and was treated well by our men for several reasons, behaved very insolently, proudly, and arrogantly, fulminating against the Dutch, the Sincandians, and the neighbouring villages, suggesting that the Dutch were afraid of him because his men had killed some of them and that if the people of Sincan wanted to be feared by the Dutch, they should do the same. As a result of this the Sincandians were very upset about it and much inclined to declare war on the people of Mattau, the more so because they tell us they have heard that men from Mattau wanted to set fire to their village, as there were only 10 to 12 Dutch soldiers. They also report how this Taccaran has not failed to carry a particular implement, which they called a *pockon*, to Teopan, as an expression of his protection for them for the future. And, because all this will injure and disparage the authority that the Company had already gained, if it was not counteracted, the ministers

send an urgent request to the Lord Governor for a group of 80 to 100 soldiers, because they estimate and know for sure this will buoy up Sincandian spirits and will deflate the conceit of the people of Mattau and hold the other villages in obedience and fear. And to frighten this insolent nation even more, the ministers envisage the Lord Governor might launch an expedition to Baccaluan (under pretence of going out for a walk), but without the use of arms.

May 10: Northerly wind. Because of the minister's letter it was decided early in the morning that the Lord Governor would go immediately to Sincan with a group of 75 to 80 soldiers; and the preparations being finished, His Honour has departed. After his arrival in Sincan at the end of the afternoon it was decided and immediately given consent, (fol. 241v.) in accordance with the ministers, to burn the *pockon* (which had been brought to Sincan by Taccaran and left there before it was meant to go to Teopan) at once in one of the main 'churches' with the assistance of the Sincandians; which was carried out directly to the great pleasure of the Sincandians.

May 11: In the morning the young fighting men of Sincan, well armed according to their fashion, marched close to the fields of Mattau to declare and commence a war, closing off the road between Mattau and Sincan. Marching forward they encountered on the way some men from Mattau, who immediately fled. After this, some people of Mattau came to the elders of Sincan, who happened to be in Baccaluan, where the occasion of this new war was announced to them [the Mattau people], namely that His Honour on arriving in Sincan had heard of the behaviour of Taccaran, that he was very upset and angry about it, like the Sincandians, as a result of which he had had the *pockon* burned. Here upon the people of Mattau soon relented and confessed that Taccaran had done an evil thing, that he had already fled to another village with his belongings, that they were going along to give him a proper punishment to ease the situation and reconciliate. They would report this to the village of Mattau and reappear in Baccaluan the next day.

May 12: Because of the conflict that had risen, the elders of Sincan and several representatives or principals from Mattouw have been deliberating on the fine the people of Mattou should pay to the Sincandians and finally, in accordance with their rough manners, they came to a decision that the people of Mattou should present the Sincandians with nine pigs, alive, and 6 to 8 of their biggest assegais as an acknowledgement that the people of Mattou had harmed the Sincandians and that they would submit themselves

voluntarily to them since they had been defeated and would ask to live in peace in the future, so that this proud village has (thank God) been contained for now simply by this little action. This makes us also realize that this entire village may easily be destroyed with a substantial army of approximately 400 soldiers, as a just punishment for their crime committed against our men 6 years ago, the massacre of 61 soldiers and officers.

May 13: The agreed assegais and five pigs were brought to Sincan to the Lord Governor by the people of Baccaluan, whereupon the four remaining pigs would soon follow. When everything had been arranged satisfactorily and matters were running, in the afternoon His Honour left again for Tayouan, where he arrived early in the evening.

154. Missive Reverend Robertus Junius to Governor Hans Putmans. [Sincan], 15 May 1635. TEDING 15, fol. 39-40.

"De 4 resterende varckens van Mattau, daer onder 3 van redelijcke groote, zijn gisteren tegen den middach van den Bacluanders hier gebracht, verhaelen dat Doswan ende eenige andre vande groote dicht voor Sincan waren om bij ons te comen, maer dat (doordien het vogelsang niet goet was) wederom zijn gekeert, zoo dat noch geen Mattauwers zijn verscheenen, dewelcke over 4 dagen alhier verwachte, hebben de Bacluanders andermael aengesecht de meeninge van zijn Ed. ende zoo verschijnen dat haer niet qualijck zullen bejegenen maer aenseggen de reden van des Heers ontsteltenissen over Dakaran, zij zeyden dat Doswan ende andre Dakaran seer bekeven hadden ende vraegden waerom wij Dackaran niet vattede ende hem alleene straffe affhaelden alsoo hij gepecceert hadde dat wel hadden meugen lijden dat den Ed. Heer met een macht gecomen hadde ende Dackarans huys in brant gesteecken ende hem aengetast hadden, zouden oock geseyt hebben dat wenste het in toecomende het zoo mochte geschieden dat die quaat doen oock quaat zouden lijden, Dackaran wert gesecht dat al zijn goet gebercht heeft op een plaetse onse Sincanders wel bekent niet verre van Mattau, eenige seggen dat hij soude geseyt hebben: '*ick nu wil geen straffe geven ick heb mijn goet gebercht, laetse vrij comen*',

fol. 40: Andre seggen voor de waerheyt dat den 5 varckens diese eerst brachten vande Bacluanders waren diese uit vreese gegeeven hebben, maer de laetste waer dat die uit Mattau waeren. Hoe 't is of niet Sincan heeft heden de varckens gedeelt ende zullender heden feest mede houden, zijn seer wel tevreden, houden nu meer van ons als te voren niet tegenstaende zijn Ed.

pays met haar maeckte ende de wapenen neer te leggen belaste. Hebben evenwel eenige doen de Heer vertrocken was als vergramde verthoont op de velden van Mattau ende hebben der den brant ingesteecken dat Mattau noch doet in vreese zijn, zijn Ed. weet immers hoe hert dat wij Tikuta bejegenden om dat het voorgecomen zoude werden, maer heeft niet geholpen, zijn tegen lasten ordre heenen gegaen ende hebben daer bravade voor Mattau gemaeckt. Daervan was den leyder Tavangel ende Fisick, zoo dat dit volcq met een harden toom moet bereden werden sal men der gehoorsaemheyt van ver-wachten.

Mijns oordeels is 't zeer geraden om dese Mattauwers noch meer te verne-deren dat met Soulang ons zeer familiair houden, nu dan haer gaen bezouc-ken, Autul hier en op Tayouan gelegender tijt met noch eenige outsten ontbieden, onthaelen ende vrundelijcker zijn dat zal den Mattauwers suspect wesen hoe minder vruntschap met Mattau houden des te beter datt oock onse natie niet veel in haer dorp comen is geraeden, daermede zullen zij vernedert ende bevreest blijven, ende wij bevrijt van haere ongeregeltheden."

The four pigs that remain at Mattau, three of which are of a considerable size, were brought to us yesterday around noon by the people of Baccaluan. They told us that Doswan and a few of the other chiefs of Mattau had approached close to Sincan with the purpose of coming to us, but that (because the singing of the birds did not augur well) they had returned. So that nobody from Mattau has appeared yet, but we expect them to arrive here in about four days. Again we passed on to these people of Baccaluan His Honour's opinion that should they [Doswan and comrades] appear we will not treat them badly, but that it is our firm intention to tell them the reason why His Lordship is so dismayed about Dackaran. They answered us that Doswan and the others were greatly opposed to Dackaran[70] and asked why we had not arrested Dackaran to punish him alone, as it was he who had sinned and that they wished that His Honourable Lordship had come with a military power and set fire to Dackaran's house and had apprehended him. They also supposedly said that they wished that, should it happen in the future, those who perpetrate evil should be paid with their own coin. It was said that Dackaran had hidden all his goods on a spot not far from Mattau, well known to the Sincanders. Some of them tell us that he is supposed to have said: '*I do not want to pay a fine. Now as I have brought my goods to safety, let them come as they will*'. Others say that the truth is that the five pigs they first brought, actually belong to Baccaluan but were handed over to Mattau out of fear. But the latest message we received was

that the pigs did belong to Mattau. Be that as it may, today the people from Sincan have divided up the pigs, and today will celebrate with these their festivity. They are highly satisfied and love us now more than they ever did before, nothwithstanding the fact His Honour concluded peace with them [Mattau] and ordered to lay down arms. However, after the departure of our Honourable Lordship some of them did show their wrath by setting fire to the fields of Mattau, holding Mattau in fear. After all, His Honour knows that we have treated Tikuta severely to prevent arson. This was to no avail. Contrary to our last order they have gone there and have made a show of bravado in front of Mattau, Tavangel and Fisick being their leaders, so that these people should be curbed in sharply if one is to expect any obedience from them. According to my view, it should be wise to humiliate the people from Mattau a little bit more and at the same time we should act in a very familiar way with Soulang, every now and then pay them a visit and invite and entertain Autul, along with some of the other elders, to come over to Tayouan and treat them in a very friendly fashion, which the people of Mattau will distrust very much. The less the friendship we will maintain with Mattau and the less often our nation visits their villages, the better it will be, because in that way they will continue to be humiliated and fearful, which will safeguard us from their disorderly behaviour.

155. Dagregister Zeelandia.
VOC 1116, fol. 242. Extracts 15-18 May 1635.
DRZ, Vol. I, p. 216.

"15, 16, 17 ende 18[en] ditto. Op dato ontfangt d'E. heer gouverneur een missive van den predicant Robartus Junius, waerinne adviseert, die van Sincan haere excusie nemen, zij niet en wisten Zijne E. verboden hadde tegen die van Mattau geen verder vijantschap en souden thoonen, versoecken oversulcx Zijne E. haer daerinne geliefde t'excuseeren; met Soulangh meerder alliantie als met die van Mattau te maecken, dunct hem met Zijne E. geraden om d'selve meer ende meer te vernedren ende Soulang aen ons te verbinden, doch zoodanich niet, dat zij conden bespeuren wij bij haere vruntschap eenich proffijt souden connen erlangen. Verders advijseert, dat op gisteren twee van de outsten uut Mattau aldaer waren geweest, aen dewelcke de gramschap van Zijne gemelte E. op Taccaran hadden voorgedragen, haer vorders gelastende, dat niemant van de Chinesen, onder Compagnies pas in Wanckan calck brandende ofte met visschen haer generende, moesten

injurieeren ofte andersints beschadighen, 'twelck belooffden naer te comen
ende aen alle die van Mattau voor te draegen; versochten dienvolgende tot
een teycken van vruntschap 2 à 3 Hollanders om met haer te gaen, 'twelck
bij voornoemde Junius tot naerder ordre van Zijne E. gerefuseert is."

fol. 242: May 15-18: Today the Lord Governor received a letter from the
Reverend Robertus Junius, advising him to accept the apologies made by
Sincan. They did not know that His Honour had forbidden any more
animosity towards the people of Mattau and they ask him to pardon them
for it. Junius agrees with His Honour that it is a good idea to make a closer
union with Soulang than with the inhabitants of Mattau in order to put
increasing pressure on the latter and to bind Soulang to us, but not in a way
that they would be able to discover that we could gain any profit from our
friendship with them.

Junius goes on to report that two of the elders of Mattau had been there
yesterday, to whom he had mentioned His Honour's anger on account of
Taccaran, enjoining them further, that they should not injure or harm any
among the Chinese, who burn lime in Wancan with the permission of the
Company, or be in their way while fishing. They promised to comply with
this order and to pass it on to all the villagers of Mattau. They then asked
to be accompanied by two or three Dutchmen as a proof of our friendship,
which was refused by the said Junius until His Honour decides otherwise.

156. Missive Governor Hans Putmans to the Reverend Georgius Candidius.
Tayouan, 4 September 1635.
TEDING 14, fol. 4.

"Ued. missive gedateert 3e deses is ons op stante pee wel geworden den
teneur desselffs hebben oocq wel verstaen. Wat aengaet Ued. intentie ende
meninge dat het goet soude zijn men eerst een tocht op 't Goude Leeuws
eylant dede comt met de onse ten principale overeen, weshalven oock al
verleeden weecke ('t selve alvooren bij ons wel geëxamineert ende over-
wogen sijnde) hebben geresolveert 300 soldaten herwaerts te ontbieden om
die bij gelegentheid ende bequaem weder apparentelijck (soo den raet daer
niet tegen heeft) derwaerts te gebruycken. Om de Chineesen als inwoonders
van dat het op Mattau gemunt soude zijn uit het hooft te diverteeren gelijck
Ued. in sijne missive in 't breede is denoterende dat die van Mattau van de

hant des Heren soodanig besorgt werden is ons lieff datter eenige van de groote belhamels in 't leven waren gebleeven op dat in tijt ende wijlen de rechtvaerdige straffe over haere begaene fauten hadde mogen genieten (...)."

From the tenor of Your Honour's letter, dated the third of this month, which we received without delay, it became clear to us that we have understood well Your Honour's intention and opinion that the best thing would be first to start with the expedition to Golden Lion Island, which concurs with our intentions, because we already decided last week, after a close examination of the matter, to summon three hundred soldiers to come over to use them for that purpose as soon as the weather sets fair (and if the council does agree with it). In order to talk the Chinese as well as the inhabitants out of the fact that this does not concern an expedition against Mattau, we will tell them, as Your Honour describes elaborately in the letter, that Mattau has already been procured by the hand of God, yet we wish that some of the big rogues had remained alive so that they eventually had received just punishment for the crimes they had committed.

157. Missive Reverend Robertus Junius to Governor Hans Putmans. Sincan, 12 September 1635.
TEDING 15, fol. 12.

"Het gepasseerde alhier gelieve zijn Ed. tot dit naervolgende te verstaen, den principaelste die wij meest van doen hadden is door een gauwicheyt met stilte zonder eenich tumult te maecken gistren na den middach in de boeyen geraectt. Heden hebben wijder noch 3 (zijnde hooffden van haer kercken) bijgevougtt daervan eene ons is ontslipt. Zijnde noch vande 4 de beste soo ick oordeele, grouwelijcke dingen hebbenden voorgenomen gehatt, mijn cleene kinderkens souden niet gespaert sijn geweest. Daer resteren noch jonge gesellen die tot dese moorderij mede gestemt hebben, die wanneer zij gecregen sijn dan den E. luytenant met de soldaten wederkeeren. Over lant weder te keeren is om het regenig weder seer beswaerlijck ende oocq ongeraden, beter met champans die met den aldereersten dienen te comen, alsoo oordeelen dat met 't eerste moye weder dienen aff te gaen. De andre sullen nu beswaerlijck te becomen sijn. Slordige dingen werden mij gesecht als dat den dach als 't soude aengaen al bestemt was, doch heel seecker ende duidelijck can daer noch niet van schrijven dat sal den tijt leeren. De Heere moet gedanckt zijn die ons dese bloedige conspiratiën tegens onse persoonen ende natiën heeft geopenbaert."

We would like His Honour to be aware of what has happened here: yesterday afternoon the chief of Sincan, with whom we have had the most intercourse, by means of a ruse, was put into chains silently without causing any commotion. Today we have added three more (being the headmen of their 'churches') to him. One of whom managed to escape, being in my opinion the most guilty of the gruesome things they intended to carry out, even my little children would not have been spared. There remain young bachelors who had also connived in this murderous attack, but we will get hold of them as soon as the honourable lieutenant accompanied by his soldiers has returned. Because of the rainy weather, the condition of the roads is very bad, therefore I would strongly advise them not to use the overland route but to return aboard sampans. Alas, we think that it would be best to await the first fair weather. The others are now too difficult to be captured. Loose-lipped things were said to me about that day, had it indeed come to pass as had been planned, but most certainly and clearly I cannot yet write of this, time will tell that. The Lord must be thanked who has revealed to us these bloody conspiracies against our persons and our nations.

158. Dagregister Zeelandia.
VOC 1116, fol. 248, 249. Extracts 12, 17 September 1635.
DRZ, Vol. I, pp. 227-228, 229.

"12en ditto. (…) wert op heeden op 't versoeck van de predicanten bij d'E. heer gouverneur ende raedt goetgevonden (ten aensien uut domine Junii, op stant pee alhier verscheenen, verstaen, dat eenige rebellen in Sinckan zouden geconspireert hebben tegens onsen staedt aldaer ende op de predicanten nevens de soldaten, aldaer in guarnisoen leggende, altsamen te vermoorden ende doot te slaen), dat men om des Compagnies alreets vercregen gesach ende authoriteyt zooveel mogelijck te mainteneren, principael in deese gelegentheyt, nu de bequame middelen om 'tselve uut te voeren sich daertoe presenteeren, een troupe van 80 soldaten noch op vandage sal darwaerts senden om bij de bequamste middelen dese principaelste belhamers in handen te becomen ende herwaerts af te brengen om alsdan verder in haere saeecken te disponneren. (…)
15en ditto. Becomen 2 missiven van de predicanten als oock een ditto van den luytenant uut Sinckan, uut welckers teneur verstaen, dat drij van de conspirateurs in handen hadden becomen - den 4en was door versuym van d'goede toesicht weder ontlopen - mitsgaders hoe dat de gemoederen der Sinckanders zeer ontstelt waeren ende wel lichtelijck, naer zijluyden advij-

seeren, de wapenen bij der handt mochten nemen om, wanneer de gevange-
nen bij d'onse van daer gevoert wierden, d'selve te verlossen, sulcx dat den
luytenant bij twee wegen ordre versoect, oft hun niet verdistrueeringe van 't
gantsche dorp daertegen sullen stellen, ofte oock wel zoo sulcx (dat mede
wel zoude connen gebuyren) in 't afcomen der reviere voorviel, oft alsdan
tot uutvoeringe van 't gemelte (denoterende de ruyne van 't dorp) weder
sullen keeren, oftewel hare reyse vervolgens naer Tayouan vervoirderen.
Ende vermerckt deese saecke geen dilay en vereyscht, zoo heeft d'E. heer
gouverneur Putmans op stante pee den presenten raet doen beroepen ende
naer rijpe deliberatie van 't bovengeseyde met denselven geresolveert om dit
heerlijcke werck des Heeren, dat nu in 7 à 8 jaeren met groote moyten
gewonnen is, niet weder in eenen ogenblick te vernielen ende onder de voeth
te smijten, dat men alle de aldaer zijnde soldaten daer noch zoolange sal
laeten verblijven, totdat de gemoederen wat ter needer geseth zijn ende dat
men onderentusschen met sachte middelen (doch echter zoodanich dat onse
authoriteyt gepreserveert blijve) zal wercken om alsdan, verseeckert zijnde
geen molestie hebben te verwachten, af te comen; oordeeldende den raet dit
de bequaemste middel te zijn, doch wanneer sich de saecke zoo verthoonde,
dat de uutterste middelen dienden bij der handt genomen, dat men alsdan
gewelt met gewelt sal tegenstaen.
17en ditto. Naer den middach arriveert alhier uut Sickan den predicant Junius
nevens den luytenant ende 50 soldaten, hebbende 30 derselver aldaer tot ver-
sterckinge des guarnisoens gelaten, medebrengende de drij becomene conspi-
rateurs, raporteerende, dat de gemoederen ten deele, maer noch niet geheel,
geseth waeren, doch twijffelen niet ofte de saecke soude sich mettertijd
weder naer wensch toedragen. Dit uutval desselfs wil ons den tijt submini-
streren. De gevangenen zijn in hechtenisse geseth."

fol. 248: September 12: (...) today it is decided by the Honourable Lord
Governor, at the request of the ministers (because information had reached
us from the Reverend Junius that several rebels in Sincan were conspiring
against our position there with the purpose of killing the ministers and the
soldiers in garrison there), that - in order to maintain as far as possible the
power and authority the Company has already gained and because primarily
the proper means for carrying this out now happen to be at hand - today a
group of 80 soldiers will be sent forthwith over there for the purpose of
capturing the principal scoundrels and bringing them over to see what must
be done with them. (...)

fol. 248v.: We received two letters from the ministers and one from the lieutenant at Sincan, from which we understand that they have captured three of the conspirators (the fourth escaped again for lack of proper supervision) and also how the Sincandians were in a state of horror and may easily, as they believe, take up arms to free the captives when these are taken away by our men. It is because of this that the lieutenant asks for orders of two sorts, in the first place whether the entire village should not be destroyed, and, secondly, should such things occur (which is a possibility) while descending the river, whether he should not then return to carry out the destruction of the village or whether he should continue the march to Tayouan.

Because this affair allows no delay, the Governor has convened immediately the present council and has resolved, after careful consideration of the above, not to destroy and trample under foot the glorious work of the Lord that has cost so much time and trouble during the last seven or eight years, but to command the troops garrisoned in that place to remain there till the people shall have calmed down somewhat, and that in the meantime gentle persuasion - but only such as will leave our authority unimpaired - be employed, without attempting to repel force by force, unless it is a case of the direst necessity. (...)

fol. 249: September 17: During the afternoon the Reverend Junius has arrived from Sincan together with the lieutenant and 50 soldiers. They left 30 soldiers over there as reinforcements for the garrison and brought with them the three arrested conspirators, informing us that, although feelings were partly tempered, they had not completely eased, but they themselves did not doubt that in due time matters would change in the way we wanted. What will emerge from it, time will tell. The captives have been imprisoned.

159. Original Missive Governor Hans Putmans to Governor-General Hendrick Brouwer. Tayouan, 19 September 1635. VOC 1116, fol. 368-375v. Extract.

fol. 373: "(...) 't voorleeden jaer is hier mede preuve genomen van hennep, cattoen ende oock de geëijschte cangans-verven, 't welck altsamen, naer seggen van den coopman Hambuan, immers zoo goet als in China selffs is gevallen. Zulcx dan hier niet en manqueeren van volck om 't lant te bebouwen ende van goede verseeckeringe van 's Compagnie's staet, die door stercke garnizoenen ofte Hollantsche borgers, die hun met inlantsche ofte

swarte natie in den huwelijcken staet hebben begeeven, allencxkens in toecomende, naer dat den staet van negotie toeneempt, zall dienen versorcht te werden. (...)

fol. 375: Den spetie van kinderpocken, die onder dese inlantsche natie somtijts (doordien deselve in hare jonckheyt niet crijgen) verschijnen is dit Zuydermousson met sulcken pestelentialen infectie in de dorpen Soulang ende Mattauw verscheenen, dat die van Soulangh van ontrent 400 weerbare mannen maer ontrent 200 in't leven hebben behouden. Die van Mattauw, daer dese siekte noch dagelijcx is regneerende, hebben mede ontrent 2 à 300 weerbare mannen all verlooren, waeronder meest alle de cloeckste ende bevelhebbers van 't dorp, principaell (gelijck ofte het een merckelijcke straffe van den rechtvaerdigen Godt ware) die hantdadich aen het vermoorden van d'onse zijn geweest.

Baceluan, tusschen Sinckan ende Mattouw gelegen, die mede aen de voorengem. moorderie van d'onse zijn schuldich geweest, wert mede op 't swaerste aengetast.

In Sinckan nochte d'andere omliggende dorpen wert dese siekte niet vernomen. Alleene treft het diegeene die aen dit enorm faict zijn doende geweest, sulcx dat aen de fictorie int straffe van die van Mattouw, Godt de Voorste niet en is te twijffelen.

Ende blijven geresolveert, zoodra de soldaten uit de Piscadores hier zijn verscheenen (om die van Mattouw geen achterdocht te geven dattet op haer gemunt is als ons volck wat te vervrisschen ende ververschen), het Goude Leeuws eijlandt aen te tasten, het volck (soo 't mogelijck is) uit de speloncken, 't zij bij hongersnoot ofte anders iets, te crijgen ende dito eijlant van die gespuis te suyveren, opdat hetselve in tijt ende wijle bij gelegenheyt mochte gebruyckt ende eenige verversinge van gehaelt werden. (...)

Op gisteren zijn ons hier dry gevangene Sinckanders in hechtenisse gebracht, die, naer wat de predicanten verstaen, met den anderen geconspireert hebben omme (fol. 375v.) gem. predicanten ende soo't mogelijck ware geweest de soldaten altsamen aldaer in guarnisoen, om den hals te bringen. Off het geheele dorp (om ons quyt te werden), hier mede aen schuldich is, weetmen noch niet, alsoo op heeden ofte morgen eerst sullen geëxamineert werden."

(There are high hopes for the harvest of the sugar-cane planted in Saccam.) fol. 373: (...) Last year the cultivation of hemp, cotton, and also the dyes desired for cangans was given a trial, all of which turned out to do just as well as in China according to the merchant Hambuan. There is no shortage of labour for cultivating land and the safe situation of the Company will have to be, while the expansion of trade develops, gradually assured in the

future by strong garrisons or by marriages between Dutch citizens and the natives or black nation. (...)

fol. 375: An outbreak of smallpox, that among this indigenous nation will sometimes erupt, as they do not catch it in their youth, during this south-west monsoon, has struck the villages of Soulang and Mattau with such pestilential contagiousness, that of the approximately 400 fighting men in Soulang only about 200 are still alive; the people of Mattau, where this disease is still raging daily, have already lost approximately 200 to 300 fighting men, among them all the bravest and the commanders of the village, especially (as if it were a sign of the just punishment by God) men who had been active in murdering our soldiers. Baccaluan, situated between Sincan and Mattau, also guilty of this murder of our soldiers, was also most heavily affected.

This disease was not noticed in Sincan or other neighbouring villages. It strikes only at people who have committed this crime, so that in the punishment of the people of Mattau the victory of God Almighty is not to be doubted.

And we abide by our decision to set out as soon as the soldiers from the Pescadores have shown up here to prevent arousing suspicion among the people of Mattau that we might be aiming at them while we are refreshing and feeding our men here for a while, to attack Golden Lion Island, get the people out of the caves (if possible) either by starving them or by something else, and to cleanse the island of this vermin, with the purpose of putting it to use at some time or another and reaping some refreshments from it. (...)

Yesterday three arrested men of Sincan were incarcerated here in prison. As far as we can gather from the clergymen, they have been conspiring with others (fol. 375v.) to murder the [clergymen], and if possible also to finish off all the soldiers of the garrison there. We do not know if the whole village, in order to be rid of us, is also guilty of this matter, but today or tomorrow the prisoners will undergo further examination.

160. Missive Reverend Robertus Junius to Governor Hans Putmans. Sincan, 27 September 1635.
TEDING 15, fol. 13.

"Saterdach lestleden is bij ons gecomen 'snachts den persoon die ons dit verraet der Sincanderen eerst heeft geopenbaert ons noch openinge doende van verscheyde saecken. Soo hij getuygt, soo zoude weynige van desen

aenslag op onse persoonen ende goedren vrij sijn. Wij wisten niet beter off de helft van 't dorp was daer met besmett. Maer uit hem verstaen dat de westelijcke zijde, te weten Gillis volcq daer oock mede aen vast zijn, dat is dat dit heel dorp 't voorgenomen hadde. Hij zelve die 't ons geseyt heeft zeyde mede dat uyterlijck het toestemde van ons doot te slaen, wie zoude hier niet van weten ende wie sou 't niet hebben gedaen seyde hij. De outste ende insonderheyt Tioulatt is hier mede aen vast, één vande laetste vorspreeckers heeft ons alles wijtloopig verhaelt zoodat bij haer comende op Tayouan noch veel bekennen zullen. Tot dit haer schelmstuck soudense getrocken hebben Backluan ende cleene dorpen. Souden ons dootgeslagen hebbende het dorp niet verlaten hebbende maer ons verwacht ende mannelijck verweert, langs de revier haer verstroyt ende alsoo ons geoffendeert. Soo wij uit hem bemercken letten zij op onse personen ende soo de gevangenen gedoot wirden sullen sij 't aen dominee Candidius ende mijn revengeeren. Den persoon die 't ons openbaerde hebben voor eerst goedgevonden te vereeren (opdat eenigsints zijne affectie 't sijnwaerts mochte bespeuren) met zes realen dat niet twijffelen off sijn E. aengenaem wesen zal. Wat men hierom dit dorp wel hoort te leeren willen wij gaerne UE. wijsheyt ende verstant beveelen, ondertusschen Godt danckende dat niet gevangen zijn in dat nett dat voor ons gebreydett hadden. Zoo haest de soldaten van Pehouw arriveren sullen, soo 't Godt wil, met eenige oudsten affcomen. Tot Lamey te gaen vreese sal beswaerlijck de Sinckanders kunnen doen resolveeren alsoo bewust zijn in haer gemoet van haer voorgenomen feyten, gebruycken daertoe zoo veel list met Gillis spreeckende als mogelijck is."

Last Saturday, at night, the person who first revealed to us the conspiracy of the Sincandians came to see us. He again brought several things into the open, according to his testimony a few of them had nothing to do with the planned attack on our persons and goods. We are perfectly sure that half of the whole village had taken part, yet he gave us to understand that the western side, namely Gillis's people, were also included, which means that the whole village had partaken of that intention. He himself who informed us of it said that he had pretended to apparently agree to the plan of beating us to death. In answer to our question about who did not know about the conspiracy and who would not have done it, he said that the elders, including Tioulatt, had also taken part in the conspiracy. One of the last persons to vote in favour has told us everything in great detail so that when they are brought to Tayouan, they surely will confess much more. Into this dastardly ploy they also had talked Baccaluan and the small villages. After beating our

people to death they intended not to leave the village but to await our men who would come to avenge us in order to defy them manfully. Also some of them would have scattered themselves alongside the river to challenge the Company troops. We are aware that they keep a very close eye on us and if the captives will be killed, they will take vengeance by murdering the Reverend Candidius and myself. We did agree first to bestow on the person who revealed the conspiracy to us (so that one way or another we can show him our affection) six reals, that we do not doubt would please His Honour. We gladly entrust Your Honours' wisdom and powers of judgement what lesson this village should be taught. In the meantime we are thanking God that we are not caught in the web they had spun for us. As soon as the soldiers out of Pehou arrive here, if God allows it, we will come over with some of the elders. I fear that it will be very problematic for the Sincandians to decide whether they will come with us to Lamey, because in their hearts they are aware of the deeds they had planned. We will employ as much guile while talking to Gillis as is possible.

161. Dagregister Zeelandia
VOC 1116, fol. 250v, 251. Extracts 9, 14 October 1635.
DRZ, Vol. I, pp. 232, 233.

"9en ditto. Op dato wert over 't voorstel op gisteren gedaen (off men niet behoorden, om die van Mattouw van haere meeninge te diverteeren, een tocht op 't Goude Leeuw Eylant vooreerst te doen) andermael beraetslaecht ende bij d'E. heer gouverneur Putmans ende raet te verscheyden respecten goetgevonden, dat men 'tselve, tot naer den tocht op Mattau ende Taccareyangh gedaen is, sal uutstellen. (...)

14en ditto. Naer de middach verschijndt alhier uut Sinckan den predicant Robartus Junius, die ons raporteert verstaen te hebben, dat die van Mattouw ende Soulang hadden geswooren malcander te assisteeren, alsoo verstaen hadden, dat men haer den oorloge wilde aendoen, dat oock ten dien fijne die van Mattauw alreede eenige goederen, die voor desen in haere velden gebercht hadden, weder terugge brachten mitsgaders hoe dat seeckren Sinckander, Tabeja genaemt, zijnde eene van de principaelste conspirateurs, naer de zuyt, om zijnen vijant afbreuck te doen, was vertrocken ende dat men denselven, alsoo volgens hunne gewoonelijcke manier den strandt van Sacam in 't wedercomen sullen passeeren, aldaer zoude connen attrappeeren ende in onse handen becomen. 'tWelck bij d'E. heer gouverneur ende den raet in bedencken genomen zijnde, conden om verscheyden swarigheeden,

die daeruut (zoo deesen parsoon zijn medemackers ende complicen haer tegens d'onse quamen te canten) zouden connen ontstaen, niet resolveeren sulcx bij der handt te nemen, maer vinden goet 'tselve tot beter gelegentheyt uut te stellen." (...)

fol. 250v.: October 9: Today yesterday's proposal (the question of whether an expedition to Golden Lion Island should not be undertaken first in order to dissuade the people of Mattau from their ideas) was under consideration again and in view of several things, it was decided by the Honourable Lord Governor Putmans and the council to postpone this until after the expedition to Mattau and Taccareyan.

fol. 251: October 14: Late in the afternoon Reverend Robertus Junius arrived from Sincan, informing us he had heard that the inhabitants of Mattau and Soulang had sworn to help each other, because they thought that we wanted to make war on them; also that the inhabitants of Mattau were already bringing back some goods that they had hidden in their fields so far; moreover that one of the leaders of the conspiracy, a certain Sincan man named Tabeja, had left to go southwards to trouble his enemies and that he could be trapped and captured there, because, as they always do, he would pass the beach of Sacam on the return back.

This was taken into consideration by the Honourable Lord Governor and council, but because of some difficulties which could emerge (were this person to antagonize his partners and fellow-conspirators against us), no decision was reached to carry out the operation, but it was decided to postpone it until a better opportunity.

162. Missive Governor Hans Putmans to the Amsterdam Chamber. Tayouan, 23 October 1635.
VOC 1116, fol. 257-260.

fol. 257v.: "Seecker cruijtt bij de Chineesen *tcee* genaemt, waervan een soorte van blauwe verve, die geheell vasthout, in China zijn makende ende bij d'Ed. Hr. Gouverneur-Generael ontrent 600 hondert picoll om naer patria tot een preuve te versenden geëijscht wert, is 't voorleden jaer hier bij de Chineesen op 't vastelant aen Saccam gesaijt, geheel well geslaecht ende tot verve gemaect geweest. Van meeninge zijnde om deselve van hier naer China te vervoeren ende zien wat daerop souden connen proffiteeren (...). (...) indigo hier weynich te becomen.

Van een colonie in Teyouan te stabiliseeren hebben U Ed. 't voorleeden jaer, mitsgaders d' Ed. Hr. Gouverneur-Generael ende Raden van Indien, beginnen openinge te doen, doch alsoo 't selve een seer wichtige sake is, die seer veele omhelst ende naer sich sleept (...), niet altsamen soowell met de penne als met den monde connen voorgedrage (...).

fol. 258: De principale poincten daerin wij bemercken uit missiven met Zijne Ed. verschillende zijn, is, dat Zijne Ed. verclaert met U Ed. bij naer te despereeren om eene permanente colonie met ofte door de Hollantsche natie in Indien te beginnen; 't welck wij mede wel zijn concideeerende, soo onze natie niet en conde resolveeren (gelijc alreets veele doen ende noch meer voordesen gedaen hebben) met inlantsche vrouwen te trouwen, dat, bij manquement van Nederlantsche in toecomende zoo wanneer U Ed. geene van 't patria meer herwaerts senden, genoechsaem weder sall toenemen, daervan men gemeenelijck siet de kinderen voortcomen ende allencxkens naer alle apparentie de vermeerderinge staen te volgen; daeruit wij dan oock hoopen door de hulpe Godes een Gereformeerde colonie zall connen gestabiliseert werden. Onderentusschen souden andere van redelijcke middelen, die noch met Hollantse vrouwen getrout zijn, om den handell in treijn te brengen all mede, onses oordeels, hier niet buijten dienen gehouden te werden (...).

fol. 259: Tot het distrueeren ofte vermeesteren van het dorp Mattouw, om het inorm faict ten tijde van d'Hr. Nuyts bij de natie aen d'onse begaen te revengieeren, is tegenwoordich seer goede apparentie, ten aensien Godt Almachtich dit voorsz. dorp nu eenen tijt lanck herwaerts met zijne machtige hant seer hart heeft aengetast met een pestelentiale sieckte, zijnde een spetie als kinderpocxkens, die nu all ontrent de twee maenden meest onder all het beste ende weerbaerste mannevolck heeft geringneert ende noch continueert, zulcx dat de meeste helft zeer miserabelijck, daeronder vele van de principale voorvechters ende aenleijders van 't bovenverhaelde boose faict, door den doot zijn wechgeruckt.

In het dorp Soulang, die mede aen dit faict ten deele (fol. 259v.) nevens die van Bacaluan zijn schuldich geweest, is de meeste helft van het weerbaerste mannevolck van de zieckte verslonden.

In Baceluan is deselve tegenwoordich noch ringneerende ende verslint aldaer van gelijcken veele menschen.

In Sinckan ende andere omliggende dorpen (die alle onse vrinden ende op dit dorp Mattouw gebeten zijn) wert dese sieckte noch niet vernomen; alleene in dese voorn. drij dorpen, die aen het voorverhaelde leelijcke stuck zijn hantdadich geweest. Zulcx dat, Godt de Voorste, (te meer onse d'Ed. Heer Gouverneur-Generael op ons versoeck met 400 soldaten nu heeft gelieve te versien) aen de victorie niet en is te twijffelen, 't welck des Compagnie's

authoriteijt ende gesach onder dese brutale natie en het getal der nieuwe te winnen Christenen (hoopen wij) grootelijcx zall vermeerderen ende niet minder het getall der Chineesche bouwlieden (die dagelijcx meer van deese barbarise menschen plegen geplaecht te werden) doen toenemen.

Onder die van het dorp Sinckan, alhoewel meest alle gechristent zijn ende vermeijnden dat zeer getrouw ende t'onswaerts genegen waren, heeft sich eenige dagen geleeden een seer leelijcke conspiratie geopenbaert, waervan drij van de principalen, die de sake (namentlijc om beijde de predicanten ende de soldaten die der in garnisoen leggen te vermoorden) hadden voorgestelt ende geresolveert, in hechtenisse hebben genomen om een exempel tot affschrick van alle andere omliggende dorpen onder dese natie te statueren. Doch wert hetselve om verscheijdene consideratien, tot naerder tocht van Mattouw zall gedaen zijn (die door de reegen in november aenstaende eerst zall connen verricht werden), uitgestelt. Echter hoopen door de sonderlinge bestieringe Godes dit stuck, ten principale int voortplanten van de Christelijcke religie, niet schaddelijck zall zijn, 't welck ons den tijt wert leeren."

fol. 257v.: A certain herb, called *Tcee*[71] by the Chinese, from which they make a sort of fairly fast blue dye in China and of which approximately 600 picol were demanded by the Honourable Lord Governor-General to send to the fatherland, was sown at Saccam last year by the Chinese. It was a great success and was processed into dye. We plan to transport this to China and to see what profit can be made. (...) Indigo is almost not available.

Last year we put forward to Your Honours as well as the Lord Governor-General and the council of the Indies a tentative plan for the making of a permanent colony at Tayouan, but because this is a very important matter, involving and touching on many aspects (...), I should perhaps rather not present it by pen but by mouth (...).

fol. 258: The main points on which we hold divergent views, as is clear from the letters, consist of the fact that His Honour declares that he together with Your Honours is almost desperate about starting a permanent colony in the Indies with or by the Dutch nation. We are considering the feasibility of this too, should our nation decide not to marry native women (like many already do and even more have already done, but which in the future will be more frequent because of the lack of Dutch women, if Your Honours do no longer send these over from the fatherland). Generally, offspring are the fruit of these marriages and it is likely that the community will grow as a result. It may be clear that we expect a Reformed colony to be founded as a consequence, with God's help. In the meantime others of reasonable

means, who are still married to Dutch women, should (in our opinion) not be excluded from this place in order to stimulate trade.

fol. 259: Time seems ripe for the destruction or conquest of the village of Mattau, with the purpose of avenging the crime that the nation committed against our men in the days of Mr Nuyts, because now for some time the Lord's mighty hand has smote this village very hard with an infectious disease, an epidemic like smallpox, that now has already been prevalent among the best and most valorous fighters for two months and still continues to rage to such an extent that half of the people, among them many of the principal fighters and instigators of the abovementioned crime, have been overcome by death.

In the village of Soulang, that in some respect has also been guilty of the crime in collaboration with the people of Baccaluan, half of the strong fighters have fallen victim to the disease. In Baccaluan it is still prevailing and is likewise overwhelming many people there.

In Sincan and other surrounding villages (all of which are our friends and bear a grudge against this village of Mattau) no sign has yet been seen of this illness. It is present only in these three villages mentioned that have been active in the nasty event told before. So that, praise the Lord, there need not be any doubt about the victory (the more so because it has pleased the Honourable Lord Governor now to honour our request and provide us with 400 soldiers), all of whom will greatly enlarge both the Company's authority and power among this rude nation and the number of new Christians-to-be (we hope) and no less will increase the number of Chinese land labourers (who are molested by these barbaric people with ever greater frequency every day).

Among the people of the village of Sincan, although most have been Christianized and although we thought that they were very faithful and well disposed towards us, some days ago a very nasty conspiracy was revealed. As a deterrent to all the other surrounding villages of this nation, we have arrested three of the leaders who had proposed and resolved to carry out the murder of both ministers as well as of the soldiers stationed in the garrison. But for many reasons it was postponed until a reconnaisance trip to Mattau has been carried out (which will not be done before November because of the rain). But we hope that through God's miraculous intervention this fact will not be harmful, especially not for the propagation of the Christian faith, which time will tell.

163. Missive Governor Hans Putmans to the Reverend Robertus Junius. Tayouan, 8 November 1635.
TEDING 14, fol. 4-5.

"Ued. missive gedateert 7en deses is ons des avonts wel geworden waeruit verstaen hebben dat Ued. den *caffer* met den soldaet Willem om een wech op te soucken gesonden hebt, maer en connen niet wel verstaen off Ued. den eerst genoemden wech meent die met halffwassent waeter eerst met champans connen aencomen off den ordinairen die Ued. secht de Baculuanders soucken als den zeestrant pazzeeren weshalven Ued. sulcx wat pertinenter sult dienen te notificeeren insgelijx welcken van beyden Ued. voor het best oordeelt om ons daer naer behoordelijck te mogen richten, laet mede den caffer ende voornoemde Willem desen wegh twee à drie mael besoucken opdat hun de passagie des te beter bekent werde. (fol. 5) 't Rapport vanden Chinees hebben mede wel verstaen doch wensten wel Ued. 't selve watt nauwer aenden selve ondervraegde off den gront vande revier cleij, steen, sant, op ofte nedergaende is om ons in tijt ende wijlen behoorlijck daer naer te mogen reguleeren. 't Vordere bij Ued. (nopende die van Mattau haer in 't lange gras om hun vordeel also op ons te soucken sullen onthouden) gedenoteert om door de honden sulcx te doen ontdecken, sullen mede opletten. Dat die van Tirosen met die van Mattauw in oneenigheyt zijn vervallen connen niet anders bespeuren ofte sal in ons voorgenomen dessein vorderlijck zijn. Wat aengaet om den caffer na Mattau te senden soo denselven bij Sambdau niet selffs gehaelt ende bij die van Mattauw ernstelijck versocht wert sullen Ued. sulcx executeeren ende alsdan niemant als den caffer alleen zenden, ten waere heel hert aenhielden om Hollanders in sulcken gevalle zullen Ued. niet meer als tot eenen verstaen ende denselven serieuselijck vermaenen op alles behoorlijck te letten op de diepte, gront als anders vande reviere, mitsgaders de gelegentheyt van 't dorp. Doch soo 't sonder aen die van Mattau achterdocht te geven can geexcuseert werden, laet dan sulcx niet geschieden alsoo achten alreede onderricht genoug vande Chinees (soomen hem gelooven mach) becoomen hebben.
Belangende dat die van Sinckan als de omleggende dorpen haer tegen die van Mattauw wel souden laeten gebruycken, ick gis segge wij achten dat sij alle d'indianen souden slachten als wij met Godt de Voorste de victorie hadden bevochten dat zij dan de hooffden souden zoucken ende anders niet sonders veel uitrichten sulcx dat haer oock niet soude connen mede gaen ende dienvolgende aen Ued. gesecht heeft dat sich daertoe wel mach prepareeren daer over is bij den raedt tot noch toe niet geresolveert weshalven Ued. geen sekerheydt daervan cunnen aencundigen, doch echter mocht UE. wel vrij

gereet houden dat de zuydelijcke zij van Mattau maer één pagger heeft zulcx
is niet dan te beter alsoo van meeninge zijn door ofte voorbij Sincan te
marcheeren."

From Your Honour's letter, dated the 7th of this month we were informed
that in the evening Your Honour had dispatched the *caffer*[72] together with
the soldier, Willem, to scout out a certain road, yet we do not understand if
Your Honour means the road that was first mentioned, the one which can
only be reached by sampans at half-tide when the water is rising, or the
ordinary one about which Your Honour says that is used by Baccaluan
people when they take the beach route. Therefore, Your Honour should
describe it a bit more clearly. The same also counts for what Your Honours
both consider best so that we can act according to your directions. Do let
the *caffer* and the aforementioned Willem also pay a visit to this road two
or three times so that they shall be better acquainted with this passage. We
have also understood the report made by the Chinese, yet we do wish Your
Honours to question him in a little more depth about the soil consistency of
the riverbed and if it is composed of clay, stone, or sand, and whether it
becomes more shallow or whether it deepens, so that in time we can act
accordingly. Considering your further remarks (concerning the people of
Mattau who wont to hide themselves in the long grass so that they can seek
their advantage against us) that they should be sniffed out by the dogs, we
shall heed attention. There is no other way to view the fact that those from
Tirosen have fallen out with the people of Mattau than that it will fit very
well into our plan and will be very beneficial to it. Concerning the sending
of the *caffer* to Mattau which was most earnestly requested by Mattau, if he
is not already met by Sambdau himself, Your Honours should execute this
and ensure that nobody but the *caffer* is sent with the sole exception that
they would earnestly beseech Dutchmen, in which case Your Honours are
only allowed to send one, whom you will order to be very observant about
the depth, the soil consistency and everything else concerning the river. He
must also note how the village is situated, yet in such a way as not to arouse
any suspicion among those of Mattau. However, should he have to take any
risk by behaving too conspicuously, then he can be excused of that assign-
ment because the information we have already obtained from the Chinese we
consider to be quite sufficient (if he can be trusted).
Concerning the fact that Sincan as well as those from its surrounding
villages are possibly willing to let themselves be used against Mattau, I

guess that if we, by help of God the Foremost, had won the victory, that they would kill all the Indians and seek to take their heads. Otherwise they would not accomplish much so that it would not be of much use were they to go along and therefore the council has not decided at this moment to tell Your Honours to prepare themselves there to. So we are not able to announce anything to Your Honours yet, though Your Honours might well be prepared for the fact that the southern side of Mattau has only one bamboo fence, which is so much the better because we are intending to march through or past Sincan.

164. Missive Reverend Robertus Junius to Governor Hans Putmans. [Sincan]. 17 November 1635.
TEDING 15, fol. 13-14. Extract.

"De Sinckanders gevraecht zijnde wat dat Mattau voorgeven te seggen wij anders niets dan dat Sabdou gevraecht soude hebben wanneer dat wij trecken zouden. Hij wilde mede gaen dat sij selver houden voor een praatjen.
Sabdou met noch één vande outste staet hier morgen off overmorgen te ver-wachten. Wat dat verzoucken sullen wel den tijt leeren."

When the Sincandians were asked what Mattau claimed to say, we heard nothing other than that Sabdou should have asked when we would march and that he wanted to come along, which they themselves assume to be a fib. We expect Sabdou here tomorrow or the day after tomorrow with one of the other elders. What it is that they want to ask we will learn sooner or later.

165. Missive Governor Hans Putmans to the Reverend Junius. Tayouan, 21 November 1635.
TEDING 14, fol. 5-6.

"Op gisteren hebben wij met den raet geresolveert alsoo den tijt hart begint te genaecken om op overmorgen in den naeme des Heren den tocht op Mattau bij der hanth te nemen soo bij aldien Godes weder ende wint sulcx wil toelaeten dat met de champans aen mont vande revier van Sincan connen comen, weshalven U.E. bij desen aencundigen dat op ons vertrecq van hier 3 canonschooten sullen doen, wanneer U.E. met de soldaten die bij den luytenant om tot den tocht gebruyckt te werden sullen affcomen, doch bij

aldien U.E. sulcx niet mocht hooren sullen echter over Saccam een swart Ued, toesenden. Ingevalle 10 à 12 Sinckanders onder pretecxte van dese gevangens alhier te comen besoucken off onder eenen anderen deckmantel cont medebrengen zulcx soude gerade zijn omme de andre dorpen daermede te doen waerschouwen.

Boven de geordineerde soldaten tot den tocht blijven noch 21 soldaten in Sincan waer van U.E. noch 6 vande cloucxte gangers sult medebrengen ende de rest zijnde 15 in 't getal aldaer verblijven laten, Ued. connen champans om de soldaten aff te voeren (fol. 6) huyren ofte pressen nadat sich de gelegentheyt sal verthoonen, ofte anders soo zulcx niet conde wesen ons ontrent Baculuan waer men den Bededach sullen op morgen ochtent in 't Godt gelieft aenvangen. Soo den selven al mede onder d'onse secreete (sonder dat d'Sinckanders sulcx quamen te weten) conde gedaen werden can U.E. sulcx mede doen, maer soo d'onse zulcx niet soude connen swijgen ende tegens de Zincanders seggen is 't beter gelaeten.

Dominee Candidius sal in U.E. plaetsen als U.E. affcomt met dito champans weder naer Sincan vaeren om soo lange alsdaer te verblijven ende somtijts ons met een letterken te versien hoe sich de saecken daer gedragen. Sijne residentie sal hij daer houden in één van de camertjes van Joost off Agricula. 't Zoude onses oordeels goet sijn dat UE. Joost mede brachte ende Agricula neffens Candidius aldaer verbleve (...)."

Yesterday, because time is running out the council decided that on the day after tomorrow in the name of the Lord we will depart on the expedition to Mattau if God's weather and wind permitting we will be able to reach on board of the sampans the mouth of the Sincan River. Therefore we herewith make known to Your Honour that upon our departure from here we will fire three cannon shots. At that moment Your Honour will depart together with the soldiers drafted by the lieutenant for the expedition. However, should Your Honour perhaps not hear the shots we will send a native over to you from Saccam. If you could bring with you ten or twelve Sincandians on the pretext of visiting the captives over here or any other pretext under which you can bring them along, it would be wise to warn the other villages about it.

Besides those soldiers who have been ordered to participate in this expedition, twenty-one soldiers remain behind in Sincan. From these Your Honour may choose another six of the most stalwart men to take along, while you should leave the other fifteen men behind. Your Honour can either rent or commandeer sampans in order to transport the soldiers (fol. 6) as it suits you.

If this does not work out do meet us near Baccaluan, from where we will start tomorrow morning, if it may please the Lord, the day of prayer. If only this can be done in secret (without the Sincandians knowing about it) then Your Honour can do that as well. However, if our men are unable to keep silent about it so that the Sincandians are informed about it, then better let things ride at that.

If Your Honour comes over, the Reverend Candidius will in Your Honour's stead once more set sail back to Sincan with the aforementioned sampans in order to stay there (as long as you are absent) and write a little note to us every now and then, apprizing how things are going. He can use one of the little rooms of either Joost or Agricula as his residence. In our opinion, it would be excellent if Your Honour would bring Joost along and would leave Agricula[73] behind there together with Candidius (...).

166. Missive Reverend Robertus Junius to Governor Hans Putmans. [Sincan] 27 November 1635. TEDING 15, fol. 40.

"Heden ontrent den middach (naer dat gistren een hasegay ende een houwer mij toegesonden hadden) verschijnen hier 2 vande principaelste van Mattauw ootmoedig versoucken ernstich aenhoudende dat vreedsaem met haer wilden spreecken, hetwelcq haer niet afsloug, naer datse gesoubatt hadden in presentie van dit dorp, dede haer bij mij comen, een tijt lang met haer gesproken hebbende nopende het leelijck vermoorden van ons volcq voor desen begaen, deden haer spreecken, bekende faulten, belooffden beterschap, willen haer onderworpen alles wat Bacluan sich onderworpen heeft, willen gehoorsaem zijn. Gaff haer ter antwoort zoo twijffelde niet ofte zoo zijn Ed. met haer in vrede treden wil, die niet anders begeert als gehoorsaemheyt ende behoorlijcke subjectie, zeyde haer aan dat dan dienden omleeg te gaen met zijn Ed. te spreecken, dat dorsten zij niet bestaen maecten veel excusen. Onse Sincanders zeyden recht uit zij derven niet door vreese, niettegenstaende haer verseeckerden dat haer niet misschieden zoude, ten hielp niet. Ten laetsten zeyden haer zoo dan zelffs met haer ginck off dan wel zouden derven gaen. Daer hadden zij niet tegen soo dat genoodsaect ben, wil ick haer daer crijgen, selver mede aff te comen. Derhalven haer zeyden weder nae 't dorp loopen zouden ende crijgen meer [volk], [op 't] roupen vande outste dat haer zoude geleyden ende dat niet twijffelde den pays zoude getroffen werden, zoo dat zijn Ed. morgen namiddach soo Godt wil ons op Saccam vinden zal, wensten wel 2 à 3 champans daer dan claer hadden,

alsoo met ons velen zullen affcomen. Mijns oordeels behoorden dese oocq te soubatten op Tayouan ende opdat de Chineesen zien mochten die haer altijt gevreest hebben, diende het te geschieden in 't quartier ontrent Hambuans huys voor de voeten van zijn Ed. Daer dan de soldaten in een lange rij staen door welcq zij mosten marcheeren, dit meene proffijttelijck zoude zijn, zoo zijn Ed. dit zoo verstaet hij gelieve mij een brieffken op Saccam te laeten vinden, daer mij na mach reguleeren, off anders sal aende logie aanleggen. Doch als boven is veel beter, op dat blijcke dat diegenen die noch voor donder noch voor den blixem vreesden, even meer voor onsen natie (Gode zij loff in den eeuwicheyt) vreesen."

Today around noon (after they had sent me an assegai and a chopper), two of the principal headmen of Mattau made their appearance, who requested us humbly and insisted gravely on speaking with them peacefully, which we did not refuse after they had beseeched me in the presence of the people of this village. I let them come over to me and after speaking with them for some time about the horrible murder committed earlier on our people, they spoke and confessed their faults and promised to behave themselves better. They wanted to submit themselves to all that Baccaluan had submitted itself to and they wanted to be obedient. I answered them that I did not doubt that His Lordship (the Governor), if he would like to make peace with them, desires above all else obedience and a suitable subjection, and said to them that in that case they had to come down to speak with His Honour, which they did not dare to do making us many excuses. Our Sincanders told us right away they did not dare to go out of fear, notwithstanding we guaranteed them that nothing would befall them, all in vain. But in the end I asked them if they would dare to go were I to accompany them, to which they were not at all opposed, so that I am obliged if I want them to get to Tayouan to come down over there myself. Therefore I told them to walk back to the village and obtain more people to join on the announcement of the elders that we will accompany them and that I did not doubt peace would be concluded. Consequently His Honour, so it pleases God, will find us tomorrow in the late afternoon at Saccam. We would appreciate it if about two or three sampans would be made ready there because we will come down with many. In my opinion these people from Mattau also ought to beseech you in Tayouan. In order that the Chinese, who have always feared them will see this, it should take place in the (Chinese) quarter near Hambuan's[74] house, where they will have to throw themselves at the feet

of His Honour. They must march through a long row of soldiers who will be drawn up in lines. This I judge would be beneficial. If His Honour agrees, I would like him to send me a note at Saccam, on the instructions of which I will act accordingly, otherwise I will call at the castle. Yet it would be much better were it to pass just as I have described above so that it will be proven that those who do not fear thunder or lightning, (God be praised throughout eternity), do fear our nation even more.

167. Missive Reverend Robertus Junius to Governor Hans Putmans. [Sincan], 14 December 1635.
TEDING 15, fol. 14.

"Alzoo de oudsten van 7 resterende 'kercken' in Mattauw (want van 2 alleen verscheenen zijn) noch niet bij ons geweest zijn, die nochtans dienden te spreecken, hebbe haar alsoo vertouffden een bode gesonden opdat met den eersten quamen, die haer tot noch toe geëxcuseert hebben, seggende dat besich zijn maer zoo ick verstae sijn noch verveert, senden een jonckman die mij zoude aenseggen dat niet comen connen; den welcken wederom gesonden hebbe, hem bijvouchende den Sincander andermael haer laten weten dat selver dienen te comen ende op dat vreese laeten vaeren soude, hebbe hem op haer versoucq 2 verckjes laten volgen voor de 2 kercken die hier geweest zijn soo dat haer morgen hier verwachten sal. Soo ick uyt den Mattauw verstae zoude gaerne hebben dat 3 à 4 Hollanders met mochten gaen dat oock morgen weder verzoucqen sullen, 't welcq niet sal doen zonder last, consent ende ordre van zijn Ed. mijns oordeels waer het goet dat Joost met 3 à 4 op haer versoucq met gingen, soude haer noch meer gerust maecken derhalven hierover ordre verwachten sullen, conde ick tegen morgen avont bescheyt hebben soo soude Joost noch met haer connen gaen want van meeninge zij haer tot morgen avont op te houden in welcken tijt wij verhoopen zijn E. ons antwoort toestieren sal ende alsoo versta Bacluan oock verveert te sijn hebbe oock hare oudsten ontboden die ick niet en twijffele off contentement doen ende alle vreese benemen sal. Het schijnt eenige Sincanders haer vervaert gemaecktt hebben want al eenige weder haer kisten gebergt hebben soo mij wert gesecht."

Because the elders of seven of the remaining 'churches' in Mattau - the people who did appear belonged to only two of them - have not yet come to us, even though we do have to speak to them, we have sent a messenger over to the place they are bivouacked to request those who have stayed

behind until now to show up immediately. To this, so far, they have refused to listen under the pretext of being busy, but as I understand they are really afraid. They have sent a young man who came to announce to me that they could not come and whom I did send back to his village accompanied by the Sincanders. Once again I let them know that they should come themselves. In order that they should cast off their fear, I have given him two little pigs at their request for the two 'churches' who had come over to us, so that I do expect them to come and see me here tomorrow. So I learn from Mattau they would like to have three or four Dutchmen to go along with them, which they will request again tomorrow, which I will not grant them unless with the consent and upon the orders of His Honour. In my opinion it would be a good thing if Joost should accompany three or four men as they requested, which would make them feel more at ease. Therefore we will expect instructions about this. If only I could have your message by tomorrow evening, then Joost could accompany them, because I think that we could keep them here until tomorrow evening. By that time we do hope His Honour will have sent his reply to us. I understand that Baccaluan fears us as well, so we have also invited its elders, whom, so I do not doubt, we can make happy and relieve of their fears. It seems that some Sincanders have made them afraid, because some of them have again hidden away their chests with belongings as I was told.

168. Missive Governor Hans Putmans to Reverend Robertus Junius, Tayouan, 15 December 1635.
TEDING 14, fol. 6.

"UE. missive gedateert 14 stantij is ons op gisteren ontrent 4 glasen inden avontt wel geworden. Uit desselffs teneur verstaen dat die van Mattau gaerne hadden dat 3 à 4 Hollanders in haer dorp quamen ende dat UE. oordelen sulcx om haer gerust te stellen goet soude zijn, dewijle alreede onse meeninge aende gecommitteerde van daer genouchsaem in 't vrundelijcke te verstaen gegeven hebben. Weshalven oocq oordeelen dat men sulcx tot naerder proclamatie ende bevestinge van het contract daermede alreede in onderhandelinge staen, behoorden te delayeeren waer op UE. naerder advijs sullen verwachten. Off het contract voor off naer den te doene tocht op die van Taccareyang effect sal sorteeren, dienen mede te weten opdat ons daernaer mogen richten ende de articulen in 't Chinees laeten translateren, maer dient genoteert datt 't selve in presentie van alle de omleggende dorpen tot meer-

der bevestinge behoort te geschieden. Wij sullen UE. advijs hiermede op tegemoet sien oftewel soo 't den tijt ende gelegentheyt toelaett mondelinge rapport verwachten. UE. connen die van Mattauw echter vriendelijck bejegenen ende animeren op onse goede genegentheyt wanneer haer wel dragen ende de voorgestelde artiquelen behoorlijck achtervolgen, hun mede aenmaenen dat ons uit haer dorp de geseyde dubbelde persoonen om bij ons de hooffden uitgecooren te werden voorbrengen opdat in tijt ende wijlen de saecke tot een goet uiteynde mach gebracht werden. (...)."

Your Honour's letter, dated December 14, reached us yesterday at about 4 glasses in the evening[75]. From its contents we are led to understand that those of Mattau would like three or four Dutchmen to come (and reside) in their village and that Your Honour considers it to be a good thing as it would make them feel at ease, so that we have already given our opinion to the emissaries from there in the most friendly way. Consequently we judge that we should postpone that matter pending the proclamation and the conclusion of the contract, for which negotiations are already afoot. On this matter we will await further advice from you. We also would like to know if the contract should be factualized before or after the planned expedition to Taccareyang, so that we can act accordingly and so that we can have the articles of the contract translated into Chinese. Yet it should be noted that it should be concluded in the presence of all the surrounding villages in order to vouchsafe better compliance. We look forward to receiving Your Honour's advice or expect an oral report if time and occasion permits. Your Honour could however treat those of Mattau in a friendly fashion and at the same time inspire them to believe in our good intentions, if only they behave themselves well and if they obey the proposed articles sufficiently, and you could also urge them to bring forward to us the two mentioned persons from their village so that we may elect these here as headmen, so that in time we can conclude the matter well. (...).

169. Missive Reverend Robertus Junius to Governor Hans Putmans. [Sincan], 18 December 1635.
TEDING 15, fol. 14-15.

"UE missive vanden 17[en] is mij gisteren in den avont wel geworden uit welcqe verstont mijnen joncxte aen zijn Ed. ter hant gecomen was, als desen schreef was noch niemant van d'andre dorpen verscheenen, doch twijffele

niet off meest tegen den middach hier wesen sullen. Soo veel Tevorang belangt wert van de Sincanders getwijffelt off comen zullen ende dat om de besmettelijcke siecte der kinderpocken die seer begint te regueeren, sijnde daer al 5 van gestorven, (fol. 15) veel daarmede noch gequelt sijnde, als onder anderen Tapegij ofte Gilles alias genaemt. Soo veel Tirosen belangt hadde gaerne gesien dat mede gecompareert hadde maer can in dese conjuncture niet wesen alsoo geen rechten pays is tusschen haer ende Mattauwers. Ick twijffele niet off sijn Ed. is noch indachtig dat bij hem sijnde verhaelde hoe dat Tirosers de Vovorolangers van haer lieten vallen dat de Mattauw beoorlogen wilden, ergo connen niet verschijnen. Eer dat wij Tirosen hier connen crijgen, dient eerst de controversie die onder haer is gedecideert ende den onvrede wechgenomen hetwelcke niet twijffelen off eerlange sal connen geschieden soo 't niet is voor den tocht, immers cort na den tocht soo dat alle dese omleggende dorpen vast aen malcanderen sullen konnen binden ende ons doen voor haer heeren bekennen."

Your Honour's letter dated December 17 reached me yesterday evening, from which I understand that His Honour must have received my most recent letter. While I am writing this one nobody from the other villages has sofar appeared, yet I do not doubt that most of them will show up around noon. Concerning Tevorang, the Sincandians doubt if they can come, because the contagious smallpox has really started to exert its sway over there. Five people have already died and many are suffering from it. Among the latter is Tapegij who also bears the alias Gilles. Concerning Tirosen we would have liked to see that they had also taken the trouble to appear but that is impossible in this situation because there is no true peace yet between them and the people of Mattau. I do not doubt that His Honour still remembers that I, when I saw him, told him how the people from Tirosen had insinuated the Vovorolangians that they wanted to make war on Mattau, which is why they cannot appear. Before we can convince Tirosen to appear we must first make an end to the quarrel among them and remove wrath, which we do not doubt will actually happen sooner or later if not before then shortly after the expedition so that we can bind all these surrounding villages to each other and cause them to acknowledge us as their lords and masters.

170. Missive Reverend Robertus Junius to Governor Hans Putmans. [Sincan], 29 December 1635.
TEDING 15, fol. 15-16.

"Nopende het suspect van Soulang daer ontrent doen sich op verscheyde bedenckingen soo dat niet wel yet wat sekers daer van sijn Ed. toeschrijven can, achtende het sekerder ende beterder mijns gemoets concepten mondeling zijn E. te communiceren als schriftelijck toe te stieren, heeft dan sijn Edelheyt (soo Godt wil) morgen tegen de avont op Saccan mij te verwachten, sullende versorgen dat Tilach den Soulanger ende Tabeja (die beyde in dese zaecke noodich zijn) mede aldaer haer verthoonen soo we sijn Ed. daer conde vinden soude Tabeja datelijck weder connen keeren om alsulcx te roupen die daer mede toe noodich zijn; zoo niet, versoucken zijn E. gelieven te versorgen een vaertuyg op Saccan vinden mogen daermede bequamelijck connen oversteecken.

Tabeja is nae Soulang niet alleen om Tilag te roupen maer oock om te gaen sien de plaets waer de Chinees Souroug hem onthout op dat in hem te vangen des te sekerder mach gaen.

't Is seker dat Soelang een groote straffe verdient heeft, sijnde zoo wel schuldich als Mattau, want van haer de eerste bitchiaring gecomen is zijnde oock hantdadig want 20 sterck in de revier geweest zijn doen ons volcq dooden ende ettelijcke hooffden met haer na Soulang namen daer over sij oock triompheerden ende hare heydense feesten hielden daerbij comt de mutilisatie vanden dominee ende den jongen Pieter in 't dorp selffs begaen sijn Ed. genoug bekent. Soo dat bedenckelijck is off niet soo veel quaett als die van Taccareyan hebben gedaen, verbij gaende het rooven der chineesen goederen die meenden met des Compagnies pas versekert waeren.

In dese conjuncture soo onse zaecke nu staen oordeele ick dat wel hert met haer gehandelt mach werden, hebbende nu tot tweemael sulcken grooten victorie vanden hant des Heeren ontvangen soo dat alle dorpen voor ons vreesen ende hoe harder met haer handelen hoe beter deeg met haer in toecomen hebben sullen, ick spreecke inde quaetdoenders, sijn Ed. doe ondertusschen na zijn welgevalle, dat resteert can mondeling verhandelt worden fol. 16: De onlancx gehaelde victorie smaeckt dese inwoonders wonderlijck wel. Daer zijn 9 hooffden gecregen aen het tiende wert getwijffelt. De kinderpocken in Sincan neemt seer toe."

Concerning the matter of the suspicion of Soulang, there seems to be such a plethora of possibilities that I cannot write Your Honour anything about it with certainty. Therefore I consider it to be much better were I to com-

municate the concepts in my mind orally to Your Honour than to send these to you in a written form. Therefore His Honour can expect me (God willing) to arrive at Saccam towards tomorrow evening. We shall take care that Tilach, the Soulangian, and Tabeja (who are both needed in this case) will show up there as well. If we could meet His Honour there, then Tabeja can immediately return to call those who should also be necessary. If it is not possible for His Honour to be present, then we would like to ask him if he could arrange for a vessel at Saccam on which we can conveniently cross over (to the castle).

Tabeja has left for Soulang, not only to get Tilag but also to search for the place were the Chinese Souroug is holed up in order that we will be sure to be able to catch him without fail.

Soulang has surely deserved serious punishment, being just as guilty as Mattau, because they were the first to start in the plotting and planning and they were also actively involved, because twenty men were at the scene in the Mattau River when our people were killed and they also took several heads to Soulang in triumph on account of which they celebrated their pagan feasts. Added to that is the molestation of the reverend and the boy named Pieter committed in the same village, about which Your Honour has been adequately informed. So it cannot be doubted that they have done as much harm as those of Taccareyan, leaving aside the stealing of goods from the Chinese, who thought their safety to have been guaranteed by the Company's pass. In the present situation, our cause being as it is, I feel that we should be hard on them. Twice so far we have received a great victory out of the hands of the Lord so that all villages fear us. The tougher we are with them, the better we can knead the dough in the future, as far as malefactors are concerned. Your Lordship, may do as it pleases him. What remains can be transmitted orally. (...) The inhabitants tasted the recent victory miraculously well. They took nine heads, and perhaps even ten heads of the enemy. In Sincan the smallpox is getting worse.

(The events of the months November and December 1635 are mentioned in the letter of Governor Hans Putmans to Governor-General Hendrick Brouwer, Tayouan, 18 January 1636,[76] and are summarized in: Dagregister Batavia, 11 February 1636, pp. 18-23, and in: Dagregisters Zeelandia, Volume I, pp. 234-235.

On 23 November 1635 a punitive expedition of five hundred European men, divided into seven companies set out to Mattau under the command of Governor Putmans. Twenty-six villagers of Mattau, men, women, and children were killed in the clash. Their heads were taken as trophies of war by the Sincandians who accompanied the Company troops. The invaders hardly had met with any opposition and burnt the entire village to ashes. On 3 December a delegation from Mattau accepted the following terms for peace:

1). The remains of the murdered Dutch soldiers will be handed over.

2). Symbolic dedication of Mattau and surrounding fields to the Dutch States General by planting pinang and coconut trees.

3). Mattau will never again take up arms against the Dutch nor their allies.

4). Mattau will assist the Dutch in their wars.

5). Chinese burning lime in Wancan or buying deerskins inland will not be molested but will have free passage.

6). Upon orders the village elders will go to the castle without delay and meet the Governor.

7). As penance the elders must bring a big sow and a boar to the fort each year exactly on the day of the crime.

On 22 December another punitive expedition set out to Taccareyan. This time about five hundred Sincandians accompanied the Company troops. The rebellious village of Taccareyan was also razed to the ground.)

NOTES

1. *Hongtsieusou* or '*alias Langen baert*' (Long beard) as he is called in the Dutch sources, probably is the interpreter *Hung Yü-yu*.
2. *Quelang* (Chilung) and *Tamsuy* (Tanshui), two villages in northern Formosa, fortified trading posts of the Spanish from 1626 until 1642.
3. See also: W.P. Groeneveldt, 'De Nederlanders in China, de eerste bemoeiingen om den handel in China en de vestiging in de Pescadores 1601-1624', in: *Bijdragen tot de Taal-, Land-, en Volkenkunde van het Koninklijk Instituut voor Taal-, Land-, en Volkenkunde 48* (1898), p. 176.
4. During their raids in the Bay of Amoy, the Dutch had kidnapped several hundred Chinese whom they held prisoner on the Pescadores with the intention of settling them in Batavia.
5. *Liqueo Pequeno*, old name for Formosa which literally means *little Ryukyu*.
6. The Description of Soulang was, together with a short version of that text (which is included below 16 February 1624), published earlier in: L. Blussé, M.P.H. Roessingh, 'A visit to the past: Soulang, a Formosan village anno 1623', in: *Archipel 27*, (1984), 64-80.
7. A Dutch mile measured about 7400 metres.
8. A type of Chinese vessel.
9. *Capitein China*, name in the VOC sources for *Li Tan*, supervisor of the (illegal) trade between Chinese and Japanese merchants that took place on Formosa.
10. The meaning of these Malay words is respectively: *pig, afraid, rotten, to eat, fish*.
11. *Maccselo* is possibly a corruption of Sinkan/Siraya *mackdiou*: *to make friends*; *Mapilo* from Sinkan/Siraya *mapil*: *to return*. See: Blussé, Roessingh, '*A visit to the past*', note 22.
12. The *Sangir* (Sangihe) archipelago is situated to the north of Celebes (Sulawesi). The *Talaut* (Talaud) language belongs to the Philippine language family.
13. *Joristen*, Muslims, probably Malay sailors from Johore.
14. Chinese on Formosa (*Liqueo Pequeno*).
15. The manuscript does not give the figure.
16. *Cangans*, piece-goods, pieces of cloth.
17. *Liquio*, Formosa
18. See: Resolutions. Tayouan, 17 November en 20 December 1626. VOC 1090, fol. 192-193.
19. *Hamada Yahyōe*.
20. *Hizen-no-kami*, in the documents referred to as *Figensamma*.
21. *Yokota Kakuzaemon*, was secretary to one of the councillors in Edo. Pieter Nuyts called him unreliable.
22. *Hirano Tōjirō*, merchant at the Imperial Court at Miyako (Kyoto).
23. *Seppuku*, popularly known as *Harakiri*.
24. *Bugyō*, Official. Here the title is used for a senior official at the Court of the Shogun in Edo.

26. For the next episode see also: 'Justus Schouten en de Japanse gijzeling, memorabel verhael van den waeren oorspronck, voortganck ende nederganck van de wichtige differenten die tusschen de Nederlanders en de Japansche natie om den Chineeschen handel ontstaen zijn. Een verslag van Justus Schouten uit 1633'. Edited by J. L. Blussé in: *Nederlandsche Historische Bronnen*, deel 5 (Hilversum 1985), pp. 69-110.

27. 120.5 picols raw silk, 18,5000 reals and the assumption of the Japanese debts in China for a period of three to five years.

28. The date is not readable due to the damaged manuscript.

29. A somewhat different version of Candidius' Discourse is published in: Grothe, *Archief voor de geschiedenis der Oude Hollandsche Zending*, III Formosa 1628-1643 (Utrecht 1886) pp. 1-28.

30. *Parts which nature itself wishes to be covered.*

31. a span, c. 22 cm.

32. *Sampan* (Malay) little boat.

33. *In ambush.*

34. Grothe, *Archief Zending*, III, p. 10, reads *Tugin*. The island is also called *Lamey* in the VOC sources.

35. Altar. house.

36. The manuscript reads *'preceptresses'*.

37. *By virtue of our profession.*

38. *Oath.*

39. See: Grothe, *Archief Zending*, III, pp. 28-35.

40. The word is not given in the manuscript. Grothe, *Archief Zending*, p. 32, gives: *errors.*

41. *Cabessa*, headman of a Chinese settlement on Formosa.

42. Candidius had been to Batavia on furlough, were he had married Governor-General Specx's daughter, Sara.

43. *Dungaree*, thick cotton from Bengal.

44. Resolution, Tayouan, 30 April 1631. VOC 1102, fol. 529-529v.

45. The manuscript of VOC 1103, fol. 345 gives: 20 miles.

46. The manuscript of VOC 1103, fol. 345, gives: 15 miles.

47. See: 14 September 1629.

48. The trade embargo which the *Bakufu* had enforced on the VOC as a result of worsened trade relations in Formosa had been lifted when in 1631 ex-governor Nuyts was sent to Japan to explain his past actions.

49. *Dika*, see: introduction and entries of 1628, 1630.

50. Indication of time based on an hourglass: 30 minutes is one glass. Here Junius probably means: 2.30 hours past noon.

51. Junius probably means the same person as messenger *Isbrant*.

52. Senior Merchant Gidion Bouwers.

53. The meaning of these words is incomprehensible. Or does *soulatt* refer to *surat (Malay) letter*, so that *soulatt van den Tion* concerns the fishing licenses distributed by the Company to the Chinese?

54. *Tioulatt (Sioulatt)*, headman of Sincan.

55. Visitor to the Sick, *Jan Gerritsen*, was stationed in Sincan. He dies there shortly before September 1634.

56. See entry 49: *Discourse* (December 1628); in which Candididius describes this ritual.
57. *Ticuta*, one of the elders of Sincan.
58. *Doswan*, one of the elders of Mattau.
59. *Paulus Struys/Stroes*, soldier stationed in Saccam.
60. *Autul*, one of the elders of Soulang.
61. *Maleyer* (Dutch), a Malayan.
62. Sergeant *Teeck Lachnan*, of Irish descent.
63. *Atap* (Malay) roof covered with palm leaves.
64. *Dagregisters Zeelandia*, Vol. I, p. 195 gives: *Tilosien*.
65. *Dagregisters Zeelandia*, Vol. I, p. 195 gives: *Camassurey*.
66. See entry 100: missive Governor-General Hendrick Brouwer to Senior Merchant Nicolaes Couckebacker. Batavia, 12 May 1633.
67. The full description of the island, by Commander Claes Bruyn (VOC 5051), will be reproduced in Volume II.
68. See entry 143: original missive Governor Hans Putmans to the Amsterdam Chamber. Tayouan, 28 October 1634.
69. This letter, of 9 May, has not been found in the VOC archives.
70. *Dackaran* is probably the same person as *Taccaran*, headman of Mattau.
71. *Tcee*, probably a word in Fukien-dialect for Indigo or another plant from which a blue dyestuff is extracted.
72. *Caffer*, (Arab) *Kāfir*, literally means: an unbeliever in Islam. The Arabs also applied this word to dark coloured Pagans in general. In this sense it was taken up by the Portuguese and others. On the Philippine Islands it applied to the Alfuras of the Moluccas and the Papuas of New Guinea, brought into the slavemarket. In this text *Caffer* probably refers to: a dark coloured Company slave.
73. *Joost van Bergen*, a soldier stationed in Sincan who later got promoted to interpreter and visitor to the sick; *Carolus Agricola*, schoolteacher and visitor to the sick in Sincan and Tavocan.
74. *Hambuan*, Chinese merchant.
75. Probably about ten o'clock in the evening.
76. This letter will be published in the next volume on that date. This volume concludes with the summary.

GLOSSARY

a costi	at your place
Atap	(Malay) roof constructed of palmleaves
Attenter	(French) be after someone's blood
Backeleyen	(Malay *berkelahi*) to quarrel
Barang barang	(Malay) goods, merchandise
Cabessa	(Spanish *cabeza*) head, here headman of a Chinese village on Formosa
Canaster	(Portuguese *canastra*) basket
Catty	Chinese weight. 1 *catty* is 16 *taels*; 100 *catties* is 1 *picol*
Constringeren	to order
Emboccadero	(Spanish *embocadura*) river mouth
Gauwicheyt	ingenuity
Gootelingh	small type of gun
Negorij	(Malay) settlement
Pagar	(Malay) fence
Papen	term in the VOC sources for Catholic or pagan priests
Parang	(Malay) machete, chopper
Patatta	(Portuguese *batata*) sweet potato
Patria	(Latin) Fatherland, i.e. the Dutch Republic
Pecceeren	to sin
Picol, picul	(Malay) a man's load. 1 *picol* is 100 *catties* is 125 Amsterdam pounds
Pisang	(Malay) banana
Pitchiaren	to consider
Pragger	grumbler
Raptar	(Portuguese) to kidnap
Raseren	to destroy
Soubath	(Malay *sahabat*) friend, here to beseech someone
Spolieeren	to loot
Tackasach, Tackakusach	Formosan village council
Thail, Tael	Chinese unit of weight and monetary unit
Tyfferen	to tap
Verdeck	upper deck
Villipender	(French) to drag someone's name through the mire
Witt	target

BIBLIOGRAPHY

Beylen, J. van
Zeilvaart Lexicon, viertalig maritiem woordenboek
Weesp 1985

Blussé, J.L., M.E. van Opstall, Ts'ao Yung Ho eds.
Dagregisters van het kasteel Zeelandia, Taiwan 1629-1662
Volume I: 1629-1641, Rijks Geschiedkundige Publicatiën (RGP) grote serie 195
's-Gravenhage 1986

Blussé, J.L., Ts'ao Yung-ho, W. Milde, N.C. Everts, eds.
Dagregisters van het kasteel Zeelandia, Taiwan 1629-1662
Volume II: 1641-1648, RGP, grote serie 229
Volume III: 1648-1655. RGP, grote serie 223
's-Gravenhage 1995, 1996

Blussé, J.L., M.P.H. Roessingh
'A visit to the past: Soulang, a Formosan village anno 1623'
in: *Archipel* 27 (1984), pp. 64-80

Campbell, W., ed.
Formosa under the Dutch, described from contemporary records
(reprint, Taipei 1992) First edition London 1903

Chang Hsiu-jung, A. Farrington, Huang Fu-san, Ts'ao Yung-ho, Wu-mi Tsa,
Cheng Hsi-fu, Ang Kaim eds.
The English factory in Taiwan, 1670-1685
Taipei 1995

Chen Chi-Lu
Material Culture of the Formosan Aborigines
Taipei 1968

Cheng Shaogang
De VOC en Formosa 1624-1662, een vergeten geschiedenis
(Thesis) Leiden 1995

Colenbrander H.T., ed.
Jan Pietersz. Coen, Bescheiden omtrent zijn bedrijf in Indië, Volumes I-VII
's-Gravenhage 1919-1953

Coolhaas, W. Ph., ed.
Generale Missiven van Gouverneurs-Generaal en Raden aan de Heren XVII der Verenigde Oostindische Compagnie. Volume I
Rijks Geschiedkundige Publicatiën, grote serie 102
's-Gravenhage 1960

Groeneveldt, W.P.
'De Nederlanders in China. De eerste bemoeiingen om den handel in China en de vestiging in de Pescadores, 1601-1624'
in: *Bijdragen tot de Taal-, land-, en Volkenkunde van het Koninklijk Instituut voor Taal-, land- en Volkenkunde 48* (1898), pp. 1-598

Grothe, J.A., ed.
Archief voor de Geschiedenis der Oude Hollandsche Zending. Volumes III, IV: (Formosa 1628-1661)
Utrecht 1886, 1887

Heeres J.E., ed.
Daghregisters gehouden in 't Casteel Batavia 1624-1629
's-Gravenhage 1896

Papinot, E.
Historical and Geographical Dictionary of Japan
Rutland, Tokyo 1984

Raben, R., H. Spijkerman, eds. (Inventory by M.A.P. Meilink-Roelofsz)
The Archives of the Dutch East India Company (1602-1795)
's-Gravenhage 1992

Shephard, J.R.
Statecraft and Political Economy on the Taiwan frontier 1600-1800
Taipei 1995

Teding van Berkhout Collection
Algemeen Rijksarchief
Inventory by M.C.J.C. Jansen-Van Hoof
's-Gravenhage 1974

Teeuw, A.
Indonesisch-Nederlands Woordenboek
Dordrecht 1990

Ts'ao Yung-ho, Pau Lo-shih, Chiang Shu-sheng eds.
The Inventory of Dutch East India Company Related Documents (Holan Tung Indu
kungsze you kuan T'aiwan tangan mulu)
Vol. 10 of the *T'aiwanshih tangan, wenshu mulu* Series
Taiwan University, Taipei 1997

Verdam, J., E. Verwijs
Middelnederlandsch Woordenboek
's-Gravenhage 1885-1941

Yule, H., A.C. Burnell, eds.
*Hobson-Jobson, a glossary of colloquial Anglo-Indian words and phrases, and of
kindred terms, etymological, geographical and discursive*
(reprint London, New York 1986) First edition London 1886

INDEX

THE FORMOSAN ENCOUNTER
Volume I: 1623 – 1635 定價720元

編 著 者	L. Blussé, N. Everts & E. Frech
出 版 者	順益台灣原住民博物館
	台北市(111)至善路2段282號
	☎(02) 2841-2611　Fax: (02) 2841-2615
國際書號	ISBN 957-99767-2-4
版　　次	一九九九年三月初版一刷
印 刷 者	國順印刷有限公司
廠　　址	板橋市中正路216巷2弄13號

..

發 行 者	南天書局有限公司
	台北市(106)羅斯福路3段283巷14弄14號
	☎(02) 2362-0190　Fax: (02) 2362-3834
	郵政劃撥 01080538號